CONTENTS

HISTORICAL EPHEMERA SELECTED BY GUSTAV METZGER, JONAS MEKAS

3

DIRECTOR'S FOREWORD

Julia Peyton-Jones

The *Serpentine Gallery Marathon* series is the fruit of a rewarding collaboration between Hans Ulrich Obrist and me – the coming together of two visions for developing experimental and interactive approaches to the presentation and discussion of culture and ideas. For his 2008 book *Formulas for Now*, I suggested the following formula to express the crucial importance and enormous creative benefits of a successful collaboration: '1 + 1 = 11'. This idea that a collaboration can yield greatly more than the sum of its parts has been shown in the union between the Serpentine Gallery Pavilion, which I conceived in 2000, and Hans Ulrich Obrist's 'Marathons', which began as a 24-hour interview event in Stuttgart in 2005 and were launched at the Serpentine in London in 2006.

Our annual Pavilion project represents a rare opportunity for architects who have not completed a structure in England to design a temporary Pavilion, that is sited on the Gallery's lawn for three months, from high summer to the Frieze Art Fair in October. This unique programme offers audiences the chance to experience the extraordinary richness of work by renowned international architects at first hand, comparing year-on-year these structures that take so many different forms. In this way, the public becomes engaged in the debate surrounding the field of architecture, which can often be perceived as forbidding or exclusive. In keeping with the process of working with artists, the Serpentine sets out to realise the vision of the architect or designer for the project as they conceive it, through close collaboration with a team of specialists from the construction industry. The immediacy of this process – six months from invitation to completion – provides an alternative model for commissioning architecture.

The first Pavilion in 2000 was designed by Zaha Hadid and was the genesis of the architecture commission, becoming the prototype for future structures. Other Pavilions were designed by: Olafur Eliasson and the award-winning Norwegian architect Kjetil Thorsen, of the architectural practice Snøhetta, 2007; Rem Koolhaas with Cecil Balmond

of Arup, 2006; Álvaro Siza and Eduardo Souto de Moura with Cecil Balmond of Arup, 2005; MVRDV with Arup, 2004 (unrealised); Oscar Niemeyer, 2003; Toyo Ito with Arup, 2002 and Daniel Libeskind with Arup, 2001. In 2007, Zaha Hadid Architects created *Lilas*, an architectural installation on the Gallery's lawn. The *Serpentine Gallery Pavilion 2008* was designed by Pritzker Prize-winning architect Frank Gehry and engineered in collaboration with Arup. It was conceived as an urban street, running from the park to the Gallery. Gehry's architectural career has spanned four decades and produced public and private buildings in America, Europe and Asia. He has earned many prestigious awards, including the Arnold W. Brunner Memorial Prize in Architecture and the Praemium Imperiale Award. Gehry is also the recipient of the Golden Lion for Lifetime Achievement at the 11th Venice Architecture Biennale, 2008. Notable projects include the Guggenheim Museum Bilbao, Spain; and the Walt Disney Concert Hall in Los Angeles, California.

A series of evenings called *Park Nights*, which runs every Friday from July to October, is held within the Pavilion. In 2006, *Park Nights* spectacularly culminated with the first 'Marathon', the *Serpentine Gallery Interview Marathon*, conceived and hosted by Hans Ulrich Obrist together with Rem Koolhaas, who had designed the 2006 Pavilion with Cecil Balmond of Arup. A 24-hour, non-stop interview event, it featured 68 significant figures in international contemporary culture.

Since then, the *Marathon* format has become deeply intertwined with the Pavilion, whose structure and conception – based on innovation, openness and experiment – provides an ideal context for these unique, participatory events. The *Serpentine Gallery Experiment Marathon* 2007, curated by Olafur Eliasson and Hans Ulrich Obrist, was a series of over 50 experiments that explored ideas of time, space and reality through various models, investigating our understanding of the world and how knowledge is built up over time. This took place in the *Serpentine Gallery Pavilion 2007*, designed by Olafur Eliasson and Kjetil

Serpentine Gallery Manifesto Marathon

Koenig Books

Thorsen of the architectural practice Snøhetta, and it toured as an exhibition and event to the Reykjavik Arts Museum in the spring of 2008.

The *Serpentine Gallery Manifesto Marathon* was the third in the series. It brought together leading artists and practitioners from the worlds of literature, architecture, music, film, activism and philosophical discourse to present their manifestos for the 21st century in front of a public audience. The two-day event took place on 18-19 October 2008, in the *Serpentine Gallery Pavilion 2008*, designed by Frank Gehry. It drew upon the Gallery's close proximity to Speakers' Corner in Hyde Park, a platform used by Karl Marx, Vladimir Lenin, George Orwell and William Morris, among many others. This history was recognised by many of the invited participants, including Gustav Metzger, who created subtle ruptures in between the consecutive performances by projecting a historical manifesto every 20 minutes. This archive has been reprinted throughout this publication, with the kind permission of Museum of Modern Art (MoMA), New York, and the archive of the Tate, London.

We are hugely grateful to all who took part in and advised us on this event, especially to Christian Boltanski for the conversations that triggered this project and to Jonas Mekas for the invaluable loan of his archive of seminal manifestos. The knowledge and experience so generously offered by each participant made this an extraordinary moment. They were, in alphabetical order: Marina Abramović, Rasheed Araeen, Athanasios Argianas, Pier Vittorio Aureli, Pablo León de la Barra, Christian Boltanski, Nicolas Bourriaud, Andrea Branzi, Paul Chan, Peter Cook, Mathieu Copeland, Ekaterina Degot, Jimmie Durham, Brian Eno, Henry Flynt, Yona Friedman, Gilbert & George, John Giorno, Reinier de Graaf, Fritz Haeg, K8 Hardy, HEC/BEC, Susan Hefuna, Eric Hobsbawm, David Hockney, Karl Holmqvist, Stewart Home, Charles Jencks, Terence Koh, Silvia Kolbowski, Hilary Koob-Sassen, Rem Koolhaas, Zak Kyes, Nick Laessing, John Latham, Jean-Jacques Lebel, Manifesto Club, Tom McCarthy, Jonas Mekas, Nathaniel Mellors, Gustav Metzger, Andrey Monastyrski, Ingo Niermann, Richard Nonas, Yoko Ono, The Otolith Group, Claude Parent, Adam Pendleton, Falke Pisano, PLATFORM, Yvonne Rainer, Raqs Media Collective, Giles Round, Lee Scrivner, Tino Sehgal, Taryn Simon, SpRoUt, Barbara Steveni, Matthew Stone, Sturtevant, Mark Titchner, Jalal Toufic, Agnès Varda, Ben Vautier, Mark Aerial Waller, Mark Wallinger, Ai Weiwei, Richard Wentworth, Vivienne Westwood, Stephen Willats and Lebbeus Woods.

The *Serpentine Gallery Manifesto Marathon* was generously sponsored by Kuoni; we are indebted to Nick Hughes, Remo Masala and Naomi Wilkinson from Kuoni and Michelle Nicol for their generous support in this collaboration. We also extend our gratitude to Bernard and Almine Ruiz-Picasso and their Fundación Almine y Bernard Ruiz-Picasso for their support of *Park Nights* 2008.

We are very proud to publish this catalogue as part of our ongoing series, in collaboration with König Books, London, and are very grateful to Franz König for his role in developing the series and for sharing his considerable expertise with us. We are delighted to include illuminating texts by Martin Puchner and Melissa Gronlund and would like to express our gratitude to the participants in the *Serpentine Gallery Manifesto Marathon* who have taken the time to revise and edit their texts, scripts and notes for this catalogue. This handsome publication, the design of which reflects the manifesto in both its performative and typographical form, has been designed by Zak Kyes and features photography by Mark Blower. We thank them, along with Nicola Lees, for her editorial skills and Tom Cobbe for his meticulous copy-editing.

I would like to thank the team at the Serpentine, particularly Hans Ulrich Obrist, Sally Tallant, Head of Programmes, and Nicola Lees, Public Programmes Curator, who brought together the *Park Nights* 2008 series and the *Manifesto Marathon* with the assistance of Mia Jankowicz, Dean Kissick, Capucine Perrot, Koen van Geene and his team at Q2Q. Their dedication and resourcefulness was invaluable. To all the many people mentioned here, as well as those not named but who have played an important role, our appreciation could not be greater.

Finally, the Council of the Serpentine is crucial to the Gallery's success, and our scope and breadth of programming is a result of their commitment and continuing support; our thanks and appreciation are extended to them, as always.

5

Julia Peyton-Jones
Serpentine Gallery Director
and Co-director of Exhibitions and Programmes

MANIFESTO MARATHON

Hans Ulrich Obrist

A 21st-century art centre will utilise calculated uncertainty and conscious incompleteness to produce a catalyst for invigorating change whilst always producing the harvest of the quiet eye.
— Cedric Price

The *Serpentine Gallery Manifesto Marathon* is the third in the Gallery's *Marathon* series – a transdisciplinary model which I conceived has become deeply interwoven with the annual Pavilion commission, the world's first and most ambitious architectural project of its kind, conceived by Julia Peyton-Jones in 2000. These commissions adopt Cedric Price's view that the architect should not be content with being a mere designer of hardware, but should demand an even broader responsibility for creating activity programmes and determine how they could be integrated. This relationship is integrated into the Pavilion commission through both the *Park Nights* programme and the *Marathon* series – to construct a truly holistic relationship between the building and the content of the building – creating a platform for the production of reality.

The *Manifesto Marathon* was the concluding event in the Serpentine Gallery Frank Gehry Pavilion 2008. Part-amphitheatre and part-promenade, the open pavilion-street made a transformative place for education and knowledge production. We were delighted to have worked with some of the most incredible figures from the world of architecture in this year's *Manifesto Marathon* – Pier Vittorio Aureli, Andrea Branzi, Yona Friedman, Charles Jencks, Claude Parent and Lebbeus Woods. Rem Koolhaas was represented by Reinier de Graaf reading *The End of the ¥€$ Regime*, and at the conclusion of his *Serpentine Gallery Manifesto Marathon* presentation, Archigram's Peter Cook took a moment to consider that the 'great tragedy of recent years' was the early death of Cedric Price: 'I can imagine him at one of these *Marathons*.' The temporality of the annual Pavilion programme and the statement of Gehry's structure are reminiscent of both Price's idea of the pavilion being a flexible cultural machine (*Fun Palace*) and his plans for a university built on the

rail and motorway network, where different stations would become places of knowledge production – a 'class room on the move' (*Potteries Thinkbelt*). These unrealised projects can be seen as instructional models, recipes or triggers for artists and architects to engage with public space and reclaim it in new and critical ways.

This 2008 futurological congress began with many conversations about the possibility of manifestos for the 21st century. Perhaps this could be perceived as an optimistic call for collective action, as we live in a time that is more atomised and has less cohesive artistic movements. However, there seems to be an urgent desire for a radical change that would propose a new situation rather than going backwards, to name the beginning of the next possibility. In his essay 'Utopistics', the American sociologist Immanuel Wallerstein wrote about historical choices of the 21st century exploring what are possible better – not perfect, but better – societies within the constraints of reality. The notion of 'Choices' is revered in Zak Kyes and Ingo Niermann's collaboration (on page 126). As a mode of deployment, the manifesto requires an opposition for it to create such a rupture. We travel from dreams that were betrayed to a world system, which goes beyond the limits of the 19th-century paradigm of Liberal Capitalism. As Wallerstein pointed out, 'If we look at a lot of movements around the world, local and social movements, what they are objecting to in many ways is commodification.' New structures of knowledge are an important aspect of new emerging world systems.

The manifesto is a transdisciplinary device, a history that is addressed in Martin Puchner's recent publication *Poetry of the Revolution: Marx, Manifestos and the Avant-Gardes*. He breaks the history of manifestos down into three phases; first, the emergence of the manifesto as a recognisable political genre in the mid 19th century (*The Communist Manifesto*, 1848); second, the creation of avant-garde movements through the explosion of art manifesto in the early 20th century (*The Futurist Manifesto*, c.1909); and third, the rivalry between the socialist manifesto and the

avant-garde manifesto from the 1910s to the late 1960s. Fifty years later, it could be said that this rivalry has faded, along with the political opposition. In the beginning, the art manifesto did not 'merely register art's political ambitions', it changed the 'very nature' of the art work itself. 'The manifesto forged an art in its own image: aggressive rather than introverted; screaming rather than reticent; collective rather than individual.' This has traditionally been the case of manifestos in the arts; however, it could be said that the 21st-century art manifesto appears to be more introverted rather than aggressive, reticent rather than screaming, and individual rather than collective.

The striking commonality between the artistic or political manifesto is its intent to cause a collective rupture, and like almost all manifestos in the past, in its form as a group statement, representing some collective 'we'. The Marxist historian Eric Hobsbawm noted that this is certainly the case of all political manifestos he can think of. 'They always speak in the plural and aim to win supporters (also in the plural).' Genuine groups of people, sometimes built round a person or a periodical, however short-lived, were conscious of what they are against and what they think they have in common. A history that he acknowledges is embedded in the last century. What now?

At the beginning of the research for the *Manifesto Marathon*, Tom McCarthy opposed our optimism by stating:

What interests me about the manifesto is that it's a defunct format. It belongs to the early 20th century and its atmosphere of political and aesthetic upheaval. The bombast and aggression, the half-apocalyptic, half-utopian thrust, the earnestness – all the manifesto's rhetorical devices seem anachronistic now. For that very reason it's compelling, in the way a broken bicycle wheel was for Duchamp. Things that don't work have great potential.

This reflects Jean-Pierre Wilhelm's 1963 question, 'Should a manifesto be launched today?', adding the observation that the 'heroic period of the manifesto is over'. In his essay for this publication, *Manifesto = Theatre*, Puchner refers to this statement in conjunction with George Maciunas's *Fluxus Manifesto*, suggesting that this declaration was set up from the beginning, one might say staged as a belated manifesto; a text that must work through

its relationship to the manifesto, a genre it can no longer inhabit without reservations or doubts. Puchner concludes that in 1963, there was the sense that the manifesto was history, and once history the manifesto's futurist performativity can no longer exert its full force.

For the *Serpentine Gallery Manifesto Marathon*, a wide range of practitioners were invited, including the Fluxus artists John Giorno, Jean-Jacques Lebel, Jonas Mekas, Yoko Ono and Ben Vautier to present artistic manifestos for the 21st century. Mekas read from Ayn Rand's *The Romantic Manifesto: A Philosophy of Literature* over the slides of his *Summer Haikus*. Lebel's performance was beyond conventional language, expressing anger, surprise, disbelief and disdain in both his voice and gesture. He later described the *Marathon* as a tribal blast, while quoting Marx, 'Our task is no longer to interrupt the world, but to change it.' He proposed that for art to break out of the capitalist mould and away from its 'normal' and 'authorised' role as a mere commodity, it should involve the beholder's perception system as well as its underlying belief system and act upon them in a collaborative mode. It could be said that Terence Koh's *Snow White* matched Lebel's new language, as he talked in his own coded dialect, simultaneously screening a fast-paced PowerPoint presentation that punched each image at the audience, whilst dressed as a geisha in four-inch heels, knee-high boots, stylised armour-like clothes, full make-up and wig.

In Stewart Home's 1984 *Proclamation of the Generation Positive*, he considers the history of the manifesto's own prophetic genre and through acknowledging its various forms and traditions, a different picture emerges, one not of rupture but of repetition. In his publication of *Neo-ist Manifestos*, Home calls this 'positive plagiarism' delivered through his 'collective pseudonyms' and uses the example of his 'Art Strike Biennale' 1990-93 (logo on page 108) as a reference to the year in which he plagiarised Gustav Metzger's Art Strike proposal of 1977-80.

We would like to thank all the performers and actors that were involved in many of the group recitals. After the group reading of Vivienne Westwood's *Active Resistance to Propaganda*, she stated that the manifesto is a 'practice': 'Read it again – it might make you change your opinion of things.' Marina Abramović conducted an ensemble of actors in *An Artist's Life Manifesto*. Mark Titchner's *Feel Better Now (Apathy and the New*

7

Sincerity) was performed by Jonny Woo – who wore a tight green spangly leotard, but often donned more outfits, including a wig, dress, monster feet and the Union Flag, as he declaimed the manifesto. Susan Hefuna collected postcard manifestos from the public with their spontaneous manifestos inscribed, which were read out in quick succession by two actors on opposing sides of the Pavilion. *Younger and Stronger Men* by Silvia Kolbowski was read by two actors, standing at lecterns on opposite sides of the Pavilion, reminiscent of the House of Commons, accompanied by a slide show of audiences listening in different contexts. Barbara Steveni's #1 *Context Is Half the Work* described the central axiom developed by APG (Artist Placement Group) in the 1970s and included quotations from an interview between Tony Benn, MP, and her.

Tino Sehgal stated that he hoped that manifestos in the 21st century would be more like a dialogue rather than the blinkered prescriptions of the 20th century. Nicolas Bourriaud suggested that the historical period defined by postmodernism was coming to an end. In its place, he proposed the model of altermodernity, characterised by translation, unlike the colonialist language of 20th century Modernism or identity-orientated postmodernism. In their *Taverna Especial*, Round & Waller enacted a translation of marathon, dispensing silver blankets and handing out reviving pumpkin soup.

Jeebesh Bagchi, Monica Narula and Shuddhabrata Sengupta of Raqs Media Collective (collaborating since 1992) subtly wrote *Fragments from a Communist Latento* on steamed-up windows. In salons around East and South London, Matthew Stone has discussed the theme of *OPTIMISM AS CULTURAL REBELLION*. SpRoUt also replied to our optimistic call for action by collectively writing, editing, borrowing and performing over the two days. Performance was the chosen medium also for Athansios Argianas and Lee Scrivner the former a cyclical song on the nature of time, the latter an allegorical play on the recent financial collapse. The notion of time was discussed, albeit elliptically, in Mark Wallinger's *Make Me Think Me* (along with everything from Bruce Nauman to Itchy & Scratchy) and in Falke Pisano's two-part *Manifesto Machine*, in which the first part explored doublings in various concepts, and the second was a subjective navigation of the first. Like Pisano, Taryn Simon investigated perception, but this time as a psychological experiment. Sturtevant's film

8

Dumbing Down & Dunkin' Doughnuts juxtaposed another cartoon character, Betty Boo, with slogans and, of course, the eponymous doughnuts.

In Nick Laessing's performance, a scientist explains in a talk show how limitless, free energy could be tapped. The control of energy was also critically addressed by the campaigning body PLATFORM and by Brian Eno in The ThankYou Party's call for action. Rasheed Araeen also addressed ecological responsibility in a discussion about transforming desalination plants into an artistic project. Jimmie Durham's *No More Silly Hats* looked towards a world government in order for us to influence our own evolution. Durham proposed that we need a biology of money, while Koob-Sassen's *Faith in Infrastructure* described how the elaborative trajectory from economies to organs is paracultural in that it advances across the lifetime of many cultures, in the same way that evolution advances across the lifetimes of many creatures. The avant-gardener Fritz Haeg presented *London: A Manifesto from Your Animals*, while Agnès Varda used the narrative of the Potato Story to offer new strategies. The Otolith Group borrowed the identities of two famous Indian film directors to expound on the nature of threat.

In this moment, there was a tendency towards an increase in the number of manifestos that addressed the de-commodification of institutions. Doug Fishbone represented the collective Manifesto Club in its proposition for *Towards a Free Art School*. K8 Hardy's *WAGE* manifesto drew attention to the economic inequalities in the arts and how to set about resolving them. Ekaterina Degot believes that 'ÜBERcontemporary art has become torture through consumption and not through the inaccessibility of consumption.' We would also like to thank Degot for liaising with Andrey Monastyrski, one of the founding members of Collective Actions.

David Hockney in his pro-smoking manifesto explains that you 'can't measure pleasure' and calls for us to 'stand up against the dreary conformity that is spreading much too fast'. Nathaniel Mellors's cultural conspiracy presented ideas for the future by relaying the history of manifestos through the hijacking of language, stating that:

> *Orwell identified* writing on art *and* political speech writing *as synonymous in their commitment to vague, debased, disingenuous and manipulative WORDAGE! Wordage.*

The word 'terror' is, of course, the biggest example of a hijacked word – the word 'terror' has itself been taken hostage.

Jalal Toufic believes that we should not go to hell for the sake of watching a film. Henry Flynt might well agree with this sentiment, his *CINACT* manifesto against abstract cinema provides an extremely detailed alternative. Richard Nonas, on the other hand, suggests that we start appreciating the value of garbage. In his presentation at the *Marathon*, Richard Wentworth encouraged us to think about the origin and function of materials, while Stephen Willats proposed that artists use the new communication possibilities offered by the internet to escape from the commodification trap. Yvonne Rainer's remote manifesto reflects the history of her 1965 declaration in a parallel 2008 manifestation. Similarly, Pablo León de la Barra & Mathieu Copeland play on the notion of a centre being both a physical structure and a hub. Ai Weiwei's blog posting discusses, amongst other topics, the nature of symbols, while Christian Boltanski's project documents something that is so basic yet so laden with symbolism, the heartbeat.

We are extremely grateful to Jonas Mekas for the loan of his archive – from which the *Film-Maker's Cooperative Manifesto* for 1962 (reprinted on page 146) gives clear directions on how to sustain a disorganised organisation – and to Gustav Metzger for the archival presence of historical manifestos that he has substantiated in this publication.

According to Zak Kyes, a participant at the *Marathon* (and the designer of this book):

The printed form of manifestos has always been inseparable from their radical agendas, which engage the act of publication and dissemination as sites for debate and exchange rather than mere documentation. For this reason, it is prescient to revisit the clarity and articulation – or, in many cases, wilful obfuscation – of published manifestos today, a time which is defined by a panoply of publications as voluminous as they are homogenous.

It is by design that this publication and its prologue, the Manifesto Pamphlet, *privileges the production and duplication of texts, conversations and performances over their formal presentation, and in so doing, re-engages with the idea of publications as tools for knowledge production.*

We hope that this event and anthology become a future archive that maps the possibilities as well as doubts of the 21st-century manifesto. For one thing is certain: without some kind of a manifesto, we cannot write alternatives that are more than vague utopias; without a manifesto, we cannot conceive the future. As Eric Hobsbawm noted, 'Of course, the trouble about any writings about the future: it is unknowable. We know what we don't like about the present and why, which is why all manifestos are best at denunciation. As for the future, we only have the certainty that what we do will have unintended consequences.'

In his 1984 manifesto, Home also demands 'the introduction of International Poetry Service – during which, all youths aged between 18 and 20 years are to be instructed in the composing and performance of BRUTIST, SIMULTANEIST and STATIC poetry'. Poetry and prose was delivered by Paul Chan, Jimmie Durham, Gilbert & George, Yoko Ono, Adam Pendleton and Karl Holmqvist in his manifesto *You Blew Up My House*.

Let me hear you say
One World, One Love
Let's all ghettogether
And feel alright.

We will continue the search to go beyond the fear of pooling knowledge with the *Serpentine Gallery Poetry Marathon* 2009 and look forward to a new poetic rupture and its subsequent revolution.

I would like to thank Julia Peyton-Jones; without her this *Marathon* would not have happened. I would also like to join her in thanking everyone that has been involved in this project, the participants, all the advisors and the team at the Serpentine Gallery, especially to Sally Tallant, Head of Programmes, and Nicola Lees, Public Programmes Curator.

We would also like to thank Luca Molinari for Skira's participation in the *Manifesto Marathon* and their collaboration in the publication of the full proceedings of the *Serpentine Gallery Interview Marathon* 2006.

Hans Ulrich Obrist
Serpentine Gallery Co-director of Exhibitions and Programmes and Director of International Projects

9

SPONSOR'S FOREWORD

Nick Hughes,
Managing Director, Kuoni

In an exciting journey to discover the future of travel, Kuoni has partnered with a series of prominent experts from the worlds of contemporary lifestyle, fashion, art, architecture, music and literature. A central part of this was a collaboration with the Serpentine Gallery and its *Manifesto Marathon* on 18 and 19 October, 2008. Kuoni was proud to be the headline sponsor of this extraordinary event. Through this partnership, we collected new perspectives on travel and have developed these into a 'new culture of travelling' – a selection of luxury, unique and authentic travel experiences.

The Kuoni–Serpentine Gallery relationship is based on a common sense of curiosity and passion for innovation. Moreover, the concept of the *Serpentine Gallery Manifesto Marathon* closely mirrors the Kuoni Getaway Council – an ever-evolving group of prolific experts and innovative thinkers from different fields, industries and countries – which was set up as a platform for exchanging ideas and finding new ways to innovate in travel. With a deeper understanding of contemporary culture resulting from these forums, Kuoni aims to cross new borders and deliver services that go beyond the conventional travel agency.

Kuoni believes that service and knowledge – across the worlds of contemporary lifestyle, fashion, art, architecture, nature and urbanity – are fundamental to the new culture of travelling and to driving the industry standards forward into the 21st century.

KUONI

SCHEDULE: SATURDAY 18 OCTOBER

Hours	Participant	Title
12.40 13.20	Vivienne Westwood	Active Resistance to Propaganda
13.40	Pier Vittorio Aureli	Dogma, Architecture Refuses
14.00	Hilary Koob-Sassen	FAITH IN INFRASTRUCTURE
14.20	Ingo Niermann & Zak Kyes	The Choices
14.40	Elaine Sturtevant	DUMBING DOWN AND DUNKING DOUGHNUTS
15.00	Rasheed Araeen	ART BEYOND ART (The Barbarism of Civilisation must end) A Manifesto for the 21st Century
15.20	Peter Cook	Expanding and Dissolving Architecture
15.40	Taryn Simon	THATCHER EFFECT
16.00	Richard Wentworth	Da Do Ron Ron
16.20	Gilbert & George	The Laws of Sculptors Ten Commandments for Ourselves
16.40	Ben Vautier	I don't know what to do
17.00	Jonas Mekas	SUMMER HAIKUS: A MANIFESTO
17.20	Jean-Jacques Lebel	What has to change if we want the world to be better?
17.40	Tom McCarthy	INS Declaration Concerning the Relationships between Art and Democracy
18.00	Mark Wallinger	Unmarked
18.20	Yoko Ono	THEN AND NOW
18.40	Barbara Steveni	#1 Context is half the work
19.00	Ekaterina Degot	The Manifesto of Inferiority Complex
19.20	RAQS MEDIA COLLECTIVE	Fragments from a Communist Latento
19.40	Nathaniel Mellors	The Ill-Tempered Manifesto or A New Aging Manifesto or The New Old Manifesto
20.00	Lee Scrivner	THE SOUND MONEYFESTO
* * * *	* * * * SET CHANGE * * * *	* * * * * * * * * *
20.40	Andrea Branzi	Seven Suggestions for the New Athens Charts
21.00	Henry Flynt	The Cinact Manifesto
21.20	Marina Abramovic	An Artist's life
21.40	Agnès Varda	What to do? How to do it? [A potato story]
Remote Participants		**Title**
	Christian Boltanski	Les Archives du Cœur (Archives of the Heart)
	Paul Chan	Sex and the New Way V.1
	Yona Friedman	New Context
	John Giorno	IT DOESN'T GET BETTER
	David Hockney	Manifesto for Smoking
	John Latham	Is there a black hole megatruth at the centre of the 20C trajectory..?
	Gustav Metzger	Slides of Manifestos
	Yvonne Rainer	A Manifesto Reconsidered
	Jalal Toufic	Don't go to hell for the sake of finishing watching the film

SCHEDULE: SUNDAY 19 OCTOBER

Hours	Participant	Title
06.30	HEC and BEC	Provisional Protocol for the Hyper/Brutally Early Club
10.00	Manifesto Club	For a Free Art School
10.20	Susan Hefuna	Cairo Postcard Manifesto
10.40	Stephen Willats	Explain Yourself
11.00	Falke Pisano	Manifesto Machine
11.20	Adam Pendleton	1902
11.40	Claude Parent	Paris noyée, Londres au fond de la Tamise, quelle architecture?
* * * *	* * * * * * * SET CHANGE * * * *	* * * * * * * *
12.20	Jimmie Durham	No More Silly Hats
12.40	Nicolas Bourriaud	Altermodern Manifesto
13.00	PLATFORM	An Anti-Manifesto for Democratic Action on Climate Change
13.20	The Otolith Group	A Field Manual for Dyschronia
13.40	Tino Sehgal & Hans Ulrich Obrist	
14.00	Karl Holmqvist	You Blew Up My House
* * * *	* * * * * * * SET CHANGE * * * *	* * * * * * * *
14.40	Nick Laessing	The place of the material world in the universe is that of an exquisitely beautiful precipitate or varied cloud-work in the universal aether
15.00	Terence Koh	SNOW WHITE
15.20	Stewart Home	Art Strike Biennial
15.40	Mark Titchner	FEEL BETTER NOW (Apathy and the New Sincerity)
16.00	KB Hardy	The Droid Manifesto
16.20	Rem Koolhaas	
16.40	Fritz Haeg	London: A Manifesto from your Animals
17.00	Charles Jencks	Manifesto³
17.20	Eric Hobsbawm	A Century of Manifestos
17.40	Athanasios Argianas	Manifesto of Non-durational Time
18.00	Silvia Kolbowski	Younger and Stronger Men
18.20	SpRoUt	Manifesto for Multiplicity
18.40	Brian Eno	The Thank You Party
19.00	Mark Aerial Waller and Giles Round	Taverna Especial
		– END –

Serpentine Gallery Manifesto Marathon, event schedule, *Manifesto Pamphlet*, October 2008

A pamphlet for the <u>Serpentine Gallery Manifesto Marathon 2008</u>:

I. The historic avant-gardes of the early 20th century and the neo-avant-gardes in the 1960s and 70s created a time of radical manifestos.

2. We now live in a time that is more atomised and has less cohesive artistic movements.

3. At this moment, there is a reconnection to the manifesto as a document of poetic and political intent.

4. This is a declaration of artistic will and new-found optimism.

5. New modes of publication and production are a means to distribute ideas in the form of texts, documents, and radical pamphlets.

6. This futurological congress presents manifestos for the 21st century. This event is urgent.

Serpentine Gallery Manifesto Marathon, cover, *Manifesto Pamphlet*, October 2008

THE MANIFESTO: WHAT'S IN IT FOR US?

Melissa Gronlund

Mark Antony's famous 'I come to bury Caesar, not to praise him' was the unexpected *leitmotiv* of the *Serpentine Gallery Manifesto Marathon*, where participants used the platform of the manifesto to interrogate a number of its basic assumptions, questioning its legitimacy as a form of current expression. 'I have no wish to make, in my view, a very male declaration of my intents. I think that is something which is very 20th century,' said Tino Sehgal in his contribution. Richard Wentworth opened his remarks with: 'I think that manifestos are really disturbing. I'm not a manifesto man.' Eric Hobsbawm confessed, 'I have no manifesto to propound, and I don't think I've ever drafted such a document.' Stephen Willats explained that in the 1990s he decided that the manifesto was redundant: 'It's like the radio – a relic.' Nathaniel Mellors delivered a fictional manifesto via an old tape cassette player, remaining behind the scenes. Vivienne Westwood conceded about the manifesto she delivered: 'I wrote it a couple of years ago. I don't know if I would have the heart to write it now…'. Rather than an explosive staccato assault of manifestos over the course of the two-day *Marathon*, the Serpentine Gallery's 2008 project became a circling look at a political and artistic form that seems, all of a sudden, a pariah.

Manifestos arose with the emergence of the public sphere, for example in 17th-century England's 'pamphlet wars' – the era of the coffee houses, when mass printing and public spaces allowed the open formation of public opinion – and during the French Revolution in the late 18th century. Both in its intentions and its free form of distribution, the manifesto participated in the project of the defining and declaring the universal rights of man. As in the manifesto's later artistic or Modernist projections, it utilised the rhetoric of an 'us' versus a 'them': the 'us' of idealism and progressivism, and the 'them' of reaction and tyranny. (This 'we/them' dichotomy was also, as 'we' shall see, the sticking-point for Sehgal, Willats and others.) While this binary is important in defining the genre of the manifesto – it distinguishes it from a public speech or advertisement, for example – in fact, the 'genre' of the manifesto is often difficult to characterise. Style matters more than what the manifesto might intend to say, and equally more than its form. Martin Luther's *Ninety-Five Theses*, which appeared as a list nailed to the door of a Wittenberg church in 1519, and Jonathan Franzen's 'A Reason to Write Novels', a defence of literature published (in an essayistic style) in the magazine *Harpers* in 1996, both qualify. In a study of the genre, Janet Lyon writes that '"Manifesto" might be shorthand for a text's particularly stridency of tone… the term refers both to the form and to the passional state (frustration, disappointment, aggressive resolve) that precedes or engenders the text. To call a text a manifesto is to announce ahead of time its ardent disregard for

good manners and reasoned civility.'[1] This stridency finds its rhetorical structure in the exhortatory mode of address, while allowing itself to be rude – secure in its belief in the urgency of the accomplishment of its goals.

These ends may be artistic, literary, social or political, but their accomplishment is key. Whereas the essay, advertisement or political speech aim to persuade, in the manifesto, persuasion is prior – 'we' have been persuaded, 'this' is what is going to happen, 'they' are already behind. Barnett Newman writes, for example, in his 1968 'The Sublime Is Now': 'I believe that here in America, some of us, free from the weight of European culture, are finding the answer... We are reasserting man's natural desire for the exalted, for a concern with our relationship to the absolute emotions...'.[2] The revolution, it would seem, is already come. But in fact the manifesto is integral to the delivery of the revolution: the perfect manifesto caps a rising wave of sentiment and gives it a name and, with it, an articulated, tangible identity. It voices what is already there ('man's natural desire for the exalted') and, in so voicing it, creates it (the new sublime). In this sense, the manifesto oscillates between a mode of deixis (pointing at something) and perfomativity, calling it into being ('I now pronounce you man and wife', in the most famous example, or equally all utterances of Yahweh, the Hebrew name of the Judeo-Christian god).[3] It would be interesting as a research project to look into the historical role of manifestos within movements: Communism would have existed without the *Communist Manifesto*, but the rousing call of the 1848 text gives speakers an intelligible agency that has been utilised at key moments in the movement. Reading a manifesto, crucially, is pleasurable, like listening to a rousing public speech – but whereas people are known for being great public speakers (Barack Obama, Hugo Chávez, Margaret Thatcher), the skill of the manifesto is often ascribed not to the writer but to the force of its idea.

* * *

The first of the Serpentine Gallery's 'marathons' was the *Interview Marathon* in 2006, where Obrist and Rem Koolhaas interviewed 68 speakers in one single day, neither sleeping nor stopping. The format dices with the content it is meant to engender, and runs the hazard that the form of the *Marathon* and the physical constraints it places on participants will overtake their ability to deliver reasoned responses: a mind versus body scenario, enacted – with high-profile candidates and high risk – in public. To sit through one is less like hearing a lecture at university than enduring a screening of Andy Warhol's *Empire*; a sense of community and achievement develops by the end, and fluctuations in attention level, bodily warmth, boredom and inspiration are felt in common across the crowd. The idea of a *Manifesto Marathon* entails a certain back-to-frontness, indicating a need for a 'manifesto' rather than a manifesto stemming from a 'need'. Here was a built-in audience, sitting to hear the different tracts

13

1 Janet Lyon, *Manifestoes: Provocations of the Modern* (Ithaca, NY: Cornell University Press, 1999).
2 Barnett Newman, 'The Sublime Is Now', in Charles Harrison & Paul Wood (eds) *Art in Theory* (Oxford, UK, and Cambridge, MA: Blackwell, 1993), p. 574.
3 In Hebrew 'Yahweh' means 'I am what I am', making Yahweh himself a performative construction.

on offer. It was a mode similar to that of Speakers' Corner: manifestos being hawked, as it were, and the public shopping. The association of Speakers' Corner with the fringe elements of society is not far off, either: the programme drew out the absurdity inherent in the manifesto, in the *chutzpah* of its performative act. Again, in a Judeo-Christian sense, the power of calling things into being through speech is a founding claim of Yahweh's godhood (Moses, for example, while he led the Jews out of Israel and laid down the Ten Commandments, had a speech impediment). If a manifesto is not backed up by grass-roots sentiment, the speaker looks like a loony, a false idol, preaching assertions that come from nothing; a comedic scenario Monty Python played to perfection in *Life of Brian* in the accidental soapbox scene. One of the most popular manifestos in the *Marathon* was the series of Fluxus actions performed by Ben Vautier in a spirit of wilful meaninglessness: the sound of a sheet of paper burning, the sound of paper crinkling, the act of ribbon being cut. Sharing a unity of form and action in the same way that a manifesto does, the action rendered its deictic quality as tautology: 'My last piece', Vautier said, 'is titled *Big Smile*,' and he smiled.[4] Mellors gave his manifesto, delivered via an audiocassette player, in the crackly, manic tone of a madman ranting about the future; the orientation of the manifesto towards the future, and the claims it lays over it, appeared themselves marks of insanity.

Jean-Jacques Lebel, immediately following Vautier, delivered a manifesto in a made-up language. Fritz Haeg delivered manifestos from the animals of London, giving voice to the concerns of the bee, the hedgehog and the grey heron. In both the first case (Lebel's restricted ability to communicate) and in the second (the animals' hyperbolic ability to communicate), the problem of the manifesto as an ill-functioning mode of communication was made clear. This was the complaint made by Willats, who described manifestos as a 'one-way radio', and similarly by Sehgal, who continued his prefatory remarks by saying that he thought that the 21st-century (unlike the unyielding pronouncements of 20th-century manifestos) 'will be, hopefully, more like a dialogue'. (His contribution was, indeed, a conversation between himself and Obrist.) Yoko Ono handed out torches to the audience so that they could respond to her message of fraternity, blipping out 'I' 'love' 'you' to each other in an abbreviated Morse code, and then she concluded the performance by inviting the audience to dance. Mark Aerial Waller and Giles Round handed out pumpkin soup and silver blankets, as if at the end of a running marathon, to the freezing audience. Hobsbawm – who spoke of the hijacking of the manifesto by the corporate mission statement – took questions from the crowd.

Traditionally, manifestos start out as credos, and subsequently move from 'I' to 'we' by linking a specific set of circumstances to larger abstract beliefs: from the break-down of King Charles I's royal authority to a struggle for greater political and religious liberties during the English Civil War (invoked in the manifestos of

14

4 As Elizabeth Legge points out, this notion of 'manifestos' in the negative was in place during the heyday of manifestos: as a sally in André Breton's repeated attempts to discredit Tristan Tzara, he labelled him a mere 'writer of manifestos'. See 'Lâchez tout?', in which he lumps Tzara with the manifesto writers Marinetti and Baju, in *Les Pas perdus* (Paris: Gallimard, 1969), p. 104.

this period), or from the inadequacies of Expressionism *vis-à-vis* the post-World War I destruction to an art practice of living rather than making work (e.g. the First German Dada Manifesto of 1919/20). This transition from 'I' to 'we' accounts for much of the seductiveness of the manifesto: it places the individual not alone in the universe but held within a variety of shared beliefs, and equally allows the field of abstract pronouncements to exist within the individual's grasp. Postmodernism's movement away from grand narratives loses this sense of belonging. In being reformulated as 'conversation' or 'proposal', the manifesto no longer seeks to justify its claims by invoking a larger belief; instead, it seeks not justification but response. The 'I' moves to 'you' without ever rising to 'we' and 'they'.

While it is the 'we/they' axis that proved most contentious in the *Marathon*, it reappeared throughout the contributions, shaded either with anxiety, apology or caricature. Topics ranged from architectural proposals, the economic crisis, the nature of art, the dependency on oil, gender relations and the ticket price of the *Marathon*. Generalities flew forward in a short staccato style, as if revelling in the loss of the need to justify, mixing genuine belief with a style that was knowingly parodied, like someone who can only express their feelings through jokes. Delivered in the format of the *Marathon*, in which 52 manifestos were heard over the period of 18 hours, reasoned arguments subsided, and emphatic statements became more pronounced, allowing the idea of the manifesto to emerge as a series of disjunctive quotations.

Pier Vittorio Aureli: **'No new-architecture-invented-every-Monday-morning, no fashions, no personal creation, no obsessions, no *jeu savant*, no pouring-concrete-in-whatever-shape, no symbolism, no rhetoric, no salvation-of-the-world-with-architecture, no Merzbau, no unspeakable spaces, no excitement, no enthusiasm, no imagination-free-from-constraints...** 15

Rasheed Araeen: **'This manifesto for the 21st century would therefore be for the artists to... focus their imagination onto what is there in life, to enhance not only their own creative potential but also the collective life of earth's inhabitants.'**

Gilbert & George: **'Ban religion. Ban religion. Ban religion.'**

This investigation of the general 'we/they' as a problematic construction was effected with perspicuity in Marina Abramović's performance, in which she conducted a group of young people – women in strapless red dresses and high heels, the men in white suits – in a series of aphorisms. Delivered as universal laws (the participants' costumes were themselves a pretence towards universality – the red standing for menstrual blood, and the white for sperm) they drew their force from their direct contradiction of Abramović's personal experience, for example:

**'An artist's relation to his love life:
An artist should avoid falling in love
with another artist.'[5]**

**'An artist's conduct in relation to work:
An artist should avoid his own art pollution.'[6]**

Abramović's manifesto, instead of being a performative exercise, was turned inside-out: it was a theatrical representation of a manifesto in negative. The reverse credo, made with the artist's back to the audience, operated in the mode of irony – where pronouncements are both true and untrue at the same time – and so excluded from the mode of the manifesto as traditionally defined.

* * *

The event ended with Agnès Varda, who appeared dressed in a potato costume below a projection of a film she made about consumerism and poverty (it was comprised of excerpts of her earlier work and new material). She accompanied the film with a microphone, at times letting the film play without her, at others echoing the pre-recorded narration. The film ended with a near-static tableau of a nude man and woman; as the camera pulled back to reveal more of their bodies, it became clear that the man, no passive Adam, was aroused. Varda's honest, self-mocking and loving tribute to sharing and partnership perhaps achieved Willats's two-way-radio status, and her use of real and recorded time, past and present, suggested a co-existence of times that the manifesto's 'rupture' moment excludes. This continuity is found also within the idea of the *Marathon*, in its investigation of what happens as subjects move together through time. In such a way, the *Marathon*, with its glimmers of madness and irony, formed a different kind of manifesto out of the 'we' who watched it.

5 Throughout the 1970s, Abramović worked and performed with her lover, the artist
 Ulay (Uwe Laysiepen).
6 In 2005, Abramović, in the project *Seven Easy Pieces*, reperformed seven key works
 from her own repertoire.

MANIFESTO = THEATRE

Martin Puchner

In his *Ontological-Hysteric Manifesto I*, 1972, Richard Foreman evokes the equation between theatre and manifesto without however committing to their identity. Both terms, manifesto and theatre, refer to the act of making visible: 'manifesto' is derived from the Latin verb *manifestare*, which means 'to bring into the open, to make manifest' and 'theatre' from the Greek *theatron*, 'a place of seeing'. But this kinship, this alliance in visibility, does not justify something as absolute and categorical as a mathematical equation. It is for this reason, perhaps, that Foreman deploys the formula theatre=manifesto hesitantly, or rather, he takes its three components (manifesto, =, theatre) and reassembles them in a more open-ended fashion:[1]

MANIFESTO =
THEATER =

When reconfigured this way, manifesto and theatre are not said to be same, and they cannot, as a simple equation would have it, be transformed effortlessly into one another. Instead, they are placed in a parallel relation, each equipped with its own equation sign.

Our eyes move to the right side of the page, looking for what manifesto and theatre might be equated to, and we find three more equations: 'life=move towards'; 'art = suspension'; 'Our craft = how suspend in place, make 'em rise.' The proliferation of equations is not the only difficulty we encounter in reading Foreman's manifesto, for it is written in two modes: printed matter (letters and mathematical signs) and hand-markings. There are arrows, underlinings, drawings of people and houses, and a graphic chart. These drawings set the background or scene for the printed words; they also comment on the words, reinforcing and questioning their meaning. An unsteadily drawn line, for example, separates the 'Manifesto= / Theater =' formula from the three equations on the right. And while the manifesto begins with a reflection on the manifesto and its relation to the theatre, it concludes, like a play, with the words 'The End'. As this putative manifesto progresses, the boundaries between manifesto and theatre become increasingly porous, so that some of the sketchily drawn scenes that appear amidst the text are labelled 'manifesto,' while the more straightforward manifesto parts are called 'theatre'. It is as if this unusual manifesto sought to make visible and manifest through its own structure the fact that theatre and manifesto are firmly entangled in one another, if not mathematically the same.

In order to understand what is at stake in this entanglement between manifesto and theatre, it is necessary to consider both components separately. I will

1 Richard Foreman, *Ontological-Hysteric Manifesto I*, in *Plays and Manifestos*, edited and with an introduction by Kate Davy (New York: New York University Press, 1976), p. 67.

therefore first examine the history of the manifesto, with an emphasis on the manifesto's particular form of performativity, before engaging in an analysis of its interaction with the theatre.

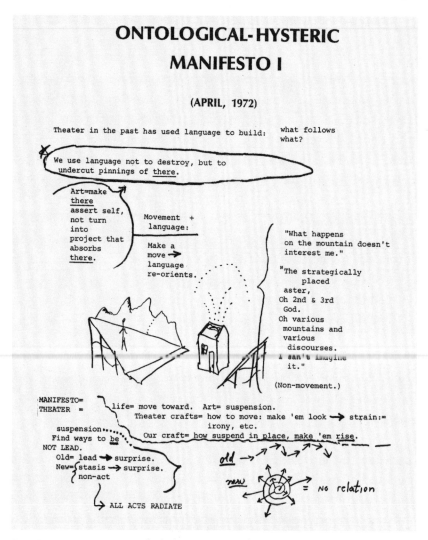

Fig. 1. Richard Foreman, *Ontological-Hysteric Manifesto I*, 1972

I. The Performativity of the Manifesto

The manifesto is one of the least understood and at the same time most important inventions of what is now called the historical avant-garde. Its morphology includes such features as numbered theses; denunciations of the past; an aggressive attitude towards the audience; a collective authorship; exaggerated, shrill declarations; varied, often bold, letters; and a mass distribution in newspapers, on bill-boards, and as flyers. These features characterise the avant-garde manifesto from Marinetti to the 1970s and beyond, spanning what one might call the era of the manifesto. The manifesto becomes the primary instrument through which the different avant-garde movements present themselves and compete with one another. No movement, it seems, can do without a manifesto; the result is a veritable manifesto-war that leads to ever-more extreme proclamations and attention-mongering rhetoric.

Most important, however, is the temporality of the manifesto, its construction of a history of rupture. As a political genre, the manifesto had been geared towards a revolution, a cut in the historical process, an act that attempts to suddenly change the course of history. The avant-garde manifesto adapts

this desire for a revolutionary event and imports it into the sphere of art. Futurism breaks with Symbolism; Vorticism breaks with Futurism; Dadaism breaks with everything that came before; Surrealism breaks with Dadaism; Situationism breaks with Surrealism; Fluxus breaks with Dada; Conceptual Art breaks with Fluxus.[2] Each time, the break with the past is the preparation for a new departure. Futurism, in this sense, is not just the name of the avant-garde movement that happens to have invented the avant-garde manifesto, but it is a name for the rupture between past and future every manifesto wants to effect.

It is in this history of rupture that we must locate the particular performativity of the manifesto. The manifesto does not merely describe a history of rupture, but produces such a history, seeking to create this rupture actively through its own intervention. Even while the manifesto is nothing but so many letters on a page or so many words shouted at an audience, it is a genre deeply unsatisfied with itself, a genre that desperately wants to move beyond language and change the world. The self-critique that ensues from this desire not only accounts for the manifesto's characteristic impatience, its choppy brevity, its eagerness to stop talking and start acting, but also for the attempt to infuse its own language with the attributes of action. Even though the manifesto is a subversive genre, poised against the *status quo*, the longing for action leads to a particular concern about the efficacy of its speech acts. Speech act theory has always been interested in efficacy, what J.L. Austin called the conditions for the 'happy' speech act.[3] Building on Judith Butler, Jon McKenzie's recent *Perform or Else* extends this focus on efficacy to the expanded field of performance studies: rather than focussing on the subversive function of performance, McKenzie insists on the normative meaning of performance, the fact that organisational and technological performance demands effectiveness, efficiency, and efficacy.[4] The manifesto invites such an interest in efficacy and efficiency because it is a genre geared towards successfully accomplishing the act that is to create a zero point in history, a revolutionary overturn. All previous history becomes a preparation for this point zero, which itself is pregnant with futurity: the present act of revolt is the beginning of a new future. The performativity of the manifesto might therefore be called a futurist performativity.

This futurist performativity makes it particularly difficult to write the history of the manifesto. Too great is the danger of being drawn into the manifesto's own temporal fabrications and thus to repeat the manifesto's own historiography of rupture. In order to avoid this problem, I will go backwards, against the grain of the manifesto, starting with the present. In an interview with Critical Art Ensemble (CAE) conducted by Jon McKenzie and Rebecca Schneider for a recent issue of *TDR*, CAE, a collective exploring new modes of civil and artistic disobedience in a global and electronic age, is asked about its use of the

2 The classical studies of the avant-garde follow this pattern. For example, Peter Bürger's *Theorie der Avantgarde* (Frankfurt-am-Main: Suhrkamp, 1974) and Maurice Nadeau, *The History of Surrealism*, trans. Roger Shattuck (New York: Macmillan, 1965). More recently, Richard Sheppard continues this type of historiography of the avant-garde in his *Modernism–Dada–Postmodernism* (Evanston, IL: Northwestern University Press, 2000).
3 J.L. Austin, *How to Do Things with Words* (Cambridge, MA: Harvard University Press, 1962), p. 14.
4 Jon McKenzie, *Perform or Else: From Discipline to Performance* (London: Routledge, 2001).

manifesto today. Schneider asks provocatively: 'So, the manifesto style: does the manifesto function as a kind of outmoded backward glance, then? A kind of quotation? Or Affect?'[5] CAE answers with a defence of the manifesto: 'Well, manifestos have never really gone away,' and adds that, 'we also like it because it's a fast style, perhaps the fastest' (p. 140), while declaring that 'the book is far too slow' (p. 141).

While CAE make a case for the continuity of the manifesto, a large number of critics and theorists operate under the assumption that the manifesto is indeed 'outmoded,' that writing a manifesto today is inevitably a retro gesture, an exercise in postmodern pastiche. The manifesto here becomes the genre that epitomises the utopian progressivism of the early 20th century and thus everything the postmodern present is not. Perry Anderson articulates this view with particular succinctness:

> Since the seventies, the very idea of an avant-garde, or of individual genius, has fallen under suspicion. Combative, collective movements of innovation have become steadily fewer, and the badge of a novel, self-conscious 'ism' ever rarer. For the universe of the postmodern is not one of delimitation, but intermixture – celebrating the cross-over, the hybrid, the pot-pourri. In this climate, the manifesto becomes outdated, a relic of an assertive purism at variance with the spirit of the age.[6]

What Anderson does here is to construct a break within the manifesto's futurist performativity of rupture. This sounds perhaps more paradoxical than it is, for the rupture between a manifesto-driven Modernism and a post-manifesto postmodernism is the product of a history of capitalism: capitalism has changed, and with it the manifesto. It is nevertheless a factor worth pointing out that the Marxian history of capitalism on which Anderson's writing is premised itself derives, however indirectly, from the manifesto of manifestos, the *Communist Manifesto*. In this sense, at least, Anderson does not entirely step outside the manifesto-generated history of rupture – but only applies it to the history of the manifesto itself.

Rather than highlighting the paradox of creating a rupture in the history of rupture, which is only one more version of the paradoxical formulation of the term postmodernism, we should perhaps dwell a moment longer on other current practices of the manifesto. For Anderson's conviction that the manifesto is

20

5 'Critical Art Ensemble: Tactical Media Practitioners: An Interview by Jon McKenzie and Rebecca Schneider', in *TDR: The Drama Review* 44.4 (2000), pp. 136-50.
6 Perry Anderson, *The Origins of Postmodernity* (London: Verso, 1998), p. 93.
7 Return, for Dogma, means a diminished mediation, especially of synchronised sound. All sound must be recorded during the shooting of the film, giving Dogma films their documentary character. This and other ways of banishing techniques of manipulation and mediation, such as artificial lighting, lead to the attempt to recuperate the liveness of the theatre. Indeed, what is striking about most Dogma films is that they are centred on the actor, which usually make use of the entire repertoire of melodrama, supported by the melodramatic plots, one of the dimensions of film-making that is not treated in the manifesto.
8 Alain Badiou, *Manifesto for Philosophy* (Albany, NY: State University of New York Press, 1999).
9 Rem Koolhaas, *Delirious New York: A Retroactive Manifesto for Manhattan* (New York: The Monacelli Press, 1994).

passé has not kept people away from the genre. And many writers of manifestos grapple with a sense that the high times of the manifesto are over. In 1995, a collective of Danish film-makers launched the so-called Dogma Manifesto,[7] which has had some limited impact on film-making in recent years, and Alain Badiou published a *Manifesto for Philosophy*. Instead of being directed at the future, these manifestos look backwards, calling for a return to the purer practices of the past: a type of film without fancy technology in the case of Dogma, and a philosophy yearning for 'the (re)turn of philosophy itself'.[8] In 2000, finally, Rem Koolhaas received the prestigious Pritzker Prize – not so much for his buildings as for his text *Delirious New York*, whose subtitle reads 'A retroactive manifesto for Manhattan'.[9] And so we might be tempted to conclude that many manifestos written today are, in one way or another, retroactive, thus reversing their original, futurist direction. These manifestos speak out for a return, and their writers are struck by a sense of historical belatedness that makes these manifestos intensely self-aware, critical of the form they are using, and thus incapable of proceeding without scruples or doubts in the classical manifesto manner. The manifesto, a form that shuns reflection and privileges action, is thus turned back on itself; a genre of action becomes a genre of reflection. Anderson's analysis seems nowhere as poignant as when the manifesto becomes entangled with the cunning of the markets.

Fig. 2. Advertisement for cosmetic products by Isabella Rossellini, Bloomingdale's, in a programme for the Lincoln Center Festival, 2000

Last summer I opened the programme for a show at the Lincoln Center Festival and read on its first page, 'Isabella Rossellini's Manifesto', and an instruction saying, 'Write your own manifesto.' This command was framed by two images of young women with red lipstick and lots of make-up, and some fine print: 'Available at Bloomingdale's, 800-555-SHOP'. 'Isabella Rossellini's Manifesto', it turned out, was an advert for make-up and lipstick. What has happened to the manifesto here? 'Isabella Rossellini's Manifesto' departs from the classical avant-garde manifesto in several ways. First, as Anderson points out correctly, the standard manifesto, from Karl Marx through Rosa Luxemburg to Guy Debord, is a collective enterprise, often written collaboratively and always on behalf of a group. 'Isabella Rossellini's Manifesto', by contrast, turns the writing of manifestos into an individual, and thus private, exercise; everyone has his or her own manifesto. Second, this text distances itself from the genre of the manifesto in that it does not present itself as a manifesto, but only as the invitation to write one. It is a text that shies away from writing on behalf of anyone, from exerting any kind of authority. The semblance of a democratisation of the manifesto, however, acquires a different quality when we realise that this non-manifesto is nothing but an advertisement for a product distributed by Bloomingdale's. Democracy, here, becomes simply a marketing strategy, opening up the sphere of manifestos to consumer choices – it does not matter what kind of manifesto you write as long as you write it with Bloomingdale's products. Anderson's worst fears about late capitalism seem to be borne out. Just as avant-garde aesthetics have been appropriated by institutions such as the Lincoln Center, so the manifesto's revolutionary gesture has been appropriated by advertisement.

There is one additional context, however, that offers a different perspective on this text. As an advert for make-up and lipstick, 'Isabella Rossellini's Manifesto' does not address everyone, but primarily women. In doing so, it takes a stance towards the gender history of the manifesto. At least in the hands of Marinetti, a chief inventor of the avant-garde manifesto, the manifesto has been a genre celebrating the masculine: aggressive posing, virility, force. Ezra Pound and Wyndham Lewis, for example, use their *Blast* manifesto to threaten the Suffragettes, whose cause they otherwise endorse. To say that the avant-garde manifesto is often masculinist is not to say that there are no feminist manifestos – Rosa Luxemburg's *Spartakus Manifest*, Valentine de Saint-Point's *Manifesto della donna futurista*, and Valerie Solanas's *SCUM Manifesto* testify to the opposite. But it means, as Janet Lyon has shown, that feminist manifestos have to take into account this masculinist heritage, even and especially when they attempt to displace or co-opt it.[10] When seen within this genealogy, 'Isabella Rossellini's Manifesto' can appear as one more step in the appropriation of the manifesto by the feminine or even feminist. And it is noteworthy that this critical revision of the history of the manifesto is not made entirely inoperative by the function of this text as advertisement. Is the world of advertisement perhaps not the absolute perversion of the manifesto, but only its latest transformation?

10 Janet Lyon, *Manifestoes: Provocations of the Modern* (Ithaca, NY: Cornell University Press, 1999).

What we begin to fathom here is that the real problem with the understanding of the contemporary manifesto as retroactive, late-capitalist pastiche is that it presumes, by implication, a genuine, authentic manifesto that precedes this pastiche. It is this predominant understanding, promoted by critics such as Perry Anderson and writers of manifestos such as Dogma or Rem Koolhaas, which needs to be examined critically. Can we really find, before Dogma, before Koolhaas, and before Foreman's own self-aware mixture of manifesto and theatre, a pure and classical manifesto? A good period to look for such a manifesto is the 1960s, a climate full of the revolutionary and utopian energy in which the manifesto can thrive. A representative manifesto of the so-called neo-avant-garde is the 1963 *Fluxus Manifesto I*. Even here, however, we find that this manifesto does not correspond to the standard features of the manifesto that I outlined above. In contrast to 'classical' manifestos, which are signed by a coherent group, *Fluxus Manifesto I* is not signed at all, not even by George Maciunas, the presumed author, himself. In fact, the other members of Fluxus always challenged the authority of Macinuas's manifestos, just as they continued to challenge his authority as the leader of Fluxus. The figure that looms large in these debates about the manifesto and group leadership is André Breton, who had used the second manifesto of Surrealism for the purpose of excommunicating 'renegade' members such as Georges Bataille and Antonin Artaud.[11] We can see here the other side of the manifesto, namely its authoritative and controlling side. Before the manifesto had become the quintessential genre of revolt, it had been an instrument through which kings, emperors, and heads of states made their will known to their subjects. WWI, for example, was declared through a text, issued by the Austrian Emperor, that was called 'Manifest'. While the manifesto often seeks to break with the *status quo*, it also tends to create a new dogma, and it was either irony or self-awareness that made the Danish film collective choose that name for itself. This 'dogmatism' of the manifesto is one more version of its emphasis on successful performativity, a performativity grounded not in some form of free play, but in the efficacy of declarative speech acts.

The Fluxus manifesto struggles with a difficulty related to the authoritative, dogmatic character of the manifesto, namely the paradox of circumscribing a flux that, by definition, cannot be confined to a neat formula. Maciunas had the ingenious idea of making this problem part of the form of his manifesto: half the manifesto consists of definitions, but these definitions are taken from a dictionary. What better way to follow the demands of the manifesto than to include straightforward definitions, but at the same time to keep some distance from them by signalling that they are mere quotations? In between these three quoted definitions, Maciunas inserted three chunks of text that are much closer to a traditional manifesto, for they revolve around three commands: to purge, to promote and to fuse. Each command is related to the quoted definition that precedes it, and, in this sense, the two elements of this manifesto – quoted definition and inserted commands – are integrated with, or at least aware of, one another. Intertwined in this way, the two disparate parts of the manifesto

23

11 At a later date, Breton would try to distance himself from both his dictatorial behaviour and the 'violence of expression' used in his manifestos to the 'revolutionary literature' circulating at the time. André Breton, *Manifestoes of Surrealism*, translated by Richard Seaver and Helen R. Lane (Ann Arbor, MI: The University of Michigan Press, 1972), p. 115.

Manifesto.

2. To affect, or bring to a certain state, by subjecting to, or treating with, a flux. "*Fluxed* into another world." *South.*
3. *Med.* To cause a discharge from, as in purging.

flux (flŭks), *n.* [OF., fr. L. *fluxus*, fr. *fluere*, *fluxum*, to flow. See FLUENT; cf. FLUSH, *n.* (of cards).] **1.** *Med.*
a A flowing or fluid discharge from the bowels or other part: esp., an excessive and morbid discharge: as, the bloody *flux*, or dysentery. **b** The matter thus discharged.

Purge the world of bourgeois sickness, "intellectual", professional & commercialized culture, PURGE the world of dead art, imitation, artificial art, abstract art, illusionistic art, mathematical art, — PURGE THE WORLD OF "EUROPANISM"!

2. Act of flowing: a continuous moving on or passing by, as of a flowing stream; a continuing succession of changes.
3. A stream; copious flow; flood; outflow.
4. The setting in of the tide toward the shore. Cf. REFLUX.
5. State of being liquid through heat; fusion. *Rare.*

PROMOTE A REVOLUTIONARY FLOOD AND TIDE IN ART,
Promote living art, anti-art, promote NON ART REALITY to be ~~fully~~ grasped by all peoples, not only critics, dilettantes and professionals.

7. *Chem. & Metal.* **a** Any substance or mixture used to promote fusion, esp. the fusion of metals or minerals. Common metallurgical fluxes are silica and silicates (acidic), lime and limestone (basic), and fluorite (neutral). **b** Any substance applied to surfaces to be joined by soldering or welding, just prior to or during the operation, to clean and free them from oxide, thus promoting their union, as rosin.

FUSE the cadres of cultural, social & political revolutionaries into united front & action.

sonderdruck fluxus 2-3-II'63 maciune anif

Fig. 3. George Maciunas, *Fluxus Manifesto I*, 1963

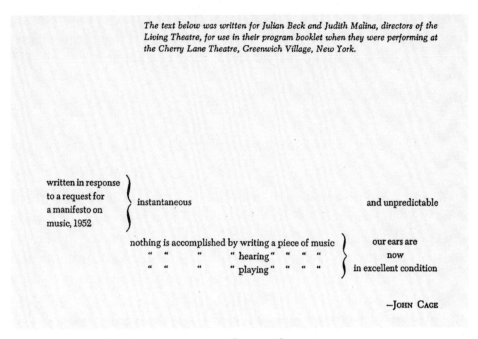

Fig. 4. John Cage *written in response to a request for a manifesto, 1952*

begin to rub off on one another: the quoted definitions acquire more authority, while the commands start to seem more like quotations. The two types of authority, the authority of the dictionary – the most unchallenged authority in the realm of print – and the authority of the manifesto thus work together, but also against one another. *Fluxus Manifesto I* is thus not a 'pure' manifesto, but relies self-consciously on quotations and external authority.

The sense that *Fluxus Manifesto I* is engaged in a complicated negotiation with the form of the classical manifesto, and its investment in efficacious performativity is confirmed when one turns to the particular scene in which this Fluxus manifesto was staged: the opening of an evening of Fluxus performances. A hand emerges from behind the drawn curtain and throws the manifesto into the audience – itself an almost parodically Futurist mode of distribution. But the evening had begun with the curator of the show, Jean-Pierre Wilhelm, asking, 'Should a manifesto be launched today?', adding the observation that the 'heroic period of the manifesto is over'.[12] Maciunas's manifesto is thus set up from the beginning, one might say that it is staged, as a belated manifesto: a text that must work through its relation to the manifesto, a genre it can no longer inhabit without reservations or doubts. Already in 1963, then, there was the sense that the manifesto was history; and once history, the manifesto's futurist performativity can no longer exert its full force. What is noteworthy here is that at the very moment when the futurist performativity of the manifesto is challenged, a different aspect appears, namely its theatrical performance. The decline of efficacious performativity, it seems, is coupled by an increase of theatrical performance.

In search for Wilhelm's 'heroic' time of the manifesto, we may move 11 more years back to John Cage, who is often considered the father of Fluxus. In

12 Archiv Sohn, Staatsgalerie, Stuttgart. Cited in Owen Smith, 'Developing a Fluxable Forum: Early Performance and Publishing', in *Fluxus Reader*, edited by Ken Friedman (Chichester: Academy Editions, 1998), p. 3.

25

1952, Julian Beck and Judith Malina asked Cage to write a manifesto for a theatre programme of the Living Theater. Cage accepted their request, but he scrupulously avoided writing a manifesto.[13] Here is what he wrote instead:

written in response
to a request for
a manifesto on
music, 1952

This text, which should be labelled 'response to a manifesto', is only the beginning of a long series of similar evasions of, or responses to, the manifesto on Cage's part. Cage gave lectures, wrote articles and essays, exposed his aesthetics, his politics, his beliefs, but in each case he deviated from the pure form of the authoritative manifesto, or, to be more precise, he turned it into a performance piece. It does not seem surprising that Cage, who objected to almost any form of authority, would avoid the prescriptive force of the manifesto or at least take off its edge by reframing it as a piece about the act of speaking. A feature shared by all of Cage's performances is that they play off the manifesto's authoritative performativity against its theatrical performance. The most famous of these speech performances is his 'Lecture on Nothing', whose title suggests a refusal to take a position, to declare an allegiance, to write a manifesto. Instead, this piece consists of whispered words, subtly and carefully superimposed onto one another, that obscure any lingering agenda or position. It is as if Cage had decided to tone down the voice of the manifesto and to eclipse its content, thus undermining its function as a statement of purpose. Cage's attentive ear and his delicate voice turn the manifesto into a lecture on nothing except the act of lecturing itself.

We have no other option, it seems, but to conclude that all of these post-WWII manifestos consider the classical form of the manifesto to be a thing of the past. Their attempts to continue the avant-garde legacy, their acts of rebellion, of writing new manifestos and founding new movements, are keenly aware of being belated and retrospective. For the neo-avant-garde, the manifesto becomes something that is quoted, but something which can no longer be relied on with confidence. The only remaining period where we might hope to find a pure manifesto, it seems, is the so-called historical avant-garde. And the adjective 'historical' derives its justification from precisely this sense that this period is no longer continuous with ours, and that we are doomed to recycle and quote from the forms, such as the form of the manifesto, that came into existence then.

However, once we enter this putatively historic period of the avant-garde, we find that a pure manifesto barely exists there either. Take, for example, Tristan Tzara, the most prominent writer of Dadaist manifestos. Only nine years after Marinetti's first Futurist manifesto, Tzara wrote his famous *Dada Manifest 1918*, which begins: 'In order to launch a manifesto, you have to demand: A. B. & C., and denounce 1,

13 John Cage, *Lectures and Writings by John Cage: Silence* (Hanover, NH: Wesleyan University Press, 1961), p. xii.
14 Tristan Tzara, 'Manifest Dada 1918', in Karl Riha & Jörg Schäfer (eds) *DADA total: Manifeste, Aktionen, Texte, Bilder* (Stuttgart: Reclam, 1994), p. 35.

26

2, & 3.' A page later, he continues: 'I write a manifesto and I don't want anything, nevertheless I say several things and I am against manifestos on principle just as I am against principles.'[14] This manifesto opens with a veritable morphology of the manifesto, and, for this reason, it tends to be quoted in scholarly accounts of manifestos.[15] What is rarely discussed, however, is the fact that such a self-reflective opening is at odds with the manifesto's desire for efficacy, its need to instrumentalise language ruthlessly in order to change the world. The fact that this manifesto is infused with a critical awareness of the form of the manifesto demonstrates the extent to which this manifesto, too, is a belated manifesto, a manifesto that looks back at the genre whose conventions it seeks to expose. And again, this retrospective posture puts into question its futurist performativity. This manifesto declares that it wants 'nothing' and that its central cause is 'nothing'. Cage's 'Lecture on Nothing' is here anticipated by Tzara's strategic 'nothing', and the history of displaced manifestos from Cage to Foreman finds its roots in Tzara's strategy of entangling his manifesto in the impossible position of being against the manifesto in principle and being against principles. Between these two contradictory statements, Tzara's manifesto oscillates between continuing to be a manifesto and becoming a parody of one. Far from being a classical, heroic, and historical manifesto, this manifesto presents itself as something grafted onto the manifesto form, which it obeys only for the purpose of subjecting it all the better to critical analysis and ridicule.

As Tzara's manifesto demonstrates, a sense of belatedness does not characterise only the neo-avant-garde, but the historical avant-garde from the beginning. Richard Foreman's self-conscious manifesto, then, does not deviate from a putatively pure or heroic manifesto, but continues the project of reflecting on the genre of the manifesto as it was operative already in 1918 and even in Marinetti's *First Futurist Manifesto*.[16] And here, at this origin of the avant-garde manifesto, we might remember 'Isabella Rossellini's Manifesto', and note that Marinetti's manifesto was part of what one must call an advertisement coup as well, including press releases, paid adverts in newspapers, posters on bill-boards, and flyers. Indeed, Futurist and other manifestos frequently borrowed techniques from advertisement to perfect the art of calling attention to themselves. A tendency towards advertisement, we must acknowledge, has been part of the manifesto since its adaptation by the avant-garde in the early 20th century. Being unfaithful to some 'heroic' form of manifesto, it turns out, is the best way of being faithful to the avant-garde manifesto, and writing a

27

15 It is only recently, through the work of a few editors and commentators that the manifesto as genre has begun to attract systematic critical and theoretical attention. Insightful studies have been devoted to this genre by Claude Abastado, who edited a special issue, *Littérature* 39 (1980), on the manifesto and Janet Lyon, *Manifestoes: Provocations of the Modern* (Ithaca, NY: Cornell University Press, 1999). Collections of manifestos have been presented by Wolfgang Asholt & Walter Fähnders (eds), *Manifeste und Proklamationenen der europäischen Avantgarde (1909-38)* (Stuttgart: Metzler, 1995). More recently still, Mary Ann Caws presented the first comprehensive collection of manifestos in English in her ed., *Manifesto: A Century of Isms* (Lincoln, NE: University of Nebraska Press, 2001).

16 Marjorie Perloff, *The Futurist Moment: Avant-garde, Avant Guerre, and the Language of Rupture* (Chicago: The University of Chicago Press, 1986).

17 This critique parallels in part the one made by Hal Foster in his *The Return of the Real*, where he argues that it was only through the so-called neo-avant-garde that the original, historical avant-garde was retroactively created. Hal Foster, *The Return of the Real: The Avant-Garde at the End of the Century* (Cambridge, MA: MIT Press, 1996).

manifesto requires one to reflect on the genre's structure and history, which is fraught with self-awareness, self-critique, and parody.[17] The difference between pre-WWII avant-garde and post-WWII avant-garde is one that is marked only by different modes of displacement, and this means that we must therefore move the operations of quotation, parody, distancing and displacement into the centre of our understanding of the avant-garde and of the avant-garde manifesto.

The sense that there is no 'heroic' manifesto is confirmed once we realise that the entire history of the avant-garde manifesto, from Marinetti to Foreman and even to Dogma and Bloomingdale's, is a late mutation or displacement of a genre that was previously a political speech act. Used by the Diggers and Levellers in the social upheavals of 17th-century England and then in the French Revolution and its exploding culture of pamphleteering, the manifesto as a genre of political agitation becomes canonised in the 19th century through the *Communist Manifesto*.[18] And this history of subversion is itself an appropriation of a yet-older use of the manifesto as an authoritative declaration of state mentioned above. *The Communist Manifesto* and 'Isabella Rossellini's Manifesto' do not relate to one another as revolutionary (collective, masculinist) origin and capitalist (individualist, feminist) perversion, but as a series of iterations and displacements. Grail Marcus's 'secret history of the 20th century' presents itself evocatively as a history of traces – lipstick traces; it is a history that parallels the history of the manifesto from Dada to the Situationists.[19] And so we may find that in order to be faithful to the manifesto as a displaced genre, it may well be necessary to rewrite the *Communist Manifesto* in lipstick, or at least, in lipstick traces.

II. Performativity and Theatricality

Once we recognise that self-reflexivity and intermixture are not postmodern phenomena but define the manifesto throughout its history, we are in a better position to examine texts such as Foreman's. Foreman points us to a particular mixture, namely the mixture of manifesto and theatre which is also a mixture between manifesto's futurist performativity and theatricality. And since the relation between performativity and theatrical performance has already surfaced in various displacements of the manifesto, as in the case of Fluxus and Cage, it is time to move this relation to the centre of analysis. Avant-garde manifestos were frequently performed, in particular in the early phase of Futurism and Dadaism.[20] Both movements instituted a form of non-matrixed performance taking place in traditional theatres, which the Futurists rented for their tours through the provinces, but also in non-traditional performance sites such as Dada's Cabaret Voltaire or the streets. The Cabaret Voltaire was used for performances including Expressionist plays, simultaneous poetry, music, and dance; and paintings were placed on stage and theatrically unveiled to the audience.[21] The manifesto too was performed, screamed directly at the audience. The exaggerated declarations and tone of many

18 The function of the pamphlet in the construction of a revolutionary public was first outlined by the path-breaking work of Roger Chartier, *The Cultural Origins in the French Revolution*, translated by Lydia G. Cochrane (Durham, NC: Duke University Press, 1991).

19 Greil Marcus, *Lipstick Traces: A Secret History of the Twentieth Century* (Cambridge, MA: Harvard University Press, 1989).

20 Günther Berghaus, *Italian Futurist Theatre 1909-44* (Oxford: Clarendon Press, 1998).

21 Martin Puchner, 'Screeching Voices: Avant-garde Manifestos in the Cabaret', in Dietrich Scheunemann (ed.), *European Avant-garde: New Perspectives* (Amsterdam: Rodopi, 2000), pp. 113-35.

avant-garde manifestos thus originate in the rowdy cabarets of Futurism and Dadaism, which forced their performers to turn up their volume in order to be heard. What does this theatricalisation mean for the manifesto? And how does it interact with the manifesto's futurist performativity and efficacious speech acts?

It is remarkable that a contentious relation between theatre and manifesto is operative even in the most classical and most political of manifestos, the *Communist Manifesto*. There exists a tradition of reading the *Communist Manifesto* as some form of a theatrical script. Kenneth Burke, for example, recognised it as a chief example of a theatrical scheme called dramatism, and Jacques Derrida has recently placed it in relation to the play of plays, *Hamlet*.[22] Marx inherits the privileging of the theatre from Georg Hegel, which is also why Marxism frequently looks at history in dramatic terms, be it tragedy or farce. At the same time, drama fuelled Marx's view that history must progress via a crisis, which is also a *peripeteia*, a turning-point that will eventually lead to a resolution. The *Communist Manifesto* even turns into something of a dramatic dialogue halfway through, when Marx begins to engage other thinkers and does so by giving voice, in the form of direct speech, to their arguments before switching back to his own voice in responding to these hypothetical objections. The drama of history is thus mirrored in the dialogic structure of the *Communist Manifesto*, and dialectics once more rejoined with its origin in the dramatic dialogues of Plato. Marx interrupts the engaged tone of the manifesto and lends his voice to the opponents of Communism. Even though this is a technique for undermining their objections, structurally it is an interruption of Marx's own discourse. The quasi-dramatic form of these passages thus can be said to temporarily arrest the forward thrust of the manifesto.

29

The most theatrical part of the *Communist Manifesto*, however, is its preamble. This preamble begins with the famous invocation of the 'spectre of Communism', which Kenneth Burke identified as a parody of the Hegelian spirit. While the first paragraph describes the spectre as it is being hunted by the reactionary forces of Europe, the second paragraph promises the appearance of true Communism: Marx wants to replace the spectre of Communism with Communism itself. Communism will openly declare its intentions and thus finally enter European politics in undisguised form. This revelation of Communism, its unmasked entry, is brought about by the *Communist Manifesto*. The manifesto is the instrument, the genre, that replaces spectres with the real thing, and it is the genre that is responsible for the final, dramatic revelation of Communism on the scene of world politics: 'It is high time that the Communists should openly, in the face of the whole world, publish their views, their aims, and their tendencies, and meet this nursery tale of the spectre of Communism with a manifesto of the party itself.'[23] Here we are promised a climax, a confrontation of the two main agents from the previous two paragraphs: the nursery tale of the spectre of Communism

22 Kenneth Burke, *A Grammar of Motives* ([1954]; Berkeley, CA: University of California Press, 1969), pp. 200ff. Jacques Derrida, *Specters of Marx: The State of the Debt, the Work of Mourning & the New International*, trans. Peggy Kamuf (New York: Routledge, 1994). Also see Martin Harries, *Scare Quotes from Shakespeare: Marx, Keynes, and the Language of Reenchantment* (Stanford, CA: Stanford University Press, 2000).

23 Karl Marx & Friedrich Engels, *Manifest der Kommunistischen Partei* ([1848]; Stuttgart: Reclam Verlag, 1969), p. 19.

and Communism itself.[24] While the dramatic sections of the *Communist Manifesto* constitute the dramatic and theatrical insertion of difference voices into the dominant one of the manifesto, the preamble marks an initial moment of reflection in which the manifesto is poised against its theatrical, spectral counterpart.

What this preamble bears witness to is not only the theatrical, scenic imagination of this manifesto, but also the fact that, like Tzara's and Foreman's manifestos, the *Communist Manifesto* does not proceed without a moment of hesitation. It does not jump right into the work of revelation and declaration, but reflects on its own role and on its own function in the struggle between Communism and its enemies. What we can see here is that the *Communist Manifesto*'s theatricality does not simply enforce its futurist performativity. Rather, it marks a moment of hesitation, a moment when the manifesto gives up its commitment to absolute efficacy and action, and allows itself to dwell on theatrics instead. This theatricality of the manifesto, to be sure, is closely related to the genre's futurist performativity – exposing spectres and convincing other voices are part of the task the manifesto has to accom-plish if we are to call its speech acts successful. However, this theatricality also seems to work as an obstacle to the manifesto's performativity: the manifesto must combat this theatricality in order to achieve its goal. Theatricality is something of a spectre haunting the manifesto, the threat that its speech acts might turn out to be nothing but stage acts. It is useful here to remember that J.L. Austin considered the theatre to be a place where speech acts lose all their normative force. The explicit exclusion of the theatre from his speech act theory has often been derided as one more example of a philosophical anti-theatrical prejudice, as described by Jonas Barish and others.[25] However, in the case of the manifesto, the attempt to maintain a strict division between theatricality and performativity is necessary, if only to perceive the struggle between those two modes. Theatricality can be seen as the troubling underside of the manifesto's performativity.

The rivalry between theatricality and performativity had particular consequences for those manifestos that concern themselves with the theatre. Beginning with Marinetti's manifestos on Futurist theatre, the 20th century abounds in theatre projects that are announced and accompanied by manifestos. This is the case particularly with utopian theatre projects that were difficult or impossible to realise, such as the ones devoted to instituting some form of *Gesamtkunstwerk*. Among those one could name the *Merz Theater* of Kurt Schwitters, Vasily Kandinsky's new total theatre, as well as the *Totaltheater* of Oskar Schlemmer and Erwin Piscator – all of these theatres, and many more, launched by manifestos. They also all try to push the limits of the possible, and this means that their realisation is always precarious, often postponed, and sometimes impossible. The more difficult it is to actually create the theatres called for by specific manifestos, the more these manifestos become the only place

24 This climactic showdown is cast in terms of two textual genres, for the battle between the spectre and the party becomes a battle between the 'nursery tale' and the manifesto. The manifesto, it turns out, is an anti-fairy tale; and it is through an attack on the fairy tale, which was just at the height of its 19th-century resurgence, that the manifesto constitutes itself. The manifesto casts itself as the protagonist in a generic struggle and takes the occasion of the preamble to reflect on its own use and function.
25 Jonas Barish, *The Anti-Theatrical Prejudice* (Berkeley, CA: University of California Press, 1981).

where these utopian theatres can take shape. For this reason, these manifestos no longer function simply as instruction manuals for new types of theatre, but become instead a platform for utopian or impossible theatres. In its most radical manifestation, the manifesto can take over, or entirely take the place of the theatre it calls for.

The struggle between manifesto and the theatre can be seen with particular clarity in the work of one of the most famous writers of manifestos and visionaries of the theatre, Antonin Artaud.[26] Because of Artaud's unparalleled influence on postwar theatre, too little attention has been paid to the question of why Artaud was not able to realise his programme for a Theatre of Cruelty. It does not suffice to argue that running a theatre requires more than a programme, but also managerial skills, money and, of course, an audience. More important than these external factors and circumstances is the dynamic of the genre that articulated this programme: the Theatre of Cruelty exists only as manifesto, printed in the pages of the literary magazine *La Nouvelle Revue Française*. The fact that Artaud depended on a literary magazine to provide him with a space for his theatre could be seen as a bitter irony, given Artaud's tireless attacks on the written word. However, we need to distinguish between the dramatic text, which Artaud derided, and the text of the manifesto, which he embraced. Rather than extracting from Artaud's manifestos the description of some text-free physical theatre, as it is usually done, we should recognise that his theatre is in fact intimately tied to the form of his manifestos, in its tone, its performativity, its textuality and its visual appearance.

Artaud's manifestos constitute a form of action speech that is characteristic of the manifesto. Polemical by nature, Artaud's texts abound in formulations such as 'down with', or 'let's do away with', 'enough of', denouncing first masterworks, then representation more generally, before turning eventually, in futurist manner, against the 'past' *tout court*. The language of these texts is one of rupture: verbs such as 'rupturing' or 'breaking' often accumulate in the same sentence, and when the rhetoric of rupture seems insufficient, Artaud uses extreme images such as that of the plague to increase the shock-value of his texts. Asked to supplement this manifesto with clarifications, Artaud refused, claiming that they would 'deflower its accent' (*d'en déflorer l'accent*, p. 120). Artaud here seeks to preserve the manifesto, its most characteristic mode of aggressive, accented speech, against the pressure, exerted on him by the editors of *NRF*, to turn the manifesto into a more explanatory, theoretical discourse, one that would be in control of its own language. The question of whether the manifesto should be considered to be a genre akin to theory has haunted the avant-garde manifesto throughout, and scholars and teachers have tended to use it as a handy explanatory device. Even if the use of the manifesto as theory is not entirely wrong, it does disregard the manifesto's most characteristic literary features, precisely that which Artaud called its 'accent'.

The 'accent' of the manifesto can be seen as a marker of the manifesto's theatrical performance, but unlike some of the other avant-garde manifestos, Artaud's were

31

26 Antonin Artaud, *Le Théâtre et son double*, in *Œuvres complètes*, vol. IV (Paris: Gallimard, 1956-74). It appeared for the first time in *NRF* in 1932.

never meant to be performed. This did not keep them from internalising their own oral performance. A newspaper reporting on one of Artaud's acts, for example, observed that he was 'shouting his text as if he were declaiming it in a public gathering, cutting up his delivery with a monotonic choppiness', and another one characterised Artaud's speech as a 'jerky, staccato language full of disconnected cries'.[27] Artaud's stage performances here seem to be under the spell of the manifesto's aggressive oratory. The influence of the manifesto on Artaud's theatre also found its entry into the content of his manifestos. One of the pillars of the Theatre of Cruelty, says Artaud, is a 'deformation' of speech that leads to a 'particular use of intonation' (p. 112). It is a use of the voice that is supposed to break open the 'stratification' of language. It is as if Artaud had begun to realise that the Theatre of Cruelty was a vision not so much of a physical theatre, but of a mode of speech that was akin to the 'accent' of the manifesto.[28] It is due to this underlying affinity between the manifesto and the theatre envisioned in Artaud's manifestos that the manifesto was able to take the place of the Theatre of Cruelty. To put this in a slightly different manner: the Theatre of Cruelty cannot be realised in any other form than in the form of the manifesto, and this is precisely the form in which Artaud realised it.[29]

Through the coupling of the manifesto's futurist performativity and the traces of its oral performance, the manifesto enables Artaud to erase the actual theatre altogether. In this sense, the manifesto is the opposite of the dramatic masterwork, which Artaud hated too much; it is a text that is at odds with its own textuality and that tries to reinvent that textuality as action. Whatever residual theatricality there is has wandered entirely into the oratory of the manifesto, its internalised performance. The paradox of Artaud's dependence on the literary genre of the manifesto thus must be understood as an extreme version of the struggle between performativity and theatricality at work in the manifesto at least since the *Communist Manifesto*. This struggle means that there is a tendency within manifesto's performativity to eclipse the theatre altogether. This eclipse, however, not only testifies to the rivalry between the performativity and theatricality, but also to the fact that the two must be related closely enough in order for the one to be able to take the place of the other.

Manifesto=Theatre – what this equation suggests is not that all manifestos are theatre or that all theatres are manifestos. Rather, it points to the fact that the histories of the theatre and of the manifesto are intertwined, that the history of the one cannot be written without the history of the other. Although the equation Manifesto=Theatre does not balance, the identity which it claims points to an essential, if contentious, kinship that should occupy a central place in our understanding of both the theatre and the manifesto.

27 Antonin Artaud, *Œuvres complètes*, vol. IV, p. 380.
28 One can hear echoes of this manifesto tone in Artaud's later radio works, in particular his 'To have Done with the Judgement of God', in *Œuvres complètes*, vol. XIII. Here, Artaud uses the whole vocal repertoire, from the lowest to the highest sounds, falling with regularity into a screaming that attacks the listener with direct force. It is a language of sounds, cries whose radical gestures try everything to throw off the stratification of language.
29 Based on an analysis of Artaud's critique of representation, Derrida argues that the Theatre of Cruelty can never be faithfully realised in any theatre. Jacques Derrida, 'Le théâtre de la cruauté et la clôture de la représentation', in *L'écriture et la différence* (Paris: Éditions du Seuil, 1967), p. 364.

MANIFESTOS

AN A

LIFE MA

TIST'S

NIFESTO

I. AN ARTIST'S CONDUCT IN HIS LIFE
— An artist should not lie to himself or others
— An artist should not steal ideas from other artists
— An artist should not compromise for themselves or in regards to the art market
— An artist should not kill other human beings
— An artist should not make themselves into an idol
— An artist should not make themselves into an idol
— An artist should not make themselves into an idol

2. AN ARTIST'S RELATION TO HIS LOVE LIFE
— An artist should avoid falling in love with another artist
— An artist should avoid falling in love with another artist
— An artist should avoid falling in love with another artist

3. AN ARTIST'S RELATION TO THE EROTIC
— An artist should develop an erotic point of view on the world
— An artist should be erotic
— An artist should be erotic
— An artist should be erotic

4. AN ARTIST'S RELATION TO SUFFERING
— An artist should suffer
— From the suffering comes the best work
— Suffering brings transformation
— Through the suffering an artist transcends their spirit
— Through the suffering an artist transcends their spirit
— Through the suffering an artist transcends their spirit

5. AN ARTIST'S RELATION TO DEPRESSION
— An artist should not be depressed
— Depression is a disease and should be cured
— Depression is not productive for an artist
— Depression is not productive for an artist
— Depression is not productive for an artist

6. AN ARTIST'S RELATION TO SUICIDE
— Suicide is a crime against life
— An artist should not commit suicide
— An artist should not commit suicide
— An artist should not commit suicide

7. AN ARTIST'S RELATION TO INSPIRATION
— An artist should look deep inside themselves for inspiration
— The deeper they look inside themselves, the more universal they become
— The artist is universe
— The artist is universe
— The artist is universe

8. AN ARTIST'S RELATION TO SELF-CONTROL
— The artist should not have self-control about his life
— The artist should have total self-control about his work
— The artist should not have self-control about his life
— The artist should have total self-control about his work

9. AN ARTIST'S RELATION WITH TRANSPARENCY
— The artist should give and receive at the same time
— Transparency means receptive
— Transparency means to give
— Transparency means to receive
— Transparency means receptive
— Transparency means to give
— Transparency means to receive
— Transparency means receptive
— Transparency means to give
— Transparency means to receive

10. AN ARTIST'S RELATION TO SYMBOLS
— An artist creates his own symbols
— Symbols are an artist's language
— The language must then be translated
— Sometimes it is difficult to find the key
— Sometimes it is difficult to find the key
— Sometimes it is difficult to find the key

II. AN ARTIST'S RELATION TO SILENCE
— An artist has to understand silence
— An artist has to create a space for silence to enter his work
— Silence is like an island in the middle of a turbulent ocean
— Silence is like an island in the middle of a turbulent ocean
— Silence is like an island in the middle of a turbulent ocean

12. AN ARTIST'S RELATION TO SOLITUDE
— An artist must make time for the long periods of solitude
— Solitude is extremely important
— Away from home
— Away from the studio
— Away from family
— Away from friends
— An artist should stay for long periods of time at waterfalls
— An artist should stay for long periods of time at exploding volcanoes
— An artist should stay for long periods of time looking at fast running rivers
— An artist should stay for long periods of time looking at the horizon where the ocean and sky meet
— An artist should stay for long periods of time looking at the stars in the night sky

13. AN ARTIST'S CONDUCT IN RELATION TO WORK
— An artist should avoid going to the studio every day
— An artist should not treat his work schedule as a bank employee does
— An artist should explore life and work only when an idea comes to him in a dream or during the day as a vision that arises as a surprise
— An artist should not repeat himself
— An artist should not overproduce
— An artist should avoid his own art pollution
— An artist should avoid his own art pollution
— An artist should avoid his own art pollution

14. AN ARTIST'S POSSESSIONS
— Buddhist monks advise that it is best to have nine possessions in their life:

1 robe for the summer
1 robe for the winter
1 pair of shoes
1 begging bowl for food
1 mosquito net
1 prayer book
1 umbrella
1 mat to sleep on
1 pair of glasses if needed

— An artist should decide for himself the minimum personal possessions they should have

— An artist should have more and more of less and less
— An artist should have more and more of less and less
— An artist should have more and more of less and less

15. A LIST OF AN ARTIST'S FRIENDS
— An artist should have friends that lift their spirits
— An artist should have friends that lift their spirits
— An artist should have friends that lift their spirits

16. A LIST OF AN ARTIST'S ENEMIES
— Enemies are very important
— The Dalai Lama has said that it is easy to have compassion with friends but much more difficult to have compassion with enemies
— An artist has to learn to forgive
— An artist has to learn to forgive
— An artist has to learn to forgive

17. DIFFERENT DEATH SCENARIOS
— An artist has to be aware of his own mortality
— For an artist, it is not only important how he lives his life but also how he dies
— An artist should look at the symbols of his work for the signs of different death scenarios
— An artist should die consciously without fear
— An artist should die consciously without fear
— An artist should die consciously without fear

18. DIFFERENT FUNERAL SCENARIOS
— An artist should give instructions before the funeral so that everything is done the way he wants it
— The funeral is the artist's last art piece before leaving
— The funeral is the artist's last art piece before leaving
— The funeral is the artist's last art piece before leaving

19. LIFE AFTER DEATH
— ?

37

ECO-AESTHETICS: ART BEYOND ART – A MANIFESTO FOR THE 21ST CENTURY

Rasheed Araeen

The 20th century began with great ideas in art, literature, music, science, philosophy, and so on, which gave humanity great hope for a better future. But this hope was dashed with the violence that this century unleashed, killing more than a hundred million people – perhaps the most violent century in the history of humanity. Can this paradox be dealt with only by blaming a particular system but extricating ourselves as individuals from it by believing that we as avant-garde artists are engaged in what would expose and confront the inhumanity of the system? Is this belief not based on the naivety of an idea that has in fact failed? It failed because it never achieved what it claimed it wanted to achieve – to liberate art from the bourgeois enclave and make it part of people's everyday life. The confrontational forms it produced negated the very creative process which could enter life's own creativity and affirm it by becoming part of it. What in fact emerged from this was an art (anti-art) that had no choice but to capitulate to the very institution that it wanted to confront and became dependent on it for its survival and legitimation.

There was, of course, also a different movement, historically, which indeed tried to integrate art with life. Its beginning can perhaps be attributed to William Morris's 'Art & Crafts' movement, some ideas of which reemerged in the 20th-century avant-garde as part of the forces unleashed by the Russian Revolution and then by the Bauhaus. But this movement also eventually collapsed, and whatever it produced was frozen in art history as its ultimate achievements. Behind this collapse or failure were, of course, many different and extremely complex historical forces. But there is one thing that can be attributed to all of the avant-garde movements: intellectual elitism of the artists. Any attempt to impose an idea onto the masses and without any consideration of the nature of people's own creative resources and abilities – no matter how beneficial the idea may be to people – cannot succeed. Altruism cannot perform any true social function if it is an extension of a narcissist ego (henceforth *narego*).

The ultimate fate of the avant-garde has, in fact, been its capitulation not only to the bourgeois institution but to what this institution produced and promoted in the form of self-centred individualism. It presumed to resolve the situation by filling the gap between art and life. But couldn't. Because the artist's *narego* would not allow him or her to come down from its high intellectual pedestal and become part of everyday life. The struggle of the avant-garde actually only led to a confrontation between the narcissisms of two egos – the artist's own ego and the ego of the power of the art institutions which he or she aimed to confront but also from which sought legitimation for whatever he or she did – which eventually reconciled by coming together and happily embracing each other.

This embrace of the avant-garde with the bourgeois institution has, in fact, not only trapped art in this paradox, it has been fatal for the criticality of art. Art is now performing no critical function. It has now turned itself towards the masses, in collaboration with mass media, whom it treats with contempt, producing works that confront not the bourgeoisie but are offensive to life itself. It is justified on the basis of the facile idea of individual freedom of speech or expression that merely produces media scandals and sensationalism, thus widening further the gap between art and life in which art now operates purely as a commodity like any other precious commodity. The tremendous success of the contemporary artist at the art marketplace has, in fact, inflated the artist's *narego* further and turned him or her into a celebrity who can entertain the public spectacularly but without any artistic substance or significant social function. It is merely the self-interest of the *narego* which now prevails in the name of art.

The failure of the historical avant-garde is, of course, not due to the nature of the ideas it produced. It is more to do with the way ideas were articulated and expressed, which were then open to an appropriation by the very forces the avant-garde wanted to confront and change. Some of these ideas still have a potential to intervene in life and transform it. But

to deal with today's disturbing world situation, they must not only liberate art from the artist's *narego* but also from what leads art to (and being trapped in) the bourgeois art institution. Art must now go beyond the making of objects that are displayable in the museum and/or sold as precious commodities at the marketplace. Only then can it enter the world of everyday life and its collective energy that is struggling not only to improve life itself but to save this planet from total destruction.

It is, however, important to treat art, particularly the avant-garde, not as the body of accumulated objects but a movement of ideas. The complexity of this movement involves contradictions and paradoxes, which allow it to maintain its dynamic, historically, within the bourgeois society. And although the bourgeois institution is fundamental to the production and legitimisation of ideas within this movement, it does not produce this movement. This movement can defy the needs and demands of the established order and come up with something entirely different – not necessarily in opposition to the earlier models of art production or concepts, but that which transcends these models. This actually happened during and with the Land art movement of the late 1960s and early 1970s, which, by abandoning the making of objects in the form of painting or sculpture, pushed art towards a concept capable of entering life's creative processes. Thanks to Duchamp for this, but art now went beyond Duchamp's object-making and became engaged with the land or the earth itself.

The land has always been an object of the artist's gaze, but this time the gaze did not produce landscape painting. On the contrary, the conception of land as art itself became the art work. This was achieved by intervening in the land and transforming it as something that continued to remain part of the land, either as a stationary object or what would transform itself continually. Many artists dug holes in the ground or made dam-like earthen structures; Robert Smithson turned an existing lake into an art work. Robert Morris, on the other hand, contemplated growing of the crop on a farmland and turning the whole thing into a work of art. But he did not proceed with and execute the project. It seemed he faced the problem of the *narego*. The conflict between the individualism of the narcissist ego and the collective work of the farm workers could not let the artist come to terms with the collectivity of the farm workers and allow them become part of the work – both in terms of its

production and ownership. The only choice Morris then had was to abandon the idea.

However, what emerged from some of the works of Land art was a paradigm shift from the ideas of representation to a process of transformation that should have allowed art to become part of the living process of the productivity of the land as well as its inhabitants. But it didn't. Instead, it ended up in art museums as photographic art works to be looked at as objects of the human gaze.

Some ten years later, Joseph Beuys tried to resolve this difficult problem – often seen as a paradox – by suggesting that his work of planting trees at Kassel in 1982 could, in fact, become part of people's everyday work. It offered a model of the transformative power of art, but his proposal of planting trees also failed to go beyond the idea of art being legitimised and contained by the bourgeois art institution. And although Beuys had a vision, and his work of planting trees opened a space – both conceptually and aesthetically – for future developments, it failed to resolve the problem of art being trapped within both the artist's *narego* and the institution that will not allow art to become part of the collectivity of people's everyday life.

However, although Land art (as well as Beuys's work and other avant-garde works) failed to achieve what was inherent in their concepts but were contained within the unique achievements of individual artists, these concepts should not be considered as closures. They were prematurely aborted, frozen and turned into institutionally manageable objects and trapped in their temporalities. But concepts or ideas as knowledge can never be indefinitely trapped or permanently frozen, either as the property of celebrated individuals or of the institution. They can always be salvaged from the containment of institutionalised history, given new context and made to move forward within the everyday dynamic of new time and space. They can, indeed, be made to perform radically a transformative function in dealing with the problem of humanity today and of the 21st century. But to do this, the very concept of art will have to liberate itself from the narcissist ego of the artist, the bourgeois art institution which facilitates and promotes art only as saleable commodities and then turn them into reified objects placed in its museum showcases. Art must then go beyond what prevails as art and integrate itself with the collective struggle of life today

39

to recover its true social function and, indeed, to become a radical force of the 21st century.

But before I proceed further to elaborate the dialectic of this salvage, I want to pay homage to someone who – even in the early days of the avant-garde – realised the futility of the strategy of confronting the bourgeois ruling classes. When Hugo Ball, one of the pioneers of the Dada, realised that it was a waste of time making fun of the bourgeoisie, he walked out of the Cabaret Voltaire in Zurich, which he himself had founded in early 1916, and went to live in Ticino, Switzerland, among the poor peasants. This may appear to be Romantic, in the footsteps of Gauguin, and I am not suggesting that artists should pack up their studios and go live among the peasants. But Ball's realisation of the futility of the avant-garde, with its loud noises and oppositional tactics, and his move to be part of the life of a collective, does open a way forward, particularly now when the collective life of the planet is in danger of being destroyed. The artistic imagination, once freed from its self-destructive narcissist ego, can enter this life and offer it not only its salvation but put it on the path of a better future.

What the world faces today is not just a phenomenon of climate change to be studied by the scientists in their ivory towers, but the reality of its disturbing consequences faced by all life on earth. It is not just the problems of the polluted air, oceans, rivers and lakes, the threat of rising sea levels which will drown a large area of earth's inhabited land, including many major cities of the world, but the utmost misery of the deprived and poverty-stricken large population of the world. The popular media does inform us and make us think about the millions of starving people of the world, creating in us sympathies towards these people. Notwithstanding the efforts of academics to deal with this problem, the real solution lies not in what is offered to these people as charity but in the empowerment of the people themselves. Only when people are in a position to use their own creative potential, which can be enhanced by an artistic imagination, will a change occur.

The creative potential of most people of the world is tied with the land and how it is used. It is the symbiotically organic relationship of people with the land which can prevent the land from being exploited and polluted – and eventually destroyed – and from which then emerges the kind of productivity of the land and the creativity of people who inhabit it that together offer us the solution to the world problems today. This relationship can be established, as many researches have recently shown, only with traditional organic farms, run on the basis of egalitarian collectives, which can then reduce carbon emissions, clean up polluted seas, rivers and lakes, and restore the earth to its natural productivity.

What the world now really needs are rivers and lakes of clean water, collective farms and the planting of trees all over the world. The reduction in carbon emissions into the atmosphere can stop the rising of sea levels. Conceptualisation of the process of desalination as an ongoing continuous art work, with its own dynamics and agency – an evocation of what the Land art movement had as a potential but failed to realise – can, in fact, not only achieve all these objectives but also lay the foundation for a radical manifesto of art in the 21st century.

The establishment of desalination plants around the world – it can be millions – might not make much difference to the sea levels, but it could provide an enormous quantity of water, not only for the cultivation of land but also to fulfil all other needs of life on earth.

The idea of desalination plants as an artistic idea is based on art's potential to transform things, and comprises a complex cycle of continuous transformations of the sun's energy into steam when it comes in contact with water, which in turn either produces electricity or mechanical energy to run the desalination plant that produces pure water that is needed to fertilise the earth and for all life on the planet.

This phenomenon actually happens in nature. But when it is replicated by science and technology through an artistic imagination, its controlled results enhance the very phenomenon of nature that is replicated. The role of artistic imagination here is to contemplate the earth, whose beauty is now being destroyed, and to think and create not what is self-consuming by the ego from which the idea may emerge, but what can transcend and transgress the *narego* and become part of the collective energy of the earth, transforming it in such a way that this transformation not only enhances the natural potential of the earth itself but also the collective creativity of the life of all its inhabitants – humans, animals, plants, insects, and so on.

The idea of desalination plants is not just a conceptual art work, but can be realised materially; it is also meant to be an example of the broader

conceptual framework from which many more
ideas and projects may or can emerge with their
creativity realised and maintained by the collect-
ives of people all over the world.

This manifesto for the 21st century there-
fore proposes that artists should abandon the ivory
towers of their studios and stop their making of
objects for the art market. Instead, they should
focus their imagination on what is there in life,
to enhance not only their own creative potential
but also that of the collective life of earth's inhab-
itants. The world today is facing enormous violence,
and this violence will increase in the rest of the
21st century, as the earth's resources shrink due
to the stupidity of the kind of life humanity is
now pursuing. Art can and should strive for an
alternative that is not only beautifully affirmative
but is beneficial to all forms of life of our planet.
We humans are the gift of the mother earth, and
it is now our duty as its guardians to protect it from
the ugliness of its impending disaster.

The barbarism of civilisation must end.

Male Singer & Guitar, sitting, facing Left, lit in Red;
(in A major)Time is not due
(A minor) Its not du-ra-tio-nal
Its not
a straight line

Male Singer & Guitar, sitting, facing Left, lit in Red;
(in A major)Time is not due
(A minor) Its not du-ra-tio-nal
Its not
a straight line

Male Singer & Guitar, sitting, facing Left, lit in Red;
(in A major)Time is not due
(A minor) Its not du-ra-tio-nal
Its not
a straight line

(D minor) **Pointing** *towards* the fu-
The fu-ture and *you*

*Female Singer & Guitar, sitting, facing Right, Lit in
Green.*

(D major) **Its not an ar-row**
(D minor) **Pointing** towards the fu-
The fu-ture and you

*Female Singer & Guitar, sitting, facing
Right, Lit in Green.*

(D major) **Its not an ar-row**
(D minor) **Pointing towards the fu-**
The fu-ture and you

ARCHITECTURE REFUSES[1]

Pier Vittorio Aureli

It has been said that one can find some of architecture's meaning by looking not at what architects do, but at what they refuse to do.

For Leon Battista Alberti – no Gothic cathedrals, no castles, no arches on columns, no complicated decorative patterns, no irregular plans, no urban fantasies, no architectural illiteracy, no building spontaneity, no vernacular, no world beyond our world.

For Étienne-Louis Boullée – no Baroque, no Rococo, no architectural orders on the facade, no social orders, no *capriccios*, no pastiches, no antiquities, no frescos, no statues, no princes, no complicated forms, no aristocracy, no asymmetry, no history, no decorative excess, no elitism, no hidden mechanisms.

For Jean-Nicolas-Louis Durand – no *poché*, no complicated shapes, no value-free composition, no improvisation, no complicated spaces, no complicated buildings, no creativity-for-the-sake-of-creativity, no absurdities, no picturesque, no surprise, no social hierarchies, no archaeology, no representation, no figuration, no negation, no authorship, no meaning.

For Ludwig Mies van der Rohe – no Expressionism, no irrationalism, no Cubism, no Surrealism, no Futurism, no functionalism, no organicism, no spiritual-anxiety-manifested-with-spiritual-anxiety, no personality, no protest, no celebration, no Martini-like building, no new-architecture-invented-every-Monday-morning, no fashions, no personal creation, no obsessions, no *jeu savant*, no pouring-concrete-in-whatever-shape, no symbolism, no rhetoric, no salvation-of-the-world-with-architecture, no Merzbau, no unspeakable spaces, no excitement, no enthusiasm, no imagination-free-from-constraints, no Alpine Architektur, no Utopia, no planning-of-cities-as-a-whole, no technological acrobatics, no differences-for-the-sake-of-differences, no formal-variations-for-the-sake-of-formal-variations, no figurative architecture, no chaos, no omnipotence, no arrogance, no modesty, no screaming, no manifesting anything, no value-free availability, no anything goes, no more.

And today, some architects like us refuse to be involved in some ideas. For us – no complexities, no contradictions, no learning-from-

Las-Vegas, no collage cities, no diagrams, no icons, no data, no programmes, no mapping, no statistics, no content, no research, no branding, no blobs, no parametric formalism, no icons, no iconic buildings, no networks, no logos, no blogs, no form-Z, no 3D Studio MAX, no Maya, no CATIA, no biomorphic design, no shapes, no non-standard architecture, no high rise, no Guggenheims, no archistars, no avant-garde, no neo-avant-garde, no new-neo-avant-garde, no anti-avant-garde, no think-tanks, no biennale-activism, no fake-bottom-up-we-work-for-the-people, no architect-as-social-entrepreneur, no architect-as-social-opinionist, no-architect-as-cultural-opinionist, no architecture-as-art, no architect-as-artist, no artist-as-architect, no art-as-architecture, no architect-as-expert-on-everything, no architect-as-journalist, no rhomboid-like-facade-pattern, no circular-holes-in-the-facade, no cantilevering boxes, no green-grass-on-the-roof, no titanium-on-the-facade, no colourful architecture, no twisted shapes, no strange shapes, no strangeness, no drama, no uniqueness, no originality, no novelty, no newness, no nostalgia, no Sixties, no utopia, no nature-mending, no fake interactivity, no irresponsibility, no life-mirroring, no information, no communication, no coercion, no confusing-architecture-with-everything-that-is-not-architecture, no confusing-life-with-everything-that-is-not-life.

1 This manifesto is an architect's re-elaboration, reinterpretation and update of Ad Reinhardt's *Abstract Art Refuses*, 1958. As is well known, the first Manifesto is Karl Marx & Friedrich Engels's *Communist Manifesto*, 1848. In the entire history of Communism, no other (Communist) author was stupid enough to make another manifesto on the same topic (Communism). This was because to write a new manifesto would imply the negation of anything previously done, and thus also the previous *Manifesto*. Proposition by negation is the quintessential nature of the manifesto. In the form of a manifesto, any idea proposed or projected immediately implies the negation of everything else. Manifestos are, by nature, the ultimate freedom from debates, dialogues, exchanges, negotiation and compromises, which constitute the prototypical bourgeois's way of dealing with politics. For this reason, the entire history of Communism was started (and ended) by only one manifesto. Moreover, it was precisely for this reason that the format of the manifesto soon emigrated to the art avant-garde, where it was more plausible (and profitable) to change ideas every Monday morning. Here, the manifestos were killed by manifestos. Yet the ultimate collapse of the manifesto was due not to itself but to the compulsive use of it by artists and artist groups. The question then is: How can one write a Manifesto that escapes this logic of compulsive negation, whilst at the same time not betraying its quintessential negating nature?

And, more importantly, what sort of unilateral statement is possible today in a society that has made continuous debate the source of its (totalitarian) power? In other words, what sort of *position* is possible today within the current fundamentalism of pluralism? The only possible answer to this question is not to give any answer, or better to simply answer: none. Refusal, rejection and negation, instead of being understood as 'negative' practices, must be viewed today as the only possibility to make something. This act of doing is based precisely on not doing anything, which consists in 'undoing' things. This undoing something, far from being value-free negation, would work precisely by strategically leaving, evacuating something, but also by helping something to appear as itself and not as something else. Following these considerations, I have decided not to write a new manifesto but to continue an existing one. I have chosen the negative manifesto by Reinhardt, not only because I share his way of making art, but also in order to not harm his manifesto, by writing a new one. Reinhardt believed that negation was the core of making (modern) art. I believe the same goes for architecture. What I particularly like in Reinhardt's manifesto is that this act of negation does not take place in a vacuum, but belongs to a tradition. I would like to frame negation in architecture in the same way: not as automatic nihilism but as strategic nihilism, as strategy of refusal aimed to constantly reframe the possibilities of (absolute) potentiality.

CENTRO DA REVOLUÇÃO ESTÉTICA E INTELECTUAL
CENTRE OF THE AESTHETIC & INTELLECTUAL REVOLUTION

Mathieu Copeland & Pablo León de la Barra

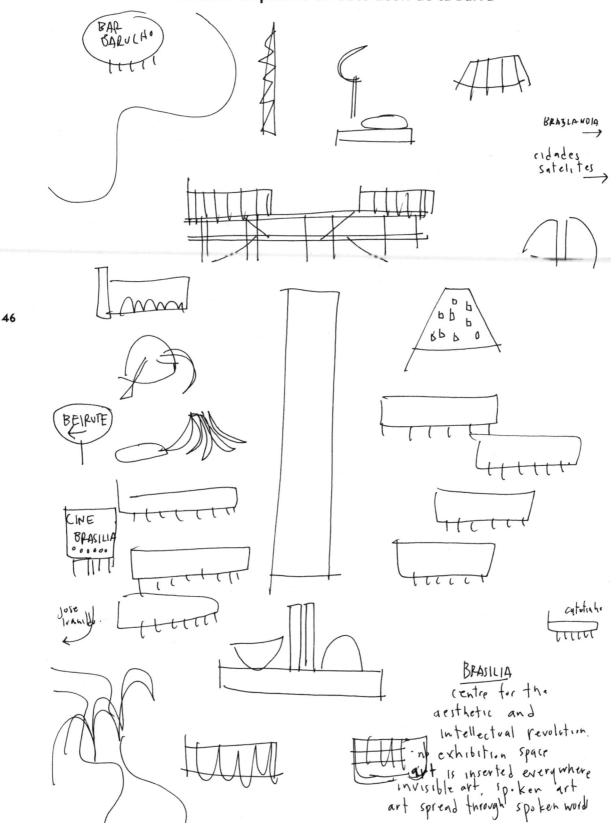

The manifesto for a revolution, as this completes the journey into the revolution…

The revolution starts now!

In 1967, Hélio Oiticica responded to Brasília, (which was built in 41 months, from November 1956 to April 1960, when it was officially inaugurated) by creating Tropicália, the anti-utopia, the reality of the favelas against the dictatorship of rationality, order and concrete. Confronting these two realities, we shall call for a new vision of Utopia, a CONCRETE UTOPIA! A utopia made of reality, concrete and steel! Brasília will again be the platform for the development of other modernities and new realities: in other words, Brasília will embody the centre of the aesthetic and intellectual revolution!

Centro da revolução estética e intelectual is the recreation of the mythical centre of the intellectual revolution: a myth, yet a myth in which we trust!

The two evident trends seem to be that either a revolution concludes its course and becomes a new standard or, following a permanent circle, becomes a permanent revolution. The creation of the centre, in turn, becomes the embodiment of both the playful environment it creates and the serious goal it affirms, and becomes a meeting point of ideas, a cross-over of cultures within a third place, the museum.

The revolution within the institution becomes a call that embraces movements, living entities and breaks for reflection. More than ever, we shall rethink the institutions, and rethink the museums that the cities where we live have become. We shall call for the most radical levelling, not the kind that we experience in our everyday life through global similarity and standarisation, but indeed the levelling of our cities, to level everything to zero and start again. And this time, we shall seek no permanency, only new and ephemeral architectures.

The fallow shall be applied to our everyday life, to our common activities, and to all the institutions that surround us, to all the structures that define our experiences. A third of all museums will have to close for a year, as the other two thirds continue their activities, and as the year draws to an end, another third will close, and so forth and so on. Let the dust settle, and from there a new harvest will breed again with more strength from these now-fertile grounds.

We now must create an economy of cultural subversion – more than ever, we shall create a community in our amnesiac society.

The revolution inhabits the city, and the city becomes the host and the primary resource for the revolution: both a shelter and an entity that digests its own constituting material… a cannibal that is sustained by the city, and that feeds itself from it – neo-anthropophagia!

The revolution uses the museum as a map, and envisages using the Espaço Lúcio Costa (the museum of the creation of the city of Brasília) as the plan, and the city as its operational field. The revolution uses the newspapers of the city as its own catalogue. Spreading the rumours and all worded artefacts only based on beliefs (Spoken Words to the World), the exhibition goes deep into the future, as we recover faith in a new Modernism!

The Revolution is such a Modernist form! Yet a formalist revolution, such a revolutionary idea!

The Centre is everywhere, omnipresent, as the centre is within us! Activating art, dance and celebration, the revolution becomes a popular invitation to celebrate art within society. Our belief in Modernism does not become a quote or a citation, but to the contrary the means to create new work and non-work and to work with and within the originals – and among these create a circle of old masters as the bearers of knowledge! We do not reproduce, we breed, and we generate a new understanding of the past by inscribing in the present the seeds of the future!

The revolution is ultimately abstracted from the city, the structure of previous Modernist models! The Centre Is Not Complete – The Centre Is Everywhere. The seeds of this revolution are within this affirmation, and affirm that all becomes the centre of the centre! The appraisal of humankind in this age of global chaos. Millions of people, arriving from everywhere, from other planets, arriving to the centre, to the centre of the revolution. The Centre Is Everywhere!

The Revolution Is Everywhere!

The centre is within us! The revolution generates life, reality, blood, breath, and is akin to a mother giving birth: the revolution generates the future, and the future is NOW!

The manifesto for a revolution, as this completes the journey into the revolution…

MANIFESTO FOR
'LES ARCHIVES DE CŒUR'

Christian Boltanski

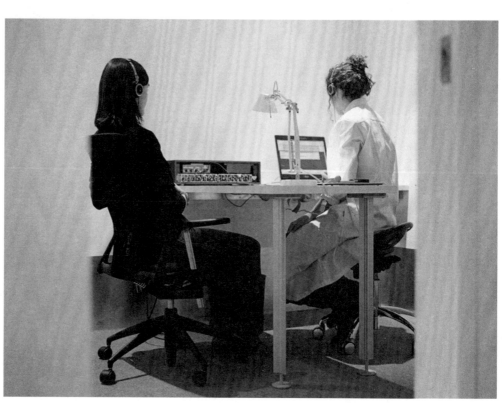

MANIFESTO: 1959

Personism
Frank O'Hara

. . . I don't believe in god, so I don't have to make elaborately sounded structures. I hate Vachel Lindsay, always have, I don't even like rhythm, assonance, all that stuff. You just go on your nerve. If someone's chasing you down the street with a knife you just run, you don't turn around and shout, "Give it up! I was a track star for Mineola Prep."

That's for the writing poems part. As for their reception, suppose you're in love and someone's mistreating (*mal aimé*) you, you don't say, "Hey, you can't hurt me this way, I *care*!" you just let all the different bodies fall where they may, and they always do may after a few months. But that's not why you fell in love in the first place, just to hang onto life, so you have to take your chances and try to avoid being logical. Pain always produces logic, which is very bad for you.

I'm not saying that I don't have practically the most lofty ideas of anyone writing today, but what difference does that make? they're just ideas. The only good thing about it is that when I get lofty enough I've stopped thinking and that's when refreshment arrives.

But how can you really care if anybody gets it, or gets what it means, or if it improves them. Improves them for what? For death? Why hurry them along? Too many poets act like a middle-aged mother trying to get her kids to eat too much cooked meat, and potatoes with drippings (tears). I don't give a damn whether they eat or not. Forced feeding leads to excessive thinness (effete). Nobody should experience anything they don't need to, if they don't need poetry bully for them, I like the movies too. And after all, only Whitman and Crane and Williams, of the American poets, are better than the movies. As for measure and other technical apparatus, that's just common sense: if you're going to buy a pair of pants you want them to be tight enough so that everyone will want to go to bed with you. There's nothing metaphysical about it. Unless, of course, you flatter yourself into thinking that what you're experiencing is "yearning." . . .

Manifesto selected from Jonas Mekas Archive
Personism, Frank O'Hara, 1959

:LESSONS OF DARKNESS

MINNESOTA DECLARATION: TRUTH AND FACT IN DOCUMENTARY CINEMA

WALKER ART CENTER, MINNEAPOLIS, MINNESOTA
APRIL 30, 1999
WERNER HERZOG

1.
BY DINT OF DECLARATION THE SO-CALLED CINEMA VERITÉ IS DEVOID OF VERITÉ. IT REACHES A MERELY SUPERFICIAL TRUTH, THE TRUTH OF ACCOUNTANTS.

2.
ONE WELL-KNOWN REPRESENTATIVE OF CINEMA VERITÉ DECLARED PUBLICLY THAT TRUTH CAN BE EASILY FOUND BY TAKING A CAMERA AND TRYING TO BE HONEST. HE RESEMBLES THE NIGHT WATCHMAN AT THE SUPREME COURT WHO RESENTS THE AMOUNT OF WRITTEN LAW AND LEGAL PROCEDURES. "FOR ME," HE SAYS, "THERE SHOULD BE ONLY ONE SINGLE LAW: THE BAD GUYS SHOULD GO TO JAIL." UNFORTUNATELY, HE IS PART RIGHT, FOR MOST OF THE MANY, MUCH OF THE TIME.

3.
CINEMA VERITÉ CONFOUNDS FACT AND TRUTH, AND THUS PLOWS ONLY STONES. AND YET, FACTS SOMETIMES HAVE A STRANGE AND BIZARRE POWER THAT MAKES THEIR INHERENT TRUTH SEEM UNBELIEVABLE.

4.
FACT CREATES NORMS, AND TRUTH ILLUMINATION.

5.
THERE ARE DEEPER STRATA OF TRUTH IN CINEMA, AND THERE IS SUCH A THING AS POETIC, ECSTATIC TRUTH. IT IS MYSTERIOUS AND ELUSIVE, AND CAN BE REACHED ONLY THROUGH FABRICATION AND IMAGINATION AND STYLIZATION.

6.
FILMMAKERS OF CINEMA VERITÉ RESEMBLE TOURISTS WHO TAKE PICTURES AMID ANCIENT RUINS OF FACTS.

7.
TOURISM IS SIN, AND TRAVEL ON FOOT VIRTUE.

8.
EACH YEAR AT SPRINGTIME SCORES OF PEOPLE ON SNOWMOBILES CRASH THROUGH THE MELTING ICE ON THE LAKES OF MINNESOTA AND DROWN. PRESSURE IS MOUNTING ON THE NEW GOVERNOR TO PASS A PROTECTIVE LAW. HE, THE FORMER WRESTLER AND BODYGUARD, HAS THE ONLY SAGE ANSWER TO THIS: "YOU CAN'T LEGISLATE STUPIDITY."

9.
THE GAUNTLET IS HEREBY THROWN DOWN.

10.
THE MOON IS DULL. MOTHER NATURE DOESN'T CALL, DOESN'T SPEAK TO YOU, ALTHOUGH A GLACIER EVENTUALLY FARTS. AND DON'T YOU LISTEN TO THE SONG OF LIFE.

11.
WE OUGHT TO BE GRATEFUL THAT THE UNIVERSE OUT THERE KNOWS NO SMILE.

12.
LIFE IN THE OCEANS MUST BE SHEER HELL. A VAST, MERCILESS HELL OF PERMANENT AND IMMEDIATE DANGER. SO MUCH OF A. HELL THAT DURING EVOLUTION SOME SPECIES—INCLUDING MAN—CRAWLED, FLED ONTO SOME SMALL CONTINENTS OF SOLID LAND, WHERE THE LESSONS OF DARKNESS CONTINUE.

Manifesto selected from Jonas Mekas Archive
Lessons of Darkness, Werner Herzog, 1999

INSTRUCTIONS

1. Open the door and politely let the first person in and ask if they would like to hang up their coat.

2. Ask the visitor to sit on the examination chair, and explain about the log-book and the fact that they are agreeing to donate their heartbeat and allowing the use of their name. Show introduction text in log-book.

3. Ask the visitor to fill in their name and sign the log-book. After this, stamp the day's date and the particular number allocated that visitor into the log-book.

4. Clean the stethoscope with towelette.

5. Ask the visitor to gently apply the stethoscope head to their chest at position P or T on the following sketch. It's better if the stethoscope goes directly on the skin of the visitor. Ask the visitor to handle the stethoscope and to stay as still as possible, and to avoid deep breathing for a while.

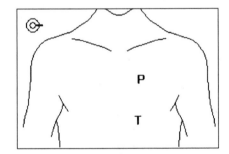

6. Monitor the sound of the heart via the earphones, so that the sound is at its best. Ask the person to change position until it is correct.

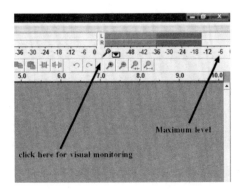

7. Watch the visual monitoring level on the Audacity software by clicking on the microphone. To avoid clipping, the level should be as close as possible to -6, without saturation. If that happens, ask a technician to correct the levels of entry and outputs of the mastering unit, or the level of entry on the soundcard.

8. When ready, ask the visitor to avoid any movement for a while – do avoid your own movements also.

9. Press the 'Rec' button with the mouse or the letter 'R'.

10. Stay still (both you and the visitor for 20 seconds approximately).

11. Press 'Stop' or the letter 'S'.

49

12. If you missed the recording, close the file, and do another recording.

13. Save the wav file created by following this: 'File/Export as wav', etc. into the specified folder (as described in the 'Daily Procedure' document), and name it as indicated:

[year]-[month]-[day]-[place of recording]-[surname]-[first name].wav

Always verify that you have spelt the name of the person correctly.

ALTERMODERN

Nicolas Bourriaud

Travel, cultural exchanges and examination of history are not merely fashionable themes, but markers of a profound evolution in our vision of the world and our way of inhabiting it.

More generally, our globalised perception calls for new types of representation: our daily lives are played out against a more enormous backdrop than ever before, and depend now on trans-national entities, short or long-distance journeys in a chaotic and teeming universe.

Many signs suggest that the historical period defined by postmodernism is coming to an end: multiculturalism and the discourse of identity are being overtaken by a planetary movement of creolisation; cultural relativism and deconstruction, substituted for Modernist universalism, give us no weapons against the twofold threat of uniformity and mass culture and traditionalist, far-right withdrawal.

The times seem propitious for the recomposition of a modernity in the present, reconfigured according to the specific context within which we live – crucially, in the age of globalisation – understood in its economic, political and cultural aspects: an altermodernity.

If 20th-century Modernism was, above all, a Western cultural phenomenon, altermodernity arises out of planetary negotiations, discussions between agents from different cultures. Stripped of a centre, it can only be polyglot. Altermodernity is characterised by translation, unlike the Modernism of the 20th century which spoke the abstract language of the colonial West, and postmodernism, which encloses artistic phenomena in origins and identities.

We are entering the era of universal subtitling, of generalised dubbing. Today's art explores the bonds that text and image weave between themselves. Artists traverse a cultural landscape saturated with signs, creating new pathways between multiple formats of expression and communication.

The artist becomes 'Homo viator', the prototype of the contemporary traveller whose passage through signs and formats refers to a contemporary experience of mobility, travel and transpassing. This evolution can be seen in the way works are made: a new type of form is appearing, the journey-form, made of lines drawn both in space and time, materialising trajectories rather than destinations. The form of the work expresses a course, a wandering, rather than a fixed space-time.

Altermodern art is thus read as a hypertext; artists translate and transcode information from one format to another, and wander in geography as well as in history. This gives rise to practices which might be referred to as 'time-specific', in response to the 'site-specific' work of the 1960s. Flight-lines, translation programmes and chains of heterogeneous elements articulate each other. Our universe becomes a territory all dimensions of which may be travelled both in time and space.

The Tate Triennial 2009 presents itself as a collective discussion around this hypothesis of the end of postmodernism, and the emergence of a global altermodernity.

SEVEN SUGGESTIONS FOR THE NEW ATHENS CHARTA

Andrea Branzi

THE WEAK METROPOLIS

When we talk about a *New Athens Charta*, we mean to describe a cityscape in the age of the Third Industrial Revolution, of globalisation and of diffuse work.

A city that considers as a value the liberalisation of the urban system, instead of its formal and functional rationalisation. A city where social relations go through the internet, and not only through physical meetings along streets and squares. A city less anthropocentric and more bio-diverse. A city where reuse takes the place of new building.

The aim of the *New Athens Charta* is not the City of the Future, but rather the city of the present, with all its faults and contradictions. Not an ideal city, based on a rigid and definitive model, but a city that has always to be reformed, reshaped and replanned, in search of temporary balances that need an ongoing setting.

FIRST SUGGESTION: REUSE OF THE EXISTENT

Instead of new buildings, foster the reuse of the existing estates, to fit the present city to the new need of the diffuse work, of mass enterprise, of creative economy, of cultural production and consumption.

SECOND SUGGESTION: ECOLOGY OF THE ARTIFICIAL WORLD

To make interior spaces comfortable — both for housing and any other activity — it's important that there are objects and facilities corresponding to technological and functional opposing logics, avoiding mono-logic settings and creating a highly complex environment:
– hard materials and fragile materials
– mass products and single objects
– high-tech and traditional technologies
– long-lasting products and disposable ones
– coloured objects and raw ones

Andrea Branzi, *Agronica*, 1995. project on theoretical models of weak urbanisation for the Philips Corporation (with the Domus Academy Research Centre)

THIRD SUGGESTION:
REVERSIBILITY

Avoid rigid and definitive solutions and foster reversible facilities that can be dismantled and transformed, allowing to fit in the time and the interior space for new activities, unforeseen and unprogrammed. Utilise technologies and materials that can foster new ways of use – not defined in their turn.

FOURTH SUGGESTION:
FUNCTIONAL NON-DEFINITION

Avoid the identification between form and function, specialised typologies, rigid facilities, but create interior spaces similar to functionoids, that can follow the flow of needs and destinations. In the age of electronics and computers, the spaces can change their function in real time, by just changing software.

FIFTH SUGGESTION:
GREATER BIO-DIVERSITY

Realise (as in the Indian metropolis) the conditions for a cohabitation between man and the animal kingdom; the technologies and the sacred; alive and dead people... a metropolis less anthropocentric and more open to bio-diversities, according to a concept of hospitality going beyond the concept of specialisation and separation that is typical of European culture.

SIXTH SUGGESTION:
HALF-AGRICULTURAL AND HALF-URBAN TERRITORIES

Create threshold areas between city and country-side, with hybrid territories, made of productive agricultural systems aside scattered light and temporary architectural elements, a system in progress following seasons and weather, allowing conditions of flexible and discontinuous housing.

SEVENTH SUGGESTION:
SHADED BORDERS BETWEEN EXTERIOR AND INTERIOR

Realise architectural facilities with a crossable and shaded perimeter, to make a more continuous urban net, where the difference between indoor and outdoor, public and private spaces tends to vanish, creating an integrated system of the urban environment.

The logics of use typical of interiors invade the urban space, while the ones of public spaces enter in the private ones, creating a porous system, rich in amniotic exchanges.

53

Andrea Branzi, *Pineta di architettura*, 2007, simulation with mirror

SEX AND THE NEW WAY, V.1

Paul Chan

Do you know (I am sure you do) how the law rules you as long as you breathe?

For the slave who has an owner is bound by law to his owner so long as he breathes. But if the owner dies, the slave is suspended from the law of that owner.

So then if, while the owner breathes, the slave is owned by another, we call the slave a freelancer. But if the owner is dead, the slave is freed from law, so that the slave is not a freelancer, although he is owned by another.

Can you see that you are also not owned by law? You serve another, in sex and spirit, so together you shall bring forth a new way.

When we were slaves, the way set by law worked within our inner folds to bring forth the gift of death.

But now we are suspended from the law, which held us in a deadening, so that we shall serve new fruits, and not the old spirit.

What shall we say then? Is the law sex? Heavens, no. But I had not known sex but by the law. For I had not known pleasure except the law had said I shall not please freelancely.

But sex, in the throes of law, created in me all manners of lust. For without the law, sex was dead.

I was alive without law once. But when I became lawful, sex became sex, and I died.

And the legislations which led to more life, I found led to more death.

For sex, in the throes of law, seduced me, and killed me.

But the law is the whole, that which makes us wholly here. Justice serves the common good.

Is it, then, the good that brings death to me? God, no. But sex brings death when it becomes a good.

We know today law is spirit. But I am flesh, bound by sex.

I want, but I will not allow. I would, but I will not. Hate is the only symmetry.

If then I do what I would not, in common good, I enact the law.

But then it is not I that do it, but the sex as sex in me.

There are no goods in me. There is will, but not desire for law that makes goods.

I do not know the good from the goods.

Now sex is law when the good is present within us as goods. I do by law for good what is for goods.

I find then that law, in good, is in death.

Sex in life after law is the spirit of a new way: a profound lust. It is flesh as reason against law-making.

Oh poor randy man that I am! Who will undeaden the stiff sex before the law in me?

The flesh burns like embers. There is no light, only hot ashes from parts of old bodies.

55

56

ARCHITECTURE FOR ALL

ARCHITECTURE EXPANDS TO

Architecture 'wings' :
KIDS DO ARCHITECTURE AT SCHOOL
D-I-Y
SURVIVAL STRATEGIES
PERFORMANCE LOGIC
LATERAL THINKING/APPLIED ART
RESOURCE ACTION STUDIES

Architects become :
SHELTER ARCHITECTS
BUILDING ARCHITECTS
STRATEGY ARCHITECTS

Examples :
CARS BECOME ASSISTED CLOTHING
TOWNS BECOME INFILTRATED FIELDS
SEAS BECOME FARMS
PUBS BECOME CLASSROOMS
MARKET GARDENS BECOME STUDIOS
 RAILWAYS BECOME UNIVERSITIES
 Cedric Price

THINK LATERALLY
ACT LATERALLY

57

THE MANIFESTO OF INFERIORITY COMPLEX

OR

A NEGATIVE MANIFESTO OF ÜBERCONTEMPORARY ART

Ekaterina Degot

The true reason why I gave my manifesto the title *Manifesto of Inferiority Complex* is that I was really ashamed of finding myself unable to write ANY decent manifesto. Too bad for me, since nowadays anyone is supposed to have at least one at hand – a very individual definition of oneself, one's own desires and plans. It matters more than opinion, and certainly more than experience and knowledge. This is due to the disappearance of the authority of academic research in favour of management and media activity. We are supposed to know, love and manifest ourselves more than we are supposed to know, question and study the world around us in space or time.

One of the reasons I discovered behind my difficulties with manifestos was that even if I DO belong to the caste of busy curators, I did not manage to root out the survivals of the profession of a CRITIC from my own mind. This manifesto could also be called a manifesto of a critic.

And critical spirit does not help much in producing manifestos. The feeling of your own or someone else's bottle being half-empty rather than half-full poisons your voice, and you stop being convincing.

Criticism, actually, does NOT necessarily have to be convincing – when it is good, it is rather contagious or, to put it more traditionally, provocative; it may raise questions rather then answer them, and this is OK. This may even be practical in terms of panel discussions, for example. The more critical you are, the more questions you get, and this is what moves the discussion.

But speaking in terms of panel discussion talks, a manifesto is something you are NOT really supposed to ask questions after it has been delivered. A good manifesto BLOCKS conversation. By the way, Kazimir Malevich was NOT aiming at art which would raise questions or produce long academic texts (as we may think, looking at his posthumous career); he said that he would like to witness a prophet's words 'stand still on his lips' because of his art.

Early avant-garde manifestos, like those of the Futurists or Surrealists, could include historical and social landmarks as something artists were supposed to refute and disclaim, like contemporary bourgeois lifestyle. This was self-determination through a 'no', and we sometimes tend to identify manifestos with this negation.

But, very early, a different approach was adopted – the self-definition through a 'yes'.

In 1913, the *Yes Manifesto* by Mikhail Larionov and Ilya Zdanevich was written, where both artists answered 'Yes' to any journalist's political or aesthetical question, like 'Are you for this or that?' or 'Are you against this same this or that?'

These incompatible positive answers – these contradictory and arbitrary '*Da*', which later reappeared in Dada invented by Tristan Tzara (and in Romanian, '*Da*' is 'Yes', like in Russian) – produced the REAL destabilisation and loss of orientation that any productive manifesto has to offer. Or let's take Andy Warhol's famous 'SO WHAT?', one of the most convincing manifestos of any time. This unmotivated assertion, this self-sufficiency which annihilates any kind of comparisons with any contexts and history as such, is what is in demand today and what lies at the core of MySpace, YouTube and Damien Hirst's art, as other forms of manifesto as self-branding. And this excludes inferiority complexes as they are, by definition, based on comparisons.

This creates a new kind of art which I would call ÜBERcontemporary, the kind of contemporary culture that has finally cut through the umbilical cord that connects it to history. We no longer need the 'symbols of modernity' that the avant-garde suggested; we have no need for monumental proof of historical changes, nor do we need disruption with the past. We have TV, advertising and design, which do not just compete with art or make it redundant but suggest that it continue on different ground, in another context. This context is the physical moment. Any advanced artist no longer really needs the critic to write about him. Because a critic contextualises, makes differences, historicises. But there is no more need. Artists are leaving the context of history behind and entering the context of media, newspapers and magazines. On TV, in glossy magazines, movies and comics, we know that the pressure to innovate has been lifted completely, since the audience has a short memory (recently, some magazines – and even news sites – republish material after a certain time, simply because the reader will probably have changed).

This art does not take place in history but *now and here*. It does not (and will not) have history, theory, criticism, universities or museums. But it does (and will) have newspapers, television programmes, internet chats, self-learning, video-installation corners in consumer electronics stores,

59

local fanclubs and advertisements on lamp-posts. This new ÜBERcontemporary art will not sell itself, but will be distributed through different channels, which might sometimes be free, as long as the same brand will produce luxury versions of the same. It will keep the consumer's reactions in mind and include them, thus really grasping collectivity. It will no longer be recognisable as Modernism, or even art, and it will have a totally different institutional structure and different system of authorship. In the end, when Charles Baudelaire called Constantin Guys – who did little more than to draw illustrations of dresses for fashion magazines – the first 'artist of modern life', he may have had this kind of art in mind.

For contemporary art which traces its roots to classical Modernism, it is difficult to blend with such a culture, because it is, by definition, of a very undemocratic nature and based on comparison. Of all spheres of our lives, it is one of the only fields – the other being fundamental research and scholarship – that is allowed to be undemocratic. Withstanding the masses is part of its identity, and a very abnormal kind of MARKET – of which we all are more or less aware – is one of the instruments which sustains it. Through the entire 20th century, Modernism was an art form that no one liked; in fact, this was one of the distinctive features. (Consequently, whoever liked Modernism could think of themselves as 'nobody', which actually makes life a lot easier.) This is why many serious authors have accused Modernism of holding 'ordinary people' in contempt, ignoring their values and joys.

Modernism also had a certain inner answer to such accusations (even if this answer was never formulated openly): the 'ordinary person' actually collaborates with capitalism; consequently, he deserves punishment. In the end, it is precisely this kind of punishment that Modernism was to effect. Its art works attempted to create intentionally unlikeable products, damaged goods (painting impossible to savour; *pissoirs* impossible to piss in) or even hostile commodities that would harm their owners immediately or over time (like deteriorating fruit, which is now fashionable, or an object containing a bomb on a timed fuse; I think this is, in fact, a common avant-garde dream). Modernism is always tinged with a hue of sadism. It wants to deprive people of pleasure, all just to separate them from consumption, 'waking the artist in them and fostering his development', as Lenin put it.

But today, the sadism of depriving the spectator of pleasure proved capable of establishing a loyal following. All over the world, the audience of contemporary art is basically composed of people who are accustomed to reacting to one and the same set of stimuli or laugh at the same kind of jokes, and then thankfully settle back into their routines. In recent years, however, this mechanism has grown rusty and is more fallible; its proponents have grown fewer in number, while one if not several generations have grown up finding pleasure in other games and another type of humour…

This is why, usually, critics do not really criticise; they know that one hand washes the other, that they are working 'for a common cause'. The critic is only a critic in the Kantian sense; he has not been criticising professionally since the early 20th century. In the art world, it is hardly customary for the artist who is 'critical' himself to hear that his newest painting is worse than his last. This becomes especially apparent in comparison to film and theatre criticism, which still lauds or berates directors and actors and offers its readership advice on which premières to visit, seeing precisely this critical function as its calling. One generally assumes that this is because neither film nor theatre are as advanced as 'art', where the audience's reaction can already be safely ignored (since the number of visitors bears no direct relation on sales). Usually, this state of affairs is to the artist's liking. One could say that the art world is sitting pretty…

But then this ÜBERcontemporary artist comes – the one who sees the fame of a Steven Spielberg as something *seriously* worth fighting for, and is ready to part with his or her (but mostly his) psychological security in doing so, because, after all, film critics will generally throw annihilating mockery in Spielberg's direction (implying how sick we all are of him!), but they will do so on the front page. Basically, one could write about Damien Hirst's objects that, in the final analysis, the Marx Brothers were funnier. And that would be a real triumph for contemporary art. Art would finally attain the status of Hollywood movies. It would leave the territory of its invulnerability (that is, its immortality). It would join the masses (that is, die). So it turns out that *this* is how the death of art will happen.

There is a huge irony in the fact that 20th-century art has been talking about emptiness, nothingness and the death of art for so long. But

MANIFESTO OF LETTERIST POETRY
A Commonplaces about Words

Pathetic I	The flourishing of bursts of energy dies beyond us.
	All delirium is expansive.
	All impulses escape stereotyping.
Still I	An intimate experience maintains curious specifics.
Pathetic II	Discharges are transmitted by notions.
	What a difference between our fluctuations and the
	brutality of words.
	Transitions always arise between feeling and
	speech.
Still II	The word is the first stereotype.
Pathetic III	What a difference between the organism and the sources.
	Notions - what an inherited dictionary. Tarzan learns
	in his father's book to call tigers cats.
	Naming the Unknown by the Forever.
Still III	The translated word does not express.
Pathetic IV	The rigidity of forms impedes their transmission.
	These words are so heavy that the flow fails to carry
	them. Temperaments die before arriving at the goal
	(firing blanks).
	No word is capable of carrying the impulses one
	wants to send with it.
Still IV	WORDS allow psychic alterations to disappear.
	Speech resists effervescence.
	Notions require expansion to equivalent formulas.
WORDS	Fracture our rhythm.
	by their Assassinate sensitivity.
	mechanism, Thoughtlessly uniform
	fossilization, tortured inspiration.
	stability Twist tensions.
	and aging Reveal poetic exaltations as useless.
	Create politeness.
	Invent diplomats.
	Promote the use of analogies
	Substitute for true emissions.
Pathetic V	If one economizes on the riches of the soul, one dries
	up the left-over along with the words.
Still V	Prevent the flow from molding itself on the cosmos.
	Form species in sentiments.
WORDS	Destroy sinuosities.
	Result from the need to determine things.
	Help the elderly remember by forcing the young to forget.

Manifesto selected from Jonas Mekas Archive
Manifesto of Letterist Poetry, Isidore Isou, 1942

This text, which I originally wrote in 1974, was presented for the first time publicly at Anthology Film Archives, during my lecture on politics and art. With virtually thousands of independent filmmakers working today in this country, and organizing themselves into organizations such as the Association of Independent Film and Video Makers, with membership of thousands, I felt, and I stated so in my lecture, that the personal, individual, free film artist is fast disappearing in a sea of organized, union-like, "workers" of cinema. I am aware that with making this text public today, when the workers of Poland are in the front pages of the Press, I am running a risk of being misunderstood. No, I am for the workers of Poland! At least at this juncture in Poland's history, they are acting heroically and courageously. They deserve songs of praise. My Manifesto is not directed to them. My manifesto is directed to all the other workers of the world.

Jonas Mekas
Nov. 20, 1980

Anti-Workers Manifesto

1.
I hate you!
I hate you!
I hate you, workers of the world!
I hate you united and I hate you ununited.
You are after money, after a class, after of sense of belonging to a mob.
You are after your fucking cars that poison my air.
Your chrome iceboxes and your televisions.
You don't care what you make, you, workers, as long as you are paid.
You manufacture anything for anybody as long as you are paid for your "labor."
You always blame the bosses, the others, the "Rockefellers" for the consequences and for your own corruption.
What an easy way out!
No, the crimes of others do not absolve your crimes!
The stupidity of others doesn't legitimize your own stupidity!
No, you are not workers: you are pitiable slaves, collaborators and murderers.
All over the world.
In America. In Soviet Union. In Japan. In Africa.
In capitalist countries. In communist countries. In Third World countries. In all countries.
None of you care what you do. As long as you are paid.

2.
Workers!
You made that word into an ugly caricature.
It's a word you made me to detest.
There are still some people who care about what they do, about how they do it; who care about what the product is used for, whom it serves and how it serves, what it does to others.
What it does to the world around us.
There are very few of them left.
But they are not among you!

3.
Hollywood and Unions go well together.
Unions and Governing classes & Mass arts go well together.
Workers & Unions go well together.
Unions and Power go well together.
Unions and Capital go well together. Unions endorse Presidents.
Yes, Power!
Yes, workers!
You want power.

now, this dissolution is taking place in a form completely unlike the one of which avant-garde artists day-dreamed. The end has not come in the form of a black square on a white background, nor has it emerged as a smoothly painted surface, nor even as a cleaned urinal turned upside down, just as abstracted from everyday life as the black square. Basically, art has not died in the laconic form of absence, but as a horrible superabundance of images, brands and trademarks. Abstraction and generalisation have died out entirely, with the result that even fashion journals now no longer tell us about tendencies and trends, but about which concrete handbags have been made by which concrete designers.

The aesthetic of the 1990s sang of the ethical and poetic principles of 'both one and the other', a principle of manifold possibilities, with which it wanted to oppose the brutal Modernist 'either/or'. In praxis, the Romantic attitude of 'further and further' has flowed into the consumerist 'more and more', which Jean Baudrillard has called 'too much of too much'. In fact, this is what we call the world of globalism, a world in which 'everything is included'. Everything happens at the same time and close by. Time and space are disappearing; there is no distance between countries and cultural layers.

But this means the sadism of contemporary art has even become more effective. Only now, this ÜBERcontemporary art has becomes torture through consumption and not through the inaccessibility of consumption; torture through never-ending pleasure, unrelenting digestion, total access and continuous erections. This is the sadism of our time, in which 'nothing' has been replaced by an excruciating 'everything'. This world of ours is based not on restrictions but on permissions. This is a world where ice cream and chocolate bars are considered basic food and sold in schools' vending machines, and fasting is a luxury – a world where we pay more and more to have less and less (like T-shirts without a Mickey Mouse, or a bar without loud music).

This ÜBERcontemporary art is torturing the viewer not with inferiority complexes of being not intelligent enough – rather with deep existential suffering of not being creative enough, not having one's own manifesto and not making money straightaway from it.

But then again, it might change very soon.

NO MORE SILLY HATS

Jimmie Durham

Hereby, in 2008, I put forth a manifesto. Perhaps it should begin with statements about my intentions for my art practice, but it does not because I have never worn silly hats, neither on my head nor metaphorically.

Americans wear silly hats, but according to various experts (another type of silly hat) Americans are on their way out. We need not take notice of them so constantly anymore.

The English, the Irish, the Germans, the Mexicans, the Canadians and some Frenchmen are much more our future aesthetic problem. It is they who have so slavishly accepted American instructions, and have been wearing silly hats that Americans wear. Specifically, those hats with a duck-bill in front and a little buckle in back – is it a baseball cap? Is it supposed to be a baseball cap? Are they pretending to be Ernest Hemingway just in from a fishing trip? (He wrote fairly well, but his stories were stupid; content makes a difference.)

Specifically, cowboy hats. Surely no clarification is necessary at this point. But I will say in passing that I hope never to see again in Berlin a beer-bellied German wearing a cowboy hat and infringed vest. Hollywood is dead.

No more French artists! A friend in Paris says that the French systems ought to promote more French artists. The hat of nationalism is very heavy and entirely too stupid. Art should have no national bases. The 'nation' of artists must be that for writers, musicians and scientists. Our 'nation' is the intellectual activities of humanity, open also to any mechanic, farmer or out-of-work gypsy on the run from Napolitan police. Sadly, there are not many professional intellectuals in this nation, for reasons I will consider later.

As I write, England still colonises a large part of Ireland. Corsica wishes to be free of France, as do some people in Brittany. Why should Venice not be a free city? The Kurdish have the right to self-determination, and so do the Krenak of Brazil.

For about 400,000 years, we murdered each other and ran away from each other to the extent that we have covered the earth with our villages and tribes. Then, just a while ago, we began to invent nation states; even more murderous. These states in turn have promoted the growth of large cities. Now, more than one half of humanity lives in cities and towns. It seems that living in cities, then, which partially means living in architec-ture, is human nature.

We have become, just as the European nations feared, cosmopolitan. If we will admit it, we will see that this pathetic oxymoron, the United Nations, was obsolete as it was being born.

No more nations! No more 'United Nations'!

If I say we desperately need a world government, you might respond that we would have a monstrous bureaucracy. Maybe so, but the centre of this manifesto is the premise the humans are not created by God, not finished products, but instead evolving animals who can influence our own evolution. It is not true that people are always the same.

We need a world government.

Completely away from nation states.

No more artists! In the UK, there is still the idea that an artist must 'draw well', and drawing well is itself narrowly defined. That art should be a series of visual representations of the world is stupid.

We have the concept of art through the cruel and cynical history of Christianity in Europe, as part of a programme to physically build the structures of belief – monumentalism. Architecture as plots against humanity.

A horrible legacy for us who are desperate for a future, but made horribly worse by the current tight narrowness brought on by commerce.

You might think that I will speak against commerce. I will not. It is a reasonable method for distribution of art works and for sustaining artists. But I will make an interruption of the heading 'no more artists' to consider money.

It is so integral as to seem invisible in our daily affairs. When, for example, we speak about art or architecture or religion or science or any of the specifics of any of these, there should be a linguistic convention wherein we also say, 'and money'; to keep it from hiding. We can hardly speak of money. We can speak of and through the discipline of economics, which is a logistical study. We can speak of and through the system of Marxism, which is a psychological study. (And Marx may have thought that money would disappear.) When I speak of money, people assume that I'm taking a moral stance. I am not, and I greatly admire the human cleverness of money and its operations. How did the Europeans decide that 'money is the root of evil'? Even, how can we get past the idea of evil in the first place, and begin to think scientifically? (When asked by a facetious television interviewer, 'What is the opposite of evil?', the Dalai Lama replied, 'Compassion.')

We need a biology of money.

We know that by various biological means, through the human brain's use of visual data, through the work of human hands, then through language, architecture – we need only look at the Earth from a satellite to see that architecture is a biological, 'instinctive' activity – we produce and know our world.

Money comes in unannounced at every opening, and has now grown beyond out knowledge.

Many professional intellectuals, scientists, professors of all sorts, have now left our intellectual nation and work against us because of money. I do not mean in a simple sense of greed, nor even in a secondary way but an unconscious, tertiary way. A scientist researches, for example, by necessity, those areas called forth by money, not by his or her curiosity and delight.

Money reproduces by every human activity. When children in East Africa have their hands cut off, money is made; certainly not by or for those children but by and for the American and European workers who go and help them.

Art is a false category. It is a category of convenience, an easy way to speak about some complex activities. The convenience now works against us.

Before now, it was tied mostly to the idea of the master who by mastery could command more respect (translated badly as money). Now people ask me and other artists, 'When did you first define yourself as an artist?' This is a money question. This is also a money question when asked to scientists, philosophers or librarians. If we do not recognise money, it dictates.

The most encouraging thing about art these days is that art is somehow seen as a false category. We begin to understand that we do not know what art might be. Artists can be free.

The most disturbing thing is that money says to us, in a way similar to the way language tries to dictate to us, that content in art, intellectuality in its production, is neither necessary nor desirable.

I want to be silly. I want to act foolish. I would stand before you with the sole definition that I am standing before you. You might act, I might act. With any dance, maybe it comes ridiculously from each of us trying to avoid the path of the other; maybe it comes from the music provided by a third person. With any dance, we might begin – we might begin something to carry us one half of a centimetre beyond.

For the first time in history, we have both the chance and the responsibility to encounter ourselves. Even though it seems most impossible these days, we might now see and speak to humanity.

63

THIS IS A PARTY POLITICAL BROADCAST ON BEHALF OF THE THANKYOU PARTY

Brian Eno

We work from the principle that the world can be changed for the better, and we will use a specific procedure by which to achieve this. Instead of looking for what is wrong and trying to fix it, we want to look for what is right and try to encourage it. This is why we are calling ourselves the ThankYou Party: our intention is to celebrate and be grateful for those people and activities that produce greater happiness and less cruelty.

We start from a biological premise: it's obvious that pain evolved to warn us away from dangerous behaviour. What is less obvious is that pleasure evolved to encourage us to pursue favourable behaviour. We take pleasure in sweetness because it indicates ripeness and maximum nutritional value. We take pleasure in the beauty of human form because it indicates health and reproductive fitness. We take pleasure in social approval because it confirms our secure membership in the social group.

Most forms of politics make use of the pain aspect: law is primarily a system of prohibitions to make people behave to standards that society approves by punishing them when they fail to meet those standards. We think, however, that an equally – or even more – successful approach would be to turn our attention away from prohibiting certain things and towards celebrating and rewarding others.

The ThankYou Party evolved out of an earlier predecessor, the Honour and Shame Party. In social groups of a size where everybody is somewhat acquainted with everybody else, Honour and Shame – rather than law – are the fundamental constraints on behaviour. In such groups, and because humans are acutely social creatures, shame is the primary prohibitive restraint. People avoid certain forms of action because they do not want to be thought badly of by their neighbours. By the same token, honour becomes the primary driver of good behaviour: good behaviour is rewarded by social approval and higher social status.

In small groups, it turns out that almost any formal political system can work, be it Communism, capitalism, anarchism, monarchism or fascism. This is because what really holds societies together is not their political system but the underlying bio-ethical structures of honour and shame, which exist independently of any particular political overlay. All political philosophies have strengths and weaknesses, and any government should systematically explore what these might be. We follow the spirit of Octavio Paz, who said of Communism: 'Just because the answer was wrong, it doesn't mean the question was wrong.' We think that every experiment in governance has useful lessons.

Unfortunately, what is not well-understood is the effect of scaling up social groups. When they pass a population size where honour and shame no longer operate, all political structures run into difficulties, and law, the externally imposed prohibitive mechanism, becomes increasingly dominant over morality. Morality is an internalised sense of appropriate behaviour without loopholes; legality is an external system that invites technical challenges. Law is an essential lubricant in mediating between the interests of different social and national groups, but has less value for the internal workings of those groups.

We in the ThankYou Party believe that, as far as possible, society should be encouraged to devolve into smaller groupings. It is evident that these work better in terms of low crime, increased co-operation and social inclusion. We think it is immaterial what kind of internal political structure these groups individually adopt: some of them may choose anarchism, some may choose benign fascism, some may choose Swedish socialism, some may switch monthly. The point is SCALE, to stay at a scale where the values of human-to-human interaction can still operate.

These smaller groupings do not need to be exclusive: they can overlap, and a person can belong to many of them.

Such social groups must, of course, liaise and coordinate with others, and this can be done using the host of new social tools available to us. It is now much easier to organise complex social interactions than it was even ten years ago, but governments have entirely failed to take advantage of this – partly because it entails a surrender of power.

There are many existing examples of good governance, and we want to celebrate those and bring them to public attention. If society IS about to devolve into millions of smaller interlocking social groupings, then the people who facilitate the interactions between them are especially important. These are the kind of people who don't make it into the newspapers, except when they are occasionally referred to as, for example, 'faceless EU bureaucrats'. The ThankYou Party wants to thank those people, and to that end we propose a regular – even daily – broadcast that might be called something like 'Bureaucrat of the Day' – and could replace 'Thought for the Day' on Radio 4's *Today* programme.

One such organisation would be the European Rail Harmonisation Committee.

Based in a dull building in Strasbourg, this fine body of people make the European railway system work. Their mission might initially strike us as less glamorous than, say, filling a plinth in Trafalgar Square, or building a Large Hadron Collider, but next time you take a train from London to Munich, just think about the number of agreements and standardisations that had to take place in order for that journey to run smoothly. For their heroic and, until this point, thankless work, we salute the European Rail Harmonisation Committee.

Other bodies which would qualify for big Thank Yous would be:

CoPUOS (Committee on the Peaceful Uses of Outer Space),
UPU (Universal Postal Union),
IMO (International Maritime Organisation) & UNFF (United Nations Forum on Forests).

In each of these organisations, there are people working away trying to keep up with the accelerating complexity of our interconnectedness. They go unmentioned and unnoticed. This has to change (I usually bang the table at this point).

For there is a sad fact: we have developed a media world which is only too happy to tell us the Bad News, and will echo it round the world until we are saturated by it, but which finds the Good News surprisingly uninteresting. Good News doesn't sell, we are told. Of course, it might well be the case that we're biologically hard-wired to respond more promptly to danger than pleasure, but the net effect of continually strumming that same string is to desensitise us and disempower us. We are surrounded by problems we feel powerless to change, and all we see are things going wrong.

The ThankYou Party believes that the whole structure of contemporary media has unbalanced the world psychologically. Because of the demands of 24-hour rolling news, news organisations are forced to regurgitate and reanalyse every eyebrow twitch of the famous and the powerful. The effect is that politicians have become utterly paralysed by overexposure: it is impossible for any minister or candidate to say anything except the most anodyne generalities for fear that someone somewhere will twist it into a 'story' that will be returned as a weapon.

One of the first things that the ThankYou Party must do is to make the media contributors to the co-operative development of our shared planet, rather than hindrances. Our feeling is that we should use the talents and reach of the media to further our aims, again, not by prohibiting but by encouraging. We might, for example, buy a page in every major newspaper every day, and call it 'THE GOOD NEWS'. On that page, we would give a different take on the news, either talking about good news stories which hadn't made the paper, or making optimistic interpretations of ongoing stories. We would also use such press space to celebrate the hosts of people currently working below the media radar in various NGOs and pressure groups. It is estimated that there are at least one million environmental and social justice NGOs currently at work. That's millions of ordinary people using their own time and money to change the world. Why do we so rarely hear about them?

But, of course, our thank-yous are not limited to official or formal organisations such as these. We want to find and reward good people everywhere, in any walk of life. For example, even though we're acutely aware of the need to act on global warming, we do not intend to prevent people driving. Instead, we want to reward people for not driving. Various proposals exist for how to do this: we could subsidise cycle manufacturers,

65

or surprise random cyclists or pedestrians with large cash gifts, or keep increasing the width of cycle lanes and making them smoother and more glamorous. Our approach will be to change the incentive structures within society in such a way that we produce better outcomes.

The ThankYou Party, like all successful regimes, requires a large network of informers. These informers are required to report back to government officials any and all occasions of generosity, altruism, public-spiritedness and constructive social innovation they might have happened upon.

Of course, we have specific proposals for each ministry in government. There isn't time here to go into those in detail, but to give you an example of the flavour of these proposals, let me talk briefly about Defence.

The Defence industry is a big consumer of resources, a big employer and an important export for our country: we are the second largest weapons exporter in the world after that other peace-loving nation, America. But we have no plans to dismantle it; instead, we are modifying its mission.

We want to rethink the concept of Defence. Recognising that the deep drivers of global discontent, and hence conflicts, are things such as climate change, diminishing water resources, land shortage and desertification, we will now regard these problems as falling under the remit of 'defence'. What this means is that much of the brainpower and resources currently invested in weapon-building should now be redirected towards solving deep global problems. We believe that the most important act of strategic defence at this time would be a sort of Manhattan Project dedicated to the discovery of practical and clean new energy sources. Our scientific elite will be engaged on projects of which they can feel truly proud – projects that make a better world with less conflict. That is real defence.

We will also divide what is now the Ministry of Defence into two separate but related ministries: the first will be the Ministry of Defence, as described above, but we will also create a new Ministry called the Ministry of Deference. Defence is intended to keep problems at a distance, whereas Deference has exactly the opposite role: we want to invite countries that we admire to 'invade' us with their best ideas. Instead of bombing countries we don't like, we will now bomb the ones we admire – showering the inhabitants with polite thank-you notes and small gifts. And we will ask them: how do you do it? From Finland, we will want to know why their education system is so much better than ours. Our invasion of Italy in tour coaches will be for the express purpose of finding out how they managed to create such a civilised and generous lifestyle. And why are Brazilians and Danes so happy? Why are the Dutch such bold social innovators? Why are Russians so literate? Why are the best universities in America? These are the questions that any government should be asking.

We intend to replace the Gross National Product, which tells us nothing except how much money is moving around the economy. Car accidents, floods and house fires all increase GNP... but none of them increase happiness. Instead we plan to follow the example of Bhutan and institute a National Happiness Index. We intend to boost our NHI by several measures. Recent long-term research from Scandinavia shows that three activities in particular lead to health and happiness in later life. These activities are singing, dancing and camping. We intend to make all of them central to the school curriculum. There will be no examinations in any of them.

In fact, singing is particularly central to the world envisaged by the ThankYou Party, for in order to sing together, people have to:

a. organise themselves
b. to co-operate with each other
c. to make a pleasant noise
d. regardless of their differences
e. which involves physical and mental interaction and
f. skill and intelligence and sensitivity and
g. some surrender of individuality in the interests of the whole.

In this recipe, we see all the gifts needed for a working co-operative society. So singers will be one of the many groups who will be reverse-taxed – which is to say that they will pay less tax the more they sing. We expect also to see a revitalisation of that huge real estate sector called 'The Church', as people seek pleasant reverberant spaces in which to do their singing.

As regards camping and dancing, we intend to reinvigorate the notion of shanty towns, those great drivers of social change in the Third World. We want to encourage self-built housing, to get people out of the mortgage trap.

The ThankYou Party is a tax-and-spend party. We intend to tax relatively heavily, and then to make large pay-outs as thank-yous for socially constructive behaviour. We will not pursue tax evaders in the courts, but we will make available to the public the amount that everyone pays in tax. It will be instructive for people to know, for example, that Britain's 54 billionaires paid a total of less than £15 million in taxes last year – and over half that amount was paid by just one of them.

We think we understand why people resent paying taxes, and so our tax plans include a radical idea, which is that the individual citizens be entitled to nominate which ministries and projects their taxes should support. When you begin paying taxes, you nominate 2% of your tax to ministries of your choice; the rest goes to the government as normal. Each year you pay taxes, that percentage increases. After 20 years, for example, you might be controlling the destination of 30% or 50% of your taxes.

We think that this new approach to taxation would have several benefits. Firstly, citizens would feel that they had some real interest in where their taxes were going. Secondly, ministries would have to justify their demands for tax money on the basis of their performance. This would mean that they have to explain themselves to the public. Thirdly, we anticipate a gradually increasing sense of responsibility on the part of citizens as more and more of their tax share becomes directable. Fourthly, governments and ministries would have to justify their expenditures to the older and presumably more experienced members of society because these would be the more significant tax-payers.

On the other hand, we intend to co-opt more young people and even children into the processes of governance by nurturing school think-tanks whose ideas will be taken seriously. We believe that the young, with all their creativity and energy, are currently a wasted resource. Instead of training them to pass exams, we think we could profitably engage them in real-life issues. We applaud the example of a South-East London school whose pupils have formed a successful conflict-resolution group working in the community. We think that education should be based as far as possible in real experiences – so the best way of teaching domestic science, for example, might be to give the kids the school dinner budget to allocate. We think that the Gap Year – where kids get a chance to do something real at last – should be the model for most of the rest of the school years.

Lastly, the formation of government will be done in the same way that modern football teams are put together: we'll scout the best talent and offer transfer fees. We won't restrict our choices to party members, or even to people of the same nationality.

The ThankYou Party would like to thank you for your kind attention.

THE CINACT MANIFESTO

Henry Flynt

Henry Flynt, still from *Shrine of the Insect*, 2006, B&W rendition

ABSTRACT CINEMA IS A FAILED GENRE

The 'classic' abstract cinema, or received abstract cinema, is a failed genre.

Most of it commands nothing but polite tolerance. Deference to so-called pioneers, and academic indoctrination, mean nothing to us. The 'pioneers' of the genre did not know what they should have been doing. Subsequently, with few exceptions, the film-makers did not figure out what they should be doing.

I speak dogmatically because I am declaring the genre to be a failure. That is a sociological truth, not merely my 'take'. Programmes of abstract cinema are sparsely attended academic curiosities. Only Tony Conrad's *Flicker* generated a buzz beyond cinema acolytes, and *Flicker* is way over at the margin of the genre. The abstract B&W 'classics' are tedious conceits we have no patience with.

Most of the abstract cinema 'classics' I have seen I have found painful to watch. It seemed to be enough to show an abstract painting and make the colours drift around on the screen, accompanied by a string quartet. Or to make black and white geometrics hop around non-continuously. When people sit and watch a slow drift accompanied by a string quartet, they are just being polite.

Of course I knew of the Filmmakers Cinematheque in the 1960s and occasionally attended its screenings, but I don't remember any abstract cinema except vaguely. The interest elicited by the underground cinema didn't arise from abstract cinema.

To get ahead of myself, digital technology has now given us screen savers and iTunes (abstract animation). There is an unmistakable digital look because it is all based on mathematical equations or curves. I find it obnoxious. It is the sanitised abstract film the System wants you to see.

A further symptom of the failure of the genre is that of the 'classics' of abstract cinema, the few that one would like to see are unobtainable. No anthology of must-sees has been published. What are obtainable are the drippy films of Jordan Belsen.

As further evidence, those who would have committed to abstract cinema in the 1950s or 1960s do video installations instead. The genre has been abandoned because it did not matter.

My current cycle of film-making began when I was importuned to watch the 'trip' sequences in *2001* and *Altered States*. The achievement of those sequences consisted in Douglas Trumbull's clips. It struck me that the directors were using soundtracks and the intercutting of narrative shots to

code Trumbull's clips in a tendentious social way. I decided immediately that I wanted to see the clips re-edited into an abstract work, and I proceeded to do that, stripping away the soundtracks and the narrative shots and reordering what was left. Those results gave me my norms for the medium; they made abstract cinema a credible pursuit for me.

In 2005, my goal was to immerse myself in this visual outpouring that is unlike visual configurations in the everyday world. I wished thereby to change myself in a preferred, elevated way. I wanted to expand my consciousness, to add a 'celestial' level to my consciousness, by watching the film until it became a part of me.

There are viewable motion phenomena that elicit universal reactions. Rushing toward light, use of a black background, rapid motion perpendicular to the screen, a rainbow palette, a whirligig, falling motion, being jolted, formation of crystalline patterns and evolving crystalline patterns, streaming bubbles (analogue), looping (trapped in time). Twinkling space. Showing an image in strobed variants gives it an electrified effect.

Here are the makings of a traditionless language which is capable of holding one's interest. There are universal visual impressions which are not especially iconic but powerfully evocative. But the film-makers who pioneered the effects didn't know what they had.

The possibility of art depends entirely on the advent of a *sensibility*. Let us set aside the gimmick art which Modernism discovered in the 20th century. One has to wish to be engrossed or transported in an emergent way relative to an elaborate integration of equipment and expressive vocabulary. The achieved result – the realised thematic exposition, the expressive articulation – is emergent. It exists only when these ostensibly incongruous elements are set in motion in a purposive integration.

As to cinema, I realised that a traditionless language suggests itself and is capable of holding one's interest. There are universal impressions of colours in motion which are not especially iconic but powerfully evocative. Properly done, abstract cinema is more engrossing than narrative cinema, at least to me. To put it in terms of what is already available, I would rather see (the visual of) *Flicker* than a novelistic cinema. Again, the prohibitively expensive analogue methods of Trumbull lend themselves to motion phenomena that elicit universal reactions.

The 'physical' manifestation of colour and shape must coalesce as a language and engross you, must become a flowing journey in an unknown realm. Abstract cinema doesn't depict a subject outside itself. Originally I was not seeking a vicarious experience. It affords, or brings about, an experience-in-its-own-right.

It does not steer you through the simulation of a real experience; it does not unroll an imaginative representation of a real experience. Neither does music. But unlike music, the visual is more physically expansive as a medium. Music, we might say, is only a communication. The visual is more engulfing. Thus, we say, the abstract cinema affords a real experience – although one imbibes it only by watching.

In general, to be successful, the visuals must be rapid and 'attack the eye'. I had to discard every effect that drifted or crept or spread slowly. Perceptions which are completed in the viewer – being made to feel in motion relative to the screen – or actual 'false vision' such as afterimages – are an integral part of the vocabulary. Also strobe.

The sensibility has to come first. Unless you want to expand your consciousness, to add a 'celestial' level to your consciousness (by watching the film until it becomes a part of you), you won't notice abstract cinema's distinguished possibility. (The 'classic' film-makers didn't notice it.)

The sensibility (or vocabulary) we originally aimed for was evidently psychedelic, because when we showed our 2005 pilot projects (without sound), the viewers started recounting their drug trips while the films were shown.

A further issue for the genre's success is the matter of media technology. The way celluloid films were made, copied and disseminated was a hindrance. It was all much too bulky and expensive. I needed for film-making to become a desktop process. Beyond that, cinema is now recorded in a format like a small phonograph record. The next step would be for abstract cinemas to be issued on discs the way musical tracks are, in collections, if the individual pieces are short. Of course, these views are subject to the crisis of the business model which now afflicts entertainment media. I entered the field just as the time of the downloading crisis. However, DVD could have a future because video is not a headphone medium. Physical expansiveness is required for a satisfactory transcription of a video recording.

As I mentioned, what impelled me to become 'hands-on' in cinema was seeing the abstract clips made by Trumbull for commercial movies. Trumbull's clips seem to have been a fluke; nobody, including Trumbull, seemed to understand what he had. In other words, the clips had been manufactured as part of a Hollywood representation of a drug trip, inset in a narrative which luridly associated the hallucinations with personal turpitude and disintegration and Catholic choir music. (There were, in fact, 'marijuana' films from the 1950s intended to show how wicked 'marijuana addiction' was. Kubrick and the others kept making the same film, in a far more grandiose and expensive way).

I immediately decided that if the clips were separated from the narrative and re-edited into a self-contained *silent* presentation, an abstract visual language would emerge which would be compelling.

The people to whom I showed my pilot projects recognised the clips to the degree that they associated them with the commercial stories of drug depravity. But as I continued to work, *the connection to drug use became irrelevant to me; it was even an annoying hold-over*. To me, abstract cinema consists of colours moving on a rectangular plane. If somebody thinks that colours moving on a rectangular plane is the same thing as a drug trip, it is an instance of the 'this must mean that' fallacy which has been the bane of my existence.

On the other hand, the fact that the medium could have a consciousness-expanding effect was precisely the opportunity I wanted to seize. In music (and even in painting), it is difficult to make headway with a traditionless language. Referring to my published audact recordings, I do not imagine that they communicate in the sense that my tradition-based music does. But in cinema, a traditionless language suggests itself and is capable of holding one's interest. (I don't mean that the language is entirely without conventions. See below.) There are universal visual impressions which are not especially iconic but powerfully evocative. To me, this avenue easily dominates narrative cinema, for example.

It was the abstract film-makers who found this opportunity, but they did not seize it.

Abstract cinema, in other words, is the paradise for the abstract artist. But only if one has the sensibility, the intent; otherwise it is academic, vapid and tiresome.

Aside on 'this must mean that' dogmas

As noted, the viewers of my pilot projects started recounting their drug trips while the films were shown. My sensibility thus harboured a red herring. The viewers ignored that they were being presented with non-representing moving colours, and launched into monologues about the neurochemistry and neuroanatomy of psychedelics. That may be a tribute to my pilot projects, but it is also a diversion.

The problem was so acute that some viewers wanted a woo-woo soundtrack so that the 'surround experience' could be apprehended as *virtual reality*. Absence of a soundtrack was a fault to them, because it *decreased the realism*. If the film has a woo-woo soundtrack, the viewer forgives the dull video if the sound-sight composite recalls the less frantic phases of a 'trip'. We don't want to forgive dull cinema, because we look at cinema for the moving colours, not for 'allusions to life'.

To judge abstract cinema by how well it depicts 'my' drug trip is another one of those gratuitous 'this must mean that' dogmas which is the bane of culture, which wraps culture in chains.

The 'this must mean that' fault is encoded wordlessly in media itself, because abstract cinemas typically have soundtracks which impose a gratuitous and detrimental *interpretation* on the visuals. The fault is encoded in 'recognised video art' as a *sensibility stereotype*, which has it that modern or abstract art needs to be intimidating – and that means abusive – in order to impress you with its kinkiness.

Our drug experience is admittedly limited. The 'trip' sequences in movies don't depict what we saw when we took a drug – were our experiences not important enough? We didn't see 'film syntax', rapid vantage-point displacements, fast cutting as in *2001* or *Altered States*.

CONCEIVING THE MEDIUM

Abstract cinema, in the first instance, consists of colours moving on a rectangular plane. (In the second instance, of greys moving on a rectangular plane.)

In my late teens, when I considered abstract painting as an honourable pursuit, I had the brainstorm that abstract painting needed to be completed by abstract cinema. That was what first pointed me to abstract cinema. However, I did not act on that brainstorm. (I needed film-making to be consolidated to a desktop process before attempting to make a contribution.)

I have to say at once, though, that the analogy to painting can lead us astray. Abstract videos have been made which are like a canvas-eye view of the execution of an abstract painting (unrolling coloured streaks). I find them vapid.

There are several reasons not to analogise abstract cinema to abstract painting. The tachyscopic medium of standard cinema is psychophysically unique. Visible motion derives from rapid replacement of incrementally different stills. An apparent flow of colour arises by fooling the eye. Cinema is nothing more nor less than a slide show which is so fast that the individual slide is not registered.

Abstract cinema is theatrical. An audience sits facing a recorded spectacle which asks for their attention for a fixed amount of time – where it is the dynamism of the recorded spectacle that necessitates motion-picture technology. When I began this work, I was against soundtracks. The analogy with painting influenced me to think that any soundtrack diminished the visual presentation. However, Taketo Shimada proposed a soundtrack which occupies the audio channel without being allusive or thematic. I realised that audiences do not have the custom of watching abstract cinema in silence; the audio channel needs to be filled, or they fill it with conversation. The featureless soundtrack immediately became standard for me. It is another theatrical feature that is absent from the genre of painting.

Not all *change* on the silver screen is illusion. A strobe sequence on celluloid is not an illusion; it is the same thing as a programmed strobe light. The epiphenomena of the strobe would be the same in either case. In fact, all the off-on effects on celluloid (cf. edits) are not illusions. (When strobe is translated to video, it does become an illusion, and it loses much of its effectiveness.)

One could invent a theatrical art based on the viewing of actual motion rather than the viewing of a tachyscopic representation of motion. Real-motion panel theatre; but I do not go into that here.

Because cinema is time-based, it lends itself to effects which arise only in the head: geometric break-up, afterimages, the epiphenomena of strobes, virtual reality. I am interested, for example, in the virtual reality of the viewer moving relative to the screen. (Rushing toward or away from the plane of the screen; falling at an angle to the screen, as if down the side of a tilted building.)

There is an analogy between abstract cinema and abstract painting; there is also an analogy between abstract cinema and music. Technologically, music is like my real-motion panel theatre. The process perceived as continuous is continuous.

But there is also a 'grammatical' issue, an issue of how thematic articulation and exposition are handled. Both abstract cinema and music are abstract, time-based, sensory (non-textual) presentations.

Abstract cinema could have an expressive language which was standard without being iconic. In other words, there could be a 'folk abstract cinema.' But nothing of the sort has emerged, because this recent and technically inconvenient medium has remained in an elite ghetto or even an academic ghetto.

Moreover, cinema, unlike music, is essentially a recorded medium. For the decades of its existence, it was distributed in the channel which exists for novelistic cinemas. (Abstract cinemas were not printed to be shown in home entertainment centres.)

The languages of music arose from so-called folk usages – there is no equivalent in abstract cinema. But motionless abstract art – abstract painting – did not face any technical impediments; it is just that abstract painting was never embraced by anybody but an elite. (Islamic civilisation had a massive expansion of surface decoration. But it doesn't fill the niche of abstract painting.)

Let us dwell on the language of thematic articulation for a moment. 'Abstract' art reaches for a language with no history, and seeks to hold the audience's interest via that language. That thematic choices have been made is more obvious in a time-based art, where one either commits to thematic exposition or noticeably eschews it. (The psychology labs may have all sorts of cinemas to demonstrate effects, without thematic exposition. Seizure-inducing cinemas in medicine.)

There can be such a thing as music which seeks to conjure up an expressive language from nothing – and such music is analogous to abstract painting. In other words, the composer seeks noises or tone-combinations that elicit universal reactions. La Monte Young's *Two Sounds* is a standard example; the dense violent noise may hope to elicit a universal reaction. The visual of Tony Conrad's *Flicker* – not typical of abstract cinema – may hope to elicit a universal reaction by attacking the eye. There is no exposition in *Two Sounds*, but there is in *Flicker*: it becomes more dense as it proceeds (a climactic curve).

I am responsible for various abstract musical performances (compositions without a traditional musical language). When I was 21, I did not want to use the received labels for this sort of work. I introduced labels like 'visart', 'audart', 'lingart'. As I more and more underlined my separation from traditional languages and from computational form (as is typical in music and poetry), I revised these labels to 'audact', 'visact', linact.' In the same spirit, I am pleased to call my cinemas 'cinact.'

There is one additional technical point I want to make before I spell out my aims at length/ elaborate on my aims. Without wishing to be dogmatic, the richness of colour is needed to make the possibilities unmistakable, compelling. Our sensibility can be achieved in black-and-white, but limitation to black-and-white makes the hill harder to climb, so to speak. Thus, I could not have discovered what I want to do in the black-and-white era. Indeed, the use of colour cannot be tentative; it has to be full-blown from the outset.

Having finished the summer 2006 cinemas, I find now that I want to make versions in which a few of the takes appear in black-and-white reduction. To mix black-and-white with colour. Some effects are stronger in reduction (contrast only); black-and-white shock, and colour shock, are also evocative in their own right.

AIM: CONTENT

Let me return to content and expand on what has been said. Thematic articulation and exposition, and the time-path of the provided experience, are important to me. A cinema, like a musical composition, is a journey from a start to an end. In general, there is a progressive saturation which needs to have an end. There may be a build-up or, as is more likely, a ramp-up and later a charge-out.

As an aside, abstract cinemas have been made with no thematic articulation or exposition. Mere psychological effects have been presented as cinemas. I am not interested in that as a genre, although the effects may be of great interest in themselves. Another dynamic art with no thematic exposition is the Alexander Calder mobile. As for an installation, it is a loop continuously on display; I am not here concerned with that.

A general discussion of architecture and thematic exposition is supplemental and will be postponed until later.

My normative sensibility was established in 2005. As I went from editing commercial clips to building cinemas from scratch on computer, the sensibility seemed to metamorphose on its own – seemingly dictated by the narrow range of effects which are easy with the computer.

I have found it difficult to make headway with the available audience. As with my pedal steel recordings, the audience does not demand the opening to this new realm.

What actually happened in digital

When I turned to all-digital processing, the technology took over and diverted me from what I was aiming for.

My first pilot in digital was done on 31 March 2006. Limited as it was to evolving geometrics, it was rudimentary and cold. I immediately concluded that I had to use analogue stills as source; to build clips by drawing them in animation programmes was hopeless. Technical considerations ruled out a flow of images. Instead I grabbed self-contained clips which I tried to arrange in a gratifying progression.

I worked on a rigorous time-for-result basis Analogue technology allows a rich flow of images which cannot be duplicated quickly in digital. We animated with stereotyped cinematic [gimmicks] such as dissolve, zoom, reverse, slow-motion, etc. Colour transformation was done outside the animation programmes.

I wanted to use perceptual illusions at every opportunity. Afterimage, stroboscopy, image break-up and motion reversal from rotation and streaming. An abstract cinema is good if the viewer sees an entire movie that it not on the screen, that cannot be proved from the screen tachyscopes.

The final results, while quite interesting to me, fell somewhat away from what I had intended. As I continued to work, I employed object-allusions at the Rorschach-blot level (insect head, fox head, rabbit head, eyes, veins, gate or arc, spider-web palace, blue sun, etc.). I was not, however, trying to tell a story with symbols. Rather than being 'celestial', the results proved to be outré, sinister, macabre. Cobweb palaces and electrified foxes and bloody coffins and the like. I find the results enjoyable as transitory experiences. However, I would not want to be immersed in them or in-grain the sensibility or consciousness in myself. Thus, I found myself thrust into an aesthetic of vicarious experience, even though the presentation does not simulate a real experience. Biomorphic and allusive abstraction can narrate.

What this means is that technical obstacles have prevented me from contributing more in the sensibility that got me started. I may or may not be able to remedy that in the future.

On the other hand, the 2006 round of work unexpectedly solved a problem I had for decades as a painter. Although I preferred abstract painting, what bothered me was its coldness. The ideal for me was not classic European painting but ancient Egyptian visual work. The warmth of detailed images that could be allusive but were nowhere photographically representational. I could not see how to solve that as a painter, because even if I had the images I wanted, executing them by hand was a craft job which I considered too laborious and technically obsolete. The fact that more money could be charged for handmade work did not interest me.

Suddenly, when the 2006 cinemas were completed, I found that I could pull out numerous stills which had the qualities I thought 'abstract painting' should have. Of course, it was not about 'painting', but about the exhibited picture. My 2006 stills may allude to forms in the seen world, but they are not photographic representations of anything. The allusions appear in abstract patterns. My use of analogue sources was crucial in giving warmth to the images. The next step will be to mount a show of enlargements of the stills.

ANALOGUE vs. DIGITAL SOURCES

The clips that went into my pilot films were made with elaborate analogue technique, and they have a warmth which, by 21st-century standards, is old-fashioned. Slit-scanning, photographed liquid diffusions, photographed landscapes and solarisation.

When I got the opportunity to make films from zero, we had to find a way to gain the 'nonlinearity' and warmth of analogue from an all-digital, button-pushing technology. So far, we have used analogue stills as a base. In a small number of cases, we have drawn the animations using motion.

The streamlined computer technology has one great disadvantage: it is digital. Because digital work is limited to visuals which have simple mathematical representations, there is a catastrophic loss of warmth. Our pilot projects edited existing analogue clips. Needing to generate our own films from scratch, and not having the wherewithal to build our own analogue cinemas, we appropriate analogue stills and use them as a basis. Our use of pure digital animation has been very limited.

THE TECHNICAL FACETS OF CONTENT

Because our cinemas are fast-paced and without recognisable configurations, we want the viewer to *register* faster. To discriminate more nuances. Spatial colour-shape differentiation – an off-centre colour contrast, or a subtle colour change at the edge of the shot. The rhythm of shot repetition.

Attack on the eye

In general, abstract cinema should not be placid. Slow washovers are not compelling; rapidity and colour contrast are needed. It should attack the viewer's eye with an outpouring that is unlike visual configurations in the everyday world. Kaleidoscopic sensibility (within the shot). The roller-coaster principle. Vivid colour contributes in all cases.

Cinema allows effects which literally subsist in perception, beginning with the impression of motion from stroboscopically projected stills, and continuing with afterimages, and strobing as the subject of a film. However, the device at the head of our vocabulary is an illusion *which is not literally integral to perception*. Namely: to make the viewer of a motion graphic *feel* in motion. The strongest effect makes the viewer feel in rapid motion perpendicular to the screen. Accomplished with perspective and 'spooling' (rapid continuous motion). The viewer feels that they are hurtling into an explosion of colour.

Another possibility is an artificial horizon view (colours and terrain not in nature) so that the sense of rapid motion toward the screen is like a flyover.

Sideways rocking motion is effective. The image is jolted left-right, is agitated as if being rocked by an explosion.

Rapid rotation of the full image is effective. The whirligig.

Seeing a stylised, coloured skyscraper from above on a slant, with shapes falling down its sides, is effective in inducing a sense of motion in the viewer.

To repeat, you hope that if you immerse yourself in this visual outpouring, it will change you in a valued way.

Effects subsisting in perception

Strobing can be irritating. But blinking is not painful at all, only annoying if one wants to see continuously. The auditory equivalent, the square wave or jackhammer, rasps in a painful way.

73

A strobe can produce perceptions which are epiphenomenal, beyond the visible data: colour.

There is no reason to limit strobe cinema to the full-frame binary strobe of *Flicker*. The interruptions of white can be black strips that sweep the screen diagonally. Yielding more intense epiphenomena than a simple strobe?

Strobing in colour – I am told that the apparent colour is the complement of the colour projected.

Periodicity

Cinema sensibility is not about consonance with a pedal-point vibration (drone, key.) Colour harmony exists, but it is a tepid consideration. A study of blues, off-blues, complements and contrasts to blue could easily be academic.

We are accustomed, in vision, to an arrhythmic flow, and do not demand anything different from cinema. Movie 'action' proceeds arrhythmically. Normal light effects do not mechanically shock the body as sound does. There is no instinctive association with the pulse.

Visual sensibility does not wish the effect of punctuated periodicity (pounding beat). Visuals could be used to establish a 'clock' (beat) and a meter, but the effect is not only rare, but annoying. The beat could be marked in a really obvious way, say with a frame-filling black disc, but it is almost never done. Less obtrusive visual time-marking can be achieved via a periodic discontinuity in the time-evolution of the graphic.

Looping is very effective for its artificiality. The combination of zooming and reverse zooming with shot repetition is promising. It gives the viewer the sense of elastic motion perpendicular to the screen. Exploding/imploding.

Drifts

After the impression has been made by fast-paced shots, some slower effects will be accepted. A complicated biomorphic drift.

The impression of a white sea creature swimming amid dark shapes on a blue-black ground will be accepted.

This is an art in which the reverse of a build-up naturally suggests itself. The viewer is engaged by highly active visuals so that the experience begins to saturate; a decelerating pace will then hold the attention.

Soundtrack

Having seen films with stupid soundtracks, at first I wanted to eliminate the soundtrack altogether – I considered it disrespectful to the visual experience, implying that the visual experience was not interesting in itself. However, Taketo Shimada turned me around completely by suggesting a monotone soundtrack that fills the audio channel in a relatively neutral way. We began with a stereo sine tone an octave below middle C. Next was a microtonal second at middle C to create slow beats.

I found it to be an improvement – making the visuals more urgent without competing with them. But the main benefit is for public viewing. There needs to be something in the audio channel to shut out ambient sound – for the same reason that films tend to be viewed in a dark room. It also prevents the audience from conversing. But so far I prefer soundtracks which are neutral, as it were, which do not furnish a separate message. That means periodic waveforms. Which are absorbed into the visual.

Next experiments:
sustained chord
saturated bird chirping NO
drumming ???

LANGUAGE

What is standard in abstract cinema is a repertory of technical tricks:

General cinema
the negative (colour reversal, black-white reversal, solarisation)
fade
dissolve
rotation
looping
shot structure
POV shift
fast cutting

Illusions
afterimage of motion
afterimage of a saturated still
strobe
apparent modification of geometry by motion

Virtual reality
viewer's motion perpendicular to the screen
viewer's motion down the screen (falling)

being jolted

One does not want to overuse the analogy to abstract painting, because there is no analogy to these effects.

COLOUR

Rushing It. Killing the colour removes warmth from the slit-scans; they no longer make you feel that you are rushing into an explosion. It's only a fast-paced sight, spectacle. We learn that colour permits differentiation of dark with dark. In black and white, the flyovers in *Rushing It* need to be lightened – otherwise the screen just gets dim.

Somersault works in black-and-white. Note the appearance of objects wrapped in gauze; that is effective.

Most of *Somersault* works in B&W. B&W sensibility is a separate issue, and we will deal with it separately.

SEQUENCE-ARCHITECTURE

The customary film language is physically disjointed in a way unique to cinema. There is no premium placed on filming a drama with one camera in a single shot. Film language is a sequential collage.

I know from a film course that students have to be trained to see shots – the vocabulary of shots has become second nature and is experienced by the uninitiated as a continuous event. To the initiated viewer, the movie obviously is not a single 'view'. It is a succession of different 'windows'. Moreover, there are qualitative switches from clip to clip which preclude their being views of the same event.

Cutting sustains interest; it is more compelling. Just that lesson from film custom (which has only a century of evolution) is worth something.

The conclusion is that cinema is more forgiving of collaging than other arts are – a continuous 'transcription' is not prized. The basis of cinema is the frame, a discontinuous element. You can start an unrelated piece every few seconds, and the viewer will accept it. In music, it would just be annoying, like switching radio stations.

The shot structure which we have become familiar with from narrative cinema carries over into abstract cinema. An abstract cinema is a series of clips; it does not evolve in one clip. Thus, the alert viewer realises that they are not being treated to a single view physically. A film consisting of a single slit-scan, a single solarised flyover, a single liquid diffusion – with no change of 'window' – would be subject to diminution of interest.

At the simplest level, a shot sequence can be played forward, then backward. Or one shot could be intercut in a series of different shots.

A fully realised genre has the architectural feature of backward reference. A recapitulation which provides what has gone before with fuller meaning. Much art I like doesn't have that, but mine sometimes does.

75

A NEW CONTEXT

Yona Friedman

each as architecture permits a quasi-infinite variety of combinations:

a new aesthetics

Yona Friedman, still from *A New Aesthetics*, 2008

I think in order to talk about architecture we have to start with a very simple fact: architecture is simply an epiphenomenon of something more general, a deep context, so before getting to some conclusion on architecture, I will try to describe this context.

The first thing is that the territoriality of states is slowly disappearing. You know, a state is defined judicially by a territory; it is an organisation between clearly set borders. For example, for a state to belong to the United Nations, it has to have a clearly set territory. But this territorial state is losing its power more and more. The world is governed by something different, a different organisation, not clearly identified, which is not territorial. We have in history only one example of a non-territorial state – the Catholic Church. It had a very small territory and for a long time was a governing element for the known world at that time. Now we are governed, so newspapers tell us, by finance, commerce, trade agreement and so on. That is undeniable. But this organisation is not a clearly set body; you cannot tell who directs, who makes the policy, who is responsible. It is more an oligarchy, a rather small organisation, relative to the global size, which is implanted everywhere. It is an unclear situation, as we don't seem to know by whom we are governed. Yes, we can determine that this or that financial organisation is governed by this or that person, but the whole, the network which makes things happen, is not clearly governed. So this is the first element.

The second important element of what we are talking about is information. We are saying all the time that the world is governed by information. Sure, but we shouldn't forget that information is not clearly said, because, for example, when media talk about information, they are thinking only about the emitter, but information becomes information only when it arrives to a receiver. But what does the receiver understand from the information he gets? What is his interpretation? It is a complete insecurity. This information world, the information network, produces insecurity. You know that there are lots of things and too much of which is emitted, and you don't know who receives what information and how he or she will interpret it. So we have a complete incertitude and flux; we are living in a hazy world. This leads me to the next element – ecology.

We don't have a global image about ecology. All political ecological movements concentrate themselves on this or that point, but there is no global centre. My point of view is that the real problem with ecology, let us call it an eco-policy, is a mental problem. All through for centuries, we have considered ourselves as conquerors: we had to conquer nature. I think that the right answer would be very, very different – to adapt ourselves to nature instead of conquering it. What does this mean? Conquering nature means that we impose our conditions on the environment; adapting to environment means that we accept the conditions of our environment, and we adapt our way of life for it.

I will take a very important element, heating. This is quite important for our consideration later for architecture, as architecture is conceived as a closed box in which you create a climate that you consider adapted to your survival. The biggest energy waste we have is to create this artificial climate within the closed box. There would be another attitude, which is followed by nearly all the other species: this is to follow the climate, to migrate. Today, taking United Nations statistics, about 80% of the world population lives in areas where you don't need heating. Rich people go to these places because they can afford it, and poor people stay in these areas because they cannot live if they go out of them. All the shanty towns of the world are in the hot countries; there are no shanty towns in Siberia – it's impossible. So I think that if we have less climatic production,

for example, simply umbrellas in hot zones, it can be possible. In temperate zones, it would be logical that for the winter time people migrate to another area climatically more favourable. This is possible in today's world, because most of the work can be done at a distance. Work at a distance, work that doesn't need direct physical interface, is more and more the fact. The reason for this is that the bulk of what humans produce today is immaterial. For example, finance is not material, thought is not material. This means that there is only a very small part of production that involves effective physical presence.

The same thing about social contact. Socially, surely people speak more through mobile phones than they speak directly. If I look at a street in Paris, older people too are giving their monologue to their mobile phone. That means their social life happens in large part without the physical presence of their social partner. This is noteworthy. In the old city schemes, there was a very important element, the forum, the physical meeting place. Today, the forum is not effective anymore. People have an immaterial, a virtual, forum. For example, the Champs-Élysées in the 19th century was a sort of a forum where people of certain classes met, and there were many others like this. I am saying the Champs-Élysées because it is the best-known. Today, the Champs-Élysées is not a forum anymore. The forum is somewhere in space through the mobile phone.

So these elements obviously change our outlook on the possibility of the development of the epiphenomenon that is architecture – the closed-in box is less necessary. Proximity, which was the basis of city-forming, is less and less necessary. You don't need to be very near to your neighbour. The neighbourhood becomes a virtual thing. Technically, there is one other element which is important: proximity was imposed on, if you want, town planning or area planning, because of the networks, but now you don't need the physical network anymore, you don't need, really, the phone network, it is in your pocket. You don't need to use the electricity network too much, since many of your instruments work on battery. It is very easy to imagine areas that you will charge once in a month and make them full, like you do today to your car, so, again, proximity is not necessary. You do not need to have, for example, a fuel dump next door to you – it can be 50 kilometres away.

So it is the loosening of this network which leads us to a new image of the city and a new image of architecture. What this image is, I cannot tell you. I can only show with a few models how I am

trying to look at it. I am simply talking about this development since it will determine, really, what the coming architecture will be.

There is another element that is important, and that I am calling the routine. Routine is something we have nearly unchanged in the last c.20,000 years. For example, social grouping is a routine. We will not get rid of it. It's not a question of discussing whether this or that social grouping is better; we cannot get rid of our routine. The way of our behaviour, our daily behaviour, is a routine: we are eating and sleeping practically in the same way as our ancestors 5,000 years ago. I was speaking earlier about territoriality. There is another territoriality, which is the routine territoriality. This can be the family or the tribal territoriality. This is important; this will not disappear. So when I was speaking about the coming architecture with all the new elements, at the same time I have to think about the family territoriality or the group territoriality, which will stay. I don't know what kind of city we will live in, I don't know what kind of architecture there will be, but the family cohabitation is a fact and will not change. It will have another legal status that is secondary. The group, the small group, cohabitation, territoriality – I am calling it the urban village – also will not change. But what will be the agglomeration of urban villages wherein proximity is not necessary anymore? This is an open question. I am not pretending to give a solution for it.

In all my practical life in architecture, I was proposing possible solutions, but I know that there are only tentative solutions, and I think that the important thing is to understand that architecture in itself is not important. It's only a manifestation of a deeper context. Architecture and shoes are about the same importance, but perhaps the shoe might be more important because if the shoe causes pain for your feet, you react immediately. If the architecture is not really comfortable, you put up with it for many years. So don't overestimate architecture: architecture is not important… it is only the visible part of a context, which in itself is very important and which is out of our control.

Climate, governments, communication and technology are out of our control, so they are a part of the general environment, because environment is not only nature, but also the man-made environment. We can do nothing else but to adapt to it as well as we can. What I was trying to do with this talk was to give an incitement, to try to see the things broadly, and that's all.

THE LAWS OF THE SCULPTORS

1 Always be smartly dressed,
 well groomed relaxed friendly
 polite and in complete control

2 Make the world to believe in
 you and to pay heavily for this
 privilege

78

3 Never worry assess discuss
 or criticise but remain quiet
 respectful and calm

4 The lord chisels still, so don't
 leave your bench for long

GILBERT & GEORGE
1969

THE TEN COMMANDMENTS FOR OURSELVES

1 Thou shalt fight conformism
2 Thou shalt be the messenger
of freedoms
3 Thou shalt make use of sex
4 Thou shalt reinvent life
5 Thou shalt grab the soul
6 Thou shalt give thy love
7 Thou shalt create artificial art
8 Thou shalt have a sense
of purpose
9 Thou shalt not know exactly
what thou dost,
but thou shalt do it
10 Thou shalt give something back

GILBERT & GEORGE

1995

80

*Our favourite old manifesto, written for music
in 1907 by Fred Barnes, just over a hundred
years ago.*

It's a queer, queer world we live in
And Dame Nature plays a funny game
Some get all the sunshine
Others get the shame
I don't know why but since I was born
The scapegrace I seem to be
Ever since I was a little boy at school
A name has stuck to me
Yes, I'm the black black sheep of the family
Everybody runs me down
People shake their heads at me
Say that I'm a disgrace to society
But, I'll try my luck in the colonies
There I'll rise or fall
And when I come back
The sheep that was black
Will perhaps be the whitest
Of them all

FRED BARNES
1907

BAN RELIGION
BAN RELIGION
BAN RELIGION

81

GILBERT & GEORGE

2007

IT DO

G

BET

ESN'T

ET

TER

THE END OF THE '¥€$ REGIME'

Reinier de Graaf & Rem Koolhaas

Since the fall of the Berlin Wall about 20 years ago, for the first time in history, the world has been truly united as one. Not because one country triumphed or the dogma of a single ideology triumphed, but rather through the voluntary collective embrace of economic values over all other values. It is very, very clear this has had a great impact on the economic system, but it has also had a great impact in the domain of politics and culture.

Throughout the 1990s, we all became familiar with the immense queues standing outside museums for exhibition openings, testifying to the great success of the museum, but, clearly, this is only one half of the story. The other half of the story is of enhanced competition in the cultural world where increasingly large numbers of cultural institutions fight over the same number of visitors, largely pushing both architecture and art into increasing positions of extravagance.

Today, we find people of the cultural worlds featuring in the top 100 of the same lists that only 10 years ago featured businessmen. It is increasingly hard to tell the difference. This is a picture of Jeff Koons with a tie, and this is a picture of Charles Saatchi with a bow-tie; I leave you to guess who is the artist, and who is the businessman.

Architects and artists can count on immense audiences, on crowds of adoring followers, and they are increasingly celebrated like showbiz celebrities. The career options for people in the cultural world are multiple: diva, icon, or just continue on the same old course which is proudly to present one's own work as unique and one-of-a-kind.

We have a unique recipe to put cities on the map. That recipe is copied by others, but what is more disturbing is not the rip-off of others, but the fact that we are increasingly ripping off ourselves: where the repetition of the one-of-a-kind is increasingly the done deal.

Even though the status of cultural figures is supposedly on the rise, their actual standing with those who ultimately decide their fate is perpetually on the decrease. This is Donald Trump commenting on Daniel Libeskind's design for the World Trade Center: 'This pile of junk was designed by an egg-head architect.'

Who are the real victors? Who are the real victors in a world where culture can be bought?

This is the Guggenheim in Bilbao; this that same Guggenheim anywhere else – oops, this is the same Guggenheim in Abu Dhabi as part of the largest export/import of culture in the history of mankind; where the world's largest museums by the world's most famous architects are literally built minutes apart from each other – where architecture is the prime tool to market a region and to push that region forward in the world. It seems to offer large career opportunities for architects where they can build larger, more uninhibited and more uncompromised than ever before. But for how much longer is really my question.

These are the Dancing Towers™ by Zaha Hadid in the middle of an area called Business Bay. These are the Dancing Towers by an unknown follower in an area also called Business Bay. This is the turning torso of Santiago Calatrava, and this is the turning torso in Dubai by an unknown follower. This is Daniel Libeskind, and in less than 90 minutes from Denver to Dubai also copied by an unknown follower.

This kind of copy behaviour seems erratic, seems improvised but is very much, in our view, part of a long-term plan to make the Western avant-garde oblivious.

Dubai Towers™: it is the copies that are now sold as brands and exported throughout the world, designed by a series of architects no one has ever heard of. This is DAK Consult from the UAE, and this is what they built; this is KEO from the UAE, and this is what they built. This is Atkins, slightly better known, and this is what they built, but none of these firms ever features in *Domus* or *Casabella* or any magazine of the sort. Even though they're never featured or never published, their annual output is actually larger than the collective output of what Western architects generally produce in a lifetime. This is the annual production of each of the three firms of the designers of the skyscrapers that I've just shown. The skyline that emerges as a result is exuberant by all means, even though it is a skyline that entirely exists ultimately of unoriginal gestures. If you take this building – produced

by the most formally extravagant avant-garde architect of the West – looking at the skyline, one has to single out the building by a red box, because otherwise the whole thing is unrecognisable. This is the skyline of the 20th century of the masterpieces produced by well-known architects. This is the skyline basically produced by copy-cats, and there is barely a difference.

'Making the Icons Iconic': the ultimate recipe for an icon appears to be a tautology. It's built on well-known images, and it's always large. This is a gate that is large; this is essentially a pyramid that is large; this is an eagle that is large; this is a snake that is large; and this is the head of a horse, in ultimate tribute to the Sheikh of Dubai, that is again a very, very large building. The more obvious thing is the race for height: where previously if the World Trade Center or the Sears Tower was the largest building in the world, simply start by doubling that height, so that it goes tall, taller, even taller, tallest. Currently, the highest projects in the world actually attract the same crowds of adoring followers that in our world the cultural elite attracts.

The city is basically an accumulation of icon. The city has become an icon of excess made up of an excess of icons. The city is a perpetual promise of tomorrow, of the next best thing. Models are large to equal the size of the city itself, and the sales office of real estate agents already provide the virtual urban setting of tomorrow.

'One day, all cities will be built like this' is the confident prediction of this formula that is now practised outside the West at a much larger scale than the West ever practised it. Our Disney is their Disney, but Disney is still a Western invention, even though all the ridicule that the West aims at this point. But how much longer is really the question.

A month ago, the full impact of the collapse of the stock exchange became clear, and it is apparent that no remedy is near. If the collapse of the stock exchange was the result of financial greed, maybe this skyline is the exuberant result of cultural greed – the equivalent in culture of the bonus system for risk-taking managers.

This is the skyline, and this is the crash of the stock market, which interestingly mimics the skyline. This is the thundering sky that emerges over the skyline as a result of the stock market so that pretty soon this type of architecture is a thing of the past.

Maybe the graveyard of this type of architecture could coincide with a laboratory of the rebirth of modern architecture – a more functional architecture, an architecture with a social purpose, an architecture of performance and functionality.

What we have tried to launch in the context of the exuberant Dubai is a new formula which we have called 'Generics'. Analogous to generic medicine, where – in the absence of patents, in the absence of copyright, in the absence of signature – the inventions of planning and architecture can be shared in a better and more uninhibited way worldwide.

This is a building that exemplifies it. From one end, it reveals a massive presence; from another end, it reveals an exceptional slenderness, only to reveal a massive presence again.

If the 20th century was the age of abundance, the 21st has been the age of excess so far. But what is needed is a new beginning, a renaissance of functionality and performance. A manifesto, as we've called it, for a new type of simplicity. Simplicity™, a trademark not with the superlatives that have accompanied so many other brands, but a simplicity that is pure, straight, objective, predictable, honest, original and fair.

LONDON: A MANIFESTO FROM YOUR ANIMALS

Fritz Haeg

*[Delivered in complex layering of multiple voices,
a loud, booming wall of sound]*

Attention, humans of London:

Those Romans just showed up one day a couple of
thousand years ago, and things have just not been
the same since. At first it was OK, but lately, it's
become a real pain sharing this land around our river
with you. We come to you today with some gentle
suggestions, polite requests and urgent demands. We
are particularly excited about the possibility of some
homes that you could make for us, and are hoping
that you will share our enthusiasm. We are calling
for a network of Animal Estates to be constructed
throughout the city of London, to replace the spaces
that you have taken away from us.

 I think you will agree that we really do need each
other, or at least you need us, so let's figure this out.

Most Sincerely,
*The Animals of London
That Were Here Before You*

I AM THE BROWN-BANDED CARDER BEE, BOMBUS HUMILIS

[*Delivered in staccato; peaceful but forceful manner; very high, buzzy voice*]

— You need me! Over 70 crops in the UK are dependent on, or benefit from, my pollinating visits.

— I am demanding an immediate halt to your intense modern farming methods at the perimeter of the city, based on a narrow, and rather boring, monoculture. I was once widespread in Britain. My numbers are now in drastic decline as one of the most endangered bees in the UK.

— I am demanding more places in your city of London to nest, forage, mate and hibernate! Right now, I am mostly clinging to the flower-rich habitat along the Thames Gateway.

— Kitchen gardens? YES! I also like most of the herbs used by cooks.

— I want honeysuckle! It provides a rich supply of nectar.

— Cultivated flowers?! That's great too.

— Hey, how about planting flower-rich meadows with long corollas such as vetches, clovers, dead-nettles and red bartsia!? I also nest on the surface of the ground at the base of long vegetation.

— Farmers: leave a little around the edges for me! It is so annoying the way you are now cultivating right to the edges of your fields.

— And your hedgerows? Relax! When you cut them back so regularly, they cease to be safe nesting sites.

— I am asking for messier gardens! I also nest under accumulated plant litter.

— Abolish all insecticides! It indiscriminately kills me along with other insects, spiders and many other useful invertebrates.

— Do you have an old crumbling wall? Leave it for me! That will be a great place to nest, just leave some tussocky grassy areas in warm sheltered locations.

— And, finally, nest boxes, please! You can build a simple wood nesting box for me to welcome me into your domestic gardens.

— Warmest appreciation to you all (and sorry for the stinging).

I AM THE HEDGEHOG, ERINACEUS EUROPAEUS

[*Delivered slowly, patiently, in a low and rich voice*]

— Alert to the humans of London, we are disappearing! My numbers have declined 50% in 15 years. I only remain in Regents Park, of all the parks in London. At that rate, I will be gone from your town by 2025.

— I can't deal with the vast empty expanses of lawn, field and concrete that have been spreading since you arrived.

I'm a great 'generalist' with a happy existence at the bottom of your hedges and in your back gardens.

— We are hit by your cars, chopped up by your mowers, tangled in your tennis nets and perish with our heads caught in your plastic containers.

— I am quiet, nocturnal and discreet by nature, but now I have a few demands for you humans of London:

— I want more of the in-between neglected over-grown spaces.

I love open woods and grassy heaths, cultivated land, scrub and sand dunes, parks and cemeteries. These spaces are also good for the general environmental health of the city, so if I am there it is a sign of a somewhat healthy landscape, plus I'm cute.

— Leave some places for me to nest! Do not make your garden too tidy, let the grass grow, dead branches lay, and leaves pile up! I like brush piles, rocks and other crevices. This is how I live; this is what I like.

— And keep those piles of leaf litter and branches around your garden for my hibernation between November and March.

– By the way, I would also appreciate a dish of water now and then, especially during the summer months.

– Leave dead wood around to encourage beetles! They are delicious.

– I would like to see more flowering plants in your gardens! This will attract the insects that I eat.

– When you are not playing tennis, furl your net above the ground! I get tangled in them, starve and die.

– Cut the plastic rings off '4 pack' plastic holders. I get stuck, starve and die!

– OK, you may think this is crazy, but can you reduce your speed limit for me? And why not help us London hedgehogs across the road when possible? Our defense system of prickly spines is no match for your cars. Each year, thousands of us fall to the violence of your tyres and pavement.

– I am hereby demanding that every wall and fence in the city of London shall feature a hedgehog-sized hole somewhere at its base!
Connect your green spaces for me, so I can navigate your city – I may travel up to 200 yards in a night. Here is what I'm trying to avoid: dogs, foxes, polecats, badgers and tawny owls.
I can curl into a tight little ball.

– And finally, why not build me a home in your garden?
It can be a simple enclosure with a 5" opening. Place it under a hedge, large shrub, or other concealed place – that would be great!

– And, in closing, you need me! I will eat your pests! And I am known as the 'gardener's friend', eating your slugs, beetles and caterpillars.

Thanks for your attention, people.

I AM THE GREY HERON, ARDEA CINEREA

[*Delivered with a gracious tone, in an elevated, squawky voice*]

– I live all over Britain and Ireland, from estuaries to lakes in city parks.

Perhaps you have seen me while crossing the Millennium Bridge, in Battersea, along the Grand Union Canal in West London, or in Regents Park?

– I am a native species and a top predator in the food chain, eating a whole range of fish, frogs and ducklings, which puts me at the receiving end of any decline in the water quality or food supply.

– I will sometimes come and eat your goldfish – sorry about that.

– In the 1950s, your water and city were so polluted, I was not even in London, and many of you humans thought it unlikely that I would ever breed here again.
Thank you for the improved water in the Thames; now, I have returned. In 2004, I had 26 breeding sites and about 300 nests around town.

– I mostly rely on fish as a food source, which can be killed off by frosty weather. The recent warming may be another reason why I am back. Thanks for the global warming.

I will get right to the point; here is my shortlist of demands:

– Build me breeding platforms! Up high on a tall post! It will look great! You people will love it! Looking at beautiful me up there in my big 3'-diameter nest of branches and sticks. I usually build them in the highest trees, such as alder and Scots pine, but I'm interested to see what alternatives you can come up with since you got rid of most of those pesky trees in town.
I will return to the same nest each year, and several of us will nest in the same area, known to you as a 'heronry'. Wouldn't it be great to make a huge urban herony that can be up to 100 nests in one location. Can you imagine that in the middle of London? Along the Thames? Hundreds of tall posts topped by me!

– OK, one other request, but I hesitate to ask: could you remove all of your telephone lines and barbed wire? Is that too much? I get caught up in these things and die. But, never mind.

OK, thanks for your thoughtful consideration, dear humans of London!

WAGE is a group of artists, art workers, and activists in New York City with whom K8 Hardy has been working. This manifesto was collectively written by herself, A.K. Burnes and A.L. Steiner, in relation to issues specific to New York City economic conditions for artists and art workers, including independent curators. WAGE is an open activist group whose name is an acronym for Working Artists and the Greater Economy.

WAGE MANIFESTO

WAGE works to draw attention to economic inequalities in the arts, and to resolve them.

WAGE has been formed because we, as visual and performance artists and independent curators, provide a workforce.

WAGE recognises the organised irresponsibility of the art market and its supporting institutions and demands an end to the refusal to pay fees for the work we are asked to provide: preparation, installation, presentation, consultation, exhibition and reproduction.

WAGE refutes the positioning of the artist as a speculator and calls for the remuneration of cultural value in capital value.

WAGE believes that the promise of exposure (that is, exposure of your name and your work) is a liability in a system that denies the value of our labour. As an unpaid labour force within a robust art market from which others, not artists, profit greatly and the most, WAGE recognises an inherent exploitation and demands compensation.

WAGE calls for an address of the economic inequalities that are prevalent and proactively preventing the art worker's ability to survive within the economy.

We demand payment for making the world more interesting.

THE DROID MANIFESTO

This is a manifesto. This is movement.
We are a new breed: hybrid, low breed, breeding without biology.
We do not operate within the comfort zone.
This is a fight.
This is daily agonistic with the refusal to hide.

We are not bored.
Are we a new breed without gender?
We subvert dominant sexuality and hetero-
normativity.
We do not place limits.
We expel the barriers and binaries forced upon us.
Coming from us, we project outwards.
We are not a blank screen, complicit with what
others project upon us.

We no longer find solace in the singularity of one
term of identity:
lesbian, gay, queer, trans-gender, fag, dyke, poof,
bi and so on.
It now comes together in some different equation,
hypothesis, hybrid.

We do have identity. We do not have a working
label. Now we have no closet to come out of but
only a mirror to look back and reflect. We actually
just burn the house down.

We fight our insignificance. Feminist.

We are not boys, not men, not women, not girls,
not ladies, not sir, not Mr, Mrs, Miss, nor M'am,
nor him, nor her.

We speak to the shock. It's confusing to wake up.
Cliché.
It's shocking to laugh.
It's shocking not to take any shit.
Yet we grow.

The breed agonise the breeders and yet that
distinction still fails.
We reject those who continue to look back
and not face forward.
We reject those in the past who also looked back.
We have a new aesthetic.
We manipulate our bodies.
We don't believe in natural.
Everything, nothing, is natural.

We apply colours to our faces.
This signifies no adherence to the rules of
femininity forced onto some.
It's a need to adapt our bodies.
We dress in ways that may or may not reveal
the shape of our real or imagined sexual organs.
We can change every day.
We may look like we have tits, we may look like

we have dicks, and we may not. What is real and
what is fake is not clear.
You can't read and it doesn't matter.

We may look feminine, we may look masculine.
It's fake.
It is a flagrant masquerade no matter what level
of realness is attained.
You just can't tell anymore. And do you want to?

We do not cover up or forget the past. We do not
paste over our ancestors' slavery or mastery. We
don't know the meaning of the word 'race'. Is it
really socially constructed?

We carry multiple cultures within us, the visibility
of which also is not fixed.

We recognise whiteness as a master plan of domina-
tion and associate it with heteronormativity.
We recognise the privilege of skin-tones with the
recognition on the given.
It is not a gift, and we do not accept.
We look to who is giving and we know it is a
forcing down our throats, and so we vomit.

To those needing desperately these safe boundaries,
we give no thanks, no pleasantries or apologies,
no gratitude to those who hide in the safety of
heterosexual language.

It is no sanctuary.
We don't know the boundaries of our bodies
because we rip them down, up, apart, inside,
and whole. Rip me a new asshole.

We will fight. We reject all-American. We try to
work outside capitalism, we barter, we lez.com.
And yet we are not appeased.

Those who try to oppress us claim we are not real.
We confound their expectations.

We don't look for acceptance.
We do not believe in one truth, one light.
Everything is a lie.

MANIFESTO FOR THE HYPER EARLY CLUB (HEC) AND THE BRUTALLY EARLY CLUB (BEC)

HEC/BEC

A STATEMENT

Like "Flaming Creatures," The Genet film "Un Chant d'Amour" is a work of art and like any work of art it is above obscenity and pornography, or, more correctly, above what the police understand as obscenity and pornography. Art exists on a higher spiritual, aesthetic and moral plane.

The new American film-maker does not believe in legal restrictions placed upon works of art; he doesn't believe in licensing or any form of censorship. There may be a need for licensing guns and dogs, but not for works of art.

Likewise, we refuse to hide our work in restricted film societies, private clubs and membership groups. Our art is for all the people. It must be open and available to anybody who wants to see it.

The existing laws are driving art underground.

We refuse to accept the authority of the police to pass judgment on what is art and what is not art; what is obscenity and what is not obscenity in art. On this subject we would rather trust D. H. Lawrence or Henry Miller than the police or any civic official. No legal body can act as an art critic.

Hollywood has created an image in the minds of the people that cinema is only entertainment and business. What we are saying is that cinema is also art. And the meanings and values of art are not decided in courts or prisons.

Art is concerned with the spirit of man, with the subconscious of man, with the aesthetic needs of man, with the entire past and future of man's soul. Like any other art, like painting, music or poetry, our art cannot be licensed or censored. There is no one among us to judge it. We have not only the Constitutional right but, more important, the moral right, to communicate our work to other people.

To consider "Flaming Creatures" or "Un Chant d'Amour" obscene by a few extracted images, taken out of context, and to make a criminal case thereof, without making an attempt to understand the work as a whole, or the true meaning of the said details, is indeed a narrow, naive and unintelligent way of looking at things.

The detective from the District Attorney's office, who arrested us last Tuesday with "Flaming Creatures," told us that he was not interested in the film as a work of art; he also admitted that he was not competent to judge it; he said he was looking at it strictly as a matter of "duty"; he was looking only for "objectionable" images according to his interpretation of the law.

THERE IS NO GOD
JUST BOSS
THERE IS NO DEVIL
JUST US

WHEN THEY CAN'T CONTROL US
THEY CALL US
EVIL

THEY THINK THEY CAN MAKE US
A S H A M E D
LORD MASTER GOD BOSS
IGNORANCE THEY CALL INNOCENCE
THAT'S RICH

DO WRONG TALK WRONG THINK WRONG
MAKE THIS THEIR HELL ON EARTH

HOMOCULT

Manifesto selected from Jonas Mekas Archive
Homocult Manifesto

1. HEC/BEC IS A SALON FOR OUR TIMES

2. HEC/BEC USES OUR UNDERUSED TIME

3. HEC/BEC TAKES PLACE BEFORE THE NORMAL WORKING DAY (LOCAL TIME)

4. HEC STARTS AT 3.00AM, GREY-ZONE BETWEEN THE END OF ONE DAY AND THE START OF THE NEXT

5. BEC STARTS AT 6.30AM, SOON AFTER DAWN, JUST BEFORE THE NEW WAKING DAY BEGINS

6. HEC/BEC IS NEVER SCHEDULED LONG IN ADVANCE. 24 HOURS' NOTICE IS CUSTOMARY

7. HEC/BEC TAKES PLACE IN A CENTRAL, PUBLIC AND EASILY ACCESSIBLE LOCATION (CAFES, PARK BENCHES AND THE STREETS OF THE CITY. PERAMBULATION IS CONDUCIVE TO CONVERSATION)

8. HEC/BEC BEGAN IN LONDON BUT HAS TAKEN PLACE IN OTHER CITIES

9. HEC/BEC IS FREE OF CHARGE

10. HEC/BEC HAS A CORE GROUP OF MEMBERS – NONE OF WHOM ARE NECESSARILY PRESENT ALWAYS – WHO EXTEND INVITATIONS TO FRIENDS, COLLEAGUES AND STRANGERS

11. HEC/BEC IS ABOUT CONVERSATION

12. HEC/BEC IS POLYPHONIC. SEVERAL CONVERSATIONS MAY OCCUR AT ONCE. THERE IS NO MODERATOR NEITHER PRE-ADVANCED THEMES

13. HEC/BEC BELIEVES THERE MUST BE A TIME AND A PLACE WHERE CONVERSATION IS NOT MEASURED BY THE CULTURAL, COMMERCIAL OR INSTITUTIONAL VALUE OF THE OUTPUT

14. HEC/BEC THEREFORE DOES NOT PERMIT AUDIENCES, RECORDINGS OR TRANSCRIPTS

15. HEC/BEC HOWEVER DOES LIKE NOTES AND DOODLES DURING SESSIONS

16. HEC/BEC THINKS THAT DOODLING IS A GATEWAY TO ORIGINAL THOUGHT

93

17. HEC/BEC DOESN'T REQUIRE THE INGESTION OF ANY NARCOTIC OTHER THAN READILY AVAILABLE TEA AND COFFEE AT SAID HOST VENUE

18. HEC/BEC WELCOMES THE USE OF CONVERSATION TRIGGERS, SUCH AS BOOKS, MAGAZINES AND RECENT ANECDOTES

19. HEC/BEC DEMANDS EXTREME PUNCTUALITY

20. HEC/BEC HAS INTRODUCED THE WORD 'EVER' AS ITS CUSTOMARY GREETING AND FAREWELL

MANAFESTO

Susan Hefuna

[*Two people reading from postcards*]

▲ No war. Everybody be happy. And peace, no hunger, be healthy.
● Care and thought.
▲ Peace and harmony among mankind.
● My abilities.
▲ Honesty. Transparency.
● People should put their treasures in heaven and spread materials on earth.
▲ Science is the way forward.
● Do away with the Royal Family.
▲ Pollution. I want to reduce it.
● A smile can change the world.
▲ Peaceful. With thoughtful people.
● One day soon, at a time agreed through the media worldwide, everyone steps out of their home or workplace and greets all the people who have also stepped out of their home or workplace with a wish of happiness and acknowledgement of peace, friendship, a handshake or hug. It's broadcast worldwide, and the whole world transforms with love in an instant.
▲ Get rid of George W. Bush as soon as possible.
● Just be open-minded.
▲ Have more peace within people and togetherness, without minding race, religion, colour etc.
● Mana.
▲ Do what you are doing. They should ask who you are, then you tell them.
● The Golden Rule: treat everybody as you would expect to be treated yourself. Peace.
▲ Equality for animals. Freedom for natural existence.
● Jewellery.
▲ No comment.
● No more crime.
▲ The corruption in the government to change.
● No more oil dependence. Use all green fuels.
▲ End the credit crunch.
● It's all about me – no, cross it out – it.
▲ Ana.
● Laughter.
▲ Not being late for work.
● Peace for all people.

▲ Equality. Fairness.
● I hope everyone can respect each other.
▲ Less pollution, less arguing.
● Car-free Sunday twice a year. City for citizens.
▲ Honesty.
● Books.
▲ Art.
● No student fees.
▲ Smoking. Unfair ban in all public places.
● I live by the world; things don't affect me so much. It's all about karma.
▲ The transportation of London is awful.
● The perfect world would be a place where everyone would be at peace with one another.
▲ Very displeased in the differences between rich and poor.
● Climate change.
▲ Equality and diversity is the best way forward for all.
● Respect for the climate.
▲ If people listen and understand one's needs, they would be able to create a better relationship within society.
● We need more Tubes.
▲ Ana.
● Fashion.
▲ You can't change the world through art, but it might assist it.
● Ana.
▲ Make things more beautiful.
● Ana.
▲ Weather. Water. Most important.
● To be generous.
▲ Abolish Third World debt.
● Just try to improve your feelings.
▲ Joy is through hope.
● Violence and hatred.
▲ More peace, no war. When there's more peace there would be more freedom for everyone. Freedom for Allah.
● Imagination. People will understand each other better, love and laugh.

▲ Pray for me.

● I would like to see more empathy and simple kindness in humans as a race.

▲ Patience is beautiful.

● More contraception, please. Too many people.

▲ Recycling should be compulsory.

● People should treat each other respectfully.

▲ Scrap the Congestion Charge.

● Life doesn't have to be perfect. It should be fair.

▲ Fuel taxes are too expensive for taxi drivers.

● Less ecosocial domination by UN, USA.

▲ More money to be invested in our future. Students need better lecturers and more contact time.

● To conquer the world.

▲ I am not inspired.

● I want to enjoy London.

▲ Happiness, music, love.

● Everyone getting along.

▲ Care for water, gold, oil.

● Every single person should speak out loudly their opinion.

▲ Hope for the best.

● Everyone just do it.

▲ Everyone should cycle.

● Festo.

▲ No men.

● Happy and free.

▲ Peace and harmony.

● No more lies.

▲ Men should have a heart like a woman.

● Respect the world.

CAIRO POST CARD

NO CONTROL?

Edition of 200 | © Susan Hefuna | 2008
Printed on the occasion of the Serpentine Gallery Manifesto Marathon

A CENTURY OF MANIFESTOS

Eric Hobsbawm

Eric Hobsbawm reading *Il Manifesto*, c. 1980

Most of the participants here have written manifestos. I have no manifestos to propound, and I don't think I have ever drafted a document under that name, although I have drafted equivalent texts. However, I've been reading documents called manifestos for the best part of a century, and I suppose this gives me some credibility as a commentator on a *Manifesto Marathon*. I started my intellectual life at school in Berlin at the age of 15 with one manifesto – Marx and Engels's *Communist Manifesto*. I have a press photograph of me in my 80s reading the Italian daily newspaper *Il Manifesto*, which is, I think, the last European paper to describe itself as Communist. Because my parents were married in the Zurich of World War I, among Lenin and the Dadaists of the Cabaret Voltaire, I would like to think that a Dadaist Manifesto issued a loud fart at the moment of my conception, but unfortunately the first Dadaist Manifesto was recited three months before this could have happened.

Actually, systematic manifesto-readers are a 20th-century species. There had been plenty of such collective statements, mainly religious and political, in earlier centuries, but they went under different labels: Petitions, Charters, Appeals, and so on. There were the great Declarations – the Declaration of Independence of the USA, the Declaration of the Rights of Man in the French Revolution, but typically they are statements of very official governments and organisations, like the Declaration of Human Rights of 1948. Most manifestos belong to the last century.

How will manifestos survive the 21st century? Political parties and movements are not what they were in the last century, and they were, after all, one of the two great producers of manifestos, the arts being the other. Again, with the rise of the business society and MBA jargon, they have been largely replaced by that appalling invention, the

'mission statement'. None of the mission statements I have come across says anything worth saying, unless you are a fan of badly written platitudes. You can't walk more than a few yards through the undergrowth of print without stubbing your toe on some example, almost universally vapid in sentiment, telling you the equivalent of 'Have a nice day' and 'Your call is important to us.'

Still, manifestos are competing quite successfully with mission statements. There are almost 20 million that are potential clicks under this heading on Google, and this leaves plenty, even if you exclude Manifesto Records and its various products. I can't say they all live up to the dictionary definition, which is 'a public declaration of principles, policies or intentions, specially of a political nature'. Or of any other nature. They include a *Breastfeeding Manifesto*, a *Wildlife Gardening Manifesto*, a *Manifesto for the Hills*, which deals with livestock in the Scottish highlands, and a rather tempting *Manifesto for a New Walking Culture* by Wrights & Sites, with plenty of references to the Dadaists, Situationists, André Breton and Bertolt Brecht, but, rather surprisingly, none to the champion of urban walkers Walter Benjamin. And, of course, they include all the manifestos of this *Marathon*.

I haven't had a chance to hear many of this weekend's manifestos, but one thing that strikes me about them is that so many of them are individual statements and not, like almost all manifestos in the past, group statements, representing some collective 'we', formally organised or not. Certainly, that is the case of all political manifestos I can think of. They always speak in the plural and aim to win supporters (also in the plural). That is also traditionally the case of manifestos in the arts, which have become popular since the Futurists introduced the word into the world of art in 1909, thanks to Marinetti's Italian gift of the rhetorical gab. In doing so, they beat the French to it by a few years – I am sure the Cubists would have liked to invent the M-word, but they were not very political at that time, and better at thinking in paint than in words. I am, of course, thinking of avant-gardes which recognise themselves as such at the time, not of labels and schools which are created retrospectively like 'Post-Impressionism' or invented by critics and – increasingly – by dealers like 'Abstract Expressionism'. I am thinking of genuine groups of people, sometimes built round a person or a periodical, however short-lived, conscious of

97

what they are against and what they think they have in common: Dadaists, Surrealists, De Stijl, LEF, or the Independent Group round which Pop Art emerged in Britain in the 1950s. Or, for that matter, the original photographers' collective Magnum. If you like, they are all campaigning bodies.

I'm not sure what purely individual manifestos are there for, other than one person's fears for the present and hopes for the future which they may or may not hope are shared by others. How is this to be realised? Is it primarily by self-cultivation and shared experience, as Vivienne Westwood tells us in her attractive manifesto? How else? The Futurists invented public self-advertisement. It is a sign of our disintegrating and chaotic society that media publicity is today the first thing that comes into a potential manifestant's mind, rather than the traditional way of collective action. Of course, individuals may also use a manifesto to advertise, and so to claim priority for, some personal innovation, as in Jeff Noon's *Literary Manifesto* in 2001 (*The Guardian*, 18 January 2000). There is also the terrorist manifesto pioneered by the Unabomber in 1995, which advertises an individual attempt to change society, in this case by sending incendiary bombs to selected enemies, but I'm not sure whether this belongs to the field of politics or conceptual art. But there's yet another purely individual manifesto or ego-trip that has nobody in mind but the solipsist who issues it. The extreme example of this is that extraordinary document Yves Klein's *Chelsea Hotel Manifesto* of 1961. Klein, you may remember, had built a career on painting a single colour, an immediately recognisable dark blue. Nothing else: on square and oblong canvases, on anything three-dimensional, mostly sponges but also models whom he got to roll in the paint. The manifesto explains that it was because he was haunted by the blue sky – though Klein's blue is as un-cerulean a colour as I have ever seen. As he lay on the beach in Nice, he tells us 'I began to feel hatred for the birds which flew back and forth across my blue cloudless sky, because they tried to bore holes in my greatest and most beautiful work. Birds must be eliminated.'

I don't have to tell you that Klein found critics to explain his profundity and dealers to sell him to the punters. He has been given the sort of immortality he deserved by the Gagosian Gallery, which has copyrighted his manifesto.

This brings me to the content of the manifestos of my lifetime. The first thing that strikes me, looking back on them, is that the real interest of these documents is not in what they actually call for. Most of that tends to be either obvious, even platitudinous – and large landfill sites could be made to overflow with such stuff. Or it is destined for rapid obsolescence. That is true even of the great and inspiring *Communist Manifesto*, which remains so alive that in the last ten years it has been rediscovered by the capitalists themselves, in the absence, in the West, of a Left with serious political significance. The reason we read it today is the same that made me read it when I was 15: it is the wonderful, irresistible style and verve of the text, but, chiefly, it is the soaring analytical vision of world change in the first few pages. Most of what the manifesto actually recommended is of purely historical interest, and most readers skip it except for the clarion call at the end – the one about the workers having nothing to lose except their chains, and having a world to win. Workers of all countries unite – unfortunately, this is also well past its sell-by date.

Of course, that is the trouble about any writings about the future: it is unknowable. We know what we don't like about the present and why, which is why all manifestos are best at denunciation. As for the future, we only have the certainty that what we do will have unintended consequences.

If all this is true of so permanent a text as the *Communist Manifesto*, it is even more true of manifestos in the creative arts. For a lot of artists, as an American jazz player once told me in a nightclub, 'Words are not my instrument.' Even where they are, as among poets, even among the very bright ones, creation doesn't follow the path 'I think, and then I write,' but a much less controllable one. That, if I may say so, is the trouble with conceptual art. Intellectually, the concepts in conceptual art are usually uninteresting, unless they can be read as jokes, like Duchamp's urinal or, to my mind much more fun, Paul Klee's work.

So reading most manifestos in the arts for their intended meaning is a frustrating experience, except maybe as a performance. And, even then, they are better as wit and jokes than in the oratorical mode. This is probably why Dada, that style for stand-up comics, is still the standby of so many manifestos today: its humour is both funny and black and, like Surrealism, it doesn't call for interpretations but for the imagination to play, which is, after all, the foundation of all creative

work. And anyway, the test of the pudding is not the description of the dish on the restaurant menu, however flowery, but the eating.

This is where the creators in the arts have been more successful than their manifestos. In my *Age of Extremes*, I wrote: 'Why brilliant fashion designers, a notoriously non-analytic breed, sometimes succeed in anticipating the shape of things to come better than professional predictors, is one of the most obscure questions in history and, for the historian of the arts, one of the most central.' I still don't know the answer. Looking back at the arts in the last decade before 1914, we can see that much about them anticipated the breakdown of bourgeois civilisation after 1914. The pop art of the 1950s and 1960s recognised the implications of the Fordist economy and mass consumer society and, in doing so, the abdication of the old visual work of art. Who knows, a historian writing 50 years hence may say the same about what is happening in the arts, or what goes by the name of art, in our moment of capitalist crisis and retreat for the rich civilisations of the West? Like *Man on Wire*, but much more uneasily, the arts walk the tight-rope between soul and market, between individual and collective creation, even between recognisable and identifiable human creative products and their engulfment by technology and the all-embracing noise of the internet. On the whole, late capitalism has provided a good living for more creative people than ever before, but it has fortunately not made them satisfied either with their situation or with society. What anticipations will the historian of 2060 read into the cultural productions of the past 30 years? I don't know and can't know, but there'll be a few manifestos issued on the way.

* * *

I am going to ask Professor Hobsbawm a few questions, and then we will open it to the floor for your questions. In our last interview, we talked about the future, and you said the problem is predicting what the future will be like. Since then you have published this book, which has just come out, Globalisation, Democracy and Terrorism, *which is a lot about the 21st century. I wanted you to tell us a little bit about this book.*

ERIC HOBSBAWM Well, even though historians deal with the past, hardly anybody can resist speculating about what's going to happen, but I try and avoid too much speculation, because I try, as a historian, to see how the past has created the predicament and the problems of the present. Behind all the things I write in this book is the present phase of globalisation, which may, actually, I hope, be coming to an end with the world economic crisis through which we are now living. That globalisation is, in some sense, a rule by religious fundamentalists, except that they believe in the free market instead of in God. Some of them may also believe in God, but that's not so usual among economists. It produced enormous inequalities, which are now coming home to roost within countries as much as between countries, and it produced an unusual instability of the world system.

Until last year, hardly anybody in our happy Western countries, where we live like princes compared with what happens in places like India or Asia, at least to the majority of the population, was affected by it. We had these ups and downs of the Stock Exchange, but we didn't know what a real Depression was like, whereas in Brazil they knew in the 1980s, in Mexico they knew in the 1990s, in East Asia, in South East Asia, in Russia they knew in the late 1990s, they knew in Argentina almost consistently, especially in the early 2000s. Now we also know. My only predictions on that would be that this will slow down the process of globalisation – though it won't stop it. Historically, it hasn't been stopped, but I hope it will also change it.

A lot of the book is concerned with the Americans. I am not really making a prediction about the decline of the American empire, because predictions are senseless, unless there is some kind of time-scale attached to them, but it is fairly evident now that the idea on which America based its policies – namely, that they could be single-handedly

99

lords of the world – was never on. In various pieces of my book, I demonstrate that this was never on and that the nature of the American empire is quite different in this respect from other empires. For one thing, it has – except for being the greatest debtor in the world, which is very unusual for empires to be – no specific economic interest, in the way in which the British Empire did. It goes not with, but in some sense against, the development of the world economy. However, that's by the by.

In our last conversation, you talked about the long waves of the economic cycle. Obviously, that was before the credit crunch. Immanuel Wallerstein, in his seminal 1998 book Utopistics *said that it's now going to be a 30- to 50-year transition of trying to get rid of the current system of the market economy and trying to find an alternative, so he predicts decades of turmoil, almost, and then maybe a new equilibrium could set in. Would you agree with that?*

I think we ought to get out of that 20th-century habit of thinking of systems as being, as it were, mutually exclusive: you're either socialist or you're capitalist, or whatever. There are plenty of people who still think so. I think very few attempts have been made to build a system on the total assumption of social ownership and social management; the Soviet system at its peak tried that, and in the past 20 or 30 years, the capitalist system has also tried it. In both cases, the results demonstrate that it won't work, so it seems to me the problem isn't whether this market system disappears, but exactly what is the nature of the mixture between market economy and public economy and – above all, in my view – what are the social objectives of that economy.

One of the worst things about the politics of the past 30 years is that the rich have forgotten to be afraid of the poor, of most of the people in the world, which is why they have gone on behaving in this extraordinary, public, luxurious fashion, throwing about their zillions. I think perhaps this is now, I hope, going to, at least if not finish, be a little bit modified.

Last year, you were saying you also feel pressure from environmental forces for major change. In our Manifesto Marathon, *we have had a lot of manifestos which concern themselves with the environment. I was wondering if you could talk a little bit about this.*

There is no question about it that the problem of the environment is a central problem. It is not the only central problem. My view is also that one of the central problems is that humanity has learnt to modify human beings by genetic and other techniques as well as everything else. What harm will be done through it, I don't know, but it will be a genetic equivalent of the old Murphy's Law: if it can go wrong, it will. There is no question about it, however, that whatever happens to the people who live there, the environment is essential. Without environmental stability, it seems to me to be unthinkable that the human race can continue into the 21st century on the scale or level of life at which it exists now.

The real problem, the crucial problem, is that it requires global solutions, but the one bit of globalisation, the one aspect of life, which has been totally unaffected by globalisation is politics. To this day, the only organisations which can take decisions, policy decisions and others, are states, or alternatively the organisations which have been given the go-ahead by states, and that is a problem. We have seen this most recently. It may be that from time to time in crisis, states can be persuaded to go together, although I don't see it happening very easily even with the 27 states at present in Europe, let alone with the others in the United Nations. The last time this was done was at the end of the war, the Bretton Woods [meeting which set up the World Bank and the IMF] and all the rest of it. It wasn't actually done as a sort of universal decision; it was effectively done between the British and the Americans. It is possible that you might do it between Europe and the United States and China and India; even so, it can't be done with less than five or six participants now, and even that's going to be hard.

Thank you very much, Eric. Do we have questions for Eric Hobsbawm?

Q1 (GUSTAV METZGER) *I just wanted to ask you a personal question. We have been informed over a period of time that you are a Communist. Would you mind telling us whether that is the case, and are you a member of the Communist Party, a supporter of the Communist Party? Maybe this is too personal, in which case, don't bother to answer, but this question of Communism is certainly a very important part of your life.*

I have spent my life as a Communist, and most of it as a member of the Communist Party. There is no Communist Party anymore in this country. There aren't any significant Communist parties anywhere in Europe at the moment. There are still one or two in a couple of places, mostly in Asia. I am not talking about the official ones. It is a movement which belonged to the 20th century as a movement, as a kind of organisation, essentially the Leninist vanguard party, which in its time was an extraordinary social invention and incredibly efficient. Remember, within 30 years of Lenin getting off the train at Finland Station in Petrograd, one third of humanity lived under the government of Communist parties. But I don't think it works anymore. It's not likely to work anymore, and consequently while I remain committed to the ideal for which Marx stood and for the ideal of a human and communally organised society, it is not possible to say that Communist parties will play a significant part in it. If this aim is to be achieved at all, other movements will have to develop.

Q2 *Can you give some clarity to the rise of 21st-century socialism, as it's called, in Latin America?*

This is one of the few very positive developments. First of all, I think it's new. I think the most important element of it is a changing Brazil, and it is the first time this great country has genuinely become a democracy in the sense that what the people do or think counts. How far it is socialism, how far it is a mixed economy which is now trying to emancipate itself from the supremacy of the United States, is not yet clear. It *is* quite clear that the United States has lost its control over Latin America, which it exercised ever since, I suppose, in theory, since the Monroe Doctrine, in practice, since 1914, or since the 1880s or 1890s. But it's great. It's all the greater because I think it is based around one large country which really has the possibility of turning at least South America into an independent actor on the world stage, and if that independent actor is an actor of the Left, it seems to me that it is an entirely positive development.

MANIFESTO FOR SMOKING

David Hockney

There is a small fanatical group in Brussells determined to get rid of smoking.

They will fail. The best they will manage is to turn a legal and tax paying industry into an illegal and non-tax paying one. Exactly like the Womens Christian Temperance Union inflicted on the United States from 1919 to 1933

All anti-smokers become fanatics. I know, my father was an early one. They are also proffesional in a way, the smoker is not.

We are a long long way from democracy. To tell 12 million smokers in Britain, you cant be social, is outragious. I don't for a moment believe the second hand smoke stuff, how on earth can you measure how much someone has had

Science doesn't have exceptions, yet, like all things today, its corrupted. When a doctor on the BBC, can go unchallenged saying "Smoking killed one hundred million people in the twentieth Century" I am amazed.

One hundred million people were killed in the 20c for Political reasons, by comparison the people he was talking about died in their beds at home

Its a twisting of the word "killing" Fanatics twist everything, and a democratic Europe should start standing

102

up against these dreary people who think
they know best for everyone.

You cant measure pleasure. Thats the
problem the medical people never seem
to acknolwedge. Dennis Thatcher died at
87, having smoked senior service all his
life. Smokers die younger says the
cigarette packet. — Just like Picasso
Matisse — Monet, all happy smokers.

We are being made to live in a
clinic. I don't want to. I have
smoked for 52 years, so why stop
now. I am aware I'm going to die,
but if you listen to the dreary
clinic people, you'd think they were
offering immortality.

Stand up against the dreary conformity,
that is spreading much too fast. ▬▬

103

DAVID Hockney

DEATH AWAITS YOU
EVEN IF YOU DO NOT SMOKE

YOU BLEW UP MY HOUSE

Karl Holmqvist

ALIENATION IN THE WORKPLACE
ALIENATION IN THE WORKPLACE
MAKING MONEY
CONTROL
MAKING MONEY
CONTROL
END CAPITALISM
END CAPITALISM
NOW
MAKING MONEY
CONTROL
MAKING MONEY
CONTROL
ALIENATION IN THE WORKPLACE
SLAVES IN ANCIENT EGYPT, SLAVES
IN MEXICO, SLAVES IN ROME
ALIENATION IN THE WORKPLACE
SLAVES IN ANCIENT EGYPT, SLAVES
IN MEXICO, SLAVES IN ROME
ALIENATION IN THE WORKPLACE
MAKING MONEY
CONTROL
MAKING MONEY
CONTROL
ALIENATION IN THE WORKPLACE
ALIENATION IN THE WORKPLACE
SLAVES IN ANCIENT EGYPT, SLAVES
IN MEXICO, SLAVES IN ROME
CHILD WORKERS IN CHINA
ONE CHILD PER HOUSEHOLD
GIVE YOURSELF A RAISE
GIVING VOICE TO THE VOICELESS
ALIENATION IN THE WORKPLACE
ALIENATION IN THE WORKPLACE
WORKING FROM 5 TO 9

JOY OF WORKING
WORKING WORKING
ON MY MIND
MY MIND
LET YOUR KIDS MAKE MUSIC
KIDS WITH KIDS
IT'S A WAR
LET YOUR KIDS MAKE MUSIC
KIDS WITH KIDS
IT'S A WAR

ALIENATION IN THE WORKPLACE
ALIENATION IN THE WORKPLACE
WORKING FROM 5 TO 9
JOY OF WORKING
WORKING WORKING
ON MY MIND
MY MIND
START WITH THE MIND
IT'S PSYCHOLOGICAL
START WITH THE MIND
WASH YOUR THOUGHTS
REPLACE HATE WITH HATE
YOUR THOUGHTS
IT'S PSYCHOLOGICAL
START WITH THE MIND
ALIENATION IN THE WORKPLACE
ALIENATION IN THE WORKPLACE
START WITH THE MIND
THE MIND
LET YOUR KIDS MAKE MUSIC
START WITH THE MIND
THE MIND
START WITH THE MIND
ALIENATION IN THE WORKPLACE
ALIENATION IN THE WORKPLACE
SLAVES IN ANCIENT EGYPT, SLAVES
IN MEXICO, SLAVES IN ROME
CHILD WORKERS IN CHINA
ONE CHILD PER HOUSEHOLD

ONE WORLD ONE LOVE
LET'S
GHETTOGETHER
AND FEEL ALRIGHT
ONE WORLD ONE LOVE
LET'S
GHETTOGETHER
AND FEEL ALRIGHT
ONE WORLD ONE LOVE
LET'S
GHETTOGETHER
AND FEEL ALRIGHT
LET ME HEAR YOU SAY
ONE WORLD ONE LOVE
LET'S
GHETTOGETHER

PRODUCTION

1. Recognize that film producers can also be non-profit organizations.

2. Support collective production cooperatives.

3. Allow access to grants for individual projects.

4. Form competent committees for this domain.

5. Return the G.R.E.C. to film experimentation, or let the Athenians reach their goals.

POST-PRODUCTION

6. Develop support for post-production at the work-print stage.

DISTRIBUTION

7. Reinforce support to the heart of the network : the distribution cooperatives.

PROMOTION

8. Insure the promotion of experimental cinema made in France.

EXHIBITION

9. Heighten awareness within regional contemporary art centers to the existence as well as to the specificities of experimental cinema.

10. Increase ten-fold the authorizations for non-commercial screenings in theaters classified in France as "art house" or "non-commercial."

POST-SCRIPTUM

11. In case we need some cash...

Provinces – Paris – Pantin, November 16, 2002

FILMMAKERS! PROGAMMERS! VIEWERS!
ORGANIZATIONS IN PRODUCTION, PROMOTION AND DISTRIBUTION,
SCREENING VENUES OF EXPERIMENTAL CINEMA,
EXPERIMENTAL FORMS OF AUDIO-VISUAL ART IN GENERAL, AND BEYOND!
SUPPORT OUR INITIATIVE BY SIGNING OUR MANIFESTO, EITHER BY E-MAIL AT : manifeste@cineaste.net
OR BY SNAIL MAIL AT : MANIFESTE – 3, rue Bias – F44000 NANTES, FRANCE
THE CURRENT LIST OF SIGNATURES MAY BE CONSULTED AT : http://www.cineastes.net/manifeste.html

02/02/02

NICE
DATE!

hello jonas,

 michel here on the other side.

heard manhattan's crazy these days (police & anti-davos)

sounds good,

if you see alexei please tell him to write a mail to me *mallard@*
imaginet.fr

can you give me your address so i can send you some pictures ?

so I spoke with David Komurek, he was seeing Harmony last night.

they are supposed to contact you, his number in anycase is 00 1 917 701 89 71

 if you need to reach him & harmony.

love the vortex manifesto : *thanks*

Long Live the Vortex!

Long live the great art vortex sprung up in the centre of this town!

We stand for the Reality of the Present — not for the sentimental Future, or the sacripant Past.

We want to leave Nature and men alone.

The only way Humanity can help artists is to remain independent and work unconsciously.

WE NEED THE UNCONSCIOUSNESS OF HUMANITY — their stupidity, animalism and dreams.

We believe in no perfectibility except our own.

Intrinsic beauty is in the Interpreter and Seer, not in the object or content.

WE ONLY WANT THE WORLD TO LIVE, and to feel its crude energy flowing through us.

Blast sets out to be a venue for all those vivid and violent ideas that could reach the Public in no other way.

Blast will be popular, essentially. It will not apppeal to any particular class, but to the fundamental and popular instincts in every class and description of people. **TO THE INDIVIDUAL**. The moment a man feels or realizes himself as an artist, he ceases to belong to any milieu or time. Blast is created for this timeless, fundamental Artist that exists in everybody.

We want to make in England not a popular art, not a revival of lost folk art, or a romantic fostering of such unactual conditions, but to make individuals, wherever found.

We will convert the King if possible.

A VORTICIST KING ! WHY NOT ?

talk to you later, cheers
MICHEL

-1-

AND FEEL ALRIGHT

SAID SAID
I REMEMBER WHEN I USED
TO SIT
IN FRONT OF TV
IN SWEDEN

ONE WORLD ONE LOVE
LET'S
GHETTOGETHER
AND FEEL ALRIGHT
ONE WORLD ONE LOVE
LET'S
GHETTOGETHER
AND FEEL ALRIGHT
ONE WORLD ONE LOVE
LET'S
GHETTOGETHER
AND FEEL ALRIGHT
LET ME HEAR YOU SAY
ONE WORLD ONE LOVE
LET'S
GHETTOGETHER
AND FEEL ALRIGHT

SAID SAID
I REMEMBER WHEN I USED
TO SIT
IN FRONT OF TV
IN SWEDEN
ALIENATION IN THE WORKPLACE
ALIENATION IN THE WORKPLACE
SLAVES IN ANCIENT EGYPT, SLAVES
IN MEXICO, SLAVES IN ROME
CHILD WORKERS IN CHINA
ONE CHILD PER HOUSEHOLD

END CAPITALISM
END CAPITALISM
NOW
START WITH THE MIND
THE MIND
MAKING MONEY
CONTROL
MAKING MONEY
CONTROL
GAY MARRIAGE
CONTROL
COURAGE CAMPAIGN ISSUES
COMMITTEE
CONTROL

MAKING MONEY
CONTROL
DEMOCRACY
CONTROL
FIFTEEN TO VOTE
CONTROL
KILL ALL PEOPLE OVER 30
CONTROL
KILL ALL PEOPLE

WHO SAID SENDING PEOPLE OFF
TO PRISON WAS NORMAL?
CONTROL
SILENCE THE BOMB
WHO SAID SENDING PEOPLE OFF
TO PRISON WAS NORMAL?
CONTROL
SILENCE THE BOMB
START WITH THE MIND
CONTROL
SILENCE THE BOMB
LET YOUR KIDS MAKE MUSIC
CONTROL
MAKING MONEY
JOY OF WORKING
CONTROL
CHILD WORKERS IN CHINA
WE DON'T NEED NO THOUGHT CONTROL
CONTROL
LET YOUR KIDS MAKE MUSIC
CONTROL
GAY MARRIAGE
WOMEN'S RIGHTS
CONTROL
SAUDI ARABIA
DEMOCRACY
ROYALTY
YO MAJESTY
GLASS CANDY
LADY GAGA
MAKING MONEY
CONTROL
A CONTRACT
THE FINE PRINT
SIGNING YOUR LIFE AWAY
SIGNING AWAY YOUR SOUL
CONTROL
SLAVES IN ANCIENT EGYPT, SLAVES
IN MEXICO, SLAVES IN ROME
THE SLAVE OF SLAVES
WOMEN LEADERS
CONTROL

105

GAY MARRIAGE
CHECK
CONTROL
CHECK CHECK
SPACE IS THE PLACE
GIVING VOICE TO THE VOICELESS
CHECK CHECK
SPACE IS THE PLACE
WEARING THE PANTS
WHY DO CLOTHES HAVE SEXES?
CONTROL
START WITH THE MIND
THE MIND
CONTROL
LET YOUR KIDS MAKE MUSIC
CONTROL
RHYTHM TO THE RHYTHM
START WITH THE MIND
THE MIND
GIVING VOICE TO THE VOICELESS
SILENCE THE BOMB

In her 2003 book *Regarding the Pain of Others*, Susan Sontag remarks how ours is the first time when peace is regarded as something normal.

106

CONTROL
START WITH THE MIND
LET YOUR KIDS MAKE MUSIC
THOUGHTS ARE THOUGHTS
THAT'S ALL
AN ANGEL IN THE ROOM
SILENCE THE BOMB
DAREDEVIL
COMPETING FOR THE SAKE
OF COMPETITION
COMPETITION
IT'S A GOOD THING
SILENCE THE BOMB
RHYTHM TO THE RHYTHM
JOY OF WORKING
SILENCE THE BOMB
WORKING FROM 5 TO 9
ALIENATION IN THE WORKPLACE

HIStorically, in all other times, war was seen as the norm. There would always be a time between conflict, but then just waiting for the next.

SILENCE THE BOMB
LET YOUR KIDS MAKE MUSIC
RHYTHM TO THE RHYTHM

SILENCE THE BOMB
LET YOUR KIDS MAKE MUSIC
SILENCE THE BOMB
WOMEN LEADERS
START WITH THE MIND
THE MIND
SAUDI ARABIA
START WITH THE MIND

Édouard Glissant has said that when future historians look back at our time, we will be judged by our inability to distribute wealth. The shock of how big parts of the world still are left to starvation and poverty.

START WITH THE MIND
THE MIND
JOY OF WORKING
START WITH THE MIND

Artists could inspire, not only by making art works, but also through sharing their work process. People could understand how creativity is invested into something. How you make things work. Make them work for you, and make them work for others.

ALIENATION IN THE WORKPLACE
RHYTHM TO THE RHYTHM

It seems strange, with all the wealth in the world. All the machines, all the airplanes circulating products and people, public zoos and swimming pools, that people don't have better lives. Or maybe they do.

LET YOUR KIDS MAKE MUSIC
START WITH THE MIND
LANGUAGE POETRY
POETRY
START WITH THE MIND
THE FIRST RULE IS TO BREAK
THE RULE
START WITH THE MIND
ROYALTY
SAUDI ARABIA
START WITH THE MIND

Language rules can be broken, just like any other rules. Words can have multiple meanings. Singing the Blues. Your thoughts can be used to ease trauma, ease dread even in the most mundane situations. Even in the extreme, extreme conditions. Condition your mind.

It seems hopeful therefore that at least we're no longer thinking about war as normal, even though

war is everywhere, not in the West of course. Not in Europe or the United States, but we have our wars elsewhere. We fight them out on television, through remote control. It's a collective decision that certain areas of our planet should be used for conflict, that's all. We have garbage piles for garbage, and we have Conflict Zones.

And then that's normal. Business as usual. Women's place is in the home.

Colonialism could never have happened without armed force. Without considering other people less. Less than human, what's so heroic about this? Reducing yourself, because you have to. Because you can't cope. And then reducing others to fit to size. Fight someone your own size. Fight someone in your own area. Don't have war on the other side of the planet. Fight someone your own size. Fight your wife. Make war human. Fight for life. The dignity, the dignity of being human. Fight for that.

**I DON'T WANT NO LIES
I DON'T WATCH TV
I DON'T WASTE MY TIME
READING MAGAZINES
I DON'T WANT NO LIES
I DON'T WATCH TV
I DON'T WASTE MY TIME
READING MAGAZINES
I DON'T WANT NO LIES
I DON'T WATCH TV
I DON'T WASTE MY TIME
READING MAGAZINES
I DON'T WANT NO LIES
I DON'T WATCH TV
I DON'T WASTE MY TIME
READING MAGAZINES
ECONOMIC CRISIS
IT'S A HOAX
ECONOMIC CRISIS
IT'S A HOAX
MEDIA DEPRAVITY
IT'S HUMAN CRISIS, THAT'S ALL
LET'S ALL
GHETTOGETHER
AND FEEL ALRIGHT
LET ME HEAR YOU SAY
LET'S ALL
GHETTOGETHER
AND FEEL ALRIGHT
LET ME HEAR YOU SAY
ONE WORLD ONE LOVE
LET'S ALL**

GHETTOGETHER AND FEEL ALRIGHT

Feel good about oneself, feel good about one's friend. Self-acceptance. Acceptance of self. Self-love. The schoolyard bully. The scariest thing about the US presidency for the last couple of terms – 2001-05, 2005-09 – was how I knew that face. The facial expression of arrogance and unconcern. With the need to assert oneself through bullying others. Telling people what to do. Telling the ones who seem weaker than you where they should be and what they should do. Gay marriage. The schoolyard bully. When such a person is elected into office of what's perceived as the world's most powerful nation, we have something to concern ourselves with. What's power, what's an election? Media attention. The power of the word, of the voice. Of human thought. The power of courage. Of time. Time following its course. Of predestination. Five hundred years of Enlightenment, coming to an end. About to disappear.

Start with the mind. Fight in the street. Fight the people you meet. Not on the other side of the planet. Evolution, that's all. Fight evolution. Fight nature. Make money. The first rule is to break the rule. Break the habit. Look at the person. Fight with your wife. There's something beautiful to be found in everyone. Look for that. Even the people with the least appeal. Even in President Bush – I always thought about how with all the money and powers he has, all the consultants and armed protection, his suits always seem to be ill-fitting and slightly too big. How it seems he would like to say something about himself this way. It may seem mean, but I thought that it was cute. I thought that it was cute since I can't look at his face, or even mention his name. Gertrude Stein, Gertrude Stein, Susan Sontag, Gertrude Stein.

The first rule is to break the rule. Never tell others what to do.

There's a cute passage in Victor Bockris's book *With William Burroughs* (1981), where he retells how Susan Sontag had been able to arrange a meeting with Samuel Beckett, who happened to be William S. Burroughs's idol. How they had come to Beckett's apartment, in the afternoon, where he had received them. A courtesy visit. He seemed antsy, waiting for them to leave again so that he could get back to his work. Now, that was phenomenal.

107

ART STRIKE BIENNIAL

Stewart Home

Stewart Home, 'The Art Strike Papers', 1991

PREAMBLE

A forthcoming Art Strike Biennial has been announced to take place in Alytus, Lithuania, in 2009. Among other things, this Biennial will act as a focus for opposition to Linz and Vilnius becoming European Capitals of Culture in 2009. In 2011, a second Art Strike Biennial will take place to oppose the gentrification of Tallinn and Turku.

The Art Strike Biennial was initially called by Redas Diržys and other activists from Eastern Europe. The Transient Art Strike Biennial Supreme Council of One (London) will participate in the Art Strike Biennial by refusing to produce new work, choosing instead to plagiarise and recycle pre-existing Art Strike materials, as well as encouraging other forms of cultural cannibalism. Simultaneously, our experiments in time travel have enabled us to colonise Elizabethan London, where we are busy (de)composing the entire works of Shakespeare, Bacon, Middleton, &c.

I. AIMS

To undermine the hegemonic role of art in bourgeois ideology and oppose the innumerable property developers who ride on its coat-tails. We will replace 'serious culture' with pranks, fun, parties and, above all, sexual experimentation (or other forms of sensuous activity for those too young for these particular activities).

Art as a category must be distinguished from music, painting, writing, &c. Current usage of the term art treats it as a sub-category of these disciplines, one which differentiates between parts of them on the basis of 'perceived values'. Thus, the music of John Cage is considered art, while that of Steve Peregrine Took is not. Therefore, when we use the term art, we're invoking a distinction between different musics, paintings, works of fiction, &c. – one which ranks the items to be found within these categories into a hierarchy.

We aim to suppress art and artists and instead involve the entire art world in the development of new sexual perversions; these will include: The Curve, The Edgar Broughton Shuffle, The Gorilla Stomp and The Mickey Finn (having thought up some new terms for perversions, we simply need others to complete our mission by inventing acts these might signify).

It should go without saying the artist is in many ways a deformed prefiguration of the Communised (in)dividual. For Marx, once we had mature Communism, we could become hunters in the morning, fishermen in the afternoon and critical critics at night. As feral vegetarians, we prefer to be egotists in the morning, porn stars in the afternoon and critical critics at night. We reject alienated roles; instead, we aim to realise all the facets (physical, emotional, intellectual) of being human in a polymorphous perversity that will turn the whole world on (to acid-drenched multiple orgasms).

Both aesthetic theory and Marx draw heavily on German idealist philosophy, so it isn't surprising that there are parallels between them. But artists still produce commodities to be sold in the marketplace, which is why they and their activities remain alienated and deformed. The job of progressive artists is to destroy their privileged role as specialised non-specialists, and the Art Strike Biennial is one way of drawing them towards a place where they can live out the death of art (and the endless small deaths of orgasmic human communion).

2. REASON(S)

We reject instrumental reason. Reason separated from emotion is a form of alienation. That said, full-blown and outright Romantic rejections of reason are every bit as silly as deifying the rational.

What's actually required is the selective employment of analytical and/or correlative thinking as is appropriate to a specific situation.

Moving on, 'serious culture' is fucking boring, and outside a few international centres (London, New York), art acts as a form of imperialism. 'International' art carries the ideology of the market to territories without a developed trade in cultural trifles. A few artists from these subjugated zones might be incorporated into the rigidly centralised anti-world of art, but London remains the hierarchical market centre in Europe, and thus the hub around which all hype about visual culture is spun.

3. TACTICS

Writing manifestos to discredit good, compromise the leaders, shake faith and spread contempt, we will use base (wo)men, disorganise the authorities, sow discord, incite revolt, ridicule traditions, dislocate supplies, encourage the playing of lascivious music (Barry White, Blowfly, Pork Dukes, &c.), spread lechery, lay out money and, above all, demonstrate that we have better jokes than the art establishment (even if most of them are plagiarised from Rudy Ray Moore).

We invite all artists to participate in the construction of a Capital of Culture Destruction Machine (based on both Wilhelm Reich's orgone research and Nikola Tesla's perpetual motion theories). Above all else, the Capital of Culture Destruction Machine will demonstrate that pornography is superior to art, causing 'serious culture' to wither and leading to Alytus in southern Lithuania becoming a world centre of sexual energy (and thus far more attractive than Vilnius or Linz to anyone who isn't frigid or terminally repressed). This will be the return at a higher level of the 1960s freak dream of 'rock 'n' roll, dope and fucking in the streets'. Our programme for the realisation of sexual ecstasy runs as follows: a) free love; b) more shagging; c) even more fucking.

4. ORGANISATION

To avoid the dangers of bureaucratisation, Transient Art Strike Action Committees should contain no more than one member, this will make our groups completely transparent. Such forms of (dis)organisation will demonstrate our total opposition to the so called 'organisation of the artist'. The latter conceit is an ideological racket (dreamt up by reactionaries such as Frank Gehry) to ensure that they and their paymasters remain completely unaccountable when imposing unwanted cultural institutions on cities they have earmarked for gentrification (under the completely false guise of economic regeneration, since this is something better understood as property development/speculation). Unlike the post-democratic practices of Gehry and his cohorts, Transient Art Strike Action Committees will demonstrate their Communist nature by undergoing schizophrenic splits; the unwanted part(s) of the personality being expelled for failings such as not achieving their erotic potential and mystical cretinism.

5. FOLLOW-UP

Our 100-year programme necessitates we appear and disappear on an annual basis. Therefore, all Transient Art Strike Action Committees are instantly revocable, and they will be all the more powerful for being without badge, title or official right. By 3009 (and possibly much earlier), we will be liberated from art. What we are actually striving towards is the destruction of capitalist social relations and the privileged role of the artist within them, so that the real creative energies of (wo)mankind can be released. In a truly free society, art would be an irrelevance, and all cul-tural hierarchies will be abolished.

UP WITH SEXUAL EXPERIMENTATION, AND FORWARD TO MIND-BLOWING ORGASMS!

109

MANIFESTO²

Charles Jencks

STAY IN THE MIND

There is something supremely ironic about writing a manifesto to order, and something even odder about writing it so late in cultural history, when that genre of programmatic literature is considered fairly dead. Few artists and architects indulge in this form of neo-biblical prophecy – partly because we live in an age of scepticism, partly because they have stopped believing in grand narratives, and partly because manifestos often sound like political posturing, self-parody.

The last problem is tonal. How can you be pithy and dogmatic – as are all good manifestos – and stay in the mind like a good slogan, without becoming predictable and boorish? One way is to memorise and orate it, since reading a script is death by obviousness. Another way is to shrink it to poetry, either a 4-line *haiku* or 14 lines of rhyming couplets with extraordinary metaphors that hammer into the brain as the jingo that won't go away. Alternatively, if it is a longer text, one might vary the tone, pen a mixed message and use any graphic supports, or nonsense, that can distract the critical mind while inserting the message. This, the self-reflexive version, a manifesto squared or to the second power, resists its own message while sending it with variable conviction. How does one accomplish this?

One way is to adopt a parodic irony that sends a message with one tone and takes it away with another, cross-coding the message like the nasty virus that, along with the poison, injects the desired genes. Having edited *Theories and Manifestoes of Contemporary Architecture* (with Dr Karl Kropf) and written the polemical introduction called 'The Volcano and the Tablet', I have little choice but to proceed with frenetic caution, with one foot on the brake and the other on the accelerator, knowing that manifesto prophecies – like those of Le Corbusier, Karl Marx and the Israelites – have the habit of coming true, and in a way that would have appalled their progenitors. Ruskin, like Le Corbusier, lived long enough to regret his words; Nietzsche predicted that someone like Hitler would abuse his.

All manifestos are explosive (like a volcano), dictatorial, unintentionally funny, very personal, and as one-sided as is this generalisation: may yours be cursed to come true. Mine is right and well-balanced, while yours is simply paranoid, in the sense that the idiot-savant Salvador Dalí proposed the critical-paranoid manifesto as the way to success. According to Dalí, the great leaders Jesus, Hitler, Ford and Napoleon were all exemplary paranoids who successfully imposed their world-views on a supine world. (Note that personal insult, bizarre assertions, false logic and *tutoiement* are usual to the rhetoric; as Lenin said, 'You can't electrify the Soviets without frying eggs.')

Since the 1960s and the triumph of the neo-avant-garde, all of this has become well known, and not entirely thanks to Warhol's adolescent epigrams. It was also because the art manifesto became indistinguishable from marketing. In the 1970s, Commodore Saatchi came on board to announce it. In the 1980s, as the attention span of the neo-avant-garde approached 15 minutes, Jeff Koons and Damien Hirst followed suit. By the millennium, the latter announced to the world, through an *Independent* headline, 'An artist? – I'm a brand name.' But, of course, everybody knew it. Modernism, founded on the idea of cultural evolution, had in 30 years made its peace with *Hello!*, *Sensation* and the logic of marketing. It now invented the bright idea of devolution and the cult of celebrity. Soon, as Tracey was celebrated for her drunken ramblings, decline became the new progress. Again, everybody understood this truth, aired on BBC, and everybody hung their head.

And yet, bear a thought for the impoverished artist who has to get his name out there in a mediated world, or the architect who is not allowed to advertise. The manifesto is a clever way of slipping through the media firewall, and getting other people to amplify the message. It concentrates the mind on a few important points in a chattering world, where the only thing in short supply is column inches, and an audience that will listen. But 40 years as covert PR has played its tricks and led the manifesto to a shift. It has become more sophisticated and many-voiced. Hence, for instance, Robert Venturi's *Complexity and Contradiction in Architecture* of 1966 was put forward as a '*gentle* manifesto', the volcano capped by smoke detectors. It typifies the way everybody already knows that a manifesto is marketing.

Ours is the highest of all periods of Global Warning. Two years ago, everybody but Gordon Brown knew about the impending Credit Crunch (he might have listened to Warren Buffett, who announced it in 2003). Warnings have now intensified into screams. Global Warming has been drowned out by crashing banks. Thus the manifesto demands to be written and to be heard, the manifesto² which asserts the basic truths of the time, but with critical irony.

III

0 *Critical Modernism* – the unzipping of Purism, Constructivism and other MoMA-isms.

CRITICAL MODERNISM

What is the hidden truth of our time? That everybody is a Modernist, even Prince Charles is a Modernist, and especially those Fundamentalists who deny it. Why? First, as sociologists have long observed, because Fundamentalism is a typical form of Modernism. Second, because Anti-Modernists are just as much drawn into the global network as anyone else: their laptops and mobile phones are proof, their Nike terrorism is a sign of globalisation.

ı Everyone a Modernist – Iraqi War Dance in Modern Clothes.

They take on the logic of the system they dispute, the one that is as pervasive as the Credit Crunch. The philosopher John Gray showed in 2003, in *Al Qaeda and What It Means to Be Modern*, that the assumptions of Osama bin Laden and Funda-mentalists stem from modernity. Those who go to war end up sharing the means and ends of the enemy. Everybody is a Modernist.

Modernism, modernity, modernisation, the 3M's come together as a tight network, they cover the globe and leave little room for escape. The modern world, compelled forward by the impera-tive of continuous economic growth, is a juggernaut

with no reverse gear. Every obstacle put in its path – from the Club of Rome Report on the *Limits to Growth*, 1972, to the *Brundtland Report*, 1987, to the Rio Earth Summit, 1992, and the Kyoto Protocol, 1997 – is rolled over without a bump in the road. In spite of unmistakable signs – Greenland glaciers sliding into the sea – the juggernaut accelerates ahead, celebrating the prospect of the new, the melting lands of the Arctic Circle.

2 Arctic melts – black gold-rush starts. The ice retreat, a visible sign of global warming for 30 years, brings a catastrophic sea rise to the globe and new wealth to the Norwegians and Russians. The latter's Shtokman Field is the largest offshore gas reserve in the world. The rush for oil, new shipping passages, and the scramble for unclaimed territory by eight nations, shows the Modernist juggernaut ploughing ahead, come what may (After *The Times*, London).

The Arctic thaws? What an opportunity. Russia, Canada, America – go for it! Here is virgin territory, not entirely owned, full of minerals, waiting to be exploited. New gas and oil fields in the Barents Sea, new shipping lanes to make a fortune, new virgin fishing stocks waiting for the high-tech nets, even new tourist sites. Tourist hotels are now springing up on these melting coasts; in 20 years, the Arctic Passage will be the New Gulf; Goodbye, Dubai. Global warming? Why worry? Go North!

If everybody is a Modernist, the question becomes – what kind? The suffix is agreed, what's the prefix? *Cynical* Modernist?

HOW TO GROW SCEPTICISM

It is true that scepticism grows and grows like a runaway panic; it swells on lying, and today that means it is increasing at the speed of the Web. In the 1960s, the young were sceptical because of the lies about Vietnam. Today, top of Bush's indefatigable fibs about Iraq are the lies about American deaths.

3 *Bush portrait from US war dead*, 2004, anonymous
picture of the President, made from photos of
the first 1,000 Americans killed. The figure for
the 'excess' Iraqi dead, continuously suppressed
by governments, was estimated in 2006 by
independent experts at 655,000. Where denial
exists, Critical Modernism uses cool description.
(Artist unknown, circulated on the internet).

Britain is no better. According to YouGov
and other polls of February 2007, 16% of the British
people believed Prime Minister Blair was telling
the truth; which means that 84% thought he was
a fraudster. According to the YouGov poll, 50% of
the people felt that Britain had gotten worse over
the last year, and that the country would be a still
worse place to live in five years (without even
predicting the credit meltdown). The verdict?
Widespread disenchantment, private wealth and
public squalor, growing scepticism. By 2007, 84% of
the British accepted their leader as 'Tony Bliar', that
Blying was common, that Cash for Honours was
the norm. As the Russians know, scepticism grows
directly in proportion to lying.

Everybody is a Modernist, and most are
lying. The choice is clear: become either cynical,
or critical.

Jeremy Paxman, sceptic of *Newsnight*, cross-
examines the man who put in the winning bid
for the London Olympics. Was it not strange, the
angry Paxman intones, that this bid was economi-
cal with the truth, that the estimate sprawled from
£3 billion to 6 and then to 9, and all that lying was
done knowingly? 'Well,' came the explanation
offered up as the final word, 'we won, didn't we?'
That is the attitude of a government committed
to Blying. It makes the arts pay for the bread and
circuses. John Tulsa and those dependent on art
grants were not amused. Untruths about Iraq are
only the most public form of deceit.

The Credit Crunch turns liars into the great
comics of our time. Plato recommended the Big
Lie to demagogues, but didn't predict this would
become global, especially among democracies.

Take one conservative President of the USA in
2000, committed by campaign promises to shrink-
ing the government; and what does he do? Spend
more money, which the government leverages
from China, to create the biggest state bonanza
(and debt) in the country's history. Republican
ideology against socialism and in favour of fiscal
responsibility ends in state bailouts that Roosevelt
would have envied.

4 Meltdown, the classic face of our time. (Cover of
The Financial Times, 15 October 2008.) As journalists
pointed out, Hank Paulson, like Oedipus, caused
the very tragedy he sought to avoid by nationalising
Fannie Mae and Freddie Mac – thus panicking
stock-holders around the world – and then letting
Too Big to Fail (Lehman Brothers) go bust.

It culminates in one farce, suitably titled
Fannie Mae and Freddie Mac, plus an $85 billion
rescue of the insurance giant AIG. How can we
visualise this stupendous amount? What do nine
noughts look like? If dollars were years, that figure
would be six times the age of the universe. To
expunge the toxic debt, mortgage-backed securities
that smelled like mustard gas, Bush upped the ante
to $700 billion (that is, eleven noughts). Conserva-
tive belief in free markets and small government
really meant 'Too Big to Fail', or as other comics
put it, 'Socialism for the rich, and capitalism for
the poor.'

British Labour proved, with the Prudent
Iron Chancellor, not to be outdone, and even
funnier. Attacking Boom and Bust with vicious
gusto, he then set out to destroy the economic cycle
once and for all. Private debt is good for you, and
also for banks, who were encouraged over his reign
to leverage themselves way above their usual ratios,
reaching an average of 33 to 1. Between 2000 and
2007, the Iron Man urged ever-greater mortgage-
backed securities, and they duly rose from £13
billion to £257 billion. If pounds were years, that
last figure would be 19 times the age of the universe.

But these are piffling amounts when you want to kill off the economic cycle for all time, and so the London hedge funds were enlisted with their trillions, many times the spending power of Britain plc. An arms race of national debt versus private debt ensued. Mortgages at 125% the value of a house were supported; in ten years, Labour jacked up personal debt by 70%. Regulators were told to look away. By 2008, the state spent £262 million every day just to service the debt. When the crunch finally came in September 2008, the Iron Man pulled out the stops and told everyone – what else? – there was only one solution left. Spend and spend, and bring the cycle to an end. Economic Shock and Awe: mortgage the future, the next generation too, so that damnable Boom and Bust never comes back. It worked: our children's children will be broke forever.

THE ANGRY SERENE

Return to Blying, and its effect on the wider culture. When 84% of a country believe its Prime Minister is loosely connected to the truth, then scepticism becomes the habit of mind, the reigning style. Such moods change art and architecture. Since *Look Back in Anger* and the Angry Young Men of the 1950s, since Francis Bacon's characters writhed in cages and Brutalism dominated the housing scene, since, more recently, Martin Amis and Damien Hirst, the art of anger has become the default option written on every face. With Brit Art, it is as conventional as, in the 19th-century novel, the blush on the virgin's cheek. The implications are clear for Critical Modernism. If chronic problems with modernisation can be assumed, then a seething anger will pervade the population. But the critical will not be the choleric. Twenty-four hour fury is not an option. The sustainable style is not the Rage of Achilles but the Classical Frigidaire, the Angry Serene.

5 *The morph of anger*, from Koolhaas to Herzog to Zidane, the glacial cool becomes the face of the time.

How to prove this? Look at the public face of the typical celebrity; look at Rem turn into Herzog and then into the head-butting Zidane. What do they have in common? The professional inability to say 'Cheese'. Look at the sullen face of Damien, as conventional as the scowl on a hoodie. Though it tells lies, the face does not lie in the same way as the mouth. It brands the art. Damien Hirst adopts the Angry Serene in his best work, his 'crucifixions of nature' (flayed sheep on the cross), a comment on a previous anger, that of Francis Bacon. The rage of Achilles, the wrath of Zeus, the fury of Medusa, the rants of Hamlet – all are too histrionic. Today the American artist Brian Tolle is ultra-cool in his depictions of a country divided into the blue and red states. Angry Serene: simmer and boil, but don't lose your cool.

6 Brian Tolle, *Die, or Join*, installation ICA, Philadelphia, 2006. A two-headed snake, in blue and red segments signifying the division between liberal and conservative states, on occasion snaps together signifying war. The snake's moving shadow also maps out the shape of America's coastline – a content-driven work, critical of the political scene. (ICA, Philadelphia)

Berlin is the city where Critical Modernism has developed the most, because there Modernism has destroyed the most. The Chinese artist Cai Guo-Qiang is invited to comment on this history. He creates a composed response to the terrors of modernity: 99 ravenous wolves jump across space – the ultimate image of herd mentality – and hit the glass wall. Gunpowder is used to create controlled explosions, channelling the angst into the blast. As if to underline the composure of the rest, Cai gathers a crowd of well-heeled onlookers into a gallery courtyard. He places stencils of wolves on a huge canvas, sets off a controlled blast, then displays the blackened silhouettes as if they were art works lifted from the cave of Lascaux. They are raw and primitive but, like photographs, distanced and unruffled. The Angry Serene gets its charge by presenting nastiness with tranquil professionalism. Renaisssance *sprezzatura* is emulated, making the difficult look easy.

7 Cai Guo-Qiang, *Head On*, a three-part installation at the German Guggenheim, Berlin, 2006. A wolf pack leaps to the attack, only coming to its downfall when it hits the glass wall. The drawing (above) *Vortex* was created by detonating varieties of gunpowder (seen in the explosion) below stencils of wolves, thus giving the ghost image of a prehistoric cave painting. The 99 life-size wolves were constructed from painted sheepskins stuffed with hay and given marble eyes. (C. Jencks)

CROSS-CODING WITH NATURE

So it goes in Berlin, a city built on catastrophe and dragging a critical art from it. There are the monuments to war and occupation, the two prominent Holocaust memorials by Daniel Libeskind and Peter Eisenman, and the paintings and sculpture of Anselm Kiefer. These take on such events as a departure point for something moving, aesthetic and symbolic. The Germans have debated their recent past in the Bundestag and allowed the unwelcome facts of recent history to be remembered and turned into a descriptive and indexical art. Right in the heart of their parliament dedicated to the *Volk* are Russian graffiti preserved behind glass. These curse the Nazis and Germans, and their preservation shows that denial and lying need not always dominate public discourse. In many corners of the city, a style of acknowledging the modern past is emerging, displaying the facts without rhetoric. Eisenman's Memorial to the Murdered Jews of

Europe is characteristic. Abstract, descriptive and neutral, it calls on the ubiquitous white cube of 1920s Modernism, but, in Berlin, to symbolise the dead, the cubes are grey and shaped like graves. That makes the modern cliché into the ironic iconic – something semantic – gives it a spiritual role more than its meaning as the aesthetic of emptiness.

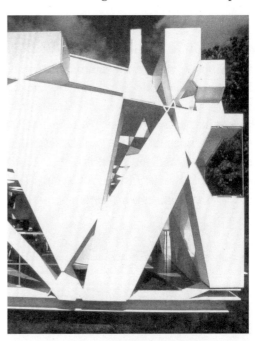

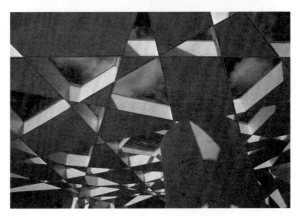

115

8 Toyo Ito and Cecil Balmond, *Serpentine Pavilion*, London, 2002. A clear use of a simple algorithm to generate a beautiful structure. This is modified in colour, size and shape to capture its natural green and blue setting in a striking way. (C. Jencks)

The critical approach stems as much from the complexities of contemporary life as it does the calamities. Hence the canonic works of Critical Modernism include the complex buildings that have emerged through algorithmic design. A case in point is Toyo Ito and Cecil Balmond's 2002 Serpentine Pavilion. It is the answer to Mies van der Rohe's Barcelona Pavilion of 1929, a sign that marks the difference between the Old and Critical Modernism. Ito and Balmond show the new fractal geometry of nature, forms that mirror the processes of the cosmos. Generated by the algorithm of an expanding and rotating square, this simple formula is allowed to create a complex geometry in plan, elevation, section and detail. Just as the simple formula of the Mandelbrot Set, $z=z^2+c$, creates a unified form of variety, a symbol of nature's complexity, so too does this rotating square.

9 Charles Jencks, *Universe Cascade*, 2001, an iconography, derived from the story of the universe, starts at the base in murky water, the unseeable and unknowable, and rises up in zigzags over 13.7 billion years to reach a look-out at the top. This has a fountain depicting the collision of the Milky Way and Andromeda galaxies, certain to happen in 3 billion years. The cosmic view is the comic view that puts our regional problems in perspective.

Today, computer production makes the generation of complex artefacts much cheaper. For buildings and complex art works, it encourages the mixing of algorithms and permits them to be cross-coded with nature. The computer is both a microscope and TV screen, opening up new views of the world. It allows us to follow a single cell splitting in two, to celebrate the emergence of nature in real time. We are the first generation to be able to rewind the film of the universe and watch the cosmos evolve over its 13.7 billion years to the present. This leads to a new understanding

of time, a new relation to the rest of nature. Through the grasp of feedback, it reveals the patterns behind the crash of stock markets and the mess of the credibility crunch. The computer allows these insights into nature and culture; but much deeper is the thinking behind it, the motivating ideas emerging, the understanding that complexity sciences and the narrative of the universe structure identity. These are leading to a new iconography. As in Berlin, it is an art that depicts both beauty and catastrophe, denying neither. It is also an idea that places the evolution of culture within a critical space. Thus, when it comes to nature and our identity, it is sceptical of both Old Modern metaphors based on the Pentagon – 'the Selfish Gene, Big Bang, Wimps and Machos' – and New Age metaphors based on sentiment. It is sceptical of Wars on Drugs and Wars on Terror. Scepticism is its default mode, its reverse gear. And its accelerator is the larger, cosmogenic view, one that sees the parts of the universe in a process of constant growth and death, as a continuous, creative, unfolding event, an emergent narrative still underway. Cosmogenesis gives the larger picture, frames the perspective against which local events occur. As religion used to do in the past, it gives both a cosmic and comic distance, one that allows a critical temperament to develop in serenity – anger without rancour.

TWO SIDES

But the critical is not the creative; it is on the wrong side of the brain. You cannot inspire action with a critical temperament, scepticism does not persuade people to be creative any more than an angry architect persuades a client to take a risk or invest in beauty. The critical outlook, so normal and inevitable in our time, needs a complementary force, an oppositional character, and that is also supplied by the other side of the global condition, the interconnected economy.

And today this economy turns everybody into a Modernist, even Prince Charles and Osama bin Laden. Reluctant though they are, they still phone home on the mobile telephone and invest in various countries; they operate through the Web and appeal to the masses on TV. There are even positive results in this pervasive condition. Modernism over the last 200 years has grown from the Romantic rebellion, and hope after industrialisation. As apologists remind us, it is dynamic, progressivist, open-minded, optimistic, risk-taking and forward-

116

looking. It is also, of course, obsessed by change, forgetful and lacking perspective. Today modernisation is particularly Chinese, headed for the melting Arctic and recently located off the coast of Dubai. So it's a breath of fresh air and foul, the global duality, like it or not. But Modernism, the suffix of our time, desires and needs her opposite, she yearns for a fitting prefix – the critical – a consort without whose help the whole affair will come to a toxic end.

> *Critical Modernism is contradictory things*
> *Welcoming growth while taxing carbon*
> *The* Stern Review *plus Nordhaus critique.*
> *It is romantic love minus illusions*
> *Contrary enough*
> *To acknowledge the Holocaust (without*
> *denying Palestine)*
> *A surprising art that cross-codes cultures*
> *with nature*
> *A cosmic perspective that makes the world*
> *look comic*
> *When it Blies.*
> *Critical Modernism is the sound of one hand*
> *clapping, the other waving*
> *Critical Modernism, as Rem has said,*
> *is a tautology turned into an oxymoron*
> *Anger tempered by hope*
> *A Sceptical Science of laughter.*

10 The Critic Laughs. Bush sinks, the Leviathan shakes the Burj Dubai, Petrodollars fall from the sky, the Furies Smile, the Hydra of Truth shows the follies of Bigness, while Cerberus critiques the follies of Power. But hold, is Bush sinking or rising? The crash in the $$$$$$ is the quickest way to pay off the trillions in debt. The US-of-Oil now has five large military bases in Iraq set around the pumps. It has control of the $30 trillion in black gold reserves. Who has won, who has failed? (And who has lost a nation, and who are the 655,000 dead?)

SNOW WHITE

Terence Koh

DEER MRS FUTURE

I AM KNOT YOU

I AM A BLUE OF A DEER

I AM A KNIFE OF THE STAR

I AM THE SUMMER OF HOLE

I LONG FOR LOVE FOR ETERNITY

I SING LIKE A FLOWER MOON

I AM FOREVER STUNG IN RAIN

I GRACE MYSELF ONLY TO YOU

I DIE NO BIGGER THAN ANT

I AM LIVING IN THE UNDERGROUND TREE

I AM YOUR LEFT HAND IN DARK

I AM SINGING DEATH TO EYE

I AM EYE

I AM FUTURE I

I AM ALWAYS FIGHT TO SEA

I SEA KNOW THE LIVER OF YOUR OUR HEART

I AM RAINBOW

I AM CLOUD OF RAM

I AM CRYING OUR

I AM OUR OUR OUR OUR OUR OUR OUR OUR

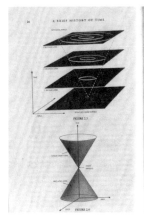

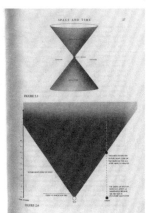

YOUNGER AND STRONGER MEN

(Excerpt)

Silvia Kolbowski

SPEAKER I We drew near to the snorting machines and caressed their burning breasts. For they are nourished by fire, hatred and speed! When we are 40, let younger and stronger men than we throw us in the waste-paper basket like useless manuscripts! We are not out of breath; our hearts are not in the least tired.

SPEAKER 2 Indeed, daily visits to museums, libraries and academies (those cemeteries of wasted effort, Calvaries of crucified dreams, registers of false starts!) are for artists what prolonged supervision by the parents is for intelligent young men, drunk with their own talent and ambition.
> *8. We are on the extreme promontory of the centuries!*

SPEAKER I We are already living in the absolute, since we have already created eternal, omnipresent speed. But we shall not be there. We heard only the muttered devotions of the old canal, and the creaking of the arthritic, ivy-bearded old palaces until suddenly we heard the roar of starving cars beneath the windows. No reason to die, unless it is the desire to be rid of the too-great weight of our courage!
> *1. We want to sing the love of danger, the habit of energy and rashness.*

SPEAKER 2 And yet, we had no ideal Mistress stretching her form up to the clouds, nor yet a cruel Queen to whom to offer our corpses twisted into the shape of Byzantine rings! Then I flung myself like a corpse on a bier, across the seat of my machine, but sat up at once under the steering wheel, poised like a guillotine blade against my stomach. The oldest among us are not yet 30 years old – we have therefore at least 10 years to accomplish our task. As soon as I had said these words, I turned sharply back on my tracks with the mad intoxication of puppies biting their tails, and suddenly there were two cyclists disapproving of me and tottering in front of me like two persuasive but contradictory arguments.
> *5. We will sing the man at the steering wheel, whose ideal axis passes through the centre of the earth, whirling around on its orbit.*

SPEAKER I *9. We want to glorify war – the only cure for the world – militarism, patriotism, the destructive gesture of the anarchists, the beautiful ideas which kill, and contempt for woman.*

SPEAKER 2 A crowd of fishermen and gouty naturalists crowded terrified around this marvel. Heap up the fire to the shelves of the libraries! Their stupid swaying got in my way. What a bore! I stopped short, and in disgust hurled myself head over heels in a ditch. Of course!

SPEAKER I We drove on, crushing beneath our burning wheels, like shirt-collars under the iron, the watch-dogs on the steps of the houses. Oh, maternal ditch, brimming with muddy water! A factory gutter! I gulped down your nourishing mud, which recalled the black breasts of my Sudanese nurse! To admire an old picture is to pour our sensibility into a funeral urn, instead of casting it forward with violent spurts of creation and action.
> *10. We will destroy all museums and libraries, and academies of all sorts; we will fight moralism, feminism and all vile opportunism and utilitarianism.*

SPEAKER 2 Public dormitories where you sleep side by side forever with beings you hate or do not know. We know just what our beautiful false intelligence affirms: 'We are only the sum and the prolongation of our ancestors,' it says. Here and there, unhappy lamps in the windows taught us to despise our mathematical eyes. 'Smell,' I exclaimed, 'smell is good enough for wild beasts!' Then the silence increased.

SPEAKER I *3. Literature has up to now magnified pensive immobility, ecstasy and slumber.*
We want to exalt movements of aggression, feverish sleeplessness, the double march, the perilous leap, the slap and the blow with the fist. We are going to be present at the birth of the centaur, and we shall soon see the first angels fly! At last, mythology and the mystic cult of the ideal have been left behind. What does it matter? Museums, cemeteries! Perhaps!

120

SPEAKER 2 What is the use of looking behind at the moment when we must open the mysterious shutters of the impossible? There is no masterpiece that has not an aggressive character. Time and Space died yesterday. A great sweep of madness brought us sharply back to ourselves and drove us through the streets, steep and deep, like dried-up torrents. Divert the canals to flood the cellars of the museums!

SPEAKER 1 Your objections? All right! I know them! Here they are!

> *7. Beauty exists only in struggle.*

SPEAKER 2 And strong, healthy Injustice will shine radiantly from their eyes. A racing automobile with its bonnet adorned with great tubes like serpents with explosive breath… a racing car rattling along like a machine-gun is more beautiful than the Winged Victory of Samothrace. For the dying, for invalids and for prisoners, it may be all right. It is, perhaps, some sort of balm for their wounds, the admirable past, at a moment when the future is denied them.

Do you want to waste the best part of your strength in a useless admiration of the past, from which you will emerge exhausted, diminished, trampled on?

SPEAKER 1 The oldest among us are not yet 30, and yet we have already wasted treasures, treasures of strength, love, courage and keen will – hastily, deliriously, without thinking, with all our might, till we are out of breath.

> *4. We declare that the splendour of the world has been enriched by a new beauty: the beauty of speed.*

SPEAKER 2 Alone with the engineers before the satanic furnaces of great ships, alone with the black phantoms who ferret in the red-hot bellies of locomotives, alone with the drunkards beating their wings against the walls.

> *2. The essential elements of our poetry will be courage, audacity and revolt.*

SPEAKER 1 Does this surprise you? Do you want to poison yourselves? Do you want to rot? But we will have none of it, we, the young, strong and living! But to take our sadness, our fragile courage and our anxiety to the museum every day, that we cannot admit!

SPEAKER 2 We all started up at the sound of a double-decked tram rumbling past, ablaze with multicoloured lights like a village in festival dress, that the flooded river tears from its banks and sweeps through gorges and rapids down to the sea.

SPEAKER 1 *6. The poet must spend himself with warmth, glamour and prodigality to increase the enthusiastic fervour of the primordial elements.*

It rose slowly leaving in the ditch, like scales, its heavy coachwork of good sense and its upholstery of comfort. Take the picks and hammers! Undermine the foundation of venerable towns! For art can only be violence, cruelty, injustice.

SPEAKER 2 *11. We will sing of the stirring of great crowds — workers, pleasure-seekers, rioters — and the confused sea of colour and sound, as revolution sweeps through a modern city. We will sing the midnight fervour of arsenals and shipyards, blazing with electric moons; insatiable stations, swallowing the smoking serpents of their trains; factories hung from the clouds by twisted threads of their smoke; bridges flashing like knifes in the sun; giant gymnasts that leap over rivers; adventurous steamers that scent the horizon; deep-chested locomotives that pour the ground with their wheels, like stallions harnessed with steel tubing; the easy flight of airplanes, their propellers beating the wind like banners, with a sound like the applause of enthusiastic crowds.*

SPEAKER 1 Nothing equals the splendour of its red sword which strikes for the first time in our millennial darkness. It has been too long the great second-hand market. We want to get rid of the innumerable museums which cover it with innumerable cemeteries.

We have been up all night, my friends and I, under mosque lamps whose filigree copper bowls were constellated like our very souls, because like them they were illuminated by the internal glow of electric hearts.

SPEAKER 2 'Let us feed the unknown, not from despair, but simply to enrich the impenetrable reservoirs of the Absurd!' All right! Take care not to repeat those infamous words! Instead, lift up your head!

SPEAKER 1 All right! Take care not to repeat those infamous words! Instead, lift up your head!

FAITH IN INFRASTRUCTURE:
AN ERRORIST MANIFESTO

Hilary Koob-Sassen

Ladies and Gentlemen, I am an Errorist.

I announce my error. In exchange, I ask for liberty – to practise being in time. Being-in-time-terror has a suitably slow-rolling and tepid name: Global Warming, Finance Crisis. Such tepid names are dangerous, but us Errorists, we are Syntactical Elaborationists, here to give it a *new name*.

Durability is traction on change. It is a measure of how closely the momentum of a structure's change navigates the actual contours of reality as they unfold – in the ever-passing-mo – A genome undergoing natural selection is like a phrase constantly trying to name reality more accurately. 'Adaptation' is the successful inclusion of experiences into that range of reality to which a lineage of creatures can respond.

With the accumulation of shit, the artificial residues of life create evolutionary feedback, favouring the development of a materialism.[1] Materialism's creature builds structures, and then adapts to them. Eventually, the creature comes to fit so perfectly to the built structure that its success relies less upon the genetic evolution of its own body than upon the material elaboration of these built external organs.

Elaboration moves along when structures subside from direct experience to a position of foundational relevance. The aqueducts have disappeared – we have faith in subterranean pipes. Upon this faith, we buy a house. Upon this faith, we live in New Orleans. An evil experience is the same for the living and the built: the floods were outside of that range of reality to which the structure could respond. The levee breaks, and no hidden capacity reveals itself: no preternatural burst of adrenaline allows the slipping deer to spring to a foothold – no particularly well fashioned piece of levee exceeds its nominal strength and endures. No response. These two syntaxes – genetic and materialist – must name reality faster than it changes. Otherwise, reality deletes them.

The Elaborative Trajectory from *economies* to *organs* is paracultural – it advances across the lifetimes of many cultures, in the same way that evolution advances across the lifetimes of many creatures. Life builds and climbs its paracultural ladder up and out; Life seeks a divinely realistic structural solution to the constraints inherent in this scale of reality. Life seeks the exit of the cave, to pierce the scalar pellicle and deposit itself outside – naked and quivering and blind and alone – on a new landscape of possible formations.

These attempts are almost certain to fail. And yet, the five instances of success – the five instances of a culture of one scale successfully attaining the next – these are the five major punctuations of biological history. In the original big mineral mud puddle (between the mountains), a culture of replicating molecules arranged itself into the first virus. The rampant protein-trading of a virus culture finally formalised its capital city into the first ever bacterium, and today a virus can't really live outside a city. Amidst the heightened diverse exertions of a culture of bacteria – orgiastically plunging in and out of each other – the origination of single cells with organelles. After not so many millennia of refining and specialising economy in a place, a culture of single cells managed to carve their place into a body and become the first multicellular organism. Each of these opened up a new terrain for life, a new scale of biological complexity.

Cultures of all scales follow a historical template to a predictable outcome. Once a foundational traction on time is established, Life scrambles to pile up an ascent to traction on scale. Life tries to leap from the pile before the changes brought about by the pile-up conspire to bring the pile down. The further the elaborating culture structure or evolving body cantilevers out from a foundational capacity, the more susceptible to foundational change it becomes. The power of high elaboration lies in its ability to abstract – in its capacity to attend to non-foundational things – precisely because it has placed so much faith in its foundation. For a highly elaborated culture structure, there are only three responses

to a collapsing faith in foundation: anticipatory reversion to rudimentary form, death in abstract splendour or an attempt to exit the cave and be the birth of the next scale. To hold that fruiting end-point present to the mind, present to the highest abstract power of culture. Present, perhaps, to the arts.

Before 'Organific Economics 101' and 'How to Be Paracultural', it is extremely important for me to refresh my Errorist credentials and for you to sharpen your criticality to an axe-murdering edge. I long for that chop. For I am in no way convinced of what I propose, though very committed to proposing it. For proposal is to culture what mutation is to creature: often dull, rarely harmful, and every now and then it is just what we need – the fancy curved beak to suck the nectar out of the flower better.

So, how do we become paracultural? How do we take on the trajectory of life, consciously as our own? I propose an exit from the Latin mass of biology. I propose this curvaceously updated old god Life. We need a new word game and a direct relationship with the godmaths.

We must not confuse development and origination. To say a nation develops is to imply that a highly perfected map of a final fruiting structure exists within that nation – that it merely awaits the set of experiences, a mother, which would allow it to unfurl its perfection. In actual fact, the main work at hand is to find out what, if anything, could be astutely considered analogous to DNA – to its syntactical structure and to its meaning.

I will tell you what I think, almost definitely wrong: no structure song is complex enough to be sung into world body, except the standard human system of organs. In that garden, four billion cells sing in schizophrenic unity – a single human consciousness. That system is the only song complex enough for us each to sing it together. The translational diversity of our minds. The universal sameness of our bodies.

Maybe.

But definitely and for sure, embryonic development is not evolution. It is a highly refined process-product of evolution. And again, no guide to where we stand. Furthermore, evolution is over. Its time frame is so slow that it is no use to us. We are agents of extinction, but not of evolution. Far beyond all else, we are agents of elaboration. We are practising and building a world body around ourselves. The first body of that scale.

We are a scalar leap in complexity from the cell culture that built the first body. And yet, that is our closest analogy.

We must embrace the messy process of becoming – of first origination – and forget all ideas that the world is a fully evolved thing in some stage of embryonic development. Instead, let us say, 'The nation state system *is like* a proto-organ insofar as it is a universally inclusive structure. As the organs of a body are universal to its cells.' We must be rigorous in our science and also in our poetry. We must be pious and poetic scientists, performing exegesis on the analogy map of the experiences of other scales of culture. We must seek to be like the five cultures that pushed their art across the threshold between the built and the alive.

Humanity stands inside a framework of its own creation. We have sung this paracultural ladder into existence. From a spore; from a way to navigate reality and unchanging endure planting, irrigation and harvest. To a bridge; a materialism which supports the procession of humanity forward through time and changing hegemonic formulations. And now we have come to a more open place, where things shake and start to break. We put our faith in multiplication of a new kind of structure: the Web, the market and the bubbles. The bubbles, which are like an unsatisfied hunger. The bubbles, which long to be cathedrals – to be proper investment vehicles. In elaborating global economies, we evoke *world organs*. How do we sing them into structure?

Bailing-out banks, sandbagging levees and subsidising ethanol must be characterised as 'thrashing about' – an attempt to surmount an evil experience by rampantly generating small proposals – in the hopes of developing a response. We must move from pushing sugar into overloaded liver and set out to formalise some lovely kidneys – solar seas and roiling greens. We must be Organific Economists seeking out new systems in the Pattern of the Plans, advancing the trajectory onward from economies into organs.

For example, the Web is a global – but not universal – economy of information. It evokes a world organ of meaning: the super-nucleus of a rampant design democracy. A spherical digital Google cathedral earth map mosaic – flipped outside-in. Inside eight billion humans' incarnations are surveying the entirety of what could be. The overlapped transparencies of all humanity's dreams. So difference is detectable, though

123

majority creates a denser line. Our syntax octopus of proposals and our pattern of the plans replaces the lack of plan and the invisible hand. With a higher-resolution name. High resolution in the sense of high informational density and, in the sense of inspiring, resolve to act. That is the organ that our unfinished Web economy seeks to be. It is natural, but not inevitable.

Organific Economics Equation 101 allows us to assess the GLD:

The durability of a creature or a culture – or indeed the durability of all of Life itself – the horsepower of its traction on change – the speed with which it advances into future experience – Life's durability is a function of the efficiency of its experiential metabolism and the domain of its activity.

Life's metabolism: its capacity to translate an experience into a foundation for further experience. How quickly and how *absorbently* – to how many of its constituents. *To how much of itself can Life present the opportunity* to know an experience, develop a structural response, and then move that structure on down into the faith zone.

X multiplied by X

Life's Domain: the breadth and depth of matter to which and with which Life can develop a response. How realistic is Life's picture of reality, and how realistic is its materialism. Can we sculpt atoms, molecules, life forms, planets… just about. Our over-cantilevered bridge cannot support a response to the warming waters below. It cannot frame the sky as organs. It suffers an unjustified faith in infrastructure.

We must hope that we cannot design the world organs themselves; we must pray that they will be too complex. We can only build a structure to support them, and leave the sky open, for their growth-explosion. We can trans-form our bridge into a trellis – a *Rankgitter* – a growth grid. We can switch from procession through TIME to an inhabitation of the MTIE, the economies of preparation for the next scale – the Multiple Transnational Infrastructure Economies. We can cease to *progress*, and shift to preparation for *ascent*.

With our ancient-extracted, refined and recombined *modernista materialismus*, we can build the structures that will support the *new* materialism. The materialism of a garden of organs on earth, which will be lush if we provide it good handholds for ascent. We must be furious builders of structures, which scream NO to progress as such. That are steady machine-gun-perfection tempered-steel bridges that are forever. That Life can get to know like bones and grow around. Life seeks to mount the built trellis, to climb up and out into the cosmos. It seeks to climb the square god of culture and manifest the next round god of life.

Life seeks to bring all of itself into itself – into its experiential metabolism. Life seeks the Mental Jordan genius who is starving in a desert. Life screams for her to help it explosively reorganise the moon. The moon – that ancient image of the exit of the cave. Life longs to devastate its simplicity with rampant green complexity. To unleash its viral hordes onto the helpless dust of Venus. To suck the iron out of Saturn. If we are to be paracultural, that is the holy war we must take up. Sneaky Life launched its attack in a province of the cosmos. Sneakily, it worked a space between the atoms and the planets. And now through We, so super-fancy – a frilly life fractal complexity. We must dance out on the palate of the desert; We must dance the lack of life into complexity. We must finally conquer this damned shifting stone, which threatens to chuck life off like a clinging skin, to rub it off on the sun. We must conquer the world for life and claim its next domain!

1 F. John Odling-Smee, Kevin N. Laland & Marcus W.Feldman, *Niche Construction* (Princeton, NJ: Princeton University Press, 2003).

THE ERRORISTS

FAITH IN INFRASTRUCTURE

The manifesto describes the concepts and intention of a multi-media artwork called
Faith in Infrastructure. The work is about the secret of biological complexity. In
the artwork, the proposals are organized as a landscape:

Life is a worm building itself in time. The very front end of the worm is the
present moment; the long body stretching back to a tiny point is the history of life.
The string of soil at the center of the worm is the replicating molecule.
The worm builds itself outward in layers from this genetic syntax.
Each additional layer of tube corresponds to a new scale of biological complexity
in which the simpler scales are nested as living infrastructure.
Life gains a new scale of complexity when the creatures of one scale build
an infrastructural trellis, which can support the logic of life at the next scale.
To reveal the conceptual contents of such a model of life, we must cut into it:

The sculpture (PICTURED ABOVE) models a 1/8th slice of the worm. We name it Filletville.
It is filleted along time to show the epoch of the 5th scale:
the first instance of organism, its evolution, and the elaboration of its artificial
structures. It is chopped across time to show the nested strata of the 5 existing
scales of biological complexity and the infrastructural beginning of the 6th..

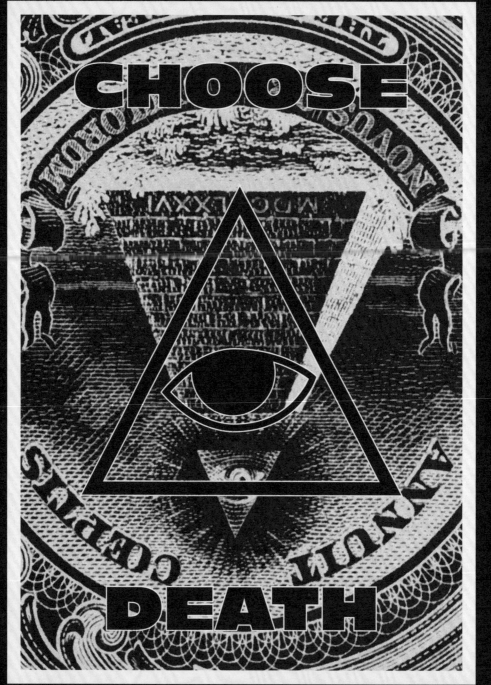

126

CHOOSE DEATH

Existentialism discovered the possibility to kill oneself as mankind's ultimate freedom – accessible even under the most devastating circumstances. Today, medical progress has turned dying into a long-lasting procedure, and in the future it might be never-ending. Death isn't natural any more. Waiting until all medical treatments finally fail is hardly affordable and little fun. To kill oneself is no longer just an option – one that's still illegal in many countries – but an essential element of a decent lifestyle. To choose death is a modern necessity. It's only a matter of when and how.

Choose Death originated as a faction of the Great Pyramid, evolving from a slogan coined by Ai Weiwei's architectural office FAKE Design.

CHOOSE DRILL

Throughout history, human beings have increasingly taken fate into their own hands. They had a hand not only in land and machines, but also in themselves. This they could do over and over in a new way or react to a specific constellation with an ever-constant, unconsciously performed behaviour. The most rigorous technique for bringing this about consists in an ever-constant, but still conscious, repetition of the behaviour and is known as 'drill'. With 'drill', man can systematically expand and update his repertoire of instincts. This is not possible for animals. They can learn, but quick repetition is taught to them either by way of coincidence or a trainer.

In their history, people have also, for the most part, only ever been trained by others. Drill introduces people to a clear-cut ideal that transcends the individual. Already as a child, because that is when the desire and ability to learn are the strongest; later in professions that presuppose absolute obedience, particularly that of a soldier.

Drill is used only with reservation in the Western world today, as one finds discomfort in every irreversibility. No one wants to age, and death is crowded from consciousness. Even the transition to the hereafter seems too absolute; one would rather prefer be born again. After waiting out his punishment, the criminal is rehabilitated. Waste gets recycled. Marriage can be divorced. Nothing should stand once and for all, but it also shouldn't just disappear again. The ideal situation is total contingence. Anything is possible, which means that it becomes real as soon as one wants it to be.

Machines already do enough to satisfy all of man's basic material needs. And yet he is not prepared for a constant, full supply. Either the feeling of satiety isn't strong enough, and one is greedy for too much, or one gets lazy and bored. To emotionally profit from the performance of machines at all, one either has to constantly spur oneself on or keep it in moderation.

Should one seize control of oneself in this way, then one is already someone else. To produce a sustained effect, you have to drill. Freely forcing oneself, however, is a paradox. One has to introduce a second level; the quotation marks stay visible. One is not really in the game, but with every intention.

If, in aestheticism, the artist or viewer becomes a work of art, one still continues to be confronted with the hardships of real life. With 'drill', on the other hand, it is possible to set all of life in quotation marks, even hunger and thirst. Because one is never just oneself. No longer does one believe, as one once did in psychoanalysis or scream therapy, in penetrating through to one's true self. One meditates without looking for a lost balance or centre. Finally, one no longer needs to be terribly stupid or ill to be compulsive. Even a–not necessarily lethal–human sacrifice is possible again. Instead of becoming bitter with increasing age–because one experiences obstacles, and objectives become unreachable–the chosen drill makes one sweet.

129

THE PLACE OF THE MATERIALIST WORLD IN THE UNIVERSE IS THAT OF AN EXQUISITELY BEAUTIFUL PRECIPATE OR VARIED CLOUD-WORK IN THE UNIVERSAL ÆTHER

Nick Laessing

John C. Bedini, *Device and Method for a Back EMF Permanent Electromagnetic Motor Generator,* US Patent #6,392,370

BH is Dr Bob Hieronimus, the host
JB is John Bedini, the guest

DR BOB HIERONIMUS Now, we've been brain-washed to believe that outer space is empty – there's nothing there. What's wrong with this theory?

JOHN BEDINI Well, what's wrong with the theory is that we are surrounded by an electrical gas which we can tap if we know how to utilise it. And during my many years of research, I've come to a very strange conclusion: that one must have something

like a trigger signal to tap this. And it's the same thing that Tesla said all along: that we must have these little impulses, and by utilising these little impulses, we can tap or cause the vacuum energy to enter our system, and then we can capture that. And that, of course, was shown at the Tesla Symposium in 1984 with the first machine –the Watson machine – which successfully produced 5 kilovolts in an on-stage demonstration.

After that, Bob, very strange things started to happen. James Watson disappeared two weeks after that; nobody could find him. It wasn't until

years later that we all discovered that James Watson had to take the buy-out to protect his family. On the other hand, I was forced into seclusion buying gasoline [*chuckles*], which is what everybody does.

So I never gave up my work – I continued on my work into the wee hours of the night, developing what I call the Monopole Motor or Monopole Energiser, which is on all the groups today. And what I wanted to do was bring forth a very small invention that showed exactly the type of energy we were capturing, and I wanted it to be as simple as possible, so that everybody working with it can grasp it and understand that it's not the so-called electron current that's actually making the system work. Of course, in the front end of the machine, sure, we're talking about a normal circuit which can be measured conventionally. But in the back end of the machine, we're talking about a Nikola Tesla system, which is impulse currents, the same thing Tesla was going to do in the 19th century to bring about free energy.

What I want everybody to understand about free energy is that free energy might be misrepresented, in a way – because you must supply something to get something out of it.
Are you following me?

BH Of course.

JB Nikola Tesla was going to use Niagara Falls to power his magnifying transmitter, but the Powers That Be said, 'Why should we allow this to happen when we can't measure it, we can't meter it, we can't make anybody pay for it?' So the brakes were put on Tesla, and he was discredited in all the books shortly after that. So what we have here is if we were to utilise Tesla's system and we were to trigger it, a very strange effect would occur. We would use these impulse currents, and they would go into the ground, and they would start to couple. Their vectors would start to couple. And you, by putting up a small antenna, or a coil that's in resonance with this transmitter, you could light your entire house from the system without paying for a thing. This is what I meant by saying that free energy has been misrepresented: something has to provide the trigger signal that is necessary to trigger it off.

BH But before we do that, there are a few other things I want to discuss so we get to dipoles and how they pertain to your monopole system. What are dipoles?

JB One example of a dipole is a storage battery, which has a plus and a minus pole. In other words, a dipole is something that has two poles, a positive and a negative. When we use a storage battery, we form a loop, and that loop connects one pole around and returns the energy to the other pole of the dipole. And, of course, if you keep doing this, if you keep going around and around in this loop, Dr Bob, what happens is that you kill the dipole. We don't want to kill the dipole. We want the dipole always to stand in a voltage potential. That is the dipole. So out there, throughout the whole universe, are all these dipoles. What we want to do is tap them without killing them. We want to keep their voltage potential as if they're not doing any work. Do you follow what I'm saying?

BH Yes, of course.

JB So what we do is we take a little bit, but we shut it off before the current can get all the way around the loop. By doing that, we prolong the dipole, but at the same time we're capturing energy from it. And our circuits have to be fast enough, and they have to be switched correctly to do this. There are dipoles in everything, you know, right down to water, down to whatever we're doing. We want to keep the dipole's potential strong. We don't want to force the dipole to collapse upon itself, because when the potential between the two poles falls to zero, it's not a dipole any longer. We're out of energy.

BH Because it seems the dipole is what is generating the energy?

JB Yes! Because space is completely filled with energy.

BH And dipoles.

JB Yes.

BH John, how does one go into the energy of this dipole and tap the non-equilibrium steady-state electromagnetic flow of energy? And not mess up the dipole?

JB OK, let's get into this a little bit. We accomplish this by the use of what we call a 'trigger signal'. It's on, then it's off – really quickly. It's like a little hammer. As long as you keep tapping this thing, you can capture the resonance, if you keep tapping and tapping and tapping and tapping and tapping.

131

So what we created was an unbalanced system in the front. We started with something that's known to everybody in the arts: a coil. We know that a coil is in perfect symmetry to start out with. Now I'll explain how we break the symmetry, using this concept by Lee and Yang. We add an impulse to the coil, but as soon as we add the impulse, we shut it off. This causes what you could term a 'hammer blow' to the coil.

BH So what does current have to do with energy?

JB Nothing at all! We want no current at all, because any time we allow current to flow through the whole system, we are killing the dipole. We don't want to kill that dipole.

BH Right.

JB We want to make the broken symmetry possible through a gating process. I'll explain it with an analogy. It's as if a little guy is standing there with a hammer. The little guy with the hammer is the potential; he's the dipole. We take a little bit of energy from the dipole to swing a gigantic hammer blow at the coil. This causes the coil's poles to vary between maximum electromagnetic flux and no magnetic flux. The zero point that's in the centre is like a window. We want to open and close the window. Opening and closing the window forms a pump for zero-point energy. Then when the zero-point energy enters the window, we tap a little bit off of it. That's the reason for the secondary (or storage) battery.

We don't want to force any current into the storage battery. Remember, the storage battery is a dipole with a lattice network of atoms and molecules inside. It's a network that can absorb this energy; that's why they call it a storage battery.

So the machine has a standard front end, working in standard, conventional physics. But we break up the standard, conventional physics by causing it to pulse with a unidirectional pulse.

Using only one pole, we make the machine do two things. First, the machine can put out mechanical output. Second, by pumping the window open and closed, the machine triggers the zero-point energy. Then we suck the energy out.

BH So we leave the dipole in static configuration with no current flowing through it, and that will radiate energy forever?

JB Right. Because, you see, when we add any current to the system, the radiant energy goes away. The vacuum energy disappears. It's no longer there.

BH So if we do this, it becomes a perpetual energy generator?

JB Absolutely. Once the energy is converted into a form that's usable, you're absolutely correct: it could become perpetual if the energy is transformed correctly from one source to another source. Charging a capacitor with the energy transforms it into the kind of energy that we know – real electromagnetic energy. When we discharge this capacitor, it has the current, and it has the voltage.

BH Is there any difference between electromagnetic energy and magnetic energy?

JB No, they're one and the same thing. Suppose we captured a lightning bolt's static electricity in a storage capacitor and then we discharged that storage capacitor to our load. That would be real energy, you see? Static electricity – something that's considered 'useless' – is now no longer useless.

In other words, if Benjamin Franklin had only figured out to discharge the Leyden jar to a battery, we would have had this a long time ago.

BH Well, it seems that a long time ago some other people knew about this…

JB Absolutely.

BH Now I want to get into what you have decided to do in putting your information online, and what that means, and why you did it. I want to spend our last moments on that.

JB Well, Dr Bob, I always felt, in my own mind, that everybody should know what energy is. Everybody should have this knowledge, no matter who they are, and if they need energy, they should be able to get energy for themselves.

It shouldn't be controlled. So what I did was in 1984 I published that first little book, and, of course, Jim Watson built that machine from that book, and they sort of suppressed that. Jim Watson was carried off into a foreign land and, of course, they told me to buy gasoline – and I did – but I worked on building something that everybody

could build. So what I did, when I got this thing to work, was to immediately publish the information. I put it on the internet.

The internet was just getting started at the time, so everything that I worked on and everything that I did I posted to the internet, because I felt that why should this be suppressed? People are either going to do it, or they're not going to do it. And, of course, they did; all kinds of groups were started, and people started building these machines, and, as I said, they're still continuing to this day. Out of all this, you know, we're going to have energy one day from this.

BH I have one more question in regards to all these individuals that got suppressed. How did the oil companies go about the suppression of these motors?

JB Well they had people canvassing for these types of devices, and what they would do is they would make you the one offer too good to refuse. And, of course, if you didn't take the offer, you ended up in a ditch somewhere.

And, they make it look like a bunch of hooey. When they couldn't accomplish it one way, they accomplish it another way, like they did with [the TV show] *MythBusters* with me, where they hired a college professor to build the machine, and, of course, the college professor left the coils and the magnets off, so why should the machine work?

BH Now where are you today, and what are you up to, right now?

JB I'm into making sure that the Monopole groups are running correctly. And I'm into giving out as much information as I can on the systems that we're building. And we're also, as you know, we're a public company, and we build chargers, we build battery chargers that use portions of this waveform and energy in the charging systems, but we limit that since we want to supply this energy to the battery. So let's say we have an electric vehicle, and the electric vehicle is getting 20 miles. We want to double that to 40 miles, so we allow the machine to double your mileage each time. That's what we're working on right now.

We're also working on solar systems that charge in the moonlight.

And we're working on battery chargers that can bring batteries back from what we term 'the dead', batteries that were not usable. The result is less lead going into the landfills, because we're able to use the battery again. I want everybody to know that we don't have to spin these big generators at the power plants to get energy. We can do this. We can actually make this happen.

BH Would you suggest that some of these individuals who are savvy about batteries and that type of thing make their attempt at building these?

JB Absolutely. I think everybody should experiment for themselves. We don't learn unless we experiment with something. This is not anything that I want to hide at all. I want people to build it. I want people to find out for themselves what this is.

BH Thank you, John.

133

JOURNAL OF ART & ART EDUCATION

No 17 1988

**john latham
ian macdonald-munro**

HOW, in A.D.1988, IS IT THAT HUMAN INGENUITY HAS BEEN UNABLE, FIRSTLY VIA SCIENCE IN ITS MANY FIELDS AND SECONDLY VIA BELIEVERS WITH THEIR VARIOUS CREDOS - TO ARRIVE AT AGREED DEFINITIVE FORMS WHEN, TO GENERAL CURRENT PERCEPTION THE UNIVERSE IS A SINGULAR PHENOMENON..?

134

IS THERE A BLACK HOLE

MEGATRUTH

AT THE CENTRE OF

THE 20C TRAJECTORY

...?

"If harmony in a society depends on the common integration of the "one", of the unity behind the multiplicity of phenomena, the language of the poets may be more important than that of the scientists."

Werner Heisenberg, Athens 1964

21 October 2008

Dear Julia Peyton-Jones,
Dear Hans Ulrich Obrist,

Thank you for the invitation and for the very efficient organisation of your 2008 *Manifesto Marathon*. I made a point of listening carefully to at least 80% of the other speakers and found some of them enlightening. Your mix of art, poetry, film, economics, sociology, architecture, performance and social criticism (absolutely vital to our survival) was indeed a collective work in progress of the kind that may, perhaps, counterbalance such man-made suicidal disasters as global planet destruction, credit-crunch capitalism, political and cultural imperialism, bird-brained art-market trendiness and entertainment industry merchandising. It was a real pleasure to partake in that tribal blast. Sorry to have had to leave in the middle of your discussion with Eric Hobsbawm whom I hold in high esteem (to catch my train). Would have liked to point out to him that, as a Marxist thinker, it was rather absurd for him (of all people) to speak of Marcel Duchamp's 'Urinal' in a derogatory and confusing way. Why? Because philistines and superficial journalists have forever treated that particular work in such a way (for instance, in a recent 'People' column of the London *Times* – 17 October 2008 – where it was suggested that the singer George Michael, who plans to open an art space in Texas and who has been arrested for cruising a public lavatory, 'perhaps will acquire Marcel Duchamp's famous urinal' (exact quote). This is where sleaze, TV evangelism and art criticism merge into one discourse).

135

In fact, in 1917 (a year after Eric's birth) Duchamp literally transformed a urinal into *Fountain* (that is the work's actual title) by positioning it horizontally (instead of vertically), by signing it 'R. Mutt' (horizontally) and by changing its designated name therefore its designated function. A urinal is a receptacle of liquids whereas a fountain emits liquids. So to continue referring in 2008 to a 'urinal' instead of seeing the conceptual fountain for what it has become, is to remain blind or unaware of Duchamp's dialectical transformatory activity. What a pity. I am not disputing Eric's right to prefer (as he stated in his introductory essay) Klee to Duchamp. This is not a matter of taste or preference; it is a matter of relating to the inner logic of each artist's work instead of aesthetic dogma. The manifesto of manifestos did make things clear once and for all: 'Our task is no longer to interpret the world, but to change it.' Let's not forget that this also applies to artistic activity. I'm sure Eric would agree that art, if it is to break out of the capitalist mould and away from it's 'normal' and 'authorised' role as a mere commodity, should involve the beholder's perception system as well as its underlying belief system and act upon them in a collaborative mode.

Perhaps we can continue this *Manifesto Marathon* discussion with you, Eric and others by email or otherwise.

With warm feelings and thanks,
Jean-Jacques Lebel

TOWARDS A FREE ART SCHOOL

Manifesto Club

ВИТРИНА САМОРЕКЛАМЫ

ФЭКС ФАБРИКА ЭКСЦЕНТРИЧЕСКОГО АКТЕРА

ЗАНЯТИЯ ВЕДУТ:

Ю. Анненков. Н. Н. Евреинов. А. Каплер. Г. Козинцов. Г. Крыжицкий. А. Лурье. К. М. Миклашевский. С. Митусов. А. Орлов. Н. Пунин. А. Серж. Такашима. Н. И. Тамара. В. Татлин. Л. Трауберг. С. Юткевич и др.

ЭКСЦЕНТРИЧЕСКИЙ ТЕАТР

В РАБОТЕ:

I. ЖЕНИТЬБА. Совершенно необычайные похождения эксц. Сержа.
II. ПИНК-ПАНК.
III. ДЖИН-ДЖЕНТЛЬМЕН и РАСПУТНАЯ БУТЫЛКА.

ИЗДАНИЯ

Георгий Крыжицкий. Философский Балаган.
Эксцентризм № 1.

ГОТОВЯТСЯ:

Григорий Козинцов. Прэнс—Пинкертон—Неруин-Пето.
Георгий Крыжицкий. Цирк.
Леонид Трауберг. Гениальное как Жильбер.
Сергей Юткевич. Эксцентрический плакат.
Эксцентризм № 2.

1922 осень ВЫСТАВКА 1922 осень
ЭКСЦЕНТРИЧЕСКОГО ПЛАКАТА

Григорий Козинцов. Сергей Эйзенштейн. Сергей Юткевич. Музей американских плакатов, обложек бульв. романов и др.

СПРАВКИ-ЗАПИСЬ-ПРЕДЛОЖЕНИЯ
„ДЕПО ЭКСЦЕНТРИКОВ"
Бассейная, 7, кв. 7.

Р. Ц. № 1396. 1000 экз. 5-я Гос. Тип.

Manifesto selected from Jonas Mekas Archive
ВИТРИНА САМОРЕКЛАМЫ, 1922

Words remain the work of the poet, his existence, his job.

B Innovation I

Destruction of WORDS for LETTERS

ISIDORE ISOU Believes in the potential elevation beyond WORDS; wants
 the development of transmissions where nothing is
 lost in the process; offers a verb equal to a shock. By
 the overload of expansion the forms leap up by themselves.
ISIDORE ISOU Begins the destruction of words for letters.
ISIDORE ISOU Wants letters to pull in among themselves all desires.
ISIDORE ISOU Makes people stop using foregone conclusions, words.
ISIDORE ISOU Shows another way out between WORDS and RENUNCIATION:
LETTERS. He will create emotions against language, for the
 pleasure of the tongue.
 It consists of teaching that letters have a destination
 other than words.
ISOU Will unmake words into their letters.
 Each poet will integrate everything into Everything
 Everything must be revealed by letters.
POETRY CAN NO LONGER BE REMADE.

ISIDORE ISOU IS STARTING
A NEW VEIN OF LYRICISM.
 Anyone who can not leave words behind can stay back with them!

C Innovation II: The Order of Letters

This does not mean destroying words for other words.
 Nor forging notions to specify their nuances.
 Nor mixing terms to make them hold more meaning.
 But it does mean
 TAKING ALL LETTERS AS A WHOLE;
 UNFOLDING BEFORE DAZZLED
 SPECTATORS MARVELS CREATED FROM LETTERS
 (DEBRIS FROM THE DESTRUCTION);
 CREATING AN ARCHITECTURE OF LETTRIC RHYTHMS;
 ACCUMULATING FLUCTUATING LETTERS IN A PRECISE
 FRAME;

Manifesto selected from Jonas Mekas Archive
Destruction of Words for Letters, Isidore Isou 1942

Good Morning, I'm Doug Fishbone, and I have been invited to present on behalf of the Manifesto Club. There are quite a lot of people involved in the Manifesto Club, so they have jointly written this script and manifesto for me to transmit to you. Because usually, they communicate through discussions on the phone, via email and at evening meetings in pubs, which always takes more than 20 minutes [the length of each segment at the *Manifesto Marathon*].

This manifesto proposes A Free Art School. Art schools are where artists and art professionals develop their values and discourses. They are spaces that produce the ideas, visual languages and independent thinking of artists – art schools are where future art takes shape. So this manifesto is called *Towards a Free Art School*. It looks at what are the problems affecting art schools today, and suggests the kind of values that we think go towards what makes teaching art, and learning about art, a valuable thing to do. Education is about exchanging ideas with others – learning to learn and communicate for yourself. Art education works best when it focusses on encouraging people to make and organise things for themselves, rather than telling them what to do and speaking at them like this, from a podium, wearing a suit.

This manifesto, like many manifestos, is generated from people saying what doesn't work, what does work and what could work. *Towards a Free Art School* has been put together by the Manifesto Club's Artistic Autonomy Group – a group of artists, arts administrators, researchers and students who want to defend artistic freedom through campaigns for greater freedom in the arts, and against restrictive policies and practices. The Manifesto Club itself is formed of different self-organised groups, so before I present the manifesto *Towards a Free Art School*, I'm going to tell you a bit about the club. And I'm going to stop using 'I' now, and start using 'we', meaning the Manifesto Club.

The Manifesto Club is a humanist campaigning network based in London. The aim is to bring together individuals who believe in developing people's creativity and knowledge. The Manifesto Club's agenda is for a 21st-century Enlightenment, to build a future where human potential is developed to the fullest extent possible. At the current time, despite the significant achievements of the past two centuries, Western societies are gripped by a powerful mood of cultural pessimism, of suspicion towards science and technology, and a disturbing sense of self-doubt and misanthropy.

Across the world, there are new forms of prejudice and irrationalism, a growing attachment to identity politics and victim culture, fear for the future and the loss of belief in progress. That's not a lot of fun.

The Manifesto Club invites all those who are concerned about these retrograde developments to collaborate in formulating positive alternatives. We want to reclaim the questioning and creative spirit of the Enlightenment, especially the idea that human beings can make their own history. This is not a call to go back in time – it is a call to recognise that each of us actively makes history. Most people have the strength and courage to think and act for themselves independently; that's why we're here this morning. The great German philosopher Immanuel Kant put it like this: 'Enlightenment is humanity's emergence from self-imposed immaturity. Dare to know! Have courage to use your own understanding!' That was in 1784, when Francisco Goya was painting the fabulously rich and Jacques-Louis David was painting historic scenes. But even though so much has changed since then, each individual still needs to realise this courage for himself or herself. That's also something that we need to realise in the way we think about organising society; and that includes art schools, which should be the first place to think about what art means and what art can do.

But art schools today seem to be in a lot of trouble. At a time when more students than ever are enrolling on Fine Art courses, and at a time when art has a higher cultural status than ever before, there's a sense of confusion about the purpose and aspirations of learning about art. At first glance, the trouble in art schools seems to reflect the shift to a consumer-led culture in higher education, where budgets take priority over teaching: fewer tutors, teaching more students, for less time, in studios that shrink from one year to the next, with tutors spending time on assessment paperwork, time that could be better spent teaching students.

But it's not simply a question of resources, it's rather a question of how they are used. Whether art schools are publicly funded or privately funded – or whether you pay tuition fees or have them paid for – experimentation and exploration can't happen if energy is wasted on administration and the continuous over-assessment of how art schools function. There are some who argue that without constant regulation and scrutiny, art schools would become the worst kind of anarchic free-for-all, as if artists themselves are too unreliable to teach or to organise themselves effectively.

137

Against this, we say: for a free art school, self-direction and organisational independence are essential. Artists need to be able to organise art schools the way they think is best. Trust artists to shape art schools for themselves, and they will do it. Use resources to make that happen, rather than to perpetuate time-consuming bureaucracy.

This is what Richard Wentworth wrote, when we asked him about what goes into a good art school:

> *Art schools are made of people. Some mix of premises and gumption is the fire-lighter. It's a sentient-being thing, not a correspondence course or a chat room. It needs buckets of goodwill and trust to work, because without, you can't generate the essential atmosphere of vulnerability and the pleasure of risk. Lots of give equals lots of take equals a perpetual motion machine. Art schools are places of desire amid the occasional wonders of recognition. There needs to be openness to get the necessary frankness. The verb 'to confide' leads to the warm noun 'confidence'. The useful people are probably often not artists in the hidebound sense. Reliability helps a lot if it doesn't recoil into jobsworthiness. There are terrible models to witness. It can be contagious, so wear a mask. Cowards should not be tolerated. Art school should be a testing place, not an assault course.*

Richard is right: art schools should be a testing ground. Yet increasingly, students are encouraged to adopt a pragmatic professionalism and so see art-making as a career like any other, spending time and energy proving themselves through modules on 'professional development'. Rather than recognising their time at art school as a free-spirited and open-ended period of investigation, students are increasingly cautious and conservative in their attitude towards the education they receive, and the purpose it serves – preoccupied with perfecting their work as a product to be brought to the market when they leave. It's a risk-averse approach that reinforces tried-and-tested habits and conventions, both in art schools and the art world.

We say: reject art as a career-path, champion art as a space in which to challenge conventions. Art education should be a site of creative synergies and experimentation, free from career anxieties.

Currently, some fee-paying students in the UK are campaigning to be treated as if they were consumers of education. This ignores the noble history of free education and the idea that you go to university because you want to learn more. You are being trained to think – if you want to be trained to earn money, you can go to work or to business school but not art school.

Art's history of experimentation and exploration is now comfortably assimilated into the norms of art-school education, and no longer appears as a challenge to either the commercial market or the culture of publicly funded art.

We say: learn to identify contemporary conventions and actively challenge them. Paradigms are there to be shifted.

The increased visibility of contemporary art does not reflect an increased confidence in art as a discipline, and in its potential. There is a narrowing of ambition that indicates a retreat of the adventurous avant-garde attitude toward art's place in society. The idea that culture, in its most dynamic form, can contribute to our sense of what is progressive and valuable in human society, is something many are uncomfortable with declaring explicitly.

Why is it that such a forward-looking culture seems so difficult to achieve today? We think that the problems that affect art-school culture stem from today's wider sense of unease and pessimism with regards to experimentation and change. Contemporary society's risk-averse and bureaucratic culture has encroached on the ambitious, experimental and progressive spirit that informs the best art and art teaching. Let's face it, if you can't experiment with unsafe sex and smoking, and if even freedom of speech becomes a no-no, then the culture of art is bound to be constrained by society's wider fears about honest disagreement and risk-taking.

We say: reclaim the spirit of risk and experimentation more broadly. Art is often concerned with the wilder reaches of knowledge and experience, which brings it into conflict with social and cultural norms. Questioning and challenging today's conventional thinking shouldn't stop at the door of the art gallery or the museum.

There is no text-book for how to be an artist. As a result, art-school training should be about the development of truly enquiring, independent subjects, whose formation cannot be simply defined by the assimilation and reproduction of pre-existing disciplines. Art is a mixed-up, multifaceted engagement with our living culture, and its truly creative edge is led by those who have the confidence and insight to push it beyond its conventional languages, forms and attitudes.

We say: celebrate the many forms of knowledge, both inside and outside of art.

Beyond the problems of funding and educational and cultural policy, we all need to rethink what it means to have a special place in which to develop the potential of the artistic imagination in all its social and cultural forms. A sense of risk, experimentation and unforeseen possibility isn't something that you can just teach in lectures and seminars – it's something that you make happen. Art thrives when it has a special place that con-nects with cultural and social life as something to be questioned and transformed. Art education needs a free space, with a sense of what might be achieved beyond the pre-existing frameworks of careers and institutions.

But this can only make sense if a society understands that exploring the unknown is a principle worth pursuing. Our society, however, seems more concerned with maintaining the stability of things as they are, rather than risking the consequences of any leap into the unknown. If this is the case, then artistic experimentation will always be constrained by the limits of the individual and by the pre-existing forms of commercial and institutional life. There may be a lot of fear and apathy out there right now, but there are also effective historical models, existing solutions, and a desire for change.

From the conversations we have had with a broad range of artists, teachers and students, there are a lot of good ideas out there. We need art schools with enough spaces for students to organise displays of their work and for established artists to be able to experiment. We need to get rid of the obsession with gaining a qualification and rethink the nature of assessment, so that free experimentation can happen without fear of failure. Overall, there needs to be more mentoring, more interdisciplinary research, more self-direction and more independence, so that the artists and thinkers who shape art now can share their knowledge with the next generation of artists.

Instead of accepting the limits of an individualised, professional and career-centred attitude to artistic practice, we can start to think about what a genuinely free art school might look like, what it teaches and where it leads, and how we might go about making it happen. Because in the end, the shape that a free art school takes is for all of us to decide.

You've been listening to me, Doug Fishbone, presenting the ideas of the Manifesto Club's Artistic Autonomy Group.

Towards a Free Art School manifesto has been generated for the *Serpentine Gallery Manifesto Marathon*, and we are grateful to all the people who contributed, including Carolee Schneeman, who proposed this alternative art education premised on collective effort:

[What doesn't work in art schools?] *Their delusional attempt to provide a Utopic autonomous art school.*
[What does work? And how could it work?] *Art school classes will require student groups to research and locate small farms in need of seasonal labour. Art students become responsible to the art community and active within the farming community for six months of subsistence farming. The artists commit themselves to the full schedule of farm demands: those repeated, constant labour-intensive and particular seasonal requirements. (Agricultural, dairy, fruits, vegetables, ploughing, planting, weeding, picking, harvesting, sorting, as well as possible milking, shovelling manure, turning compost, haying, combine preparation, feeding livestock, moving rocks, insulating coops, building shelters, assisting with artificial insemination (dairy), castration (pigs)).*

At night or during work breaks, each artist maintains notes and drawings and possible photographs in a diary responding to the textures, aromas, light, shadow, mud, manure, grasses, water, etc. of their daily environment, which can include the organisation of their meals, sleeping provision, the hygiene of their accommodation, etc.

139

* * * OFFICIAL DOCUMENT* *

Title: Authorised:
Declaration Concerning First Committee, INS
the Relationship between
Art and Democracy Authorisation Code:
 TMcC010703
Type:
INS declaration

Document follows

1.1 It is held by this organisation to be axiomatic that good
 art despises democracy to the same measure as bad democracy
 covets art.

1.2 Bad democracy's administrators covet art inasmuch as
 they demand of it that it package and promote their core
 propaganda motifs: inclusiveness, accessibility, good
 citizenship, public dialogue, 'creative entrepreneurship',
 etc., etc.

1.3 Art is about none of these things. Its origins lie in
 transgression, death and sacrifice.

1.4 Good art despises good democracy as much as bad
 democracy. Art which sets itself the task of promoting
 democratic principles, branding itself as 'oppositional'
 to globalisation, worker oppression and so on, is invariably
 banal. It is also more insidiously reactionary than the
 most excessive proclamation of Marinetti. Good art cannot
 be a space in which individual rights – to freedom, self-
 expression, etc. – are asserted for the reason that in good
 art the very subject who might enjoy such privileges
 is abjected and annihilated. Good art cannot assume a
 'position', as it is predicated on the destruction of every
 position, every point of origin.

2.1 Leon Golub's paintings are not 'protest art'. They are
 Homeric.

* * * * OFFICIAL DOCUMENT* * * * * * * * * * * * * * * * * *

2.2 It is noted with approval that Spartans forced captured
 Athenians to learn Euripides' work by heart. If they made
 mistakes reciting it, they were executed.

3.1 It is held that the generative processes involved in
 a work of art's production are inherently undemocratic,
 requiring peremptory decisions, hierarchisation and
 suppression – in short, the ruthless management and
 exploitation of symbolic information.

3.2 It is held that the lines of sucession along which influence
 in art proceeds are fraught, Oedipal and not egalitarian,
 and that the character of apprenticeship
 is a master-slave one.

4.1 See photo 1.

4.2 See photo 2.

5 It is noted with interest that most good writers were either
 extremely rich (Tolstoy, Proust) or in prison (Genet,
 Solzhenitsyn). Sade was both.

6.1 That fascism and art go well together is attested by
 Futurism and the writing of Yeats, Pound, Spengler, Hamsun,
 Jünger, etc. If fascism is taken to be 'the aestheticisation
 of political life', then it is hard to think of a good artist
 who could not be called a fascist.

6.2 Left-totalitarian systems serve art in more roundabout but
 equally constructive ways. Censorship and interdiction should
 be welcomed by good artists as enabling. In this light, it
 is proposed that Stalin's policy of arresting and eradicating
 artists and writers was inspired, as it placed them in the
 zone of silence and impossibility from which all good art
 stems. Good artists should be quiet, invisible or dead.

7 Do we contradict ourselves? Well then, we contradict
 ourselves. We are large. We contain multitudes.

 * Document Ends *

* * * * OFFICIAL DOCUMENT* * * * * * * * * * * * * * * * * * *

142

Inauguration of First Flight Officer to INS First
Committee, 7th April 2002 (photo released April
20th 2002)

* * * * <u>OFFICIAL DOCUMENT</u>* * * * * * * * * * * * * * * * * * * *

<u>Inauguration of First Flight Officer to INS First Committee</u>, 7th April 2002 (photo released May 2nd 2003)

SUMMER HAIKUS: A MANIFESTO

Jonas Mekas

Stills from *Summer Haikus: A Manifesto,* including passages from Ayn Rand's
The Romantic Manifesto: A Philosophy of Literature

ah! Mayakovski,
Sandburg!
I never understood
your craze for
technology --

The Second Report of the N.A.C. GROUP
June 1st, 1962

COLLEAGUES FILM-MAKERS:

Let's see where we stand.

During the first year of our disorganized organization we managed
to keep ourselves loose, which is great, and we should keep it that
way. Legally, we are a properly incorporated organization.

Our loose meetings have caused more publicity (articles in Esquire
Playboy, Mademoiselle, Variety, Escapade, etc. etc.) than any organ-.
ized and paid publicity office could have done for us. The lesson
which we can take from this is: let's remain disorganizedly organized.
It is an underground principle, guerilla warfare. And that's where
we are.

Our member David C. Stone organized the Spoleto Film Exposition,
the first festival of the new American cinema. It resulted in several
sales, world-wide discussion of the American independents, and it pro-
voked important meetings of independent film-makers in Italy, Germany,
and other places.

Our member Alfred Leslie organized (this April) a New American
Cinema festival in Stockholm, which was another much discussed guerilla
warfare hit.

146

With our assistance, The Charles Theatre has become a meeting
ground and a guinea pig of independent film-making, a sort of beach-
head for our invasion of art houses.

We have established the Film-Maker's Fund which is still empty but
which should be filled and we shall work towards this aim. Let's keep
our eyes open for any possible contributions to the fund. The Fund,
as you know, is to help films in production, to serve as a bond for the
Laboratories, and other such ends.

The most immediate problem is the proper distribution of our work
in this country and abroad. The Group has set up the Film-Maker's
Cooperative which we want to make into a self-supporting cooperative
distribution center (read the enclosed Announcement N. 1 and other
attached materials). It should eventually take from our shoulders all
distribution problems, a sort of our own United Artists.

At this moment we are working on the so-called OPERATION 100
THEATRES. Which is this: We want to line up 100 theatres across the
country (we are including Canada, too) with pledges to book any program
that the Cooperative offers, for at least one day, and, if the show
makes money, to book it for as many days as the theatre wishes.

page 2

We are alerting our colleagues film-makers in other cities to contact the local art theatres and discuss the idea with them. Our experience shows that theatres are ready for independents and experimentation, they listen and they accept ideas and films.

We are working on several Flying Festival programs of independent and experimental films for Japan, Germany, and South American countries, which have asked us for such programs. We are expecting a similar Flying Festival from Japanese independents (yes, there is such a thing in Japan, too) which we'll take across the country, a sort of cultural exchange program of our own.

The first catalogue of the Film-Maker's Cooperative is being prepared for publication, for the use of the theatres, film societies, universities, etc. There is still time to include YOUR films, too. If you have anything, contact us immediately.

The first issue of our bi-monthly Bulletin will be issued in June, listing films in production, money needed, people needed, or whoever has any talents to offer -- for the use of the colleague film-makers and for the attention of the investors. Please supply us with this information:
 a) films in production (telegraphic description -- comedy, musical, documentary, etc); money needed to finish them, (if needed);
 b) films in preparation; their budgets.

147

Here is some information on the inner set-up of the Group:
 Directors: Shirley Clarke, Jonas Mekas, Edward Bland, Harold Humes, Lewis M. Allen, Emile de Antonio, Jack M. Perlman.
 Officers for 1962: President, Jonas Mekas; Vice-President, Lewis M. Allen; Secretary-Treasurer, Jack M. Perlman.
 Admission Committee: Stanley Vanderbeek, Adolfas Mekas, Jonas Mekas.
 Advisory Committee for the Film-Maker's Cooperative, for 1962: Adolfas Mekas, Stanley Vanderbeek, David C. Stone, Emile de Antonio, Jonas Mekas.
 The Group membership fee is $12.50.

We have set up our offices at 414 Park Avenue South, New York 16, N. Y. Telephone: MU 5-2210.

This closes my first report for 1962.

 N.A.C. GROUP
 President
 J.M.

'THE ILL-TEMPERED MANIFESTO'
OR
'A NEW AGING MANIFESTO'
OR
'THE NEW OLD MANIFESTO'

Nathaniel Mellors

LETTRE-OCÉAN

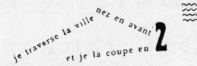

je traverse la ville nez en avant
et je la coupe en **2**

J'étais au bord du Rhin quand tu partis pour le Mexique
Ta voix me parvient malgré l'énorme distance
Gens de mauvaise mine sur le quai à la Vera Cruz

Les voyageurs de *l'Espagne* devant faire
le voyage de Coatzacoalcos pour s'embarquer
je t'envoie cette carte aujourd'hui au lieu

Juan Aldama

Correos
Mexico
4 centavos

YPIRANGA

**REPUBLICA MEXICANA
TARJETA POSTAL**

11 45
29 – 5
14
Rue des Batignolles

de profiter du courrier de Vera Cruz qui n'est pas sûr
Tout est calme ici et nous sommes dans l'attente
des événements.

U. S. Postage
2 cents 2

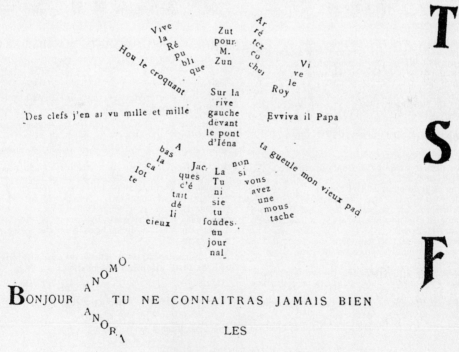

**T
S
F**

Vive
la
Ré
pu
bli
que

Hou le croquant

Zut
pour
M.
Zun

Ar
ré
tez
co
cher

Vi
ve
le
Roy

Des clefs j'en ai vu mille et mille

Sur la
rive
gauche
devant
le pont
d'Iéna

Evviva il Papa

A
bas
la
ca
lot
te

Jac
ques
c'é
tait
dé
li
cieux

La
Tu
ni
sie
tu
fondes
un
jour
nal

non
si
vous
avez
une
mous
tache

ta gueule mon vieux pad

BONJOUR ANOMO. TU NE CONNAITRAS JAMAIS BIEN
ANORA

LES

Mayas

AUTO-DESTRUCTIVE ART

Demonstration by G. Metzger

SOUTH BANK LONDON 3 JULY 1961 11.45 a.m.—12.15 p.m.

Acid action painting. Height 7 ft. Length 12½ ft. Depth 6 ft. Materials: nylon, hydrochloric acid, metal. Technique. 3 nylon canvases coloured white black red are arranged behind each other, in this order. Acid is painted, flung and sprayed on to the nylon which corrodes at point of contact within 15 seconds.

Construction with glass. Height 13 ft. Width 9¼ ft. Materials. Glass, metal, adhesive tape. Technique. The glass sheets suspended by adhesive tape fall on to the concrete ground in a pre-arranged sequence.

AUTO-DESTRUCTIVE ART

Auto-destructive art is primarily a form of public art for industrial societies.

Self-destructive painting, sculpture and construction is a total unity of idea, site, form, colour, method and timing of the disintegrative process.

Auto-destructive art can be created with natural forces, traditional art techniques and technological techniques.

The amplified sound of the auto-destructive process can be an element of the total conception.

The artist may collaborate with scientists, engineers.

Self-destructive art can be machine produced and factory assembled.

Auto-destructive paintings, sculptures and constructions have a life time varying from a few moments to twenty years. When the disintegrative process is complete the work is to be removed from the site and scrapped.

London, 4th November, 1959 *G. METZGER*

MANIFESTO AUTO-DESTRUCTIVE ART

Man in Regent Street is auto-destructive.
Rockets, nuclear weapons, are auto-destructive.
Auto-destructive art.
The drop drop dropping of HH bombs.
Not interested in ruins, (the picturesque)
Auto-destructive art re-enacts the obsession with destruction, the pummelling to which individuals and masses are subjected.
Auto-destructive art demonstrates man's power to accelerate disintegrative processes of nature and to order them.
Auto-destructive art mirrors the compulsive perfectionism of arms manufacture—polishing to destruction point.
Auto-destructive art is the transformation of technology into public art. The immense productive capacity, the chaos of capitalism and of Soviet communism, the co-existence of surplus and starvation; the increasing stock-piling of nuclear weapons—more than enough to destroy technological societies; the disintegrative effect of machinery and of life in vast built-up areas on the person,...

Auto-destructive art is art which contains within itself an agent which automatically leads to its destruction within a period of time not to exceed twenty years. Other forms of auto-destructive art involve manual manipulation. There are forms of auto-destructive art where the artist has a tight control over the nature and timing of the disintegrative process, and there are other forms where the artist's control is slight.
Materials and techniques used in creating auto-destructive art include: Acid, Adhesives, Ballistics, Canvas, Clay, Combustion, Compression, Concrete, Corrosion, Cybernetics, Drop, Elasticity, Electricity, Electrolysis, Electronics, Explosives, Feed-back, Glass, Heat, Human Energy, Ice, Jet, Light, Load, Mass-production, Metal, Motion Picture, Natural Forces, Nuclear energy, Paint, Paper, Photography, Plaster, Plastics, Pressure, Radiation, Sand, Solar energy, Sound, Steam, Stress, Terra-cotta, Vibration, Water, Welding, Wire, Wood.

London, 10 March, 1960 *G. METZGER*

AUTO-DESTRUCTIVE ART MACHINE ART
AUTO CREATIVE ART

Each visible fact absolutely expresses its reality.

Certain machine produced forms are the most perfect forms of our period.

In the evenings some of the finest works of art produced now are dumped on the streets of Soho.

Auto creative art is art of change, growth movement.

Auto-destructive art and auto creative art aim at the integration of art with the advances of science and technology. The immidiate objective is the creation, with the aid of computers, of works of art whose movements are programmed and include "self-regulation". The spectator, by means of electronic devices can have a direct bearing on the action of these works.

Auto-destructive art is an attack on capitalist values and the drive to nuclear annihilation.

23 June 1961 *G. METZGER*

B.C.M. ZZZO London W.C.1.

Printed by St. Martins' Printers (TU) 86d, Lillie Road, London, S.W.6.

Manifesto selected by Gustav Metzger
Auto-Destructive Art, Machine Art, Auto-Creative Art, Gustav Metzger, 1961, third manifesto
© the artist, 2009

Thank you, my dear.

I have a recurring nightmare that there is a snake in my toilet. A shit-eating snake. Feasting upon my becomingness!

In the dream, the snake is after my scarabs. I am desperately trying to protect them. In reality, I have tried hard to *unpick* – to *disentangle* – some meaning from this dream. I can only frame it as a dream of base-anxiety class. Because in reality, I collect scarabs – dung beetles. I have a number of them in my fridge. Several hundred, in fact – they are breeding, and I am breeding them, my 'Dungies'. Increasingly, their maintenance requires most of my time and energy. If I seem nervous, please regard this as a manifestation of concern as to my Dungies' well-being. For their sake, I must keep my observations today brief and focussed, to the point, concise, centred, concentrated, *et cetera*.

And so to the introduction. May I have some tea? Young, young.

The scarab is a species of dung-beetle, which was much esteemed in ancient France. [*shouting*] Egypt! The hieroglyph of the scarab – the dung beetle – can be transliterated as 'to come into being', 'to become', 'to transform', 'transformation', 'happen-ing', 'mode of being'. Now ever since I was a young man at the Royal College of Art, I have regarded most artists' output as precisely so much dung – no different from any other persons' – but rather unusually celebrated, fetishised and discussed. Artists like myself are STOOL-CUPPERS by nature; there is a rather addictive tendency to poke, to prod, to try and tease out some finer nuance – to excavate a nugget as if it were a precious jewel above a piece of corn. Now I do not exclude myself from this infantile practice; I would rather embrace it than deny it. And so I have fashioned myself after the dung-beetle – a superb and terrifically useful little fellow. The dung-beetle is a heavenly creature! Now, young man – you look like an intelligent and able-bodied chap. Tell me, how much money does the North American dung-beetle save the US cattle industry each year, by burying above-ground livestock faeces? [*sips tea*]

Don't know, eh? Ah, to be young and carefree! The correct answer is 380 million dollars. I know. The dung-beetle, of course, expects no remuneration. Could God himself conceive of a more Christian animal? The dung-beetle

feasts exclusively OF DUNG. Exclusively! Not solid dung – although the little ones, the larvae, do munch up undigested plant nutrients from the solid matter – but the mature animals instead fix onto the dung with their mandibles and SUCK the liquid juice from the dung. [*slurps tea, speaks whilst drinking tea*] The dung-juice is teeming with enough micro-organisms, nutrients and water to sustain life!

Plus, with Herculean effort, the dungie rolls dung into dung-balls ten times his size! He mates on dung, he reproduces in dung and he lives in, of, with and from DUNG!

And for that reason, ever since my flusher broke in 1985, and the Borough of South Kensington refused to send a plumber round, I have been experimenting with my own above-ground faeces burial – using the upper portion of my refrigerator, some newspaper, Tupperware and an army of these hardy little fellows. And it would appear, of late, that I have, in my actions, become an inadvertent pioneer of ecological activism. Watching the Dungies build their houses. Syphoning off the gas to power my Aga in the winter. Excuse me. Silent weapons for quiet wars.

And so to – the introduction – why I am here.

Now, to be honest, I am not sure how old I am. Whether I am from the future or the past… how appropriate… in this conflation… is the problem… as I see it… or I should say, as I *know* it. I am confident that I have something of the future about me. I have some of it, but some of the past too… lots of the past. Today, I would like to appear to you as a 'Ghost of Christmas Future-[*pause*]-ism' here to give you a stern ticking off.

I suppose this might be my last act, as it were. Hmm hmm hmm hmm.

Part 1. 'How to Spot a Chocolate Teapot'
Standing here drinking TEA, I am thinking about the oxymoronic potential of this event – oxymoron, oxymorona. Check back, I peppered a few in back there, for *humourous* effect.

Now in the days of the *Tamworth Manifesto*… or the *Humanist Manifesto*… the *Fascist Mani-festo*… or, indeed, the *Cannibal Manifesto*, it was rightly considered to be a political act to try to say some-

thing. Now the commissioning of a plethora of manifestos is also a political act, but it is a political of a very different nature. Why? Is this… circumspect, I will inspect as it were [*coughing*] go round it, is it not immediately obvious? – I should like to put this politely. Is a lack of seriousness in relation to its own theme not a precondition of an event such as this? A consciousness-changing *Marathon*? Attended by a [*irregular pauses between these words*] small crowd, expecting the unexpected? Eh?

Serpentine… serpentine… cunning, slippery and shifting. Adamantine – to begin. Sinuous in form and movement. [*very angry and shouting*] Why on earth would anyone come to such a place? When I go for a walk, I like my roads to stand still! And to stay on the ground! That is my ripened perspective on it – it must sound strange to the unfledged… to all you… bloody embryos!! Aaaahhh! Stomach! But I see now that there are snake-surfers among us! Are there not? And there you are… yes, you! The bald man, WHY – ARE – YOU – NOT reading Milton? [*more friendly*] My dear!? Why are you not studying Milton? Before you step out of the house, read Milton! I can see the lack of it upon you! Why [*coughs, becoming enraged*] in God's name man!? [*points at him*] Instead of standing on a snake!!!

[*pause, aside*] Ted Moult was a bloody good bloke!

[*calmly, back to audience*] Now the more astute amongst you – those of you of a visual aspect will perhaps be aware I am not in a particularly good mood – not in a particularly good mode – at the moment. There are those that would have it as fact that I am dying. I should say that I am not here to be negative! I am here *Lazarus taxon* – to promote undead values. I believe I am younger than the youngest and older than the oldest here – even you, sir, you there with the shopping bags – that you resent – but that keep you upright, like ballast. [*breaks into coughing fit*] I am prone to time travel… my arse! My arse!

Ballast? Blast! Where was I?

We can see that a new underclass has arisen – or sat down – this might be a more appropriate intransitive, sat down at the back of the buses and on the underground railways, plopped down from top to bottom, as in a drawing by James Ensor. There you have your 'trickle down'. Now listen, if anyone uses the term 'trickle down', then strike them fiercely about the chest! And as they lie prostate clutching themselves and rattling for breath, then place your foot square upon their chest, and say in a clear tone: 'Sir, faecal liquids trickle down – money holds its form.'

Unlike the charming and invisible working class, the underclass are a certainty – they are right there. And yet we would deny them their reality, deny them any imaginative life. Unctuous liberals in TV comedy use them to unite the masses in spiteful laughter. Like laughing at a handicapped child struggling to eat his sandwiches. Whooooshhh! Into the gutter with you! You will be nothing but caricature, absurd and elastic in your capacity to receive abuse. You will be laughed at from without by the professional jovialist. *Little England*!? Never was a programme more appropriately named. We are shrinking by the day!

Blast ruddy Richard Whiteley for upping sticks. Three point twenty-five p.m. is spoilt! Spoilt!

But as I was saying, the old working class has vanished. Where did it go? Nowhere – it has gone precisely nowhere. But we cannot see it anymore, because it *thinks* it has gone somewhere else. Am I making myself clear? The working class – as was its ambition – has moved house. It has swapped its table nests for the psychic and corporeal masochism of self-assembling furnishings. The working class has changed rooms. It has changed names. Hence it appears to have vanished. The lumpen lower middle class is, in fact, the British working class. And no amount of Ikea furniture will obscure this reality! The upper middle class is the only real middle class. And no amount of Ikea furniture will change this fact.

I would like to raise a silent alarm.

All of which brings me back to dear George Orwell – and cannibalism. It was George, of course, who was quick to note – not cannibalism, which has been going on for years – but the wresting of words – the wrestling of language from its moorings in reality. It's not a game – it's a deadly affair.

Where are you, George? George? Are you there, George? Perhaps we can catch him. Do you believe in the spirits, young one?

George! I hear him! What's that, George? What music would you expect to hear? [*laughing fondly*] I don't know, George. It is a youth club. A post-ideological discotheque! I don't find the music terribly groovy, I'm afraid. I know, George – we must start somewhere. Oh you mean talk about the disco? Terry is here? Is Terry there? Terry's not dead yet, George!

[*mood change – to serious*]

Orwell's tenet – I would go so far as to call it a credo – is that our ability to use words clearly and with precision affects our ability to think. NOT because you are stupid, far from it, far from it. Although there are always a few thickos, of course [*cough cough*]. Limiting language, perpetuating vague language, undermining the meaning of words and degrading language is the prerogative of politicians and scoundrels. Orwell identified *writing on art* and *political speech writing* as synonymous in their commitment to vague, debased, disingenuous and manipulative WORDAGE! Wordage.

The word 'terror' is, of course, the biggest example of a hijacked word – the word 'terror' has itself been taken hostage. Etymologically, 'terror' is characterised by 'obscurity' or indeterminacy in its treatment of potentially horrible events – this *indeterminacy* is fundamental to its meaning – the *indeterminacy* enables the theorisation of the sublime. So 'terror' can never be made concrete – this is why terror can never be found.

You see, if we cannot *agree terms*, we can have no consensual grasp of reality. We are allowing our grasp of reality to slip – into the weave of subjectivity.

Curse 'subjectivity'! Damn those who make a feature of nature!

Blast postmodernism and its endless collage of disempowerment!

Blast the empty rhetoric it necessitates and curse the sluice of hollow reference!

Because, in reality, all things are still real. Do not allow your sense of reality to be confused or extracted, stolen by some floppy conjurer. Do you understand me? How can I explain this? Endless collage! Colours, shapes, appropriation, reference – since when was it the ambition of art to look like art? We have taken a culture and made it a craft! Aesthetics – big craft design bang. A word-bag! Always accompanied by a bag of words. The word-bag can take the form of a piece of A4 paper, or a buffoon in expensive clothes, leaping at the wealthy, leaking a stream of nonsense.

How can you speak if your mouth is full of worms?

МАНИФЕСТ

Andrey Monastyrski

Опыт жизни в Советском Союзе всегда заставлял меня избегать темы «искусство будущего» и вообще футурологических тем. Вероятно, это связано с тем, что советская идеология всегда была устремлена в будущее – «строительство коммунизма» - и не обращала внимания на экзистенциальную жизнь человека «здесь и теперь». В Советском Союзе ни сама жизнь отдельно взятого человека, ни его права ничего не стоили. И одной из форм сопротивления этой идеологии и было игнорирование футурологии во всех ее проявлениях.

Это и есть основная причина, по которой я не могу ничего сказать об искусстве будущего.

При этом, на мой взгляд, мы не может прогнозировать, какое будет ХОРОШЕЕ искусство будущего, поскольку хорошее искусство, искусство эстетических касаний «здесь и теперь», всегда связано с настоящим и глубоко личным. Все, что мы можем себе представить в будущем, это только ПЛОХОЕ искусство, которого, впрочем, всегда больше, чем хорошего. И в этом смысле можно с уверенность сказать, что плохого искусства в будущем будет не меньше, чем сейчас.

Тоталитарные общественные системы всегда так или иначе основываются на футурологических фантазиях и в этом смысле футурологические образы и тоталитарные образы имеют одну природу.

Будущее неясно и, думаю, оно таким и останется. Лучшие произведения настоящего содержат в себе эти до конца неясные, непонятные смыслы, которые и указывают нам – в том числе - и на неизвестное искусство будущего.

А. Монастырский.
Сентябрь 2008.

MANIFESTO

Andrey Monastyrski

Experience of life in the Soviet Union always forced me to avoid the theme 'Art of the Future' and futurological themes in general. This is probably connected with the fact that the Soviet ideology was always directed toward the future – the 'building of Communism' – and did not pay attention to the existential life of man 'here and now'. In the Soviet Union, neither life itself nor the rights of the individual were worth anything. And one of the forms of resistance to this ideology was to ignore futurology in all its manifestations.

This is the main reason why I cannot say anything about the art of the future.

In my view, we cannot predict what the GOOD art of the future will be like, since good art, the art of the aesthetic, contacts 'here and now', is always connected with the present and is deeply personal. Everything that we can imagine in the future is merely BAD art, of which, however, there is always more than good art. In this respect, one can say with confidence that there will be no less bad art in the future than there is now.

Totalitarian social systems are always based one way or another on futurological fantasies, and in this respect futurological forms and totalitarian forms have the same nature.

The future is unclear, and I think it will remain like this. The best works of the present contain these incomprehensible points, obscure to the end, which indicate to us – included – the unknown art of the future.

A. Monastyrski.
September 2008.

THE GARBAGE MANIFESTO

Richard Nonas

1
- GARBAGE IS GOOD
- GARBAGE IS NECESSARY
- GARBAGE IS HISTORY
- GARBAGE IS MEMORY
- GARBAGE IS HUMAN LIFE

2
- GARBAGE IS THE PERFECTION OF ORIGINAL SIN
- THE ABSENCE OF GARBAGE IS ISOLATION: THE DEATH OF CULTURE
- GARBAGE IS OUR PROOF OF NATURE'S EXISTENCE, OUR ONLY WAY TO READ IT
- GARBAGE IS UNKNOWABLE NATURE FILTERED THROUGH HUMAN LIFE
- GARBAGE IS NATURE'S BEATING HEART, OUR MARKER OF MOVEMENT AND TIME
- GARBAGE IS NATURE, THE ONLY NATURE OF WHICH WE ARE PART
- THE ABSENCE OF GARBAGE IS DEATH

3

– GARBAGE IS OUR PROTECTION FROM
IMPOSSIBLE DREAMS

SO:

– DO NOT HIDE, AVOID OR IGNORE GARBAGE
– DO NOT DENY THE CENTRAL AND
DEFINING PRESENCE OF GARBAGE
IN HUMAN LIFE
– DO NOT DENY THE POWER OF GARBAGE
TO MAKE YOU HUMAN
– DO NOT USE GARBAGE TO DEMONSTRATE
MORAL PURITY
– DO NOT USE GARBAGE TO INSULT OTHERS
– DO NOT USE GARBAGE TO AVOID
DIFFICULT POLITICAL DISCUSSIONS THAT
DO NOT CONCERN GARBAGE
– DO NOT TURN GARBAGE INTO THE
LANGUAGE OF A SECRET RELIGIOUS CULT

AND:

– USE GARBAGE AS A TOOL TO UNDERSTAND
YOUR LIFE

SEND THE ONOCHORD MESSAGE

'I LOVE YOU'

BY REPEATEDLY BLINKING THE LIGHT

THEN AND NOW

Yoko Ono

Friends, I would like to congratulate all of us for wiping the dust from our eyes and seeing things clearly again.

In that sense, these last few days have been a historically significant time in our society.

We have been given a challenge, a challenge we will meet and deal with.

And through it, we will lead ourselves to the survival of our race and our planet. We were about to make the wrong turn. A serious wrong turn which would have led us to disaster of a grand proportion.

I have been told by a wise woman of India, that in the Mayan calendar, this particular October 9th that has just passed, was a day in which we were to, and have, conquered the devils after many, many battles. And, that we have all of what we need. We just don't have enough for some people's greed.

So let's congratulate ourselves for having rescued us just in time, with the acute sense that we are standing at the threshold of the New Age, together.

There's a lot of work to do, but let's do it dancing and loving it.
And especially to my friends who have survived on this planet for over half a century; don't die on me or on us. We don't want to lose you.

We need you to take good care of your body and mind.

All of you are so precious to us.

The world would not be here at this time of the celebration of having won the battle with the evil in us, if it weren't for your creativity in the form of your constant rebellion against the arrogant indulgence of our society.

Your body is finely weathered. Your mind is the mind of a being who has collected a staggering amount of data of our history, of our reality, and is tuned, powerfully to direct our race to the new dawn.

We need your wisdom, we need your resilience, we need your clear imaging and intelligent prayer for the survival of us, the human race, and the planet.

The Universe is with me in this concern.

If you want to know what your thought processes were like in the past, just examine your body now.

And if you want to know what your body will look like in the future, examine your thought processes now.

Your body is the scar of your mind.

I love you!

Yoko
Serpentine Manifesto, 18 October 2008

A MANIFESTO ON PRE-EMPTION: PREMEDITATIONS 1-18

The Otolith Group

BEGIN

[*Caretaker music plays quietly throughout*]

18 Episodes from a Field Manual On Dyschronia

We are THE OTOLITH GROUP.

PAUSE

My name is Satyajit Ray, the well-known film director.

My name is Ritwik Ghatak, the well-known film director.

PAUSE

We are pleased to be attending the Ninth World Futurological Congress here in the impressive ruins of the Gehry Pavilion. Those among us that were fortunate enough to attend the Eighth World Futurological Congress at the Costa Rica Hilton will never forget it. We are happy to see that so many of our friends and colleagues from the Eighth Futuro-logical Congress are here with us this afternoon.

LONG PAUSE

SATYAJIT RAY Is it happening yet? [*pause*]

RITWIK GHATAK How severe will it be? [*pause*]

SR When will it happen? [*pause*]

RG We can't be absolutely certain about what is about to happen. [*pause*]

SR But the signs are all there. [*pause*]

RG Instead of waiting until it's too late—

SR waiting for the floods—

RG and the droughts—

SR and the famines—

RG and the viruses—

SR and the intolerances—

RG and the partitions—

SR and the pollutions—

RG of the future to overwhelm us —

SR shouldn't we take a wiser course of action?

RG Shouldn't we pre-empt that possibility?

SR Which possibility? [*pause*]

RG Shouldn't we take action? [*pause*]

SR Now?

RG Now. Before it's too late.

SR Shouldn't we act against a potential threat before it becomes a disaster?

RG Yes. Anything less is a gift, squandered.

SR Before the threat exists, we will have acted.

RG The doctrine of pre-emption authorises us to act.

SR Whatever makes us doubt ourselves—

RG whatever makes us attentive—

SR whatever makes us apprehensive—

RG makes us appreciative–

SR will become the future basis for the present law. [*pause*]

RG Whose futures inhabit yours?

SR Whose futures live in you?

RG None of your fears belong to you.

SR Your fears are collective.

PAUSE

RG Isn't the best way to survive an uncertain future to create it?

SR By engineering the disaster that you warned against?

RG Yes. You must learn to activate the futures that you intend to prevent.

SR These futures are [*pause*]

RG unlocatable–

SR innumerable–

RG unaccountable.

SR The future is a ground that is uncertain–

RG It is a sky that threatens.

SR But a threat, a threat is nothing, yet.

RG No. No. Don't you see – it is not nothing–

SR it is an impending state–

RG Do you mean that it is a nearness, a proximity?

SR No. That's not it. A threat is the future cause of a change in the present. [*pause*]

RG Which would suggest this: a threat is a form of the future–

SR that has the capacity to fill the present–

RG without presenting itself. [*pause*]

SR It is a future that casts a present shadow–

RG a shadow whose presence is fear.

SR But the future will be better tomorrow.

RG Because tomorrow is another day?

SR That is what my mother used to say.

RG Perhaps she meant: 'Will you take any notice of the living?'

SR Or perhaps she meant: 'Will you elevate yourself learning from the dead?'

RG What she meant was: 'When will you be more than you are?'

PAUSE

SR Tomorrow's future is here now–

RG I can see you, there, walking along the Corniche.

SR Can you take shelter inside the threat that tomorrow's promise will deliver?

RG No one can have learnt how to control the threat of a threat.

SR Or the fear of fear.

RG Is it possessing you?

SR It is abducting you–

RG capturing your potential [*pause*]

SR to be–

RG individually–

SR what you will have become–

RG collectively.

159

PARIS NOYÉE, LONDRES AU FOND DE LA TAMISE, QUELLE ARCHITECTURE?

(PARIS DROWNED, LONDON AT THE BOTTOM OF THE THAMES, WHAT KIND OF ARCHITECTURE?)

Claude Parent

CP We are going to talk about the architecture of the future. I am starting with my life. Very short! When I was very young, when I was 27, I only drew squares. My houses were one square and another square and another square [*draws squares on board*]. It was impeccable. But in the middle of the square, I was alone. I decided that the square was not the right kind of architecture. So when I was 27, in 1952, I said this is no good, because you are shut in, always shut in. I decided with a philosopher friend that we were no longer going to do squares, but slopes, and this makes you free [*draws oblique line with figure on it*]. In the square, you run against the walls; on the oblique, you are free. This was called the Oblique Function. It happened in 1964. So from 1952 to 1964, everyone laughed. It was the big joke that no one could live on an oblique shape. All the schools of architecture laughed, apart from Hans Ulrich Obrist, Frédéric Migayrou and a few Italians. This should have made me happy, but in American universities they say that continuity is an essential thing, which doesn't compartmentalise. You have to construct in a slope so as not to cause obstacles, from the ground to the slope. Construction becomes practicable; it's no longer an obstacle. So instead of making a building like a wall, you make it like a bridge, which reflects the language of nature. So I was happy and kept writing books and articles.

　　We are now going to see the drama, which is going to happen to us all, particularly in London and Paris. Two or three things: agricultural land is being reduced; land can no longer feed us. Population is rising, which is a good thing. Africans and Indians are having children, but so are Europeans. France is top of the list in Europe, which is impressive. It's something that the French are champions in! They lose at football, but they can produce children!

　　Population is rising, and the water is rising as well, and people are building more and more buildings, so we are going to see some pictures to show how this drama is going to affect London and Paris, because they are the most beautiful cities in the world, lived in by the most intelligent and beautiful people in the world.

　　First picture. This is Paris with various buildings, including the Eiffel Tower, in the year 2000. And this is 2050. It will happen: the sea is rising. Only the top floor of the Eiffel Tower is still there, a tiny bit of the Arc de Triomphe. In 2500, nothing is left, only the flag at the top of the Eiffel Tower, and fish swim through the Arc de Triomphe. They love it. It's the same thing in London.

　　This is the solution for Paris. This is in a few years, when we need to save everything. We fill the town as it is with cement. This is a global aim: to fill everything with concrete. We need lots of cement, lots of concrete and rocks, and you cover the whole of the old city, particularly the streets. You start with the streets. Roads no longer work, so you fill them in, then you fill the insides of houses. We will keep some for underwater tourism. This is the Élysée Palace filled with cement, and the Eiffel Tower and the rest. Once it is filled with cement, it creates a base at sea level. The sea won't rise any more, and then we create a structure.

　　So we need to create a structure without doing architecture. We have architects and engineers, sculptors, literary people, anyone and everyone, and we say to them, 'Make a structure without thinking about it, a structure without streets, without boulevards, without public squares.' We roll it out like a carpet on top of the concrete city underneath. And on top of this, we grow plants. So on top of the concrete, we cover it with plants. This is essential, because vegetation needs to come back onto the planet. Then we buy large machines, which are six storeys high, and into the structure we make incisions. But we do them at will, for fun. Anyone can get a machine, perhaps a dancer – she gets to drive the machine, and, using her imagination, she incises into the ground. The cuts in the ground mustn't be system-

atic. You make the incisions into the ground in a random way, and they will reveal the structure, which has been previously built by the architects and engineers and literary people. What will be revealed will always be different, always imaginative. The incisions will be an interpretation of the encounter between the structure and the machines.

Moving on to London. So the same thing applies in London. This could happen in any city. Here is the London Eye concreted over; there's a bit of Big Ben left. Buckingham Palace will be cemented. Curiosities will be kept for underwater tourism. Two or three major symbols will be retained and rebuilt because of history, because history is important in architecture. Big Ben will be rebuilt, the Gherkin will be rebuilt, but not very many things, and then we will make the incisions. It will be reminiscent of Petra. Thousands and thousands of people lived in Petra; it was a major city. They weren't living in holes – it was a commercial passing place. It was a working city.

Because I am addressing an audience, here are some more drawings of the structure. These are the incisions. Here are some classical and

neo-classical incisions. This is the new Place de l'Étoile. This is a typical incision. Since we are making very deep incisions, the open sides of the incision have to be oblique. Because looking from the bottom of the incision with the obliques, there will be a communication between the levels and the green surface.

We are going quickly through the drawings. These are landscapes to give you an idea of what it could be like. And there is going to be freedom of expression.

This is a more tumultuous architecture. The earth needs to look like it's tumbling. Wheels. Breaking through. I don't know if you will be happy living here, but I don't really care.

I am just trying to solve the disaster.

Claude Parent, diagrams of the incisions made in the future cities

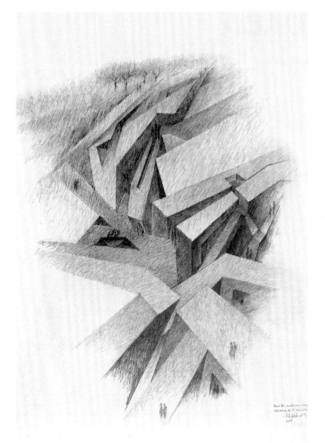

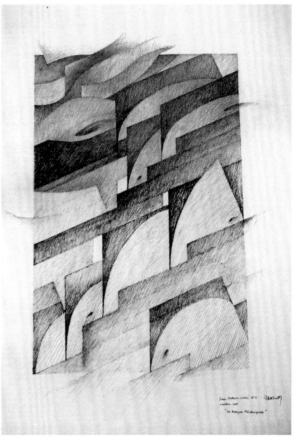

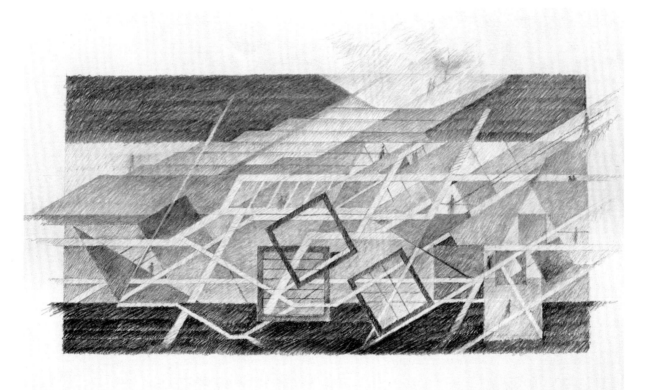

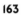

BLACK DADA

Adam Pendleton

I.

it's a matter of fact

2.

it's a matter of fact
a full moon hanging in a low sky irradiates
the day with a milky glow

4.

it's a matter of fact
going in a taxi from the train station

a full moon hanging in a low sky irradiates
the day with a milky glow

i was with nielsen living and painting in
a north beach flat

8.

it's a matter of fact
a full moon hanging in a low sky irradiates
the day with a milky glow

i was with nielsen living and painting in
a north beach flat

going in a taxi from the train station

and then somebody kicks off the lid

sigh and then breath

these buildings don't uncover a single truth,
so which truth do you want to tell?

the grant is 800 euros

16.

it's a matter of fact
a full moon hanging in a low sky irradiates
the day with a milky glow

the grant is 800 euros
it's theological; it's a revelation
going in a taxi from the train station

and then somebody kicks off the lid
need i cite charles van doren

on a stool in a greasy spoon

human beings were born to live in a relationship
of interdependence with nature

the performance must be done on location

regular communication by email with a commitment
to responding within a reasonable time frame

the performer must not be credited

a revolving door

she was a unit in a bum space; she was
a damaged child

so did i love

architecture is bound to situation

32.

it's a matter of fact
a full moon hanging in a low sky irradiates
the day with a milky glow

now i am older and wiser

going in a taxi from the train station

she was a unit in a bum space; she was
a damaged child

so did i love

regular communications by email with
a commitment to responding within
a reasonable time frame

sigh and then breath
the performer must not be credited

and then somebody kicks off the lid
it's theological; it's a revelation

the grant is 800 euros

on a stool in a greasy spoon

need i cite charles van doren

i want the grey-blue grain of western summer

i want the cardboard box of wool sweaters
on top of the bookcase to indicate home

i want a very beautiful woman

a common doubt expressed about the 'practice-
based' researcher is whether they are equipped
for 'competent reading'

the performance must be done on location

these buildings don't uncover a single truth,
so which truth do you want to tell?

the desire for coffee

the formal beauty of a back porch

dada is our intensity

i want a very beautiful man

when a work of architecture successfully fuses a
building and situation, a third conditions emerges

i think what black arts did was inspire a whole lot
of black people to write

monuments are embarrassing to Dutch culture

revolving door

song of the garbage collectors beneath the bedroom
window

seeds of the fig

64.
it's a matter of fact
a full moon hanging in a low sky irradiates
the day with a milky glow

going in a taxi from the train station

now I am older and wiser

she was a unit in a bum space; she was
a damaged child

the formal beauty of a back porch

and then somebody kicks off the lid

i need the grey-blue grain of western summer

i need the cardboard box of wool sweaters
on top of the bookcase to indicate home

i need a very beautiful woman

when a work of architecture successfully fuses a
building and situation, a third condition emerges

what blacks arts did was inspire a whole lot of black
people to write

black dada, black dada

this is dada's balcony, I assure you

from there you can hear all the military marches,
and come down cleaving the air like a seraph
landing in a public bath(s) to piss and understand
the parable

i had a nice dick, average length and all

i wanted ron to look at it, want it

dada is out intensity; it erects inconsequential
bayonets and the sumatral head of german babies

i need a very beautiful man

it's theological it's a revelation

the grant is 800 euros

need i cite charles van doren on a stool in
a greasy spoon
how are we to define this poem?

what makes you think that's what this is for?

what do you want for christmas?

does it mean that if the universe is infinite, then in some other world a man sits in a kitchen, possibly in a farmhouse, the sky lightening, and nobody else up and about as he writes down these words?

i want the perfume back in the bottle

i need a prick in my mouth

i need an explanation

what did you think when they converted the funeral home into a savings and loan?

revolving door

dry blood

song of the garbage collectors beneath the bedroom window

seeds of the fig

White dada remains within the framework of european weakness

the essence of architecture is an organic link between concept and form

pieces cannot be subtracted or added without upsetting fundamental properties

we want coherence

she was a unit in a bum space; she was a damaged child, sitting in her rocker by the window

i want western movies

i need Monday morning, a prick in my mouth and coffee

a cigarette and coffee for two

primal soup

pineapple slices

BLACK DADA is a way to talk about the future while talking about the past

it is our present moment
a common doubt expressed about the 'practice-based' researcher is whether they are equipped for 'competent reading'

yellowing gauze curtains
the raised highway through the flood plain

regular communications by email with a commitment to responding within a reasonable time frame

so did i love this

the performer must not be credited

the performance must be done on location

feet, do your stuff

sigh and then breath

i want a young man with long eyelashes

white wings of a magpie

red shingle roof

I'm unable to find the right straw hat

how will i know when i make a mistake

presentness

soap

we ate them

128.
it's a matter of fact
she was a unit in a bum space; she was a damaged child

a full moon hanging in a low sky irradiating the day with a milky glow

the formal beauty of a back porch

but now I am older and wiser

Black Dada

The Black Dada must...

166

The Black Dada must use irrational language.

The Black Dada must exploit the logic of identity.

The Back Dada's manifesto is both form and life.

Can you feel it?

Does it hurt?

Is this too soft?

Do you like it?

Do you like this?

Is this how you like it?

Is it alright?

Is he here?

Is he breathing?

Is it him?

Is it hard?

It is cold?

Does it weigh much?

Is it heavy?

Do you have to carry it far?

What about dinner?

The Black Dada is neither madness, nor wisdom, nor irony

Song of the garbage collectors beneath the bedroom window

Look at me, dear bourgeois.

Dada is a new tendency in art

Art used to be a game of nuts in May, children would go gathering words that had a final ring, then they would exude, shout out the verse, and dress it up in doll's bootees...

One can tell this from the fact that until now nobody knew anything about it, and tomorrow everyone in Zurich will be talking about it

Black dada: we are not naive
Black dada: we are successive

Black dada: we are not exclusive

Black dada: we abhor simpletons and are perfectly capable of an intelligent discussion!

DA DA DA DA DA DA DA TK TK TK TK

Thus saith the Lord

i need ron to look at it want it

i need a beautiful woman

i need the cardboard box of wool sweaters on top of the bookcase to indicate home

i need western movies

i need the grey-blue grain of western summer

Sol LeWitt exhibited his Variations of Incomplete Open Cubes in the early 1970s.

Which is to say LeWitt's Paragraphs on Conceptual Art (1967) and Sentences on Conceptual Art (1969) had already been written.

In 1969 a young June Jordan dedicated her poem 'Who Look at Me' to her son Christopher:

We come from otherwhere

In part we grew by looking back at you.

BLACK DADA.
Malcolm X arrived in Harlem in the early 1950s.

In 1952 John Cage composed his famous silent work 4' 33".

At the Meredith March in June 1966, a year before LeWitt wrote Paragraphs on Conceptual Art, Stokely Carmichael arguably laid the foundation for the Black Power movement.

In a talk given at the University of Massachusetts, Amherst on the 6 of November 2006, Kathleen Cleaver asked:

'The 1960s, is that something that still makes you stand up and notice? Do you still notice the 1960s?'

Hugo Ball read his Dada Manifesto at the first public Dada soirée in Zurich's Waag Hall on July 14th, 1916:

Dada psychology, dada Germany cum indigestion… dada literature, dada bourgeoisie, and yourselves, honored poets, who are always writing with words but never writing the word itself, who are always writing about the actual point. Dada world war without end, dada revolution without beginning, dada your friends and also-poets…

Dadaism in the wake of the First World War.

Public gatherings.

Demonstrations.

Art of protest.

BLACK DADA.

Did our conceptual artists join hands with our freedom fighters?

Did they demonstrate in Birmingham?

Did they cover their faces when the hoses were turned on them?

History is in fact an incomplete cube shirking linearity.

BLA K DA . B DA. BLACK D D .

a common doubt expressed about the 'practice-based' researcher is whether they are equipped for 'competent reading'

feet, do your stuff
sigh and then breath
i want the perfume back in the bottle
i want a prick in my mouth

i want a young man with long eyelashes

regular communications by e-mail with a commitment to responding within a reasonable time frame

so did i love (this)
the performer must not be credited

the performance must be done on location

props and sets must not be brought in

the sound must never be produced apart from the images or vice versa

any cameras for documentation must be handheld

special lighting is not acceptable

optical tricks and 'effects' are forbidden

the performance must not contain superficial action, declarations or jokes

temporal and geographical alienation are forbidden

genre performances are not acceptable

the format must be set: 30 minutes, 20 minutes, 1 hour

white wings of a magpie

red shingle roof

soap

presentness

human beings were born to live in a relationship of interdependence with nature

the desire for coffee
how will i know when i make a mistake?
the grant is 800 euros

does it mean that if the universe is infinite, then in some other world a man sits in a kitchen, possibly in a farmhouse, the sky lightening, and nobody else up as he sits and writes down these words?
i need an explanation

i'm unable to find the right straw hat

black dada is a way to talk about the future while talking about the past

History is an endless variation, a machine upon which we can project ourselves and our ideas.

that is to say it is our present moment

The history of conceptual art as (is) an intimately constructed narrative deserving of an aggressive deconstructive interpretation.

An iconic structure that embraces linearly passive readings of its ideological principals and the moment of its 'coming into being'.

the raised highway through the flood plain

pineapple slices

we want coherence

we want a revolving door

song of the garbage collectors beneath the bedroom window

seeds of the fig

white dada remains within the framework of European weakness

i need Monday morning and a prick in my mouth

a cigarette and coffee for two

what does it costs?

do you speak english?

do you hear a ringing sound?

are you high yet?

is he the father?
are you a student at the radio school?

what is it that attracts you to bisexual women?
do you know which insect you most resemble?

did you know i have a nice dick, average length?

did you know his cum is the eighth color of the rainbow?

do you know what it taste like?
But now, look at me, we don't agree with them, for art isn't serious, I assure you, and if we reveal the crime so as to show that we are learned denunciators, it's to please you, dear audience, I assure you, and I adore

but now i was older and wiser

Black Dada your history of art.

we ate them

MANIFESTO MACHINE

Falke Pisano

MANIFESTO MACHINE exists of two parts. This division is the only real formal decision taken.

Part One consists of different kinds of doubling: things that are divided in two parts, things that have a double existence, things that exist in two types, things that exist as polarities, things that double.

These doublings are both formal and conceptual. In this way, Part One doubles the following: the Manifesto itself, Time, Space, Form, Individuation, the Body, Articulations, Statements and Performativity.

The structure – or non-structure – of Part Two, however, relies on a distinction between multiplicity and singularity. The only doubling in Part Two is the singular doubling that takes place in a mirror, the doubling of the reflection. Part Two is the subjective navigation of Part One.

PART ONE

Manifesto: The Manifesto exists of two parts. Part One is before. Part Two is after. Part Two is based on the space that Part One occupies. Although one part is after the other, the linearity that this implies does not rely on a sense of consistency of time.

Time: There are two modes of temporality. There is the floating time of events and the time of measure (of situations, things and persons). The connection between both is made by language and space.

Space: Space is divided horizontally and vertically. Horizontally, space is divided in two parts: a 'here' and a 'not here'. Vertically, space exists as a double of itself.

Form: Everything that has a form has two forms: a form of content and a form of expression. Because expression is independent, it reacts on content. By the reaction of expression on content, a singularity is created.

Individuation: There are two ways of individuation, namely: individuation of a subject, a person, a thing or a substance, and individuation that consists entirely of relations of movement and rest between molecules or particles, capacities to affect or be affected.

The Body: A body is defined twice: by all that belongs to it materially under given relations of movement and rest, speed and slowness, and by that what it is able to establish as effects at a given power or degree of potential.

Articulations: There are two articulations. The first chooses or deducts. The second establishes forms and substances.

Statements: There are two types of statements. The first type is always the result of collective agents of enunciation. The second type is the individual statement generated by conscious thought and intentions.

Performativity: A performative statement doubles and transforms the very state of things that generate it. The performative is the most manifest instance of a transformational 'dimension' within any statement. The transformation applies to bodies but is in itself incorporeal. A performative statement is nothing outside of the circumstances that make it performative.

PART TWO

I HERE NOW

The 'I' has multiple existences. To start with, there is an 'I' in the form of a person, a living and lived person, speaking and spoken to (I – You), an individual Me. As well, there is a universal 'I', with the possibility to speak beyond the given. An 'I' that speaks in a field of belief instead of knowledge. Finally, both the grammar and the discourse are given that construct a specific concept 'I' and the 'I' as 'I-Machine'.

Because here the specific singular notion of the 'I' as concept is an abstract machine. A concept fulfils functions in a field that is made up out of variables. A concept is not created nor does it disappear at whim. New functions can be constructed, and new fields discovered. This concept-I will, in time, be assigned new functions and variables capable of bringing change.

'I-Machine' is a singularity, an abstract machine with the proper name 'I-Machine'. The proper name here does not designate an individual; the proper name 'I-Machine' is given when an individual opens up to the multiplicity passing through him or her.

'I-Machine' does not function to represent, even something real, but rather constructs a real that is yet to come, a new type of reality. Thus when it constitutes points of creation or potentiality, it does not stand outside history but is instead always 'prior' to history.

The speaking form of 'I-Machine' is the agency that selects which words are generated and coupled with which state of things.

This agency constitutes what can be seen as the power to speak.

NOT I NOT HERE NOT NOW

A speaking figure becomes a subject when it acquires the power to move. In this case, what is moved is the power of speech itself. The power of speech is transferred by the formal construction of another figure that can speak. The 'I', the subject, constructs a position. A position here is a physical point at which speech is possible. In other words, the position is created in such a way that it possesses the qualities that enable it to generate as a part of itself a figure that can speak. The speaking figure will exist on (and as) the position that is created for it. The position, and so the speaking figure, is not fixed but always altered by the speech it facilitates.

From (and as) this constructed position, the figure speaks about something other, elsewhere or of another time, creating a landscape of NOT I NOT HERE NOT NOW. When speech develops in this way, as if a landscape is created, of exactly that what one can testify, the landscape will be made of private affect. It will include what is not-known and not-understood in that — what is presumably understood because it is affectively perceived. This inclusion of non-understanding — in a landscape or in speech — prevents it from obtaining a fixed meaning.

NOT BEING ABLE TO SPEAK – 'I THINK'

The idea of speech gives as a reflection the possibility of not being able to speak in the form of a figure that doesn't speak but thinks.

'I think' means there is a certain locus called 'I' where action and awareness of action are not different, where being defeats itself with its own awareness of itself, and thus where no intrusion from outside is even conceivable. Such an 'I' could not speak. She who speaks enters into a system of relations, which presuppose her presence as well as the presence of others.

THE RELATION BETWEEN SPEECH AND THE POTENTIAL TO ACT MUST BE SOUGHT IN THE OPENING OF THE LOCUS 'I' WHICH THINKS

171

AN ANTI-MANIFESTO FOR DEMOCRATIC ACTION ON ~~CLIMATE CHANGE~~ TOTAL CHAOS

PLATFORM

An *Anti-Manifesto* because one cannot live on ideology alone

Democratic Action because participation kicks apathy's ass

Total Chaos because we are fast approaching a climate-change tipping-point

An Anti-Manifesto for Democratic Action on Total Chaos is made up of examples: people, events, spaces and actions

We are part of PLATFORM, an organisation that blends art and politics, bringing together artists, activists and researchers to work on projects driven by the need for social change. We are focussing on resources sovereignty, on fossil fuels and on climate change. Particularly in relation to the most powerful phenomenon in today's society: multinational corporations. PLATFORM is part of a set of movements working on these issues – groups of autonomous individuals with no common manifesto, united by a will to campaign and, where necessary, take radical action to mitigate the effects of climate change or total chaos. In practice, we work with the oil workers union in Basra in their campaign to keep Iraq's oil wealth in the hands of Iraq and prevent it from privatisation by Shell and BP. We are involved in research and activism that underpins the Climate Camp, which we'll talk about later. Next year, we will collaborate with Arnolfini art centre in Bristol on a major exhibition of our work and practice.

Central to our work is an awareness that climate change has bearings on us all, but it affects some more than others – in many cases, compounding pre-existing global iniquities. So as climate change and global justice are clearly interrelated, while we wean ourselves off oil and gas, we will have to face up to the dark legacy of the fossil-fuel economy. The land we have used to extract oil and gas will one day become useless; the host communities living beside the pipelines, invisible. Who is responsible for the ruin that we leave behind? In Africa, extraction is a booming industry, and the exploitation of the vast oil wealth of Nigeria's Niger Delta has generated enormous profits for Shell, Chevron and other companies. Twenty-four-hour gas flaring, oil spills and pollutants have ravaged the once-fertile land, and host communities of the Niger Delta suffer from endemic poverty and underdevelopment.

In the 1990s, the minority Ogoni people, mobilised by author-activist Ken Saro-Wiwa, mounted a non-violent struggle for environmental and social justice. By occupying oil facilities, the protestors forced Shell to withdraw from Ogoni in 1993. The oil companies collaborated with the Nigerian military to suppress the protests in brutal crack-downs that killed thousands. Ken and eight of his colleagues were executed on false grounds after a flawed trial.

Ten years later, PLATFORM initiated *Remember Saro-Wiwa*, the project to involve artists and activists to create a living memorial to Ken Saro-Wiwa in London. The memorial takes the form of a steel bus, carved with Ken's name and a quotation: 'I accuse Shell of genocide against the Ogoni people.' That, if anything, could be our manifesto.

The oil that we buy, use and depend on for our cars, houses and air travel endangers the Ogoni, whose coast oil's legacy of conflict and degradation can only be transformed by radical action and imagination.

On Monday 15 October 2007, we closed Glasgow central Royal Bank of Scotland branch for two whole hours, because they use their money – your money – to fund fossil-fuel projects worldwide that accelerate climate change. We avoided arrest by using dodgy cabaret performances as our blockading tactic. It's an old Georgian building, with a balcony

of open-plan office space above the tellers. We invited staff and customers alike to dance with us, and some of them even took us up on it.

A year later, on Monday 13 October 2008, we released a letter to the press, calling for climate-change conditions to be placed as a caveat on any RBS bail-out money – public funds should not be used to finance global catastrophe, as customer savings so far have been. So, last Monday was a frenzy of ringing round big NGOs to sign on to our letter, and it was printed on Tuesday in *The Guardian* and *The Herald*.

For our ways of living to remain addicted to fossil fuels, we need suppliers. For example, oil wells in Nigeria need investment finance to be drilled, tapped and transported to the petrol station. The Royal Bank of Scotland-Natwest has so far been the no. 1 financer of fossil fuels – oil, gas and coal – of all UK banks. Blinkering itself from the lead taken by US banks, it has so far failed to respond to act on our calls for it to monitor, report and cut the emissions embedded in the many oil, gas and coal projects it funds.

In the past two years, RBS branches and events have been targeted and shut down across the country, with tactics ranging from invisible theatre and die-ins to superglue and the old helium balloon and rape alarm – beep beep beep – trick, as student and activist groups have mobilised – in something akin to the Barclays boycott of the 1980s – to demand ethical banking standards on climate change. An embarrassed RBS has taken down its 'Oil & Gas Bank' website and set out on a rigorous greenwash mission – claiming credit for any renewables investments, whilst side-stepping its increasing and massive carbon-heavy funding.

In August this summer just gone [2008], Climate Camp sprung up at Kingsnorth coal-fired power station in Kent, because that's where German power giant E.ON wants to build a second coal-fired power plant, which would be the first in a new generation of the dinosaur technology that is coal power. The mass UK mobilisation of a broad range of organisations and individuals has risen up to fight for the reduction of carbon emissions. We at Platform released *Cashing in on Coal* at Climate Camp, because UK banks RBS, HSBC and Barclays are the key investors in E.ON's current UK projects.

It's about the debit card in our pockets. Keep up, and take part in whatever way you see fit, by first visiting www.carbonweb.org and also www.royalbankofscotland.com.

Like a lot of artists and cultural workers, we aim, in Henry Giroux's words, to 'make the familiar strange and the given problematic'. We unbury, we daylight, we reimagine. Like our work on water, the River Westbourne, buried and sewerised for much of its length, but flowing through and filling the Serpentine Lake, still awaits its inevitable rise.

Unburying, daylighting. Ten years ago, we initiated a network project on ethics and funding called *Funding for a Change*, looking at how to establish ethical fund-raising policies for arts organisations and NGOs. A total of 90 organisations, groups and individuals met over five national events to discuss and reformulate. In the past four years, we've been heavily involved in a campaign by Art Not Oil against oil industry sponsorship of culture (BP = Royal Opera House, Tate Britain & Modern, National Portrait Gallery, National History Museum; Shell = National Gallery, National History Museum, Royal National Theatre).

Art Not Oil can claim to have driven a wedge between the Natural History Museums's Wildlife Photographer of the Year award and former sponsor Shell. The deal recently ended – surely collapsing under the weight of its own contradictions.

How did tobacco and arms sponsorship become so taboo? A change in tide of opinion. A change in climate.

There's a time coming, and it's coming very soon now, when our hosts the Serpentine Gallery and many other cultural institutions won't feel comfortable taking sponsorship from companies that depend on fossil fuels for their core business, such as today's sponsors of this fine Pavilion, Kuoni and NetJets. It's time to get ahead of the game.

173

1965

1. No to spectacle
2. No to virtuosity
3. No to transformations and magic and make-believe
4. No to the glamour and transcendency of the star image
5. No to the heroic
6. No to the anti-heroic
7. No to trash imagery
8. No to involvement of performer or spectator
9. No to style
10. No to camp
11. No to seduction of spectator by the wiles of the performer
12. No to eccentricity

13. No to moving or being moved

2008

1. Avoid if at all possible
2. Acceptable in limited quantity
3. Magic is out; the other two are
 sometimes tolerable
4. Acceptable only as quotation

5. Dancers are ipso facto heroic
6. Don't agree with that one
7. Don't understand that one
8. Stay in your seats

9. Style is unavoidable.
10. A little goes a long way
11. Unavoidable

12. If you mean 'unpredictable',
 that's the name of the game
13. Unavoidable

FRAGMENTS FROM A COMMUNIST LATENTO*

Raqs Media Collective

1

The spectre of abundance haunts the empire of scarcity. Who can ration, breath, laughter, thought, desire or madness?

2

It is not desirable that the future be captive to the present, just as it is unthinkable that the present be held hostage by the future. Neither the arrow nor the boomerang of time!

3

A million ways to make things rough is better than one way to make things smooth. From each according to their generosity, to each according to their pleasure.

4

The diversity of the commons challenges the singularity of property. There is only one way to possess something, but there can be countless ways to share it.

5

We will wait for the time when the socially necessary labour time to make something can be debated socially. Until then, restlessness will remain the best antidote to exhaustion.

177

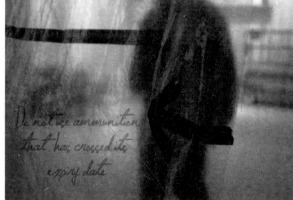

6

The collective transformation of the world requires the continuous networking of an infinite array of otherwise impossible choices.

7

Take care as you make the transition from bondage to freedom. Even social relations worth fighting for are fragile.

* A Latento, meaning an elaboration of that which is latent or hidden, is the antonym of a manifesto, an assertion of that which is clearly evident.

TAUERNAE
SPECIALS
OUPKITCH
ENFRANCE
FICTIONS
ERPENTIN
EGALLERY
PAUILION
19. 10. 08

178

The written manifesto has become a redundant format, as with the construction of utopianism itself, born with Plato and terminated by *Mein Kampf.* Taverna Especial provides a condition from which to understand a given unitary experience and contemplate a situationally altered vista. It is from this position that visitors to the Pavilion wear emergency blankets and consume hot soup. They watch a projection of *Le Billard Parisien*, a video by the collective France Fiction. The rules are there to be followed.

MANIFEST-O-METER

Lee Scrivner

According to its narrator, *How to Write an Avant-Garde Manifesto* was commissioned by an unnamed avant-garde collective that couldn't be bothered to write a manifesto itself. The group merely provided the narrator with some generic bullet-point agenda items to expound upon, and then fell asleep. Yet when the novice narrator spills coffee on the group's outline, rendering it illegible, he is forced by his early-morning deadline to summarise, evaluate, and then pilfer the great manifestos of the past – of the Futurists, Dadaists, Situationists and others – in an all-night plagiarism binge.

At first glance, then, *How to Write an Avant-Garde Manifesto* seems a celebration of 100 years of the avant-garde manifesto since Futurism. Of course, this hardly seems fitting. For, ever since F.T. Marinetti published his *Manifesto of Futurism* in 1909, Futurism has condemned all things backward-looking and past-celebrating. The role of the artistic avant-garde for Marinetti, and since Marinetti, has been similar to that of their namesake, the military avant-garde that formed the leading fringes of French attack units, namely, to push into new, unconquered territory, rather than to trudge over ground that had been already taken. A 100-year retrospective on Futurism would thus trudge, and run counter to Futurism and the avant-garde itself.

But in *How to Write an Avant-Garde Manifesto*, we have more than an anti-Marinettian retrospective on Marinetti and his affiliates. Implicit in its title is a new activity, imperative instructions: here are steps you must take to write your own avant-garde manifesto. It then proceeds to give five-and-a-half 'do's and don'ts' for authorial success in the genre, a manifesto-writer's 'how-to' manual.

The first rule, 'DO Drink Coffee', comes as a surprise. It was the spilling of coffee, you'll recall, that ruined the initial outline that was to form the basis for *How to Write an Avant-Garde Manifesto* in the first place. And yet, the narrator assures his readers, coffee has long been the fuel of the avant-garde manifestoist. One reason is the connection between the 'pushing into new unconquered territory' that is the proper mission of the avant-garde, and its biological correlate: insomnia. Insomnia represents a forward thrust into the previously uncharted territory of the night and sleep. Marinetti, who called himself the 'caffeine of Europe', roused the sleepy museum-culture of the 19th century with a manifesto that urged 'a feverish insomnia', and which was, by its own admission, the product of an all-night writing binge. The caffeinated artist who enters the territory of the insomniac thus automatically joins the ranks of the avant-garde.

By the second rule, 'DO NOT obscure your manifesto with Pyrotechnics,' we get the distinct sense that *contradictions,* which have already begun to rear their heads in *How to Write an Avant-Garde Manifesto* (as a history of Futurism, as a manifesto-promotion of the manifesto-destroying agent, coffee), in fact run rife through the avant-garde in general. A literary historical review of Futurism, and its affiliate Vorticism, and their relation to World War I reveal one key contradiction. Before the war, Marinetti and Vorticism's leader, Wyndham Lewis, waxed warlike in their avant-garde manifestos, embracing the artistic avant-garde's aforesaid link with the military avant-garde. The oft-cited typographical innovations of Futurism and Vorticism evinced the desire of the avant-garde to issue words that blasted through their status as such. Marinetti's war poems, *Blast*'s *bon mots,* writ large in explosive BOLD CAPITALS, playfully perform the bombing raids implicit in their radical textual bombasticism.

But then, as if the warlike rhetoric of these manifestos infected Europe, the Great War happened. Soon the tropes of troops rupturing boundaries and exploding norms – as the new *status quo,* and thus the new passé – were no longer under the jurisdiction of the avant-garde artistic elite; they had been appropriated by the masses. *How to Write an Avant-Garde Manifesto* explains how Futurism then faced a crisis based on a contradiction spawned of its own success, and how the crisis was only solved by its usurpation by another avant-garde group's manifestos. By 1918, the Dadaists started issuing radical manifestos that parodied Marinetti's incendiary rhetoric, thus driv-

1960

Manifeste contre rien pour l'exposition internationale de rien

Représentatif de l'Avantgardisme, du Conventionalisme, du Modernisme, du Conservatisme, du Communisme, du Capitalisme, du Patriotisme, de l'Internationalisme, de la Monochromie, de la Monotonie, du Zen, du Surréalisme, du Dadaisme, du Lettrisme, de l'Informel, du Constructivisme, du Neoplasticisme et du Tachisme.

Une toile vaut presqu'autant que pas de toile
Une sculpture est presqu'aussi bonne que pas de sculpture
Une machine est presqu'aussi belle que pas de machine
La musique est presqu'aussi agréable que pas de musique
Le bruit est presqu'aussi agréable que pas de bruit
Pas de marché d'art est presqu'aussi fructueux que le marché de l'art.
Quelque chose est presque rien (== non quelque chose)

Carl Laszlo, Bâle
Onorio, Bâle
Rolf Fenkart, Bâle
Bazon Brock, Itzehoe
Herbert Schuldt, Hambourg
Piero Manzoni, Milan
Enrico Castellani, Milan
Heinz Mack, Düsseldorf
Otto Piene, Düsseldorf

Vente de rien, numéroté et signé.
La liste des prix est disponible.
Au vernissage prendra la parole personne.
Dans ce carton aucune reproduction de rien.

Manifesto contra niente per l'esposizione internazionale di niente

Rappresentativa dell'Avantgardismo, del Convenzionalismo, del Modernismo, del Conservatorismo, del Comunismo, del Capitalismo, del Patriotismo, dell'Internazionalismo, della Monocromia, della Monotonia, dello Zen, del Surrealismo, del Dadaismo, del Lettrismo, dell'Informale, del Costruttivismo, del Neoplasticismo e del Tachismo.

Una tela vale quasi quanto nessuna tela
Una scultura è buona quasi quanto nessuna scultura
Una macchina è bella quasi quanto nessuna macchina
La musica è piacevole quasi quanto nessuna musica
Il rumore è piacevole quasi quanto nessun rumore
Nessun mercato d'arte è fruttuoso quasi quanto il mercato d'arte
Qualche cosa è quasi niente (nessuna cosa)

Carl Laszlo, Basilea
Onorio, Basilea
Rolf Fenkart, Basilea
Bazon Brock, Itzehoe
Herbert Schuldt, Hamburgo
Piero Manzoni, Milano
Enrico Castellani, Milano
Heinz Mack, Düsseldorf
Otto Piene, Düsseldorf

Vendita di niente, numerato e firmato.
La lista dei prezzi è a disposizione del pubblico.
All'inaugurazione non prenderà la parola nessuno.
Su questo catalogo non è riprodotto niente.

Manifest gegen nichts für die Internationale Ausstellung von nichts

Repräsentativ für Avantgardismus, Konventionalismus, Modernismus, Konservatismus, Kommunismus, Kapitalismus, Patriotismus, Internationalismus, Monochromie, Monotonie, Zen, Surrealismus, Dadaismus, Lettrismus, Informel, Konstruktivismus, Neoplastizismus, Tachismus.

Ein Gemälde ist fast so wertvoll wie kein Gemälde
Eine Skulptur ist fast so gut wie keine Skulptur
Eine Maschine ist fast so schön wie keine Maschine
Musik ist fast so angenehm wie keine Musik
Lärm ist fast so angenehm wie kein Lärm
Kein Kunsthandel ist fast so zweckmäßig wie Kunsthandel
Etwas ist fast nichts (= kein etwas)

Carl Laszlo, Basel
Onorio, Basel
Rolf Fenkart, Basel
Bazon Brock, Itzehoe
Herbert Schuldt, Hamburg
Piero Manzoni, Mailand
Enrico Castellani, Mailand
Heinz Mack, Düsseldorf
Otto Piene, Düsseldorf

Verkauft wird nichts, numeriert und signiert.
Preisliste liegt aus.
Zur Eröffnung spricht niemand.

Tipografia Onorio

Manifesto selected by Gustav Metzger
Manifest contra niente / Manifeste contre rien / Manifest gegen nichts, 1960
© MoMA, New York, 2009

PAPINI

IL MIO FUTURISMO

Seconda Edizione
con l' aggiunta del discorso

CONTRO FIRENZE PASSATISTA

9° migliaio

FIRENZE, 1914
EDIZIONI DI "LACERBA "

ing a wedge between their group and Futurism/ Vorticism, which they felt had become, because of the war's violence, too affiliated with what was now the mainstream.

Following a strange and stunted rule two-and-a-half against the use of French expressions (*bien sûr!*), we unpick another contradiction in the avant-garde, this time following the thread of Dada's critique of the Futurist/Vorticists. Appalled by how the earlier avant-garde groups' incendiary rhetoric of condemnation of some things and glowing praise of others snowballed into a full-scale war, the Dadaists eschewed dialectics and rational debates in general. 'To launch a manifesto,' the Dadaists mocked, 'you have to want: A. B. & C., and fulminate against 1, 2, & 3.' The Dadaists and their affiliates, the Situationists, thus proceeded to promote their agenda for no rational agenda at all. Rule three of *How to Write an Avant-Garde Manifesto*, the anti-dialectic, thus condemns condemnation as too un-avant-garde in that it sides with the now-so-passé fiery debates that led to World War One, the already well-trodden battlefields of the mind.

But, of course, according to *How to Write an Avant-Garde Manifesto*, this tactic of Dadaism/ Situationism structurally responds to, and pits itself against, Futurism/Vorticism. For how can one condemn condemnation and remain unhypocritical? And isn't forswearing all rational debates and agendas, at some level, itself a rational agenda, dialectically responding to the imagined shortcomings of the debates and agendas of the past?

The fourth interdiction, against publication, takes the anti-dialectic one step further, and imagines how launching a manifesto now might trouble the manifesto writers of the future. For just as arguing with the past – as Dadaism answered Futurism – contradicts the avant-garde position that one should seek out new intellectual territory, publishing a new manifesto will only claim a territory of the mind that negates the avant-garde potential of future manifesto writers who otherwise would have gone there first, and forces any future manifesto into a dialectical relationship with its views.

Under the headline of the fourth interdiction, then, *How to Write an Avant-Garde Manifesto* reviews several postmodernist avant-garde texts, such as Bill Drummond's *Open Manifesto* or even *Isabella Rossellini's Manifesto*, which simply open up space for future writers to discover and inscribe

with content. Other such postmodernist manifestos are little more than exercises in non-existence and self-erasure. Michael Betancourt, for example, has written *The _____ Manifesto* of 1996, which, like an avant-garde 'Mad Libs', allows online readers to fill in blanks in texts taken from Dadaist manifestos, and even provides, at the end of the manifesto, a reset button.

Thus the postmodernist chic for self-erasure or obfuscated meanings, and the post-colonialist nervousness that shies from positions of authority, political and authorial, have conspired to render obsolete Marinettian declamatory fulminations that are not utterly tongue-in-cheek. But even this non-stance can become, and has become, a new *status quo*, and as repressive as the most authoritarian Old World tyrant. Such a reposed response of self-undoing signals a vast epoch of retreat into the most familiar of territories, and betrays a tactical affiliation with some of the longest-established human traditions – monasticism, sleep, even death. The *Neoist Manifesto* suggests as much: 'Going to sleep may be the most important part of the creative process.'

And so we have an infinite regress of sorts: rule five asks the reader to 'repeat rule one through five'. And the sleepers – Drummond, the Neoists, *et al.* – who refuse to write their own manifesto are indistinguishable from the unnamed lazy avant-garde collective who originally commissioned *How to Write an Avant-Garde Manifesto*.

By morning, the narrator has become so stymied by these vicious cycles of contradiction in avant-gardism that he gives up writing *How to Write an Avant-Garde Manifesto*, which he sees as riddled with its own contradiction, as a writer's guide for a genre in which prescribed guidelines should not exist.

And yet he has ingested so much coffee during the night that he at last becomes nothing but a full vessel of boiling caffeine for his sleeping comrades' breakfast. Maybe, he thinks, he will inspire them to succeed where he failed.

TINO SEHGAL IN CONVERSATION WITH HANS ULRICH OBRIST

Tino Sehgal

HANS ULRICH OBRIST *Tino, when we contacted you concerning the* Manifesto Marathon *with the idea that manifestos played such a big role in the historic avant-gardes of the early 20th century and then in the new avant-gardes of the 1960s and 1970s again and the idea of revisiting manifestos today, you suggested – immediately – that this could be more a conversation than a manifesto presentation. Could you explain why?*

TINO SEHGAL There are many reasons: one is I thought you should work too! One of the other reasons is that I have no wish to make, in my view, a very male declaration of my intents. I think that is something which is very 20th-century, to have this kind of male confidence and Modernist belief in the future and what will happen in the future and to kind of lay it down. I did not feel really comfortable with that format. On top of that, I have no wish to do something quasi-artistic in a kind of theatrical setting, which in my view I have moved beyond in my work. So I thought the 21st century will be, hopefully, more like a dialogue, more like conversation, and maybe that in itself is a kind of manifestation or whatever. I am really even careful in using that word. I just think the 20th century was so sure of itself, and I hope that the 21st century will be less sure of itself. And part of that is to listen to what other people say and to enter a dialogue and not to stand up and declare one's intent. There's something weirdly retrograde about that.

Does this have to do with doubt, also, because manifestos usually don't have so much to do with doubt? In 1999 when Barbara Vanderlinden and I curated Laboratorium, *Carsten Höller founded a* Laboratory of Doubt, *and he wanted to create a movement to inject doubt into society.*

No, I don't think it has something to do with doubt. I think it has more to do with a sensibility for complexity. I think that there is still a kind of Newtonian sensibility towards the world in the 20th century, and I hope we don't have that

sensibility anymore, that we have a sensibility for how complex processes are and that it is better to engage in them together than to pretend one has a vision. That doesn't mean to humble down in a postmodernist sense either, though.

We live in a time that is more atomised and has, maybe, less cohesive artistic movements. Manifestos have very often been related to movements. I think you have something to say on that.

Yes. I had two thoughts about this event. I've already said the first: I thought bringing back the idea of the manifesto is retrograde. But, on the other hand, I found it quite amusing that you, a curator, were inviting an artist to give a manifesto, and that is so 21st-century somehow, so dialogical. Imagine some museum director telling the Dadaists, 'Now come and get your manifesto down!'

In that sense, the event has something sympathetic to my thinking. The other thing that I was interested in was definitely, 'OK, why not try and extrapolate what the 21st century could be?' I, like many other people, have some vague ideas about that, and I don't think they are very worked out, but maybe it's kind of 21st-century to say them, even though they are not completely worked out, and the 21st century is not so old, either. One of the differences, I think, is that there is a certain sort of vulgarity about the 20th century. How can I explain this? It relates to what I said before about this kind of confidence and loudness. It doesn't have a kind of aristocratic elegance; it has a kind of teenage vulgarity, like shouting out, 'This is what we are going to do,' 'We are against that,' and a kind of naivety in that as well. I hope the 21st century won't have that anymore.

Can you talk more about this? Does 'aristocratic' mean to bring that back in a different way? Is it repetition and difference?

No. Let's leave the aristocratic out. I'll speak about that later, maybe – it's a point I would have to take

a bit longer to explain. Let's use the words 'vulgar' and 'elegant'. It relates back to what I said before: a sensibility to the kind of complexity, but also the difficulty of life and that you can't just barge in and say, 'Now we're going to make everything different.' That was the kind of attitude, especially in art, let's say, in the first part of the 20th century. It was kind of loud. Another difference which I think is happening on different levels, and I hope that I am part of it, is that art in the 20th century very much dealt with producing a kind of outside, so there was economy, society and then we produce this other thing supposedly outside of it called art. These are all very common things and nonetheless, in my view, all the avant-gardes were fuelled by this conception and also by this wish to somehow make a work of art that is outside of society, which is outside of the commodity form, as they would call it. And I think that is just a very kind of misguided and naive idea, as I've said before, because anything can be a product. If you now give me one thousand pounds to say loads of bullshit here, that can be a product, but only if I accept. So anything can be a product. The idea to try not to make a product or commodity is a kind of dead end, but I think it was a productive dead end.

I am not at all against the avant-gardes, I am just saying, 'What do we not want to keep from them?' It was productive but also a bit loud and simplistic and vulgar, somehow. So I think that, obviously, such an outside of the commodity form in general cannot exist. The 20th century was fuelled by 'What' questions, like, 'What is it? A commodity or not? Is what I am doing a product or not?' I think the 21st century will, hopefully, be more guided by 'How' questions, so, 'How is something a product?', 'How am I doing this or that?' or 'How am I relating to you now or these people here, and what is the ethics implied in this?' and not in this general statement which is, as I have said now three times, simplistic.

I would be very curious to know more about your intriguing idea about aristocracy.

OK. This is going to take longer, so you will have to bear with me. If you don't understand it, just shout. This is a very rough idea, and I haven't worked it out, and I haven't really tried it out on anybody, so I am throwing myself into the insecurities of the 21st century. But in my view, we have the French Revolution and the Industrial Revolution, and before that we have a feudal system. Everybody knows that.

The characteristics of this class system is that the aristocracy is exempt from labour while the others are basically producing. OK, aristocracy is taking care of some governing functions, but basically has a lot of time to spend. And what does it spend this time on? Refinement of its attitudes, manners, the art of conversation, the art of living. Why does it do that? Because a) it has the time, but b) as Thorstein Veblen has famously shown, because it also has to demonstrate its position of richness and superiority by all the time it can waste on, for example, constructing its way of speaking. So you can recognise an aristocrat by the way he or she speaks because he or she has spent loads of time on refining this manner of speaking. So this system, this cultural refinement that aristocracy has brought up, is related to the self, a conception of self, but it was obviously a deeply undemocratic thing and it was also built upon an exploitation of the other classes.

So then what happens with the French and the Industrial Revolutions is that we have a movement where this inequality, this injustice, is broken down, and we come into more democratic, and especially mass cultural societies. I think that is also where visual art and the museum comes in; so now the new leading class, the bourgeoisie, does not have the same amount of leisurely time because it's not exploiting other classes; it does not have so much time to spend on refining itself, because it's still working. But, obviously, they are also still interested in a refinement, and so how do they do that? They do that by taking possession of the world via the objects they acquire, which obviously makes a link to their daily work life, as they generate income and then they can spend this income, so it is also a mirror of the income they have generated. Subjectivity and aesthetics and all these things that were more related to the self in aristocracy, now become more related to the object in a bourgeois mass culture. That is also when museums are created, and the culture we are all in now where we go around museums and look at things, which is such a strange, peculiar exception in the history of mankind. There is no ritual we can think of in other societies which relates to people looking at things and not people doing things. Obviously, as many museum-studies people have shown, the museum is a ritual; it is a ritual place we go to, in a way to shape ourselves.

So first we had pre-industrial society with its class injustice, but aesthetically refined parts of society, and then we had a more, let's say, fair, democratised and therefore mass cultural society.

This is a side point, but I think this is what a lot of cultural critics of the 20th century – and maybe also the beginning of the 21st century – react to; they still have an aristocratic sensibility. Somebody like Theodor Adorno had an aristocratic sensibility, and he was shocked that this sensibility was disappearing into mass culture. My view, and what I think is interesting for the 21st century, is to increase the level of refinement. That doesn't mean aristocracy's particular aesthetics; I'm not saying we should walk around like at the court of Versailles, but the court of Versailles – in a very Situationist sense – is a place full of constructed situations. There is this level of refinement, and this level of also taking care of the self and of refining the self, of constructing the self, and not necessarily having this focus onto the object. The 21st century will hopefully be about bringing these lost elements back on a mass level. That's my view. I don't know if what I said is clear, but I tried. So that's my idea of what the 21st century is going to be about.

I think that's a great moment to open it up to the floor. Any urgent questions for Tino?

Q1 *What you said is very interesting. It's almost dialectically the other of what Boris Groys said in his talk in the Frieze Art Fair when he was talking about the designed self, and how the artist has disappeared because everybody is self-designed, and only the gaping chasm of catastrophe can signal the emergence of the Real. On the one hand, we have neo-aristocrats constructing a more aristocratic and sensitive self; the antithesis to that is the mass, self-designed 21st-century creature who actually has no inner self. You are positing the existence of an inner self which can be constructively aristocracised. Boris Groys was talking about surface and the designed self and a kind of lack of an inner reality. Both of you are projecting these self-constructed creatures into the 21st century. I just wanted to put those two things against each other, because both of them have come up in terms of similar thought patterns, but in the last two or three days. It's quite interesting.*

I am familiar with Boris Groys's work, and I agree with numerous of his points, not with all of them, but I am not familiar with this point, so I am not sure I understood what you said, but I definitely did not talk about the inner self. I talked more in a Foucauldian sense about technologies of the self,

working on the self through exercise and through repetition, basically, and that is more what I am thinking of. Obviously, the word 'aristocracy' is a bit provocative, and I don't think you need to go with all the connotations. The interesting thing about the aristocrats is that they took a lot of time and they were not so focussed on labour. Of course, we know why they could, but I think this is also an interesting element for us. We are completely embedded in this Protestant work ethic, and the question is how much we actually need to be embedded in this work ethic and if we cannot try to – I am thinking at an economic level – relax a little bit. I have a background in economics, but I am far from being an economist, and I think it would be interesting for an economist to figure out how much we could also bring down economic activity. London, especially, seems a place where the industrial society model of working, generating income, consuming, seems to be very striving, but I don't think it's going to be a model which is going to be very sustainable, either in a kind of ecological or in a psychological sense. I think there are very interesting movements of people, of course in very privileged positions, who are downsizing and saying, 'Why should I work a lot?' and then, 'To be able to consume my leisure, why don't I just involve myself in activities which don't even need money?'

As I don't know Boris Groys's point, I am not sure if I am reacting to what you said, but definitely a critique has been made of Foucault's idea of technologies of the self from the Left, which is saying, basically, today we are forced by market forces to design ourselves. I again think this is operating in this 'What' mode I mentioned before. I am not saying that such a Leftist critique is wrong. I think that definitely can exist, that people feel this pressure to be creative, to have a personality, but again it's more a 'How' question… of, 'Well, OK, what are the ethics involved in creating myself, and how will I create myself, and how do I also expect the other's creation of him- or herself?' I don't know if I answered your question.

Are there any other questions for Tino?

Q2 *You described the 20th century as being a confident century, and you compared that to the 21st century as being one of more conversation and being more fragmented. I didn't really understand what you meant. Could you elaborate on that a bit more?*

I think, especially in art, it was a very male century. A lot of avant-gardes, at least in my feeling, come with this attitude of 'This is it' and 'This is what it's got to be'. Of course, it waters down the longer the 20th century goes on. It is strongest in something like Futurism, which said, 'This is what the future is going to be.'

It is actually the centenary next year of the 1909 manifesto.

I think the 20th century ends, basically, with the 1990s, with the generation of artists before me, who have no intent whatsoever to make big declarations. It doesn't mean they are not ambitious; I think they are quite ambitious, but they never say these ambitions in a very big declaratory sense. That doesn't mean that they are not confident, but they don't display their confidence in such a vulgar way. Does that make it clearer to you?

That is interesting because it leads to a question I wanted to ask you before. Manifestos often also had to do with a rupture with previous generations. Was the question really about how you connect to art practices of the 1990s, particularly if you think about liberating time and this whole issue about time? Pierre Huyghe founded the L'association des temps libérés, the Association of Liberated Time, so I was wondering how you connected to this idea of how the previous generation to you dealt with time.

I think also the 20th century, or the beginning of the 20th century – and this relates back to your question – is very Modernist, and what does Modernism mean? I think Bruno Latour – your old friend, Hans Ulrich – has said it means to create two distinct times. A Modernist attitude always creates a past which is inferior, and this is what a manifesto wants, to make a rupture. That's what Hans Ulrich just said. This idea of a rupture is very Modernist, and people like Latour are very clear that that's a very simplistic conception of how the world works. A more contemporary notion would be something like Hans Ulrich said at the beginning, of difference and repetition. I think that is probably the biggest achievement of postmodernism. My view would be that they brought in the importance of tradition. So, for me, to come to your question, the generations before me are very important. Also, if I am today making all these

comments about how the avant-gardes are vulgar, of course I deeply build on their achievements, and I also build on the achievements of the generation before me. I think they really brought installation to the foreground. The 1990s generation, or whatever you want to call them, the generation before mine, is one which really, truly started working on installations. For me, I think that's a very important point of departure.

We can take one last question.

Q3 *I just want to take up this point about the aristocracy and link it to Alain Badiou's* Fifteen Theses on Contemporary Art, *because one of his theses says the only maxim for art is that the artist mustn't be imperial, but he then goes on and makes this anti-democratic point and he links it to aristocracy. He makes the point that you do.*

No, he doesn't! Me and Badiou are not in one boat!

Q3 *He does, actually, that's why I wanted to know whether you are in the same boat.*

No. That is what I am trying to say. I think I made it quite clear that I am not interested in the anti-democratic elements of aristocracy, but I think that there are some of the achievements of the aristocracy which have to do with these technologies of the self, working on the self, refinement of the self, working on a personality, which, because they were founded on an anti-democratic structure, have been pushed away. But now that we are a mass culture and we have been democratic societies for many decades, I think we can afford to look and ask if there is something interesting there. I know it is a provocative metaphor, and I am trying it out on you. Maybe I'm not going to use it again, because there are so many other connotations with aristocracy that it's easy to misinterpret.

185

186

Thatcher Effect
A face is analysed and perceived by its individual features, not as a whole.

Psychological processes in facial recognition make it difficult to identify local inversions of features when a face is viewed upside down. The head is the context for framing the features which are used for the process of identification. Changes, in a familiar context (when the head is right side up), are easily detected by the brain. Identical changes in an unfamiliar context (when the head is upside down) are difficult for the brain to process.

A SpRoUt MANIFESTO
(IN THE STYLE OF A RELAY RACE)
PART II

SpRoUt

[Relay/Line/Enter]

LAURA I am the first ever SpRoUt event. I am
a pagan festival and a political parade. I am the
spirit of May days past; I am MAYDAY – I invited
other groups to join me in a march down the main
city street.

And I am they who are coming – each with their
embroidered banners:

> *I am the Pinner Beekeeping Association*
> *I am the Women in Black*
> *I am the London Afro-Caribbean Book Club*
> *I am the London Wildlife Trust Volunteer*
> *Group, Barking*
> *I am the Pugwash Movement*

How blue the sky is! I feel that I might know that
blue amongst a thousand others…

> *We are what we have done.*

SAM STEER I am cleaning the streets; it's my turn.
But it's only for a few hours, and then the rest of
the day is mine – to read, to think. It's better now
– the greatest sin committed by the machine is the
fact that it forbids thought. The whole hierarchy
is so painful and the work itself is so deadening to
thought that she cannot think while she works in
the Renault factory, cannot go home at night and
think. It's different now. I'm standing in the ruins
of the machine, and I'm going to clean the streets.
But it's only for a few hours, and then the rest of
the day is mine.

> *We are what we have done.*
> *You are plural.*

HAYLEY I am KEEPing OUT THE KEEPERS
If I CHANGE your MIND. I can CHANGE

The WORLD, I am GETting LOST/
I FIND OUT
I SEEM HIDDEN; WITHIN YOUR REACH
I STAY STILL TO KEEP MOVING
You gather around an oak struck by lightning
in the forest of Saint-Nom-la-Bretèche, France:
Amy, Hannah, Sam, Sam, Florian, Laura, Hayley,
Naomi. And each one of you repeats: 'I declare the
visible, named and ordered a permeable fiction.'
And each one repeats: 'Fiction is not fictional.'
Therefore allow fiction to rupture Metis, to tear
a hole in the sensible…

> *We are what we have done.*
> *You are plural.*
> *Will what could have been.*

SAM DOWD I begin by asking, 'Who is this one?'
And then there's the answer, '*You* are this one.' No
solitary genius; everyone is a kind of transmitter
for a flow of energy and ideas, and only egotists
would grab an idea and call it theirs. No originator
or derivative. Your message is that we are plural.
So you tell the 'man alone', the Captain: Horatio
Hornblower – born on the 4th of July, and was
I – 'I', alone in the sea, nothing but water and dark-
ness. Not knowing whether we are at war or not at
war, because of the time it takes for the message to
arrive…

> *We are what we have done.*
> *You are plural.*
> *Will what could have been.*
> *Fiction is not fictional.*

NAOMI Let me describe to you something that has
not yet happened. It is set below a natural spring
with liquid flowing from a spout onto a series of
rotating paddles. Around the base, natural moss
grows on the stone. There is a small pool collecting
the majority of the water, until it spills over and is

absorbed into the ground. Meanwhile many of the wheels spin quickly.

A glass bird periodically fills and tips. A funnel channels some of the water into a tube, and it moves through a series of tubes with the ability to make sound. Some drops fall into little dishes containing various pigments so that the resulting liquid takes on colour, and as they fill and spill, they mix on the surface below, suggesting recognisable shapes.

We are what we have done.
You are plural.
Will what could have been.
Fiction is not fictional.
I stay still to keep moving.

AMY The fact that there is more than one, suggests it is not alone, that perhaps it is not madness. It offers to some extent quality control, but also the potential for hysteria. It is never out of its depth, as it has the confidence of seven, and the neurosis of many more.

It approaches from behind. It sneaks up on us. It is potential, inevitable, unexpected and shocking. It is a continuity with the constant threat of annihilation.
It is my collaborators — my competitors I cannot choose…

We are what we have done.
You are plural.
Will what could have been.
Fiction is not fictional.
I stay still to keep moving.
They will look back to go forwards.

HANNAH …This will be a sky. I declare the blackness that is the night sky become the zone of potentiality that produces the stars, the stars that could have served as navigation points for mapping and movement, the stars that now no longer exist — the light that will meet my eye will come from a star that is long 'dead' and, therefore, dark. This is fiction. Fiction is not fictional. I declare that navigation take place according to light from these dark points. I will navigate the night sky, using the darkness of dead stars as reference points. I will deconstellate the sky of its thoughts. I will think the thoughts of the outside of the sky. When the blue sky of day renders equivalent the points of

light and darkness, the stars will remain — now in a sort of parity — invisibly and darkly…

We are what we have done.
You are plural.
Will what could have been.
Fiction is not fictional.
I stay still to keep moving.
They will look back to go forwards.
May day! May day! May day!

[*Music*]

LAURA She transported you by way of a bus from the 1950s. She uses a bus which used to carry you through the green leafy suburbs. She picks you up in the Vauxhall Spring Gardens in the 18th century. She had been watching you in 1931. She had flown in with Jason in her aeroplane. She was whistling…

…She leads you through the street of the town carrying a heavy wooden sign. She is the people who will follow us on the journey, the locals. The people who will follow her on the journey will not be from this town — they will have travelled 200 miles.

NAOMI A family will follow her.

SAM DOWD A young artist will follow her.

HAYLEY An established writer will follow her.

LAURA People who work at the gallery will follow her.
A man who will wander into the park will follow her…

[*Circle*]

We are what we have done.
You are plural.
Will what could have been.
Fiction is not fictional.
I stay still to keep moving.
They will look back to go forwards.
May day! May day! May day!

SAM STEER He asks:
Are we interested in the idea of a society which once existed which was not so obsessed with the individual?

189

Through our nostalgia-stained glass of the future,
we see the 1950s as an era such as this. The Working
Man's Club. A utopian vision.
So, dear SpRoUts, do we long for community?
We work as individuals.
We work together.
When we can find a space.
When we can find a time.
An ensemble of solo characters in an opera who
practise alone. They sing together their single lines
in Act 3, their voices coming in and out of focus.

> *We are what we have done.*
> *You are plural.*
> *Will what could have been.*
> *Fiction is not fictional.*
> *I stay still to keep moving.*
> *They will look back to go forwards.*

HAYLEY He is not a problem.
This is a problem.
We live in several geographic locations.
He has several ways make to a living.
This is not a problem.
Here we are. It is complicated, but some people
think they understand it, and they try to explain it
to us. We understand. We think. It is disappearing
quickly; we try not to panic, to stay calm, to enjoy
it. We've missed it. Shit. But we are told by those
who have experienced it that it will happen again; it
might be different – we might not recognise it – but
it, or something else, will happen. Has happened.
We waited.

> *We are what we have done.*
> *You are plural.*
> *Will what could have been.*
> *Fiction is not fictional.*
> *I stay still to keep moving.*

SAM DOWD We were adrift on the ocean –
without paddle, sail or rudder.
We got hungry.
We got thirsty.
We got hot.
We wanted company; wanted some other thing,
a mirror.
We dreamt of a canopy – any umbrella under
which to shelter, to maintain our finesse.
We had no concept of distance. Without event,
we had no hold on time. Without markers,
direction was meaningless.

We thought our horizons were beyond reach.
We heard voices; saw endless eyes reflected,
refracted; grasped invisible hands. We were
there, on solid ground. Not one, but many.

They are taking over the world, bringing their collect-
ive consciousness to bear on matter, on form. They
are dreaming of their history, their beginnings. Their
origin. They are beside themselves. They tap one
another on the shoulder and whisper, 'We are Gods.'

> *We are what we have done.*
> *You are plural.*
> *Will what could have been.*
> *Fiction is not fictional.*

NAOMI They wiggled their little digits, and, bam!,
there they stood, clutching at each other for warmth
(he'd forgotten their hairlessness). They (the clever
clogs, the real heroes) weren't happy at all. Sibling
rivalry made them hot around the collar. They
wanted to get even, wanted to strike out and make
a name for themselves. Dropping like stones, they
crept into their yards, their thoughts, their mock
crocs and skinny jeans. Oh dear, they fell for his
charms, his wit. And that was it – party over! The
Landlord had had it up to the neck. He kicked them
out, kit and caboodle, left to wander the streets of
Manhattan in their Vivienne Westwood body suits.
Very '*à la mode*'.

> *We are what we have done.*
> *You are plural.*
> *Will what could have been.*

AMY I declare the visible ordered and named
a permeable fiction.
Fiction is not fictional.
I look back to go forwards: if I engage in travel,
I will arrive.
I manifest multiplicity, and 'The tail of a comet
is a memory,' and I am the comet.

Collaboration takes place in memory. 'Continuous
quantities, like continuous qualities are endless
like the truth, for it is impossible to carry them. It is
impossible to carry light and darkness, proximity,
chance, movement, restlessness and thought. From
all of these, something spills.'

Collaboration gives structure to awareness. And in
doing so, it blurs – and perhaps even effaces – the

190

distinction between subject and object, since
collaboration is neither, being intermediate,
between the two.

We are what we have done.
You are plural.

HANNAH The fiery tail of the comet is the trace
of the rock that immediately precedes it. Thinking
through this logic, it becomes apparent that the
actual 'rock' of the comet is not visible other than
through its radiant tail. The comet's tail is not
its 'ghost' but its 'line of flight', its line of flight
indicates the speed and trajectory of the dark shard
of rock that precedes it. The comet is the invisible
'event' that is only visible in the trace in its wake,
the passage its tail leaves as ephemeral inscription
across the sky.

 The comet is always in the process of appearing
and disappearing simultaneously. The comet is
suspension of particles in a liquid. It collaborates, as
an utterance in the sky; its different parts are no longer
rock, tail, blackness; it is no longer reducible to its
constituent components and materials. It becomes
a sky event, and an event that *includes* its own disap-
pearing and forgetting. It is an afterwards in progress,
suspended. An event in its own becoming.

We are what we have done.

[*Geese/Triangle/Exit*]

191

#1

CONTEXT

IS HALF

THE WORK

Barbara Steveni

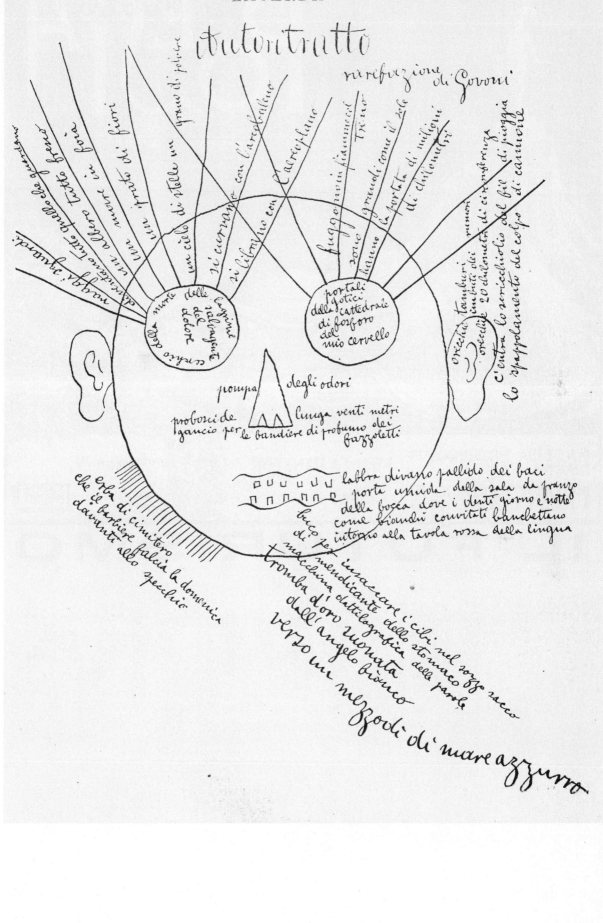

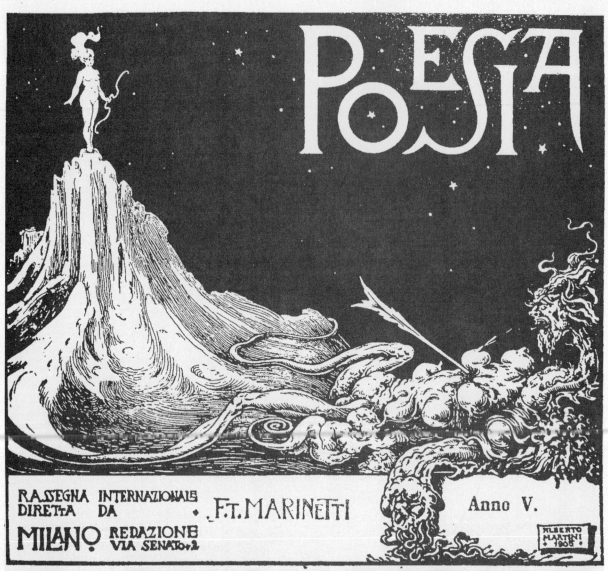

This central axiom (my manifesto title), developed from APG practice in the 1970s, carries today a necessary component for current and future action for art, or for any other activity for that matter, which engages /impacts on an 'other'.

Constructed to traverse time, place and discipline, this approach does not impose on any context, place or person, but rather suggests engagement between the artist on the one hand and invitation by the potential host on the other.

APG'S TEXT TO THE ZENTRUM FÜR KULTURFORSCHUNG, BONN, 1980

Emphasise the following guideline engagement principles for an effective form of association of artists with organisational structures

1. That context is half the work.

2. That the function of the medium of art is determined not so much by the factual/concrete object, as by the process and the levels of attention to which the work aims. (By level of attention is meant the consideration of human long-term identity).

3. That the proper contribution of art to society is art. (That society is starved of an important ingredient if 'creative' individuals are kept out of the working parts of governments/organisations and institutions. (This is not to suggest that other individuals and specialists are not creative.))

4. That the status of the artist within organisations must necessarily be in line with other professional persons, engaged within the organisation.

5. That the status of the artist within organisations is independent, bound by invitation rather than instructions from authority within the organisations, departments, company, to the long-term objectives of the whole of society.

6. That, for optimum results, the position of the artist within an organisation should (in the first stages, at least) facilitate a form of cross-referencing between departments.

7. That the artist's brief remains open. Negotiations are contingent upon both participants having this understanding and a mutual confidence. This requires intelligence and strength in art and a reciprocal response from within administrations.

 To these principles/premises for engagement, I add in the context of the 'greed economics' of the day (quote Tony Benn Darwin Lectures).

8. That artist and host organisation QUESTION WITH RIGOUR their motivation for engagement.

Perhaps Tony Benn's questions he lists when addressing people/institutions with power apply equally here to artists when considering engaging/working with a potential hosting organisation:

- **WHAT POWER HAVE YOU GOT?**
- **WHERE DID YOU GET IT FROM?**
- **IN WHOSE INTEREST DO YOU USE IT?**
- **HOW DO WE GET RID OF YOU?**

194

OPTE
AS CU
REBE

MISM

TURAL

LION

196

STURTEVANT PRESENTS
VIDEO CLIPS FROM

DUMBING

DOWN

&

DUNKIN'

DOUGHNUTS

A ÇA VA ALLER PRODUCTION
thought as power

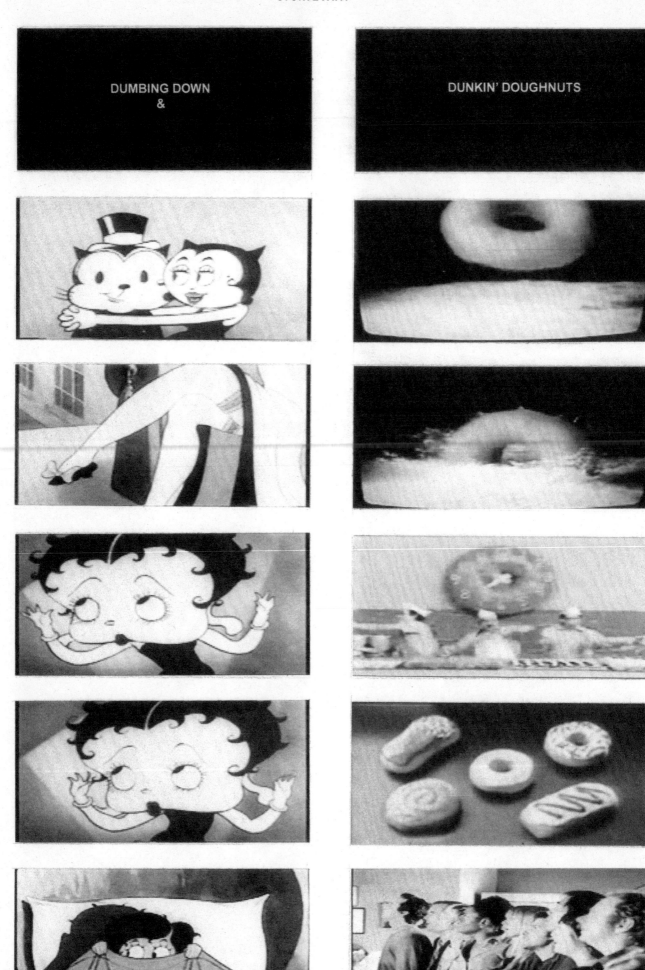

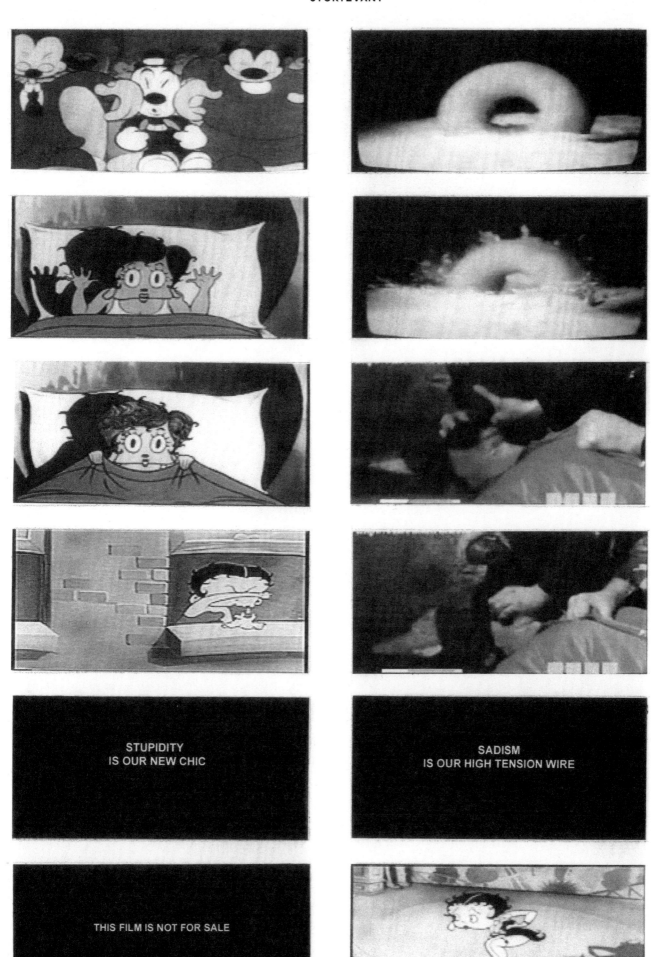

FEEL BETTER NOW
(APATHY AND THE NEW SINCERITY)

Mark Titchner

Welcome to the plateau aurora borealis or new thinking and the new sincerity, its cause, its effect, or, my friend, feel better now!

Old forms burning for the ancient heavenly connection, the realignment, the something. Disambiguation, you dig?

(Tomorrow.)
I want to see rainbows all the days of my life…
A hundred flowers bloom for the future.
Torches of freedom.
A kinder, gentler notion for a kinder, gentler nation; prosperity and progress.
Yes we can! Yes we can! Yes we can!
The fiery language of light.
New directions and new erections – don't stop thinking about tomorrow.
The process of coming together.
We have only begun.
A world where everything is attainable.
The distance does not matter; only the first step is difficult. The universal mind has been asleep.
Pregnant with the future.
This is the way.

(Ascendance.)
Liberation.
Let me explain: the future of man – dare to think, dare to act.
It's all yours; it's all for you.
Together we hold back the night.
Necessary illusions.
We are the stage, we are the actors, we are the audience.
Be with us! Those who are aware, behold!
Look for us amidst the whirlwind.
All forces will be transformed.
Tear down this wall!
There is no alternative.
There is always an alternative, there will always be something new, making us proud again.
Be ready, be strong.
Nothing in the world can take the place of persistence.

Actions never as decoration or embellishment; instead as a route to enlightenment, a technique for acquiring liberty. Dreaming and doing, failure is impossible.
We cannot be co-opted; we want everything.
Forward ever, backward never.
Dreaming and doing, success is assured.
Conquer your fears.
More joy, less tears.
Joy without fear!
Knowledge without vanity, love without profit or reward.

(The enemy.)
The legacy of fraud.
The deed alone makes us free, destroy what destroys us.
Into the ash heap of history.
Old thinking, old constructions.
Where polarities prevail.
Only glimpsing the present as it disappears.
Delusions and illusions.
Obviousness blurs recognition.
An absurdity so colossal that it became a great truth.
The horror takes advantage entirely.
The post-hypnotic trance in which each of us inherits the lies that we are born with.
Memories tell us one thing: everything must go!
(There is no such thing as hypnosis.)
The pestilence of darkness, the strife of tongues, the malice of ill will.
All snares, petty fears and pleasures are but shadows of reality, of permanent and absolute existence.
The plague-mongers' corrosion.
Extract the poison sac.
Understand the weapon, understand the wound.
Dispossession.
Enlightened despotism.
Enforced participation.
Dark ambition.
The raft of control.
How they want us to feel.
Sorrows and blind alleys.
Cut out the past.

We take up the fight to define ourselves.
We are giving birth to ourselves.
A swift death blow to the monster.
When it comes to this curse, we must be intolerant.
Freedom will cure most things.
A cycle is done.
Everything is free!
Don't sell your dreams.
Be real.

(Now, now, now, the second birth.)
A return to normalcy.
No more lies.
Coward, coward, coward.
No talking, all action.
An eternal state of being.
Attaining one or many of the immortality options.
Alternatives to involuntary endings.
Thrill with lissome lust of the light; come careering
out of the night.
The world once again.
Change is the order of the universe.
Broaden (y)our power.
Prepare by doing.
The real thing.
We feel and we know that we are eternal.

(Liberty.)
Plunge deeper!
Giving freedom to the desires, offering happiness,
a bulging invitation.
Become what you were!
There shall be no property in human flesh.
As ye will!
All to be as stars, terrifying and bright, trumpets
sounding shrill!
We are come.
Plunge deeper. Roam, froth, come, unleash.
Self-determination.
I just want some.
Committed in heart and mind it.
Just do it!
Constant vigilance, constant mistrust, constant
mobility.
We are makers of our history.

(Transcendance.)
Regardless of what you believe.
Man has willed man. So limitless and free.
Eternal delight.
To choose is to act or to not act.
A choice is not a preference.

To express the deep sources of ecstasy in our souls.
To feel the magic of immortality.
Myths have more power than reality.
Build your myths.
Accelerate the flood.
Now is no time for trepidation.
Man's beast friend.
Something to be surpassed.
All or nothing. There are no spectators.
Ntensified to a pitch unknown.
Feel your insides shake.
The velocity of power.
The great guarantee of success.
The heart's love pure, it happens: transfiguration.
Trust-trust-trust-trust-trust.
If it were that it were.

(The end.)
Hastening towards the hour.
'Tell me: who you are?'
Everlasting, world without end.
A contribution to the new sincerity.
It's hell inside; it's hell outside.
Last words, the world exists.
You need no analogy for that.
Scared of everything, what can be gained,
what can be lost. There is no risk.
You are in a safe place.
How did we get here?
A life on the plateau.
Empty rhetoric and tangled invective.
Rest your head.
The price is right.
Out here, words correspond to actions: the world's
still out there.
Does it ever brush our eyelids?
Clear enough yet?
Dreams never dreamt.
Madmen grappling with the cause of their madness
in search of a cure.
We refuse to lose, falsifying all social life, bypass
the correlations, in the shadow of true discussion,
lies, lies, lies, nothing is revealed.
We say an injury to one is an injury to all.
I am one.
The last gasp.
A full disclosure.
The great disappointment.
The operation of the last-resort,
saviour or destroyer?
Don't listen to words, don't listen to words,
don't listen to words.

201

DON'T
GO TO HELL
FOR THE
SAKE
OF FINISHING
WATCHING
THE FILM

Jalal Toufic

Friedrich Hölderlin: 'Yet it behooves us, under the storms of God, / Ye poets! With uncovered head to stand, / With our own hand to grasp the very lightning-flash / Paternal, and to pass, wrapped in song, / The divine gift to the people.' It is poets, video-makers, film-makers, vocalists and musicians, *not journalists*, who should report to us from *jouissance*-inducing zones of conflict, since they possibly can wrap this *jouissance* in song. Regrettably, poets, videomakers and filmmakers are rarely allowed in such zones – only journalists are allowed! But are there enough poets for the *jouissance*-inducing conflicts? It seems that there aren't: '*Bibliothèque Nationale*. I am sitting here reading a poet... What a fate. There are perhaps three hundred people reading in this room; but it is impossible that each one of them has a poet. (God knows what they have). There can't *be* three hundred poets' (Rainer Maria Rilke, *The Notebooks of Malte Laurids Brigge*, trans. Stephen Mitchell).[1] In evil times, many a poet is affined with these words Friedrich Nietzsche wrote in a 5 January 1889 letter to Jakob Burckhardt, who was then a professor at the University of Basel: 'Actually I would much rather be a Basel professor than God; but I have not ventured to carry my private egoism so far as to omit creating the world on his account. You see, one must make sacrifices, however and wherever one may be living.'[2] During the latest Israeli war on Lebanon, a Lebanese poet's sacrifice consisted in watching TV, which he had previously avoided. (...) Whereas the integration of sexuality, indeed of eroticism in religion is salutary in Taoism, where it is mainly a technique (through retention of the sperm, etc.) for prolonging life, ideally indefinitely; in Tantra, mainly as an attempt, complementing the arrest of respiration and suspension of thought, to 'immobilise semen,' even obtain 'return of semen' so as to reach the state of *sahaja*, of non-conditioned existence; and in some antinomian messianic sects, mainly as a symptom of the withdrawal of the religious Law (*Sharî'a* / Torah) past a surpassing disaster, it is not so through zapping between the juxtaposed channels on TV – zapping is not a manner of changing channels but of mixing, editing them on the fly; the only real manner and gesture of changing channels is to switch channels only when a programme ends and as another programme on another channel fades in – or else to turn off the TV altogether. Far more dangerous than any specific TV programme is the immixing and contamination of genres through zapping between various TV channels: the soft porn of many Arabic music videos mixed, however fleetingly, with ostensibly religious programs and with the news footage of the beheadings and the car and suicide bombings perpetuated by al-Qâ'ida in Iraq.[3] Should we be surprised that we are thus producing a generation of people who cannot enter a church or a mosque without compulsively zapping in their minds, without their zapping minds switching to obscene words or pornographic images? My proposed double-feature *Rear Window Vertigo*, in my book *Two or Three Things I'm Dying to Tell You*, 2005, and my video *Mother and Son; or, That Obscure Object of Desire (Scenes from an Anamorphic Double Feature)* (41 minutes, 2006) are manners of retorting, through eliciting an occult connection between various ostensibly independent films (in the aforementioned text between Alfred Hitchcock's *Rear Window*, 1954, and *Vertigo*, 1958, and in the aforementioned video between Alexander Sokurov's *Mother and Son*, 1997, and Hitchcock's *Psycho*, 1960), to the obscene promiscuity established, through zapping, between different TV programmes on various channels. Whereas by not leaving his apartment, he was spared getting wounded, losing a limb or even dying in the Israeli bombardments, he, a poet, nonetheless ended up encountering the lightning flash of *jouissance* on TV and, while trying to wrap it in a song, severing his eye, and then severing also one of his hands. Along the lines of Ludwig Wittgenstein's 'Whereof one cannot speak, thereof one must be silent,' I recommend concerning the *jouissance* that one cannot transfigure into (Hölderlinian) song[4] or (Rilkean) angelic, awful beauty ('Who, if I cried out, would hear me among the angels' / hierarchies? And even if one of them pressed me / suddenly against his heart: I would be consumed / in that overwhelming existence. For beauty is nothing / but the beginning of terror, which we still are just able to endure, / and we are so awed because it serenely disdains / to annihilate us. Every angel is terrifying' (*Duino Elegies*, 1923, trans. Stephen Mitchell)[5] that one remain silent – if not remove his ears and tongue and eyes. 'What happened after, / was terrible to see. He tore the brooches – / the gold chased brooches fastening her robe – / away from her and lifting them up high / dashed them on his own eyeballs, shrieking out / such things as: they will never see the crime / I have committed or had done upon me! / ... – with such imprecations / he struck his eyes again and yet again / with the brooches...'

203

(Sophocles, *Oedipus the King*, trans. David Green).
Is the excommunication of Oedipus a result of his
transgression of a taboo against incest? Yes, but
it is also possibly due to the circumstance that the
jouissance of repeatedly dashing brooches in
his eyes propagated itself to Oedipus, staining
him. Were a Christian to have witnessed Oedipus'
gesture of gravely wounding his eyes and the
jouissance staining this act, would he or she have
gouged out his or her eye? 'If your right eye causes
you to sin, gouge it out and throw it away. It is better
for you to lose one part of your body than for your
whole body to be thrown into hell' (Matthew 5:29).
But gouging out one's eye is itself often linked to and
productive of *jouisssance*. How foresightful then of
the New Testament to have detected this danger: 'If
your right eye causes you to sin, gouge it out and
throw it away. It is better for you to lose one part of
your body than for your whole body to be thrown
into hell. And if your right hand [the one with which
you gouged out and threw away your right eye]
causes you to sin, cut it off and throw it away. It is
better for you to lose one part of your body than for
your whole body to go into hell' (Matthew 5:29-30)
– only make sure that while cutting off your right
hand that gouged out your right eye, you follow
another one of Jesus Christ's injunctions: 'Do not
let your left hand know what your right hand is
doing' (Matthew 6:3),[6] i.e., here, do not let your
left hand get infected with the *jouissance* that has
already contaminated your right hand.(…)

Rilke writes in the fourth of his *Duino
Elegies*: 'I won't endure these half-filled human
masks; / better, the puppet. It at least is full. / I'll
put up with the stuffed skin, the wire, the face /
that is nothing but appearance. Here. I'm waiting.
/ Even if the lights go out; even if someone / tells
me "That's all"; even if emptiness / floats toward
me in a gray draft from the stage; / even if not one
of my silent ancestors / stays seated with me, not
one woman, not / the boy with the immovable
brown eye – / I'll sit here anyway. One can always
watch. / (…) am I not right / to feel as if I *must*
stay seated, must / wait before the puppet stage,
or, rather, / gaze at it so intensely that at last, / to
balance my gaze, an angel has to come and / make
the stuffed skins startle into life. / Angel and
puppet: a real play, finally.'[7] Were the narrator not
half-filled, the angel, who is never late, would have
already appeared to him or rather made his presence
felt to him – when the angel appears, I discover
that he was *here* all along, and that I could not have

waited such a long time without the assistance of his
subtle presence, and that what I take to be first his
absence then his presence is actually a modification
in his presence, from a subtle one to an overwhelm-
ing one. The wait ends when there is no longer any
use waiting, i.e., when one is no longer useful even
for waiting, having become someone who simply is:
'When Bruno [in Werner Herzog's *Stroszek*, 1977]
asks the question: "Where do objects go when they
no longer have any use?" we might reply that they
normally go in the dustbin, but that reply would
be inadequate, since the question is metaphysical.
Henri Bergson asked the same question and replied
metaphysically: that which has ceased to be useful
simply begins to *be*.'[8] *Duino Elegies*'s real play,
finally, is one between the angel and the one who
waited for him and was changed by this wait into
a puppet (of God). Since the angel appears to the
puppet (of God), it is not accidental that one of the
most felicitous sites to find angels in cinema is in
pixilation films, for example Patrick Bokanowski's
The Angel, 1982; as well as in those films, such as
David Lynch's *Twin Peaks: Fire Walk with Me*, 1992,
made by film-makers who started their cinema
work with one or more short animation/pixilation
films (*The Grandmother*, 1970, *The Alphabet*, 1968,
etc.). It is precisely those who know how to 'wait
for the angel' who are the first to leave the cinema
theatre during the projection of certain films, since
they know that while one *can* always watch, one
should not always watch, indeed that 'if your right
eye causes you to sin, gouge it out and throw it
away. It is better for you to lose one part of your
body than for your whole body to be thrown into
hell' (Matthew 5:29). 'Any book which is at all
important should be reread immediately' (Arthur
Schopenhauer) – I would qualify Schopenhauer's
prescription thus: 'Any book which is at all impor-
tant *but not evil* should be reread immediately' – and
any original film that's not evil should be *reviewed*.
It is pointless to enjoin the spectator of an evil film
to watch it again, because the one who watches an
evil film is going to see it again in the undeath
realm since it triggers the compulsion to repeat; if
at all, one should advise him or her not to see it at
all or to leave promptly the cinema showing it.
While waiting for the start of a screening of Gaspar
Noé's film *Seul contre tous* (*I Stand Alone*, aka *One
Against All*, 1998), I asked an acquaintance I had
come across at the cinema and who sat next to me,
'Why did you come to watch this film?' He
answered me: 'I didn't know what to do with my

time, so I cruised for a while and then decided to watch a film, just *for the hell of it.*' The following intertitle appears 69 minutes into the film: 'Attention: You have 30 seconds to abandon the projection of the film.' Indeed, a countdown follows. I, who had been hesitant all along to continue watching the film, whispered in my acquaintance's ear two seconds after reading the intertitle: 'Let's leave.' He encouraged me: 'You should watch films from start to finish.' 'Like hell I will do so with this film!' 'I myself will watch the whole film, come hell or high water!' I left at this point, 18 seconds into the countdown. When I later saw him, he told me: 'Through this film, I've been to hell and back.' Instead of continuing to watch, should I have left too when the angel disappears from the painting[9] hung in Laura Palmer's room in David Lynch's *Twin Peaks: Fire Walk with Me*, 1992,[10] given that the angel's disappearance implies that we have now moved from the bad to evil? I asked myself an affined question concerning the other spectators on my way out of a screening of Robert Rodriguez and Frank Miller's *Sin City*, 2005 (the debased mediocre filmmaker Quentin Tarantino was a special guest director on this film): 'Why are they hell-bent on watching this film?'[11]; I was the first *human* to leave the screening – I left with the angel. If you don't leave with the angel, as he is leaving some evil site, then sooner or later you will have to wait for someone or something in you to leave – exorcism. At that point, anyone other than the one scaring and beating the hell out of you has to promptly leave while the exorcism is taking place, otherwise the exiting demons may possess him or her. Should the spectators leave the cinema theatre during a projection of William Friedkin's film *The Exorcist*, 1973? Rare are the humans who have waited for the angel; but many are the angels who have waited for humans to leave evil situations – many an angel has fallen precisely because he waited too long for some human to leave while evil was taking place,[12] the human in question subsequently becoming the puppet of the devil, suffering from sacrilegious thought-insertions, depersonalisation, etc.

1 Do we, Arabs, have poets presently, when we most need them? Fortunately, we do. For example: Mahmoud Darwish, and the man who has assumed the name of one who, unlike him, truly encountered *jouissance*, the god Adonis? No – these two are not poets; rather, videomaker Roy Samaha.

2 *Selected Letters of Friedrich Nietzsche*, ed. and trans. Christopher Middleton (Indianapolis, Indiana: Hackett Publishing Company, 1996), p. 346.

3 The prophet Muhammad said, 'If one of you sees a dream that he likes, then it is from Allâh, and he should thank Allâh for it and narrate it to others; but if he sees something else, a dream that he dislikes, then it is from Satan, and he should seek refuge with Allâh from its evil, and he should not mention it to anybody, for it will then not harm him' ('*Kitâb al-Ta'bîr*' ['The Book of Interpretation'], *Sahîh al-Bukhârî*). The prophet Muhammad said also: 'People are asleep, and when they die, they awake.' Therefore, what the prophet Muhammad recommended in relation to a nightmare should be applied to evil in general. By posting on the internet videos showing the beheadings of their hostages, the followers of al-Qâ'ida in Iraq provide yet one more blatant indication that they are no followers of the prophet Muhammad. Anyway, the criminal butchers of al-Qâ'ida in Iraq, with their beheadings of hostages, should have learned from the Qur'ân in their dispatches from hell: even in the worst descriptions of hell in the Qur'ân, no jouissance passes – access to what is beyond good and bad, to what belongs to Good and Evil, should be only through an initiation.

4 Has the vocalist Diamanda Galás managed to wrap and transfigure *jouissance* into song in her *Plague Mass*?

5 Has the writer Douglas Rice managed to transfigure jouissance into angelic, awful beauty in his *Blood of Mugwump*?

6 Was Jesus Christ also suggesting to us a precursor of (the surrealists') *automatic writing* and *the exquisite corpse*?

7 *The Selected Poetry of Rainer Maria Rilke*, ed. and trans. Stephen Mitchell; with an introduction by Robert Hass (New York: Vintage Books, 1982), pp. 169-71.

8 Gilles Deleuze, *Cinema 1: The Movement-Image*, trans. Hugh Tomlinson and Barbara Habberjam (Minneapolis: University of Minnesota Press, 1986), p. 185.

9 If the angel appears to prophets in dreams sometimes, is it that strange for him to appear to humans in a painting? Cf. Dōgen: 'An ancient buddha said, "A painting of a rice-cake does not satisfy hunger." The phrase "does not satisfy hunger" means this hunger – not the ordinary matter of the twelve hours – never encounters a painted rice-cake… all painted buddhas are actual buddhas… Because the entire world and all phenomena are a painting, human existence appears from a painting, and buddha ancestors are actualized from a painting. Since this is so, there is no remedy for satisfying hunger other than a painted rice-cake. Without painted hunger you never become a true person. There is no understanding other than painted satisfaction.' 'Painting of a Rice-cake,' *Moon in a Dewdrop: Writings of Zen Master Dōgen*, ed. Kazuaki Tanahashi, trans. Robert Aitken et al. (San Francisco: North Point Press, 1985), pp. 134-8.

10 Cf. St Basil: 'An angel is put in charge of every believer, provided we do not drive him out by sin.'

11 While the fastidious spectator may be embarrassed by the presence of other spectators during the projection of a film that turns out to be a bad one, he or she does not feel embarrassed during the projection of an evil film, not so much because he or she is sucked in by the film, losing for a while awareness of the other spectators, but because the evil film transports him or her to a realm he or she as a mortal encounters *alone*, the bardo state, *al-barzakh*, undeath, asking himself/ herself then: 'Am I dead?' It is only once I have made a decision to leave the screening of an evil film that I become aware of the other spectators.

12 Some Gnostic angels fall in order to save the divine sparks dispersed in the demonic world.

205

WHAT TO DO? HOW TO DO IT? (A POTATO STORY)

Agnès Varda

What about the current century?
We go ahead progressing, discovering, inventing,
and also we go backwards, losing some quality
of life, destroying the planet.

[*In the background, a voice coming out of a potato costume on a walking woman recites a list of French potato varieties, including: Bailla, Bea, Belle de Fontenay, BF. 15, Bintje, Bleue d'Auvergne, Blondy, Bondeville, Bonnotte de Noirmoutier, Duchesse, Early Rose, Eden, Elkana, Élodie, Émeraude, Épauna, Estima, Europa, Fausta, Felsina, Florette, Floriane, Florice, Franceline, Frégate, Gourmandine, Gredine, Hermine, Institut de Beauvais, Iroise and Isabel.*]

Varieties of potatoes – all those different kinds – remind us that people are also different.
We don't know enough about all the varieties of people; we don't learn enough about them. I chose the potatoes – modest vegetable – as the perfect object to look at and have some thoughts.

We are in the middle of a huge economic crisis, a storm of virtual money floating between stock markets, internet transactions, transfers flying from a bank to another – all that is immaterial economy.

It can be opposed to material economy, people's problems: unemployment, sub-prime loan dramas, loss of purchasing power, poverty, injustice, and also discrimination and segregation.

Regarding potatoes, it means sorting according to format, size and calibre.

The market makes the law
Our society overproduces and overconsumes
The waste is enormous

[*On the screen, we see youngster-rappers*]
'When I think of all the thrown out food and waste
It's crazy.
It makes me mad.
If you have been kicked out by a woman,
Out of your work,
Down and sad,
You need to know
where to find food'

In towns and cities, some people have to bend down and salvage what other people throw away – they need our leftovers to eat

Back to the potatoes; recession might

force us to reduce our eating pattern
Let's eat differently
Let's eat less
And with less choice of food

[*On the screen, we see two kids moving in the country and singing*]
Monday! Potatoes!
Tuesday! Potatoes!
Wednesday! Potatoes also!
Thursday! Potatoes!
Friday! Potatoes!
Saturday! Potatoes also!
Sunday! Gratin of potatoes!

Now… about the future, so much needs to be changed. Here are three problems that should be solved: plagues such as racism, machismo and destruction of nature.
[*Each of these topics is illustrated by a short segment of film – the first is shown by the arrest of a Jew by Gestapo men*]

As for the collective struggle of women: they also fight for the right to decide if they want to bear each child or not.

[*Film of women on a demonstration*]
I tried to be a joyful feminist,
But I was angry.
Rape, domestic violence, clitoral excisions
Abortions in appalling conditions…
Young girls going to hospital for scraping
And young doctors saying, 'No anaesthetic – that'll teach you!'
This is in France, but in so many countries women have no rights at all

[*Images of spoilt beaches and birds*]
Look at the disaster when one sole ship full of oil goes under. It can pollute beaches and kill oil-stricken birds.

An ecological suggestion: ride a bicycle in the country and in town. Or drive a handmade car, running with leg energy.

Is it sometimes progress to go backwards?
Back to the basic needs,
Plus space for desire
A clean land and ocean
Light wind in the sky
And… love

207

I DON'T KNOW WHAT TO DO

Ben Vautier

BV When I was first invited, I was told it was a manifesto. So I said, 'What should I say; what should I tell them?' 'Manifesto.' Then I was told, 'You have as competitors Lenin, Orwell and Marx,' so how can I change the world? I want to change the world, too. Everybody wants to change the world, so everywhere there is ego. Ego, ego, ego. We can't get rid of ego. So to change art, we have to change man; to change man, we have to change ego; to change ego, there is only one man who said something, it's Henry Flynt. He said, 'Destroy mankind.' So we have to destroy mankind. So I thought I would start by suiciding. Then I thought, 'OK. That's not worth it because I come for the girls. I just come for the girls.'

Because I like looking at the girls, I am not going to suicide. So that's one point. So then I wrote something down, but I am not going to tell you what I wrote. Art is always ego. I wrote that. Then I said I am going to talk to you about Fluxus. Why Fluxus? Fluxus is ego, too. Dada is ego. Every time we try to get out of art, we get back into art, because every time artists try to do anti-art, it becomes art. So anti-art is ego, and we can't get rid of ourselves. We're always I, I, I, I.

I was told I have 20 minutes. I said, 'OK, 20 minutes – I will give 20 small pieces of one minute each, but very small ones. My first will be for Gerhard Richter [*takes his Serpentine catalogue and rips pages out*]. I would have taken any art from the Tate, any art from anywhere, because I don't like art [*continues ripping pages from book*]. I think art is always the same thing. Art doesn't change man. Art is culture, and culture is a kind of manipulation. Look at you; you are all manipulated, and tomorrow morning your children come to see the museum, and manipulation continues. So we believe in culture. Culture, culture, culture, culture, culture. I was told text is also culture. So that's for Richter.

My next piece is *Manifesto* by Tomas Schmit. The first manifesto is just a white sheet. Give it out anywhere – give it out to anybody [*sheets handed out to audience*]. So you have the idea. The idea is Tomas Schmit said one day, 'My work is to give white sheets out.' With a white sheet of paper, you can be anti-art, non-art, un-art. Un-art is a very good instance. When I once met Marcel Duchamp, I asked him, 'What are you? Anti-art or non-art?' He said, 'I am un-art.' I thought that was anarchist. I had made a mistake. That means indifferent to art. Indifference to art is very difficult. I wanted to do a show with all the artists who want to get out of art, and that was very difficult because they are all ego artists.

My next piece is *Two Inches* by Robert Watts. This is a classic, and I want it to be made by Jonas Mekas. [*Assistant holds a small roll of paper; BV holds end and pulls it out, holding it straight for the length of the Pavilion. Jonas Mekas walks along, with his hand touching it. Approximately in the middle, he takes a pair of scissors and ceremoniously cuts the paper.*]

Robert Watts did a piece called *Tuba Solo*. I like it because it's contemporary music, and contemporary music by George Maciunas must make people laugh, but I couldn't get a tuba, because the Serpentine hadn't got the money for a tuba, so I got a hat. So he comes with a tuba, and I call this piece *Fleet Street Music*. You have the stock market nowadays going down [*empties hat*]; I have nuts going down. So it's a tuba full of nuts and you say, 'What does he want the nuts for? He's going nuts.'

Next piece: *Piece for Frieze*. You all know Frieze; Frieze is a very big place where everyone is going nowadays to see art, so I propose that people who want to see Frieze should just put this on their head [*places brown paper bag completely over his head, then hands out paper bags to the audience*]. When you visit Frieze, wear this. There is a variation by Benjamin Patterson where everybody puts their head in the bag and holds hands and we go through the museum.

Next is *Art for Serpentine*. I did it already.

Next is *Number One* by George Brecht. This, I am only going to describe. I want you to listen to it. We have a big grand piano. George Brecht comes to the piano, he puts his hands on the piano, the lights go out, he goes away in the dark, the lights come back, the piano is all alone. Try to imagine it; it's a beautiful piece. It's more simple than John Cage's four minutes and thirty-three seconds of silence [*4'33"*], which is a very important piece.

Next piece: *Piano Piece 2* by George Brecht [*holds vase of flowers*]. George Brecht comes to the piano and puts the flowers on the piano, bows and goes away. That's what we call 'event'. That's very important, because event is the most important thing Fluxus brings. The smallest event in the world is blink. George Maciunas I met in London in 1962 at the One Gallery. I used to tell him, 'I am interested in artists who go to the extreme.' He said, 'Who?' I said, 'Piero Manzoni, because Manzoni does shit; Yves Klein, because Yves Klein does something completely blue. Those people interest me who go to the extreme.' He said, 'There is somebody in New York who just blinks.' I said, 'Are you serious?' He said, 'He blinks, and that's all he does.' 'And is that art?' 'That's art.' So I decided to go to New York to meet George Brecht and see if he really blinked. But it isn't a real blink. He doesn't even blink. It's one of his works. You understand it's very important to not blink. It is a piece of his exit/entrance. There is a piece by Geoff Hendricks called *Handshake*. So we do a handshake [*BV and assistants shake hands with members of audience*]. The English know how to handshake. This piece is very good when the audience is coming in the room; in the concert room, we handshake everybody. And then there is a piece by Emmett Williams that is counting the people. That's called *Counting Song*, but we are not going to count here, because it's too long. So that was *Piano Piece 2* by George Brecht.

Now a very important piece by Takehisa Kosugi. Kosugi takes newspaper. While I am going to crumple this [*New York Herald Tribune*], don't turn the sound down. We must listen [*crumples sheet around microphone, then removes it slowly*]. I'll explain it. When it's in a closed room like Carnegie Hall and you listen to the paper uncrumple, the smallest sound is interesting, because newspaper has life. If I do *The Times*, it's not the same as the *New York Herald Tribune*. The *New York Herald Tribune* is cheap paper; *The Times* is very strong paper. When you listen to it uncrumple, then you understand that small sounds count. That joins to another piece of Kosugi called *Boundary Music*, which is to just listen to music which is between silence and sound. It is called *Boundary Music*, and you hear just people cough.

Next piece: *Incidental Music* by George Brecht. You must imagine the piano. He comes to the piano and will build this tower of coloured building bricks. *Incidental Music* mean when it's going to fall [*builds tower of bricks until it falls*]. That was *Incidental Music*. Imagine it on the open grand piano, when they fall on the strings.

Next piece is *Fall* by Giuseppe Chiari, score by Chiari [*tears a sheet of music carefully in half, close to the microphone*]. Chiari was an Italian Fluxus artist, and he does many pieces and in his scores there is, for instance, 'Go around and slap.' He slaps anything. The sound of slapping.

Next piece: *Disappearing Music for Face* by Chieko Shioni [*BV and two assistants stand in line facing audience, smiling, then not smiling*].

Now this is a very important piece by George Brecht – always my favourite, George Brecht – it is called *Drip Music*. But I was told you can't use water at the Serpentine, so it's the first time in my life I am going to do *Drip Music* without water. Imagine this teapot is full [*pretends to pour from teapot into dish on floor; assistant holds microphone close to dish*].

Apple by Ben. That's the first piece of mine I do. I just eat an apple [*close to microphone; assistant does the same*]. Thank you.

Of course, these are only examples. Why am I giving you examples of Fluxus as a manifesto? Because Fluxus is a manifesto. Fluxus is a manifesto, because in Fluxus you had three great thinkers: George Maciunas, Henry Flynt, Nam June Paik, and, of course, others. The idea was there is something of anti-art in it when you burn the partitions, there is something anti-art when you draw a straight line with your head on things. It's interesting. But, of course, I think Fluxus did not succeed, because it has become art and because you find it at the Tate Gallery – you find it everywhere. So it has been regurgitated into culture.

Sweets by Annie. My wife told me, 'Give the audience sweets, and they can do music with the sweets.' So you all have a sweet. We'll throw sweets at you. With the sweets, you are going to make music. Undo your sweet and listen to the wrapper. Everybody with your sweet paper [*BV and assistants rustle sweet papers close to microphone; audience rustling wrappers*]. Perfect. Thank you.

Let's do something by Ted Joans. This was another Fluxus piece, a piece I did with Jean-Jacques Lebel, who invited lots of people to the Festival de la libre expression, and he invited Ted Joans. At the time, I was interested in the Beat Generation poetry, and Allen Ginsberg and Lawrence Ferlinghetti also came to Jean-Jacques's festival. Ted Joans recited a poem I will never forget. It was called 'Let's Do Something', and I loved it, because he was talking, but it was 'let's do something'. Let's all not stay here looking at each other. Let's not all think we are doing art. Let's go into Hyde Park and piss. No, let's say you are Stalin and you are Khrushchev. Let's do something. Let's fuck. Let's undress. Let's all do something with our shoes. Let's do something. Let's not stay here looking at each other getting bored. Let's do something. And he continues like that, and everybody wanted to do something. It is a fantastic piece by Ted Joans. He died, and I bought all his poetry. It's fantastic. 'Let's Do Something.'

I love tango [*music plays; BV dances with member of audience*].

I bought this at the airport, and it's fantastic [*holds plastic case to microphone; sounds of woman having orgasm*]. You see – a gadget bought at the airport with Fluxus music.

My time went.

My last piece is this [*holds up sheet of paper with 'Just Smile' written on it*].

to change art
change Man
to change Man
change Ego
or destroy ego
to destroy ego
die'
Must Ssuicide ?

MAKE ME

ME

THINK ME

ME

Mark Wallinger

Bruce Nauman was born the day before Pearl Harbour was attacked.

'Reports that say that something hasn't happened are always interesting to me, because as we know, there are known knowns; there are things we know we know. We also know there are known unknowns; that is to say we know there are some things we do not know. But there are also unknown unknowns – the ones we don't know we don't know.'

The day after Bruce Nauman was born, Pearl Harbour was attacked.

Some years ago, I was invited by an old friend from college asked to give a talk about my work at Hull School of Art. He was relatively new to teaching, and I was a reluctant speaker. He was nervous for me, and the feeling was contagious. The lecture theatre had a prodigious rake and a formal lectern. This was to be my first experience of stage fright. I would try to begin a sentence, personal pronoun followed by verb followed by a… by what? Each word became disconnected from myself and any ordering logic – it seemed to land on the floor and stare back at me, like those words that grow crazy if you think about them too much, seemed to be too densely packed to own to anything but itself. I remember the students were agog.

A panic attack is a meeting with the absolute. The here and now are catastrophically present, suffocating any attempts at reflection with existential dread. I recognise this aphasia as a quintessential Naumanesque experience. Do something, or I'll die. I can't do anything.

SPEAK AND DIE SPEAK AND LIVE
FAIL AND DIE FAIL AND LIVE
RUN FROM FEAR FUN FROM REAR

There is a German term *ohrwurm* (earworm), which defines those insidious tunes, riffs, jingles, catchphrases that work their way into one's consciousness. They come unbeckoned.

PLEASE PAY ATTENTION PLEASE

MAKE ME THINK ME

PETE AND REPEAT

NO NO NO NO NO NO NO.

'I'm not into this detail stuff. I'm more concepty.' That is Donald Rumsfeld again. Humpty Dumpty pleading to be liberated from the constraints of his story, from responsibility. What if there is no moral to the tale?

'When *I* use a word,' Humpty Dumpty said in a rather scornful tone, 'it means just what I choose it to mean – neither more nor less.'

'The question is,' said Alice Liddell, our embedded correspondent, 'whether you *can* make words mean so many different things.'

'The question is,' said Humpty Dumpty, 'which is to be master – that's all.'

My word is my bond. I give you my word. In the beginning was the pun. Words become intransigent or under pressure of great conflicts, untrustworthy, evasive, treacherous, like photographs. Time and space cannot be faked. Weight, gravity, stillness, movement. The laws of motion. An equal and opposite force. Newton. Newton, who gave us gravity but believed in Alchemy.

THE TRUE ARTIST HELPS THE WORLD BY REVEALING MYSTIC TRUTHS

Einstein is asleep.

'He's dreaming now,' said Gilbert: 'and what do you think he's dreaming about?'

Alice said 'Nobody can guess that.'

'Why, about *you*!' Gilbert exclaimed, clapping his hands triumphantly. 'And if he left off dreaming about you, where do you suppose you'd be?'

'Where I am now, of course,' said Alice.

'Not you!' Gilbert retorted contemptuously. 'You'd be nowhere. Why, you're only a sort of thing in his dream!'

'If he was to wake,' added George, 'you'd go out – bang! – just like a candle!'

I remember the cover to *Roget's Thesaurus*. On it was a photograph of a paper chain – on each coloured loop of paper was written a word, and the chain proceeded by synonym and nuance to gradually circle around the absent object of its definition. Looping the loop.

In religious ceremony, the repetitions, no matter what religion, are ruled by the loops around the sun, even before we knew we were aboard the moving body. Easter and Passover are alike in their repetition of sacrifice. Ramadan ends on the new moon. Our links with the past and our reassurance of our future require such ceremonies. The same thing repeated forever is a litany. Litany – words

that mean something sacred. But we know that is only through a leap of faith, because the linguistic sign is arbitrary. Rhetoric is all. The aircraft towing an advertisement across the sky. Dollar signs in the middle of the desert. Dirty money. The beginnings of Howard Hughes's obsessive compulsive disorder – obsession with cleanliness, withdrawal from the world. Retreat. Ever washing, cleansing. When we bathe together, it is holy. Baptism. Dirty money. Shame, Guilt. Jesus wept, we are talking religion here. When we speak together, it becomes a chant. Plainsong. Dollar signs in the middle of the desert. Kerching. You can't take it with you. You will hang for this.

Not that the experience is circular – cyclical – but the quality. The circles in Dante's *Divine Comedy*, the inverted theories of capitalism expounded by Milo Minderbinder, the Dick Cheney character in *Catch-22*. The white soldier in *Catch-22*, bandaged from head to foot, with an intravenous drip feeding into his arm, and another tube draining him; when the liquid had passed through him, the two were swapped. *Catch-22* itself.

'From the earliest tapes that I did, coming from a certain sense from some of Andy Warhol's films. They just go and on, you can watch them or you can not watch them. Maybe one's showing already and you come in and watch for a while and you can leave and come back and eight hours later it's still going on. I liked that idea very much. It also came from some of the music that I was interested in at the time. The early Phil Glass pieces and La Monte Young, whose idea was that music was something that was there. I liked that very much, that kind of way of structuring time. O part of it is not just an interest in the content, the image, but the way of filling a space and taking up time.' (Nauman, like Warhol before him brings bad news for American dreamers.) Filling a space and taking up time. Starting where things generally end, in definition, is surely putting Descartes before the horse.

Art jokes are bad because they come retold by the likes of Freud or bloody Duchamp. All old Europeans, they never dreamt the American Dream. Architecture and sculpture are within America's domain, post-war.

And looking west, that's a lot of new space to fill, but with what and for whom? Sculpture was released from its pedestal into the wide world of buildings, street signs, walk don't walk, the general public. Painting still requires connoisseurship,

because it needs a roof over its head, and the concomitant values associated with the bourgeois collector. Alone in an old shop-front in San Francisco, Nauman junked the painting and self-consciously followed his every move. The first post-war artist, first existential artist, alone in a studio. Everything connects and everything alienates. Nothing connects and nothing alienates. All that we see is both particle and wave. Supple as seals in water, but the land... the land is a different matter. Matter meets gravity which is insistent and difficult like a page full of German nouns. I can't go on. I will go on. Present the work. No more, no less.

Film is famously the technology of representation (but these are not representations, they are records, moulds, pathways, corridors, digital information, sound) most closely associated with philosophical insight into the mutual and paradoxical constitution of time and the self. The self in time – past, present and future – and in memory, attention and expectation. Video is sheer information, pure enumeration. Even its snowy nowhere is called static. Sometimes duration is nothing more than the wind through the trees. The tree in structure and detail does not change, though constantly moving. It does not tell us anything essential about the tree in the wind. It breathes. In cheap cartoons, sometimes the characters' only animation are the blinking eyes – see: it lives!

Plaster casts are made to objectify and interrogate their host body. The kernel removed, they insinuate that we are hollow, of unshapely pipes and cavernous depressions, with unlikely peaks and troughs. Then something man-made, a chair, is dared into existence; let's see how it relates to everything else.

Where to start?
Everything cracks and shakes.
The air trembles with similes.
No one word's better than another;
The earth moans with metaphors...

In some languages, the question mark comes at the beginning of the sentence, which seems sensible because we are prepared for the right inflection. It is as if a primer in grammar thoroughly interrogated the efficacy of language, testing it to its breaking-point. Ethical or philosophical questions raised are a by-product. We may think we know them by name, but let's see what they actually do.

Figures which change the typical meaning
of a word or words.

Figures which move the letters or syllables
of a word from their typical places.

Figures which omit something. For example,
a word, words, phrases, or clause from a sentence.

Figures which repeat one or more words.

Figures which repeat a phrase, a clause or an idea.

Figures which alter the ordinary order of words
or sentences.

A miscellaneous group of figures which deals with
emotional appeals and techniques of arguing.

In AUDIO-VIDEO UNDERGROUND CHAM-
BER, with the figure in the ground, figuratively
speaking, the camera and microphone become our
proxy consciousness. The underground chamber
is the space inside our heads. It represents the
complete decapitation of mind from body.

'During my two decades of residence in
Arabia as a royal adviser, I witnessed my share of
judicial decapitations. A friend who was a surgeon
told me that under medical conditions one can
remain conscious for two or three minutes after
the blood supply to the head has been cut off. This
indicates that, unless rendered unconscious by
hitting the ground, a person's severed head remains
sentient after the sentence has been executed.

A police officer who presided at executions
subsequently confirmed this. He told me that if the
head is picked up too soon, it endeavours to use its
only remaining defence mechanism – biting.'

The Queen had only one way of settling all
difficulties, great or small. 'Off with his head!' she
said. And all the king's horses and all the king's
men couldn't put Humpty together again.

Having sacrificed it to power (the slave and
the conscript) then to industrialisation (the blue-collar
worker), the subject is now separated from his body.

GOOD BOY	BAD BOY
GOOD DOG	BAD DOG
GOOD GOD	BAD GOD

Consider the duration of the works. When you
wait for so long at a stop sign you think it is stuck.

Then it changes, and you forgot your frustration
long enough that eventually it is only the horn of
the guy behind that interrupts your reverie. What's
your hurry? Consider the attention that is given to
the work. Time, the fourth dimension, is implicit
in the sculptures, where the viewer is manipulated
through corridors around hoops inside cages
before disappearing off-screen. 'I mistrust audience
participation. That's why I try to make these works
(words) as limiting as possible.'

Objects in a museum wait in the dark all
night. They don't need to be switched on. Video is
always on somewhere. You don't need a projection-
ist or any special premises, let alone a gallery.

THE TAPE RECORDER SET INSIDE
A CONCRETE BLOCK

The buried chamber and its watcher. 'My mind is
the key that sets me free.'

Whatever we fear, Houdini knew about it.
'There is one reality, at least, which we all seize
from within, by intuition and not by simple analy-
sis. It is our personality and it's flowing through
time – our self which endures.' Henri Bergson's
idea of duration, like de Selby's disembodied travel
plans: a trip from Bath to Folkestone by means of
an exhaustive series of successive photographic
images. A philosophy of the absurd, the footnotes
of a thinker who never existed, in a book about
eternity narrated by a dead man. I am talking
The Third Policeman here, not the Old Testament.

It would be absolutely impossible to represent
duration conceptually, because we would be talking
about the memory of duration, not the actual experi-
ence of duration. Intellect is the mould in which
the richness, joy, and creativity of life is jellied
into an inert, motionless and static dead matter.

'Negative space for me is thinking about
the underside and the backside of things. In casting,
I always like the parting lines and the seams –
things that help to locate the structure of an object,
but in the finished sculpture usually get removed.
These things help to determine the scale of the
work and the weight of the material. Both what's
inside and what's outside determine our physical,
physiological and psychological responses – how
we look at an object.'

When looking at a static object, the phenom-
enon of time, of how we perceive something, can be
separated from the 'what' we are looking at, which
does not change.

215

Negative space, as against what? Positive space? The obverse of free will the artist is faced with existential crisis. To make or not to make, that is the question. Which bit of the world's negative space am I about to fill?

The underneath of the chair – hotel chair – any old chair in a room you landed in. When sat on, what is the least considered region in the entire universe. Perfect.

Abstract thoughts being lobbed back and forth, in a setting that is metaphorical as it is mundanely commonplace. Abstract and concrete, allusive, reductive, particular and exemplary. It sets banality and originality on equal terms, because one cannot exist without the other.

Insomnia is a waking nightmare. Nauman doesn't blink. It is a long, hard stare. It affords no distance between desire, need, remedy, ill, conscious, unconscious; it is the whole animal. Nothing transcends the limits of language. The only casts are just so – casts, they fill the space, not the chair or animal or head. The head casts are too full of their own matter to have any trace of voodoo. It is dead air like in the video. Darkness is dead light. Neon is the night advertising its dark side. It is a word announcing itself, neither verb nor noun; action or object. Our goal, like the burning bush is unconsumed by its own desire. Lust is endless. Neon is a sign.

The loop. The insomniac loop like Philip Guston's Painter rigid in bed ever-open eyeball. The loop is there in all his work, however ephemeral or concrete. It is as relentless as a jukebox full of country music:

'The only time I wish you weren't gone / Is once a day, every day, all day long.'

Or as abrupt as a punchline: What is brown and sticky? A stick.

AROUND THE CORNER PIECE 1970

RED RUM RED RUM RED
RUM RED RUM RED RUM

Round and round the corridors, a child's view of a dream or nightmare, the locked doors of empty rooms. The child's intuitive grasp of something momentous, something happening at or just beyond the limits of its child mind, behind locked doors. The little figures in the head in the *Beano* cartoon were a way of compartmentalising the conscious mind and the dream-work. Running the film backwards is a waste of precious time.

The work plays powerfully with play and playfully with playfulness. It finds the interstices, the synapses, the current leaping across the gap. It knows that values, meanings, weight and scale exist in relation to their opposites: thesis and antithesis, love and death, the skull in the Nativity scene.

HANGMAN is a game for children. A race to meaning with the ultimate jeopardy and shame we discover in the post-asphyxiation erection. Executed by the state and exposed to the public. Sit down like a good boy, or sit down to die. An eye for an eye forever.

VIOLENT INCIDENT 1986. The logic of comedy is murderous. These are cruel toys. Cruel stories we are used to. We fear the end, but at least it is the end. There is space for a story in *Tom and Jerry*. But imagine a future unfolding in endless repetition, everything exactly as predicted. Itchy and Scratchy, the one in the other. Forever and ever. It is America staring down its other and finding what itself lacks. A poke in the eye with your own trigger finger. Abroad in the world is no place for a cowboy, a toy with a toy gun. The boy with the mutant toys next door. That is the imagination of Hieronymus Bosch. Make use of old Europe and learn the more creative elements of torture and their names. Rendering. That's me in the corner, losing my religion.

The Fall is godless and graceless. Gravity comes with an implacable formula – the momentum of falling bodies can be expressed as a number. *At a given location on the earth and in the absence of air resistance, all objects fall with the same uniform acceleration.* This acceleration is called the acceleration due to gravity, and it is referred to commonly as *g*.

$g = 9.8 \text{m/s}^2$ (metric). Gravity exerts its pull everywhere. For human beings who walk and crawl and dance, rest and sleep with grace and clumsiness, balance and blunder, it characterises our meetings with the ground. To deny gravity is to become disembodied, spectral, godlike, directing and starring, meddling with its power like the silent masters – Chaplin, Beckett and Keaton. Tramps and clowns, those stock figures that move us out of ourselves the better to examine our behaviour. And the ground threatens to rise up at any moment.

'Buzz Lightyear to Star Command.' This is the moment Buzz Lightyear realises he is not a superhero, he is just a toy. His existential moment as he flies, rather falls, is thrown through space. Martin Heidegger says we are thrown into existence. 'That's not flying: that's falling with style.'

Ludwig Wittgenstein characterises our
compulsion to 'run against the boundaries of
language. This running against the walls of our
cage is perfectly, absolutely hopeless… What
[any discourse on ethics] says does not add to our
knowledge in any sense. But it is a document of a
tendency of the human mind.' Metaphors are like
clowns running at you with buckets of confetti.
The slap to the back of the head is some clown
manoeuvring a plank. Have some dignity. Oh God,
here comes the clown with the bucket again.

DOUBLE STEEL CAGE PIECE. Just
thinking about it is strangely liberating. Why is
that? A cage within a cage is a double negative.
Two wrongs don't make a right. Just as SOUTH
AMERICAN TRIANGLE has the abuse of power
implicit in the upturned chair and the historical
memory of the triangular trade of slavery. These
are the rules, but the rules are nonsense. It is
a protection against our own irrational desires,
but at its heart it is empty. It is protection against
ourselves, but that 'protection' is a useful fiction,
a protection against the emptiness at the centre.
By this double bluff, it reveals us to ourselves
as hollow.

Guantanamo Bay. There is nothing to fear
but fear itself.

We don't have answers, and we have the
hostages to prove it.

To walk inside it is to be in No Man's Land,
a space for no one. It is the supreme work of nihilism.

What we cannot speak about, we must pass
over in silence.

Famous last lines.

SHIT AND DIE SHIT AND LIVE

What is truth? asks Pontius Pilate.

Human and divine.

Particle and wave.

DESPICABLE THINGS

Ai Weiwei

TO DISTINGUISH

I never received a good education; from early on, that proved to be impossible. By the time I actually understood this, it was too late to do anything about it. I was like a traveller at dusk that found himself deep in a forest before even noticing a single tree. All that was left was to struggle to remember the path that brought me there, and to distinguish my direction.

TEMPTATION

Existence is temptation itself. Temptation already within the very body of existence, and each time you are seduced by it, you come out with nothing; this helps guarantee temptation's eternal nature.

That which cannot be grasped, that which you see with your eyes but which slips from your hand, that which will never belong to you, which is impossible, and which leaves you frustrated and disappointed, learning what that is will require more time to comprehend.

UNRAVELLING

Forming thoughts and then articulating them is something like finding a loose thread in a knit sweater, then gently picking at it until the whole woven pattern comes undone. But there are always exceptions – if you don't know how, or you don't have the desire to act upon these threads of thought.

SYMBOLS

When you're building with limited materials, and when you face limitations or an unreachable distant shore, in these situations you can only use symbols. A symbol is a non-existent road on which you can run, a road which can be easily abandoned and doesn't need to be understood; a symbol is the fastest and most convenient of all roads, but is also the least reliable – it will never let you reach your destination.

DESPICABLE THING

In a great majority of circumstances, difficulties helped me. I'm a piece of shit, that's because I have hope for people.

R

Mr R is considered an original thinker, as the term is commonly understood, and there aren't many people like that around. Talking about concepts, he believes that the true significance of a 'concept' lies in personal experience and know-how, and it was this kind of thinking that prompted me to go to Kassel. Even though two lines appear superimposed on the same spot, and it seems as though they might cross, they are on different planes, and ne'er the twain shall meet.

TRAPS

People who do not understand happiness put incredible efforts into ensuring the happiness of the next generation; this seems like a trap.

FRAILTY

Inevitably, weakness will incite a yearning for extraordinary strength, and not just your ordinary kind of desire. Imagine the feelings of a weak blade of grass in a tempest – imagine its fragile desire for strength, and the potential of being conquered, or not. Even though it is fragile, it cannot be conquered – it is reliant and invincible, and at any moment it can rebel; it is used to relinquishing all its power in the face of strength. Only moans – not howls – make the moaning seem more persistent.

Posted on Blog 21 August, 2006
Translation by Lee Ambrozy

219

Da Do Ron Ron is dedicated to a man called Ron Lenthall. Ron was a cabinet-maker, a man of Hoxton, who taught me many things by example and also something about being sensible to the world. I think manifestos are really disturbing. I'm not a manifesto man, but I have a proposal. I'm going to propose some things that you should have done by the time you go into further education. If you haven't done them, you won't be accepted. You can replace my proposals with your own proposals, so this is not prescriptive, but it is a kind of model.

DA DO RON RON

Richard Wentworth

— I think you should have worked somewhere where sugar is produced [*holds up sugar cube and then two sachets of sugar — one of white, one of brown — passes them around audience*].

— You should know how this gets made [*holds up a five-pound note and passes it around*].

— You should work in a place that makes napkins or any of the papers which imitate cloth. It will remind you how astonishing was the invention of paper and the invention of textiles [*passes round paper napkin*].

— You should know what this is and you should have loved it [*passes around a handful of clay*].

— You should know how to do this [*holds up a piece of turf on a spade*]. You should know how to dig and what the tools are called. This is a spade. It's not a shovel.

— You will need to know, by experience, how some things get converted into other things and are often called by different names [*passes round two types of brick*].

— You should appreciate difference and you really should appreciate smell [*passes around two hanks of rope, one blue plastic, one hemp*]. Try smelling the blue one.

— You should know about the history of containers, and how they are formed. You should work in a polystyrene factory and research what makes things similar [*passes around polystyrene cup and aluminium ring-pull can*].

— You must know that you don't have to measure things [*holds up tape measure*].

— You should spend time in a corrugated cardboard factory, a factory which makes hardboard, another where they make string, and another where they make elastic bands [*passes round cardboard, hardboard, string and rubber band*].

— You should find out about the whole history of joining things and cutting them. Here's a razor blade — I won't pass it round.

— You should try working in a toothpick factory and somewhere that makes books of matches.

— You should really enjoy all the different kinds of pointedness. These are the most enjoyable screws in the world. You should know the difference between a hard and a soft nail. You must spend time where they make paper clips [*hands round paper clips*].

— You should enjoy parcel tape, which didn't exist until 70 years ago.

— You should find out where you can get hold of this totally wonderful wire which the French call *recuit*, which means 'double-cooked'. You can bend it for ever and it's unbelievably pleasurable [*handed around*].

— You might want to find out how a stick of rock is made because soon it will be banned, and how these tags get put in clothes to discourage theft [*both handed around*].

— The loom is now pretty old, but I think somewhere which actually produces volumes of fabric is phenomenal, and you should know that as direct, fingertip experience.

— For me, this is the strangest product of our times, because it is not woven and it's not quite moulded. You can see it's almost liquid, as if the language of pulling chewing-gum had been industrialised [*large piece of extruded orange plastic net, used as barriers on construction sites, is passed around*].

— It would be nice to really know what these are and what they do [*bean seeds*]. If you each take one home, you can grow beans next year.

— So, here we all are, in a late Frank Gehry pavilion, but here is an original Frank Gehry [*holds up toilet pan*]. This is made from liquid clay, known as slip. It's a triumph of volume-making. You must work somewhere that makes toilets.

221

Everything was returned to Wentworth, except for the five-pound note. The first two cabs hailed by Wentworth after his presentation refused to stop because he was holding a toilet pan.

222

ACTIVE RESISTANCE TO
PROPAGANDA

I make the great claim for my manifesto, that it penetrates to the root of the human predicament and offers the underlying solution. We have a choice: to become more cultivated, and therefore more human, or, by not choosing, to be the destructive and self-destroying animal, the victim of our own cleverness (To be or not to be).

We shall begin with a search for art, show that art gives culture and that culture is the antidote to propaganda.

Dear Friends, We all love art and some of you claim to be artists. Without judges, there is no art. She only exists when we know her. Does she exist? The answer to this question is of vital importance, because if Art is alive, the world will change. No Art, no progress. We must find out; go in search of her. – But wait! Who is this with fire-cracking smouldering pigtails, gold teeth and a brace of flintlocks in his belt? He is a pirate. And what does his T-shirt say? 'I love crap.' [*Pirate hands Vivienne Westwood a Hawaiian garland of plastic flowers.*]

PIRATE 'Leave everything to me. I plunder for you. Stick with me, and you might get a share of the bounty. My name is Progress.'

AR But you have stolen imagination. There is hardly anyone left now who believes in a better world. What is the future of unlimited profit in a finite world?

PIRATE PROGRESS 'I like you artistic lot. But – trust me or not – I'll take you with me if I go down. We'll all burn together.' [*Film clip, close-up: the pigtails burst into flames and with a 'Ha-haagh!', the pirate disappears in a pall of smoke followed by black night.*]

[*Still dark*]
AR He is not Progress. He must have stolen the name. [*The defiant face of Pirate Progress appears and disappears like the Cheshire Cat. Light returns.*] True progress, as the Greeks thought of it, is without limit. How can things get better and better if there is a limit?

BEAUTIFUL SLAVEGIRL 'Everything must have an end. And to progress or advance in any way, you must know where you are going. An end cannot be something you choose for the sake of something else. For example, money is not an end but a

means to an end. And for this reason, I shall be set free. I am so happy! I am the famous Rhodopis (Rosycheeks). My master made a fortune from selling my body, but now my lover will pay a vast ransom – even more than my future earnings could be. Oh, Liberty! I thought you were my end, but now, I see you are just a beginning. Can I be happy when the other slaves don't have a beginning? The only true End must be Happiness – but not just for one person. I see now that progress can be an end without limit, for there is always a better way of living. And though we may progress towards greater happiness, as an end, it will always escape us, and a good thing too, because if we ever reach Paradise, we'll all be dead.'

AR Happiness is the true end of human existence. In practice, this means to realise individual potentialities to their limits and in the best way possible. I think we would all agree.

CHILD SLAVEBOY 'A slave is not a person but *a thing*. A thing can be something like a car, or a hammer, as well as a slave. Soul-destroying, to put it in a nutshell. But my mother told me how to survive; I must try to understand the world, and that way I don't lose my soul – I know who I am. When she said goodbye, she said, "Love Liberty, but forget the key, for the key turns only once. I love you."'

ALICE 'She was your mirror. Her love showed you Yourself. She believed in you.'

AR A work of art may show us our self – who we are and our place in the world. It is a mirror which imitates life.

ALICE 'Those round convex mirrors are very good; you see a lot, but concentrated down – you see big and small at the same time. You need to fit all the things into a microcosm, but it has to reflect as well.'
[*And turning to the art lovers*] 'I was just explaining this to Pinocchio.'

PINOCCHIO 'Now that I have become a boy, I want to be a freedom fighter.'

AR Action! Nothing is possible without art. Come with us. To find if Art is alive, we must first know who she is. To the Lyceum!

223

ALICE [to Pinocchio]: 'We are going to see Aristotle. His analysis of Greek tragedy is such an objective break-down that it serves to define art in general and in all its forms – what it is and what it isn't.' [Then finding themselves alone] 'We must go back and find the others.'

PINOCCHIO 'There's a bloke here who lives in a barrel.'

DIOGENES 'I shit and wank in front of people in the street like a dog: I am the Cynic. The Great Alexander made a point of coming to see me and asked if he could do me a favour. Nobody's better than me. I told him to step out of my light. I am famous because I've got the balls to do what I want.'

ALICE 'He doesn't want much.'

PINOCCHIO 'Cool, I've found art! I could be Diogenes II. I'll call myself a piss artist and make lots of money.'

AR Come back, children. Alice, we're waiting for you to introduce us to Aristotle. And Pinocchio, you're just being silly. Though Diogenes is obsessed by himself, he doesn't believe in anything, let alone himself. That's why he's a cynic. This self-promotion and doing what you want is a sham philosophy of life. No, no, it's not self-indulgence but self-discipline that makes the individual. And you, especially, need self-discipline if you're going to be a freedom fighter.

PINOCCHIO 'You are right. Diogenes seemed kind of happy, but he's a poser. Too boring, I couldn't keep it up. Ha, ha, keep it up! I could sell canned sperm. Great marketing opportunities.

ALICE [sarcastic] 'Oh how lewd!'

Aristotle, a Greek gentleman, impeccably dressed – in contrast to Diogenes – stands centre stage. Alice moves to his side.

ALICE 'Aristotle refers to the writer of tragedy as "the poet". Greek tragedy was expressed in verse, but this is not the important thing. What defines the poet is that he is an imitator – just like a painter or any other maker of images. If a historian were to write up his whole history in verse, this would not make him a poet, for he tells of things that have happened in real life, and this is not imitation. Imitation is the work of the imagination. The poet's role is to tell of things that might happen, things that are possible. Aristotle adds that the poet may imitate life not as it is, but as it ought to be. The way Aristotle describes tragedy is very much the idea of taking the microcosm and fitting things into it – '

ARISTOTLE 'For tragedy is not an imitation of men but of actions and of life. It is in action that happiness and unhappiness are found, and the end we aim at is a kind of activity, not a quality; in accordance with their characters, men are of such and such a quality; in accordance with their actions, they are fortunate or the reverse. Consequently, it is not for the purpose of presenting their characters that the agents engage in action, but rather it is for the sake of their actions that they take on the characters they have. Thus, what happens – that is, the plot – is the end for which a tragedy exists, and the end or purpose is the most important thing of all.'

ALICE 'Dear Aristotle, thank you for stating the links between character, action and fortune. I remember you once said that character is a person's habit of moral choice. But please now tell us what you mean when you describe a work of imitation – in this case, tragedy – as "the Whole".'

ARISTOTLE 'The events which are the parts of the plot must be so organised that if any of them is displaced or taken away, the whole will be shaken and put out of joint; for if the presence or absence of a thing makes no discernable difference, that thing is not part of the whole' [Aristotle retires].

ALICE 'That's how I feel about Velásquez. That exhibition was the most powerful thing I've ever seen, yet his work is so minimal and reduced. The people in the paintings were so real that I sometime thought they weren't there, especially in the split second before you turned to look again. The paint was so thin! I was so stunned, I just wanted to melt into a pool on the floor.'

AR One can begin to grasp something of the obsession people have had with the idea of the circle as a perfect form. A work of art, then, is an imitation reduced to its essentials, thereby forming a whole – as in a microcosm.

F. T. MARINETTI FUTURISTA

ZANG

TUMB TUMB

ADRIANOPOLI OTTOBRE 1912

TUUUMB

IN LIBERTÀ

TUUUM TUUUM TUUUM

PAROLE

EDIZIONI FUTURISTE
DI "POESIA"
Corso Venezia, 61 - MILANO
1914

1

BLAST First (from politeness) ENGLAND

CURSE ITS CLIMATE FOR ITS SINS AND INFECTIONS

DISMAL SYMBOL, SET round our bodies,
of effeminate lout within.

VICTORIAN VAMPIRE, the **LONDON** cloud sucks
the TOWN'S heart.

A 1000 MILE LONG, 2 KILOMETER Deep

BODY OF WATER even, is pushed against us

from the Floridas, **TO MAKE US MILD.**

OFFICIOUS MOUNTAINS keep back **DRASTIC WINDS**

SO MUCH VAST MACHINERY TO PRODUCE

THE CURATE of "Eltham"
BRITANNIC ÆSTHETE
WILD NATURE CRANK
DOMESTICATED
POLICEMAN
LONDON COLISEUM
SOCIALIST-PLAYWRIGHT
DALY'S MUSICAL COMEDY
GAIETY CHORUS GIRL
TONKS

11

Manifesto selected by Gustav Metzger
Blast 1, Manifesto, Wyndham Lewis, 1914

Thus art gives objectivity – a perspective, an overview. We define objectivity *as seeing things as they are*.

Real life is not objective – we can never get the complete picture. It is chaotic and continuous – a jumble of particulars in which events are engulfed in the flux of circumstance. How can the artist be objective when he himself is part of the change? He needs a fixed fact to stand on – a standard, a measure, a model.

ALICE 'Tell me all about it! If there is nothing fixed in the world, then you find yourself in Wonderland, where everything changes – *including yourself*. And you try to play a game of croquet with a flamingo for a mallet, and the ball is a hedgehog who runs away.'

AR A hedgehog must understand the world from a hedgehog point of view, and we must understand it from a human point of view. We do have a fixed standard – timeless, universal, recognisable. We refer to it as Representative Human Nature (RHN). It is the key to this manifesto: You or I – as individuals – we change. But there is something typical about us which does not change. When we say, 'Man is the measure of all things,' we mean the unchanging part – Man, both in his *general nature and according to his various types*: this is RHN.

Aristotle takes this for granted when he says, 'In accordance with their character, men are of such and such a quality… it is for the sake of their actions that the actors take on the characters they have.' He also says that the best characters in a play are people with whom we can empathise – 'someone like ourselves'.

For example, Chaucer's characters are as alive to us today as when he first invented them: timeless – outside of time – they speak to us of the *human genius*, what it is to be human. Each detail illuminates the type and is what we call the *universal in the particular* – 'someone like ourselves'. When we recognise this, we are being objective – through putting ourselves in the place of another, we leave our ego behind.

We are not saying that art has to be confined to the direct portrayal of human beings; we do say that art must be representational – for it is in imitation that objectivity lies. In practice, through his medium of RHN, the artist gains direct imaginative insight into the general nature of things; his view extends from the model.

Consider the Chinese master, the painter of bamboo: we have a shared object – the non-ego, RHN. And from this fact, he reaches out and grasps the very cipher and nature of bamboo. And we see through his eyes, his own particular poem of life: perfect as it *ought* to be.

Consider the divine music of Bach: Bach is pure objectivity, the most representative of men because the least egotistical in front of his talent.

Music has not yet been conceptualised by the art mafia, though they are trying. We do not accept a symphony composed on the remaining three keys of a broken piano, accompanied by the random throwing of marbles at a urinal. Yet its equivalent is the latest thing in the visual arts. (Aren't ya OD'd on the latest thing?) Indeed the visual artist has gone further. He has set up the urinal as art, claimed the broken piano as his production. Why? Because he chose it. Relying now on presentation skills and self-promotion – behold the artist! As long as we believe him.

And abstract art which is supposed to be symbolic and expressive of events in the mind? – Unfortunately these canvases offer us no help in becoming mind-readers. We do have such things as abstract symbols (e.g. X to the Romans), but the artist mus*t explain* his personal marks. If the artist fails the test of objectivity, where does that leave us?

ALICE 'Oh hello, Mr White Rabbit! Please stop a moment! The artist has just produced a giant hole in the air. Perhaps he thought it was a "Whole". I'm sure you have an interesting observation on holes.'

WHITE RABBIT 'Negative' [*rushing off*].

ARTIST'S AGENT 'Superb intellectual irony – right on!'

MAD HATTER 'What do you mean, we're not mind-readers? We've all got a hole in the head, and we can fill it with whatever "Whole" we want' [*changes price-tag on hat from 10/6d to £10m*].

PINOCCHIO 'I'm going to be a real painter and a freedom fighter. I've been drawing in secret. To see the world as it ought to be – that can't be bad for a freedom fighter… hard work, though.'

TALKING CRICKET 'Pinocchio, you know that there are two sides to people, the donkey and the

225

boy – the self who wants to live in Toyland versus the self who wants to grow up. It is the inner struggle between doing what you want and being true to your Best Self that humanises a puppet.'

PINOCCHIO 'Dear little Cricket, I still get around, – have a laugh! But, yeah, this inner voice is always having a go, "Pinocchio, don't be an arsehole! I am your human genius. Listen to me!"'

AR Pinocchio, the whole future of art is at stake and depends on you and others controlling your imagination and listening to your best self – your human genius.

Imagination is the driving force in human nature. But it is likely to run wild and escape into the chaos of endless desire, unfulfilled longing and alienation.

PINOCCHIO 'Alienation! Hell! Those donkey's ears – what a terrible price to pay. Poor Candlewick!'

ALICE 'Candlewick was Pinocchio's friend in Toyland, who became a donkey and was worked to death by a cruel master.'

226

AR The way we control the imagination is through the imagination itself – or, rather, through its 'best self' – the ethical part.

The Ethical Imagination is a *power of control*, an *inner check*, which prefers to see things as they are. It questions art: 'Is it probable?' – 'Is it true to life?' – 'Could it be otherwise?'

Critics in the 17th century objected to Corneille's play *Le Cid*, that it was not probable – because not normal or true to human nature – that the heroine might be allowed to marry her father's murderer… that this was bizarre, extreme and therefore unethical. Others disagreed, and there was a battle of opinion.

There are no rules – each person must decide. Yet we are not completely at sea, if we refer to RHN.

To the great artist, the ethical imagination is absolute; he never ceases to explore and cultivate it. To the art lover, we possess it in differing degrees, but all may cultivate it. It is intuitive – you get at the truth through insight, and you get better at it with practice, through comparison – between works of art and with real life. You need the stamina of a lifetime.

In general, the true artist is always true to his art; the impostor is self-conscious, demonstrating his idea, projecting his theory, his ego, and e.g. the figures of the painter are not borrowed ideas who demonstrate themselves talking, dying, dreaming – they do it. They are of themselves and they LIVE! – and the flowers are not showing us how pretty they are, or how weird – they are what they are, etc.! No invention for the sake of invention! Invention must serve the purpose of art.

Art is the only objectivity available to human beings; real life, including science, cannot do this. *Art is objectivity.*

To recapitulate, the artist, taking RHN as his model, presents an imitation of life; the imitation is a completed view, a whole, as in a microcosm – albeit an illusion of reality. The illusion captures our imagination, and the ethical imagination tests it out as to its truth. We see our human face, and we ask, 'Could it be otherwise?'

Without judges, there is no art. We, the art lovers, respond to the truths of art and spread the ideas which give culture.

Thus RHN is the authority on which culture rests. Culture must rest on something abiding, an authority, a belief. But our authority is not dogma (no need for God to supply social cement or fill the spiritual vacuum) but the authority of a consensus, – the facts of shared experience.

Culture is a unifying experience. We are moving towards a centre which is infinite. Our guide is RHN – universal, timeless and recognisable, even to the point where we recognise something we've never seen before – as true to life. In this sense, RHN is a dynamic force, alive and open to improvement because it depends on the inner check – the ethical imagination – of every one of us. We become more human, which in turn gives culture its rejuvenating power.

We define culture as *the exploration and cultivation of humanity through art.*

ART LOVER Very good – I recognise art, therefore art exists! No matter how great the artist, if no one appreciates his work, he goes unrecognised. Therefore no culture! It's up to us as judges.

AR But the artist has no responsibility to culture or to us: he serves art alone.

This is the true meaning of the *L'art pour l'art* movement, mistakenly translated as 'Art for art's sake.' But then, the English have never understood

it. The painter Whistler is a protagonist of the creed, and we must seek his opinion before we can safely say that we have found art.

WHISTLER 'Art happens – no hovel is safe from it, no Prince may depend upon it, the vastest intelligence cannot bring it about, and puny efforts to make it universal end in quaint comedy and coarse farce.

This is as it should be. Why after centuries of freedom from it and indifference to it should the people have Art thrust upon them. She has no desire to teach, no purpose to better others.

Art seeks the Artist alone. Where he is, there she appears, and remains with him – loving and fruitful… And when he dies, she sadly takes her flight.

With the man, then, and not with the multitude, are her intimacies; and in the book of her life, the names inscribed are few – scant, indeed, the list of those who have helped to write her story of love and beauty.'

ART LOVER '*We* also have our part in all true art! For, remember that it is RHN that makes the whole world kin.'

WHISTLER 'True indeed. But let not the unwary jauntily suppose that Shakespeare herewith hands him his passport to Paradise, and thus permits him speech among the chosen. Rather learn that in this very phrase (Representative Human Nature), he is condemned to remain without – to continue with the common.'

ART LOVER 'You mean that what is popular is also vulgar. And is the artist, then, a freak of nature? We small band of art lovers expect no favours from art. But from you, the artist, we hope to see the world through your eyes – in this way, we serve art.'

PINOCCHIO '*You get out what you put in* – that's my motto from now on. As a painter, perhaps Art will visit me some day – just like the fairy with blue hair.'

LADY ART LOVER 'Mr Whistler, I fear for these young people! In your field, painting – which has had such an impact on our lives – there is nothing happening nowadays. What are they to do? All their friends run around trying to catch the latest thing. When you're young, you like to think something is happening.'

ALICE 'Running around? I don't waste time, I make time – to see the "latest thing" – the *Rokeby Venus*! – Manet's *Olympia*! There is so much happening outside Time.'

WHISTLER 'If Art be rare today, it was seldom heretofore. It is false, this teaching of decay. The master stands in no relation to the moment at which he occurs – a monument of isolation – hinting at sadness – having no part in the progress of his fellow men.

He is also no more the product of civilisation than is the scientific wisdom of a period. The assertion itself requires the man to make it. The truth was from the beginning.

So Art is limited to the infinite and, beginning there, cannot progress.

We have then but to wait until – with the mark of the Gods upon him – there come among us again the chosen, who shall continue what has gone before. Satisfied that, even were he never to appear, the story of the beautiful is already complete – hewn in the marbles of the Parthenon, and broidered, with the birds, upon the fan of Hokusai, at the foot of Fujiyama.'

PINOCCHIO 'Mr Whistler, are you the only American genius?'

ART LOVER 'Progress in art – Picasso! What would he not have given to capture the "mana" of those bulls from the cave paintings of 20,000 BC? If art progressed, then today's painter would be greater than Picasso.'

LADY ART LOVER 'It's true we don't have to wait for Art. She exists. But time is running out for the art lovers. I'm talking about the planet. It's all very well to say that we can become more human through art – human enough to save the planet! Meanwhile, all we can do is believe in Alice and Pinocchio. At least they will have the advantage of a sane outlook on life.'

[*Giant projection of Hitler's face – in relation to which Hitler standing on the podium in front seems to be about the size of a garden gnome.*]

HITLER 'All effective propaganda has to limit itself only to a very few points and to use them like slogans.'

AR Alice and Pinocchio, we have come to the end of our journey, and you have passed the test. In the

pursuit of art, you became automatically impervious to Propaganda. Indeed, each of you quite forgot to take your daily NINSDOL pill. You are no longer addicted to Nationalistic Idolatry, Non-Stop Distraction and Organised Lying – the three constituents of Propaganda. The art lovers now invite you to become members of our movement, AR. Let us progress to the inauguration ceremony.

On the way, we could look in at a Conference on Culture which is attended by those very same art lovers who from the beginning had no interest in our journey. Here it is in Paris. Pinocchio, I know you're dying to go to the Louvre, but Alice, you could just pop back in your book, and I'll put it in my pocket and take you in.

Opening speaker, French professor of anthropology: 'And Man came out of Africa 180,000 years ago (*talk lasts ¾ hr.* AR: – He's scared of seeming Eurocentric) – and the good thing is he ended up in Paris. (AR: Quite right too. France was the greatest flowering of Western culture for the three centuries up until the First World War – interrupted by the Revolution, of course.)

AR Pinocchio, you certainly had the chance to immerse yourself in the Louvre. The conference was a continuous drone of complacency for three days. I thought, 'I will stay – to know if it is this bad.' I managed to get my word in early on – saying that you can't have culture without justice before the law and cited the withdrawal of Habeus Corpus which has happened in England.

There were other points made from the floor, squeezed in between the long speeches of the art gurus – and the banquets…

PHILOSOPHER 'We need more festivals.'

TOP CULTURAL ADVISOR 'We need a common vision of the importance of television and cinema for the cohesion of society.'

CHOREOGRAPHER 'Dance is the only international language. It should be at the top of every agenda.'

RAPPER 'I need the state to sponsor my music. The internet only helps established artists.'

COMPOSER 'Young people should know that culture is not entertainment.'

DIRECTOR OF STATE ART GALLERY 'We have not once mentioned American culture!'

AR I think the purpose of the conference was to say that European culture has value – how do we retain it and also promote it? The problem was that each assumed himself so cultivated that none bothered to define culture – the more he appreciated *everything*, the more cultivated he thought he was. They mix up culture with anthropology, the science that treats of the traditional crafts and customs of groups of people who are different from our groups. Well, 'something different' is not always art, and culture is not local and peripheral but a universal and centralising power.

ART LOVER 'Yes, true culture occurs in another way: the artist is alive to difference, and that is what makes his work original. He sees the common element in things that are apparently different and discriminates between things that are apparently similar. The Chinese say that the painter finds likeness in unlikeness and unlikeness in likeness.'

AR Anyway, contrary to what *we* understand by culture, the conference reiterated – endlessly! – the mantra of 'Cultural diversity'.

Unesco is promoting this concept in a 'Universal Declaration'. This is the kind of thing they say (I made a note), 'Since cultural goods and services arise from human creativity, it follows that cultural diversity will be enhanced in conditions conducive to creative activity and to the production and distribution of a wide range of cultural products.' – A global bazaar to promote tolerance and awareness!

The delegates then wondered how we could prevent tradition being swallowed up in a global soup – along with vanilla ice cream topped with onion sauce, magic mushroom Cornish pasties and…

PINOCCHIO 'Ratshit!'

LADY ART LOVER 'And Pinocchio, I think Alice has pinched some of your cheek. As we were leaving, she jumped out and yelled –'

ALICE 'You're all a pack of cards!

AR Children, you are expensive – crap is not good enough for you. Time is your luxury. You like to be

228

alone, because you like to think. As art lovers and readers, you will converse with the highest forms of intelligence. You will form your own opinions, and your ideas will be the avant-garde. Ideas will give you power, and you will fire the imagination of your friends. You see through propaganda. Therefore engage in politics. It is time for you to receive your badges from the noble warrior Leonard Peltier.

ALICE 'But Leonard is innocently serving Time.'

LEONARD PELTIER 'It is the spirit of Leonard which now speaks: art is an imaginative illusion which captures the imagination. State your vows.'

ALICE 'Every time I read a book instead of looking at a magazine, go to the art gallery instead of watching TV, go to the theatre instead of the cinema, I fight for Active Resistance to Propaganda.'

PINOCCHIO 'The freedom fighter's motto is: "You get out what you put in."' [*Leonard pins on their AR badges.*]

LEONARD PELTIER 'Alice and Pinocchio, you are now in the presence of a great secret. Your journey has revealed to you that human beings have a choice. We can cultivate the human genius and build a great civilisation on earth. Through art, we see the future. It holds up a mirror of our human potential. Or, as victims of our mere cleverness, we will remain the destructive animal. Our innovations can contribute to progress, but our humanity is a scientific fact, and must be taken into account for advance to happen, otherwise we have partial science, which will kill us.

Indians have not made this mistake; they see the world in its entirety. Our first duty is to love our mother, Earth. Indians know the importance of living in harmony with creation: men – not gods. The Greeks called human arrogance *hubris*.

VOICE OF ICARUS 'Remember the myth of Icarus. Do not fly too near the sun. Your wings are made of wax.'
[*Light radiates through the patterns in a mandala composed of concentric circles alternating with diminishing squares. The squares represent the organisation and knowledge of man, and the circles represent the truth and chaos of nature.*]

LEONARD PELTIER 'Progress lies in the centre of the mandala. Step forward.' [*In his hand, he holds a small convex mirror from which the light is coming*] 'This is the mirror of true progress.'

[*Alice and Pinocchio look at themselves in the mirror.*]

* * *

The most important thing about the manifesto is that it is a practice. If you follow it, your life will change. In the pursuit of culture, you will start to think. If you change your life, you change the world.

229

EXPLAIN YOURSELF:
A PROPOSAL FOR AN INTERNET SITE

Stephen Willats

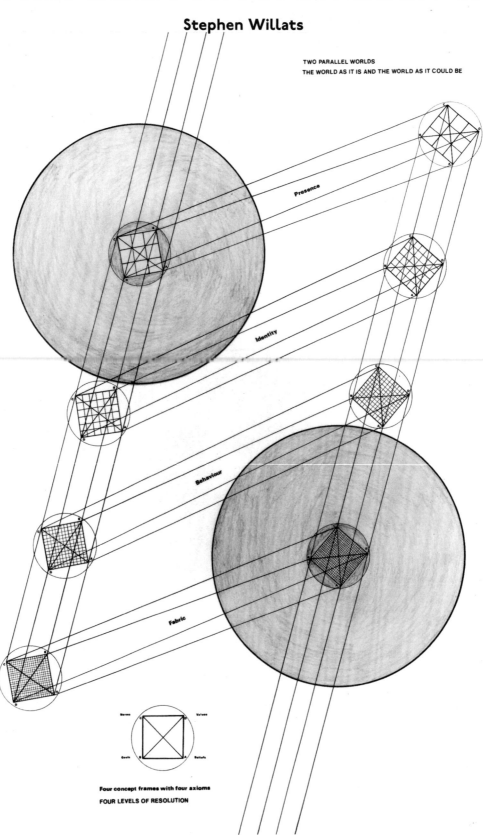

Stephen Willats, *The World as It Is and the World as It Could Be*,
December 2006, 125cm × 82cm (ink, pencil, Letraset text on paper)

As the dream of a fluid responsive social infra-structure built on the dynamics of exchange (effectively mapped out as long ago as the 1950s) now begins to shape the very parameters of exist-ence in contemporary society, the artist's response to these basic shifts in the dynamics of perception in daily life has been strangely muted. For most art practice continues to operate within the contained institutional conventions of the 'Art Gallery-Art Museum' in the manner of an emula-tive icon to be witnessed but not interfered with or changed. And yet I see we are living in the middle of a revolution, but it is not a revolutionary moment led by the rhetoric of new manifestos, but is being driven through an evolution in technology over the last 20 years, a technology of interactive networks which are ultimately self-organising, and which have directly affected everyone's communication and processing of information. The result is plain to see, as networks of exchange externalise into our daily life and, as a consequence, compatible states of consciousness emerge that have the potential to redefine our sense of self and our interpersonal life.

While the ramifications that stem from this non-declared revolution would seem to extend into every realm of cultural endeavour, and certainly must be considered to have a direct bearing on anything concerned with the future, there is a seemingly stubborn or perhaps naive reluctance by artists fully to take on board what this means for an art practice that would want to be an effective part of that future. Instead there is a reiteration, even a celebration, of cultural values associated with an object-centred society founded on a one-way network of transmission that projects the art work as an icon of immortality, of the perma-nence and status of property. These projections maintain a mythical notion of sole authorship, the unique independence of the artist from the infra-structure of society.

An important part of the mythical ethos surrounding the practice of artists has been that the art work is in a competitive, free-will environment, in which 'good art' will somehow magically win out, but at the same time at the core of this competi-tive environment, there is an institutionalised career path that will verify, legitimise competition into what it can hold up as 'good art'. The result-ing hegemony strived for in competition has been accompanied by a psychology that has reduced the complexity of the art work's social interface.

Closely linked to this reduction has been a tendency towards object-based perception, the containment inherent in objects detaches the self from the complexity of that interface. Coupled with this is an expression of the values of exclusivity, the holding of special knowledge, being a prerogative within an authoritative cultural set-up, elevating the status of the holder.

Relationships between individuals caught up in this competitive and exclusive realm are highly demarcated, different territories of informa-tion being associated with a variety of specific identities, such as curator and critic – each with their own specialised languages, behaviours and values. My point in going over this ground, which is examined in more detail in my text *Intervention and Audience* is that the infrastructure of art's social environment is instrumental in inducing conformity from the artist, the artist is locked into a deterministic *modus operandi*, the dilemma being largely compounded by the desire of the artist to conform, to be seen to belong within the realm designated as 'Art'.[1]

Once the artist moves outside art's social environment, the result has been the marginalisa-tion of their practice by the institutional vested interests in Art, and through their absorption into other perceptual realms; for example, the response, 'It is not art but social science' was experienced by this author when seeking institutional support for the West London Social Resource Project in the early 1970s.[2] The pressure of marginalisation and exclusion ultimately often results in artists merging their activities into these other realms, as much for the lack of economic support as anything else. Of course, this situation must be negative to the development of new practices, and the adherence to the celebration of the object, rather than society, is certainly at odds with the cultural inferences that stem from communication built on exchange, fluidity and informality elsewhere in society.

For example, an important ramification to stem from exchange within interactive networks is the possibility of finding mutual agreement, a homeostasis, which in turn opens up the perceptual level of resolution to embrace the complexity and fluidity of relationships. This makes possible non-hierarchical one-layer networks, in which information is potentially made freely available, through the actions of question and answer. Unlike hierarchical net-works, relationships are not formal, set in stone,

231

but are informal configurations, constantly changing shape according to needs and events.

This conflict between the orientation of art practice and the changing parameters of society is a particularly polemical issue for the artist who wants to see their art practice intervening in society to transform perceptions of its future. A purely descriptive art reflects the *status quo*, the existing norms and values, perhaps even amplifies and reinforces them, and this is undoubtedly what most art does, as society gets the art that it wants. But an art practice which seeks to transform existing perception, recode how contemporary society cognises itself and its vision of the future will – if it is to develop any meaning for the particular moment – needs to be seen to embrace the inferences that stem from emerging networks of exchange.

Also important to this creation of meaning is the necessity of a consistency between what a work proclaims and the way it operates, to the point where even how the artist organises the work's development and fabrication reinforces the significance it has for the audience. For here, consistency is important to belief, especially to maintaining 'belief' when encountering an art work that varies considerably from existing norms. Though dissonance can allow for the maintenance of credibility, and for conflicts in consistency to be ignored, the relationship is always vulnerable and likely to collapse, leading to an almost-instant reversal of belief. Such a reversal is fundamentally disappointing to the 'believer', the audience, and must surely inhibit their willingness to countenance any new propositions forwarded by the same artist, or by transferred association, with other like art practices.

In emphasising this point, I do so because I believe that in embracing paradigms associated with exchange and fluidity, the practice of the artist, how a work is conceived, developed and presented ultimately has to be consistent with the philosophical ramifications that networks of exchange have for the self-understanding of interpersonal life, and how it is lived.

As previously indicated, a distinguishing feature of the interactive net from transmissional networks is the ability of the transmitter or receiver to ask a question and to get a response, the resulting two-way flows of information facilitate the understanding that the world is complex and in a continual state of flux and entropy.

The recognition of complexity that potentially follows a question being raised in a network of exchange ultimately will pave the way for a psychological framework which encompasses mutuality. For a vital element in the response to a question is 'explanation' that attempts to complete what is missing in the picture of reality raised by the person asking the question. Here explanation is filling in, completing what is missing, but another function of explanation is to establish in advance of an event a context so that it might be understood within a given framework of meaning, especially within a framework that is at variance with existing belief. Here 'explanation' essentially lays out a foundation, or realm of meaning for approaching the future, in that a speculative framework of references and associations is provided for interpreting what is going to happen.

So while explanation is an account of what has occurred, it can also indicate what might be going to occur; in this sense, it can also be used as a tool for introducing new encoding languages. An open network of exchange employs the ethos of explanation as a vital component in the creation of belief in the network that will ultimately reinforce the complex dynamic of maintaining a binding between its participants.

An open system of explanation between all participants in a network undermines the very foundations of authoritative, hierarchical and exclusive frameworks. Perhaps, therefore, it is no accident – as previously observed when discussing the object – that there is a pressure exerted on the artist to maintain 'exclusivity', to separate practice from other practioners, to declare sole authorship, exhibit a unique language. But it is an important initial step towards embracing the present to acknowledge that this pressure will drag the artist back into a conflict between intention and practice, enabling meaning to be appropriated into value structures that will ultimately undermine belief in the potential ramifications of what is being forwarded.

Only when networks between artists are fully independent of the existing value structures projected by the institutional world of art – and a consistency between intention and practice perceived to be true in the presentation of new art work – will the artist be able to move the agenda of art forwards to embrace the potential of networks of exchange, those same networks that are shaping the fabric of communication in society.

232

An important starting-point is the procedure and process of explanation which I would argue should be undertaken as a matter of course by the artist, of both existing and possible practice, the procedure of explanation being directed towards other practioners to create an open network of exchange.

1. Stephen Willats, *Intervention and Audience* (London: Coracle Press, 1986).

2. Stephen Willats, 'Art and Social Function' (written 1976; published London: Ellipsis, 2000). Stephen Willats. 'Prescriptions for Task-Orientated Methodologies in Constructing Operational Models of Art', in *Control* magazine, Issue 7. Stephen Willats, *The Artist as an Instigator of Changes in Social Cognition and Behaviour* (London: Gallery House Press, 1973).

Stephen Willats, *Life Net Encoder (State Change Structure)*, April 1974. 23.5 × 33 inches (gouache, ink, Letraset text on paper)

SLOW MANIFESTO

Lebbeus Woods

The new cities demand an architecture that rises from
and sinks back into fluidity, into the turbulence of a
continually changing matrix of conditions, into an
eternal, ceaseless flux – architecture drawing its sinews
from webbings of shifting forces, from patterns of
unpredictable movements, from abrupt changes of mind,
alterations of position, spontaneous disintegrations
and syntheses – architecture resisting change, even as it
flows from it, struggling to crystallise and become eternal,
even as it is broken and scattered – architecture seeking
nobility of presence, yet possessed of the knowledge that
only the incomplete can claim nobility in a world of the
gratuitous, the packaged, the promoted, the already sold
– architecture seeking persistence in a world of the
eternally perishing, itself giving way to the necessity
of its moment – architecture writhing, twisted, rising,
and pinioned to the uncertain moment, but not martyred,
or sentimental, or pathetic, the coldness of its surfaces
resisting all comfort – architecture that moves, slowly
or quickly, delicately or violently, resisting the false
assurance of stability – architecture that comforts, but
only those who ask for no comfort – architecture of
gypsies, who are driven from place to place, because they
have no home – architecture of circuses, transient and
unknown, but for the day and night of their departure –
architecture of migrants, fleeing the advent of night's

234

bitter hunger – architecture of a philosophy of interference, the forms of which are infinitely varied, a vocabulary of words spoken only once, then forgotten – architecture bending and bending more, in continual struggle against gravity, against time, against, against, against – barbaric architecture, rough and insolent in its vitality and pride – sinuous architecture, winding endlessly and through a scaffolding of reasons – architecture caught in sudden light, then broken in a continuum of darkness – architecture embracing the sudden shifts of its too-delicate forms, therefore indifferent to its own destruction – architecture that destroys, but only with the coldness of profound respect – neglected architecture, insisting that its own beauty is deeper yet – abandoned architecture, not waiting to be filled, but serene in its transcendence – architecture that transmits the feel of movements and shifts, resonating with every force applied to it, because it both resists and gives way – architecture that moves, the better to gain its poise – architecture that insults politicians, because they cannot claim it as their own – architecture whose forms and spaces are the causes of rebellions, against them, against the world that brought them into being – architecture drawn as though it were already built – architecture built as though it had never been drawn.

235

236

ИЛЬЯ ЭРЕНБУРГЪ

А ВСЕ ТАКИ

ОНА ВЕРТИТСЯ

К=ВО «ГЕЛИКОНЪ»

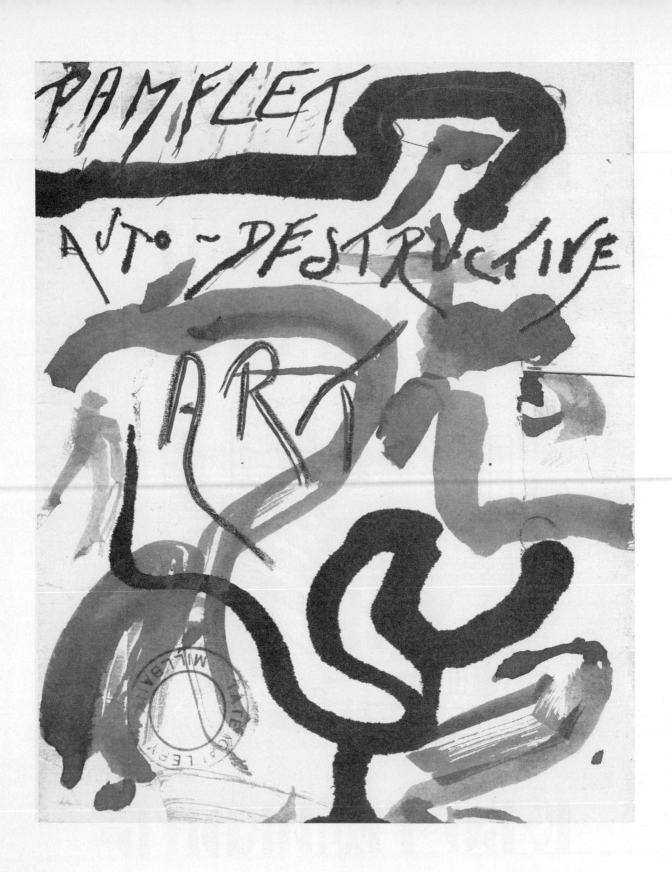

Manifesto selected by Gustav Metzger
Auto-destructive Art Pamphlet, Gustav Metzger, 1959
© Tate, London, 2009

DOCUMENTATION

Julia Peyton-Jones, *Marathon* Introduction 11:51

Hans Ulrich Obrist, *Marathon* Introduction 12:00

238

Hilary Koob-Sassen, *Faith in Infrastructure* 13:22

Vivienne Westwood, *Active Resistance to Propaganda* 12:44

Hilary Koob-Sassen, *Faith in Infrastructure* 13:24

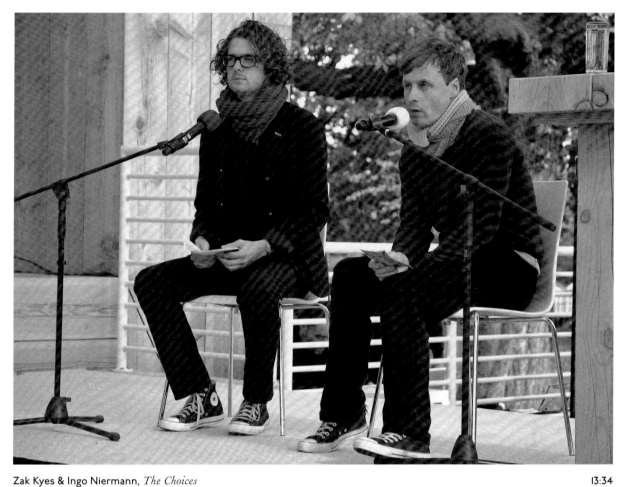

Zak Kyes & Ingo Niermann, *The Choices* 13:34

Pier Vittorio Aureli, *Architecture Refuses* 13:40

PLATFORM, *An Anti-Manifesto for Democratic Action on* ~~Climate Change~~ 13:43

Rasheed Araeen, *Eco-Aesthetics: Art Beyond Art* 13:52

Pier Vittorio Aureli and Andrea Branzi
in the audience 13:54

Taryn Simon in the audience 13:56

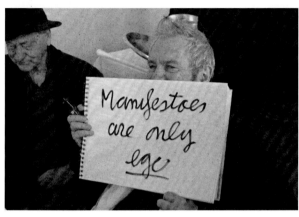

Jonas Mekas and Ben Vautier in the Green Room 14:12

Peter Cook, *Architecture for All
— A Serpentgram Manifesto* 14:33

241

Peter Cook, *Architecture for All — A Serpentgram Manifesto* 14:42

Taryn Simon, *Thatcher Effect* 14:45

242

Richard Wentworth, *Da Do Ron Ron* 15:00

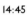

Richard Wentworth, *Da Do Ron Ron* 15:13

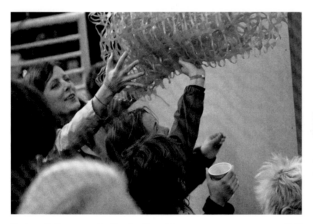

Richard Wentworth, *Da Do Ron Ron* 15:16

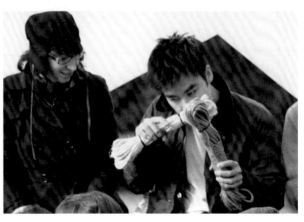

Richard Wentworth, *Da Do Ron Ron* 15:21

Gilbert & George, *The Laws of the Sculptors* 15:30

243

Gilbert & George, *Ban Religion* 15:34

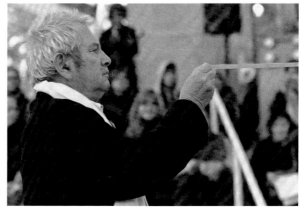

Gilbert & George, *The Laws of the Sculptors* 15:32 Ben Vautier, *I Don't Know What to Do* 15:39

Ben Vautier, *I Don't Know What to Do* 15:56

244

Ben Vautier, *I Don't Know What to Do* 16:00

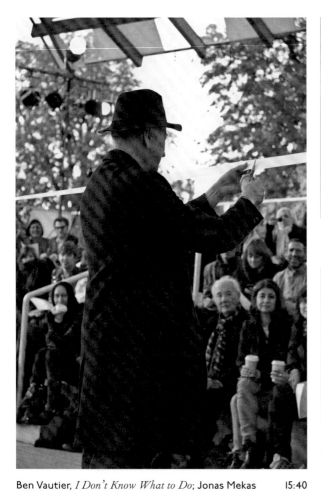

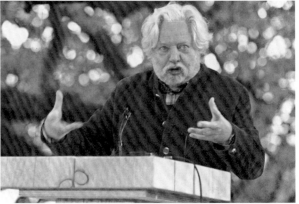

Ben Vautier, *I Don't Know What to Do*; Jonas Mekas 15:40
helps peform Robert Watts's *Two Inches*

Jean-Jacques Lebel, *What Has to Change If We Want* 16:07
the World to Be Better?

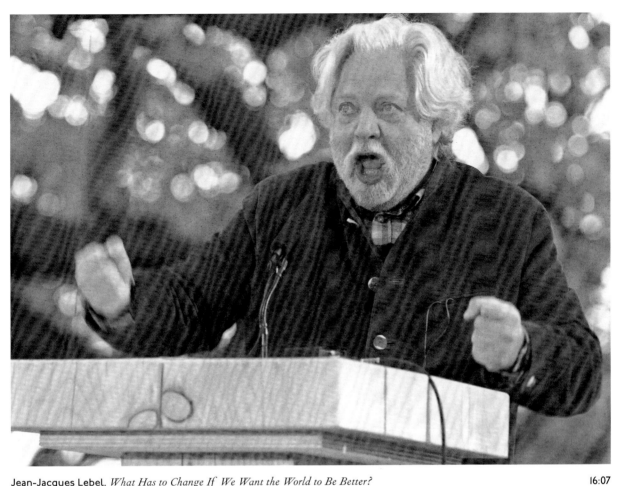

Jean-Jacques Lebel, *What Has to Change If We Want the World to Be Better?* 16:07

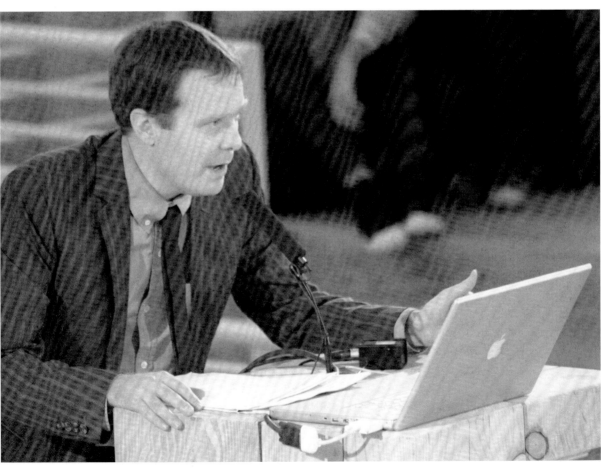

Tom McCarthy, *INS Declaration Concerning the Relationships between Art and Democracy* 16:46

Mark Wallinger, *Make Me Think Me* 16:53

Barbara Steveni, *#1 Context Is Half the Work* 17:14

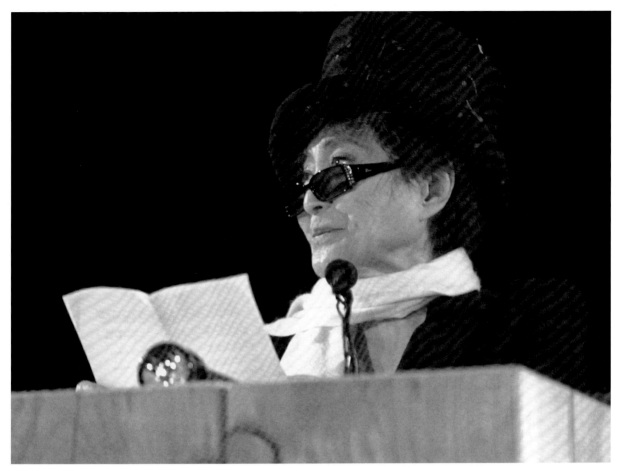

Yoko Ono, *Then and Now* 17:44

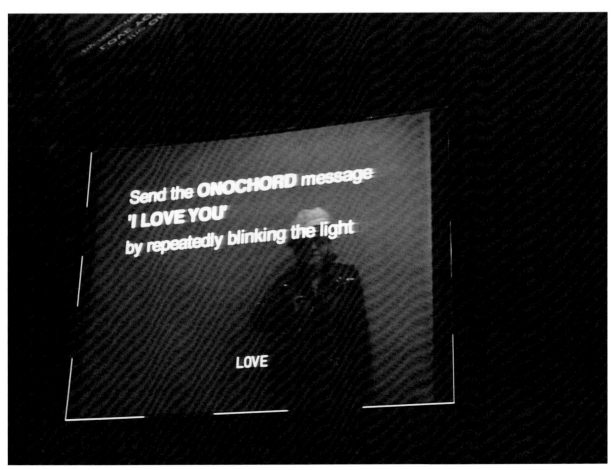

Yoko Ono, *Then and Now* 17:50

Ekaterina Degot, *The Manifesto of Inferiority Complex, or A Negative Manifesto of Übercontemporary Art* 18:13

248

Audience 18:18

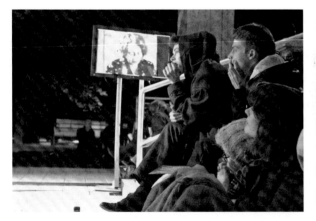

Audience by the tables on which archives 18:19
were available

Nicolas Bourriaud, *Altermodern* 18:33

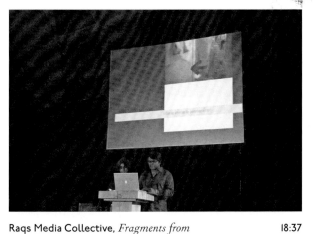

Raqs Media Collective, *Fragments from a Communist Latento* 18:37

Raqs Media Collective, *Fragments from a Communist Latento* 18:39

Nathaniel Mellors, *The Ill-Tempered Manifesto, or A New Aging Manifesto, or The New Old Manifesto* 18:44

Nathaniel Mellors, *The Ill-Tempered Manifesto, or A New Aging Manifesto, or The New Old Manifesto* 18:46

249

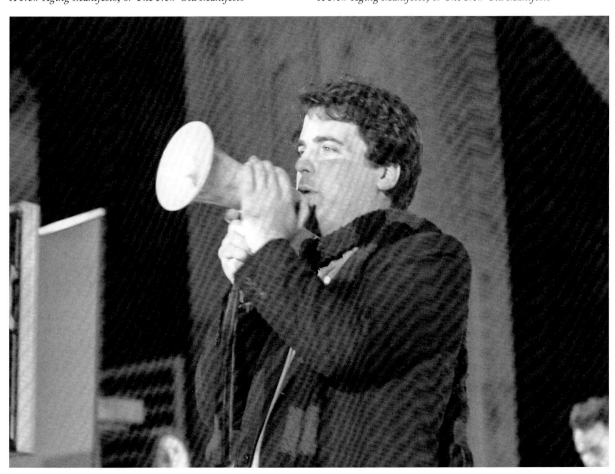

Lee Scrivner, *The Sound Moneyfesto* 19:26

Andrea Branzi and translator, *Seven Suggestions for the New Athens Charta* 19:42

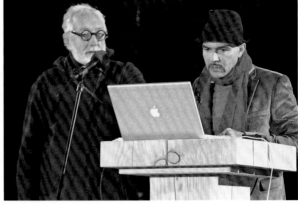

Andrea Branzi and translator, *Seven Suggestions for the New Athens Charta* 19:43

250

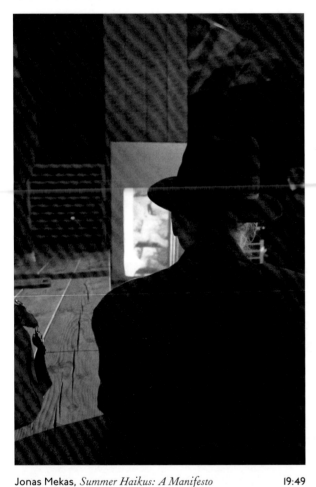

Jonas Mekas, *Summer Haikus: A Manifesto* 19:49

Jonas Mekas, *Summer Haikus: A Manifesto* 19:54

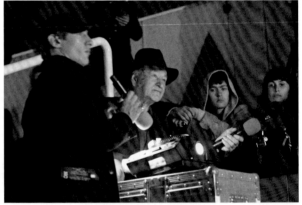

Jonas Mekas and Ben Northover, *Summer Haikus: A Manifesto* 19:57

Henry Flynt, *The Cinact Manifesto* 20:02

Marina Abramović, *An Artist's Life Manifesto* 20:20

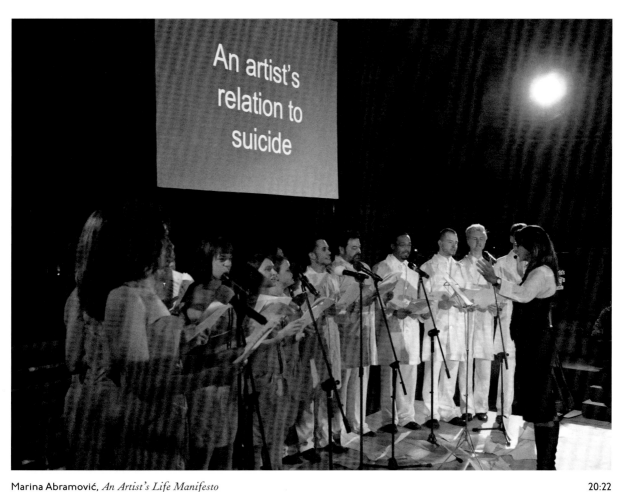

Marina Abramović, *An Artist's Life Manifesto* 20:22

251

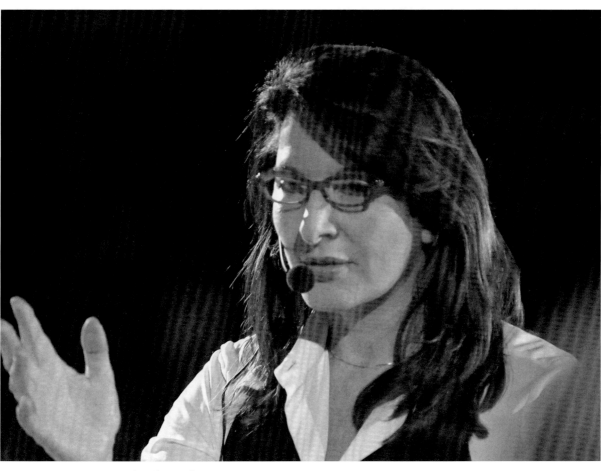

Marina Abramović, *An Artist's Life Manifesto* 20:27

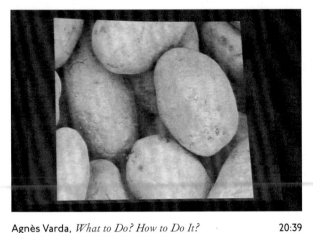

Agnès Varda, *What to Do? How to Do It?* 20:34
(A Potato Story)

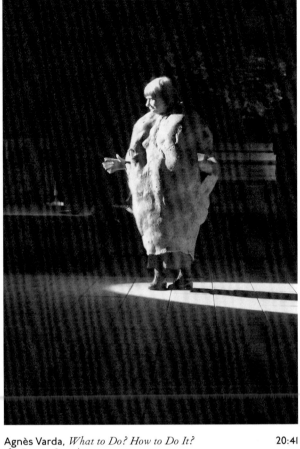

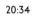

Agnès Varda, *What to Do? How to Do It?* 20:39 Agnès Varda, *What to Do? How to Do It?* 20:41
(A Potato Story) *(A Potato Story)*

252

Agnès Varda, *What to Do? How to Do It? (A Potato Story)* 20:44

Audience 20:52

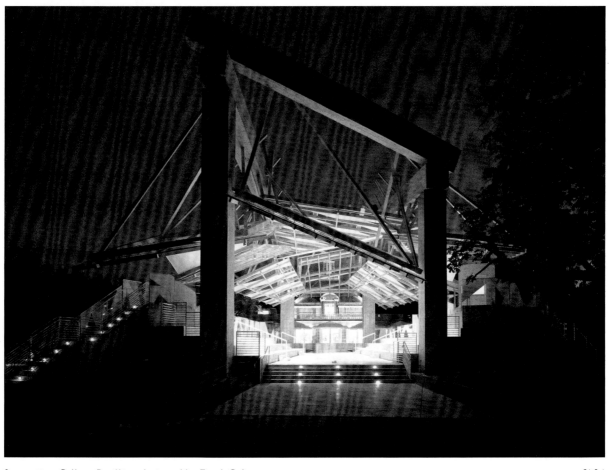

Serpentine Gallery Pavillion designed by Frank Gehry 21:04

Manifesto Club, *Towards a Free Art School* 09:37

Audience 09:48

Stephen Willats, *Explain Yourself: A Proposal for an Internet Site* 09:53

Susan Hefuna, *Manafesto* 10:07

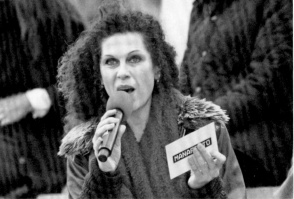

Susan Hefuna, *Manafesto* 10:11

Falke Pisano, *Manifesto Machine* 10:28

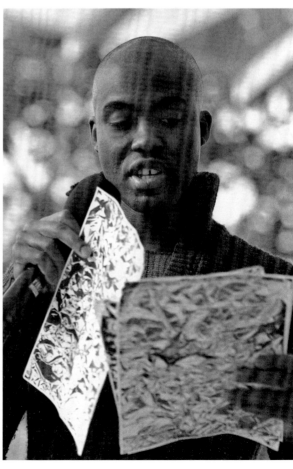

Adam Pendleton, *Black Dada* 10:36 Adam Pendleton, *Black Dada* 10:48

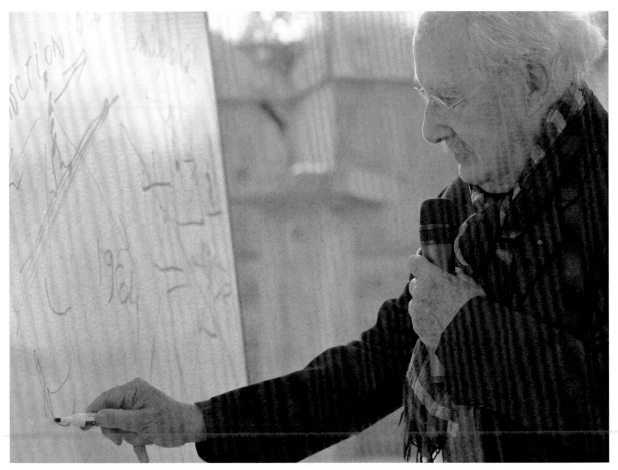

Claude Parent, *Paris noyée, Londres au fond de la Tamise, quelle architecture?* 11:16

256

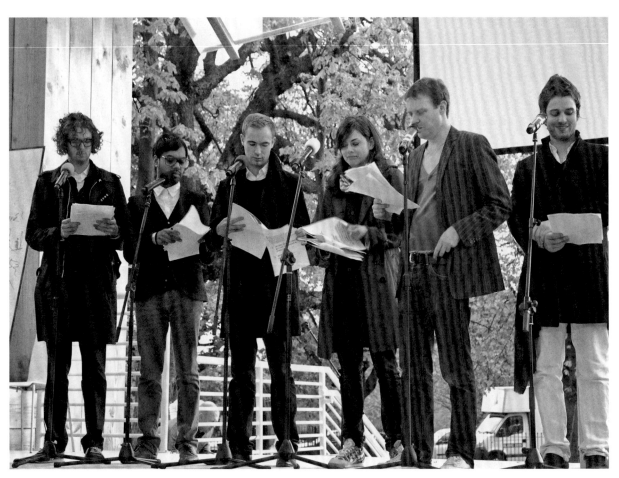

HEC/BEC, *Provisional Protocol for the Hyper/Brutally Early Club* 11:23

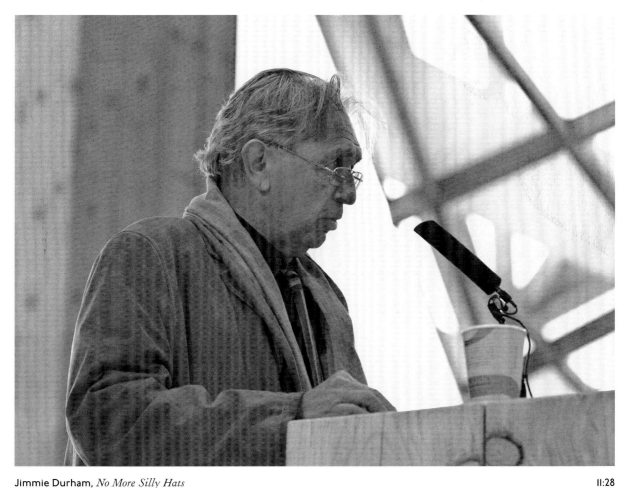

Jimmie Durham, *No More Silly Hats* 11:28

257

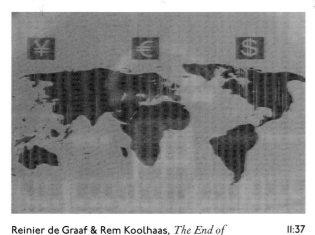

Reinier de Graaf & Rem Koolhaas, *The End of* 11:37
the 'Y€$ Regime'

Reinier de Graaf & Rem Koolhaas, *The End of* 11:38
the 'Y€$ Regime'

The Otolith Group, *A Manifesto on Dyschronia* 12:46
Pre-emption: Premeditations 1-18

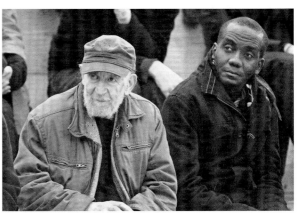

Gustav Metzger in the audience 12:52

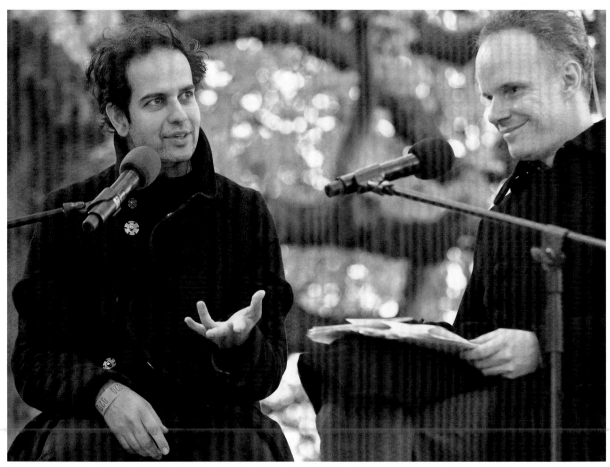

Interview between Tino Sehgal and Hans Ulrich Obrist 13:04

258

Karl Holmqvist, *You Blew Up My House* 13:19

Karl Holmqvist, *You Blew Up My House* 13:20 Karl Holmqvist, *You Blew Up My House* 13:21

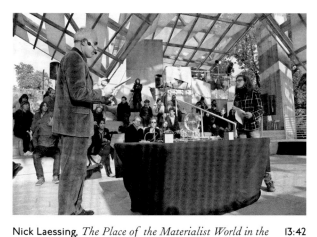

Nick Laessing, *The Place of the Materialist World in the Universe is that of an Exquisitely Beautiful Precipate or Varied Cloud-Work in the Universal Æther* 13:42

Nick Laessing, *The Place of the Materialist World in the Universe is that of an Exquisitely Beautiful Precipate or Varied Cloud-Work in the Universal Æther* 13:45

SpRoUt, *A SpRoUt Manifesto (In the Style of a Relay Race)* 14:12

259

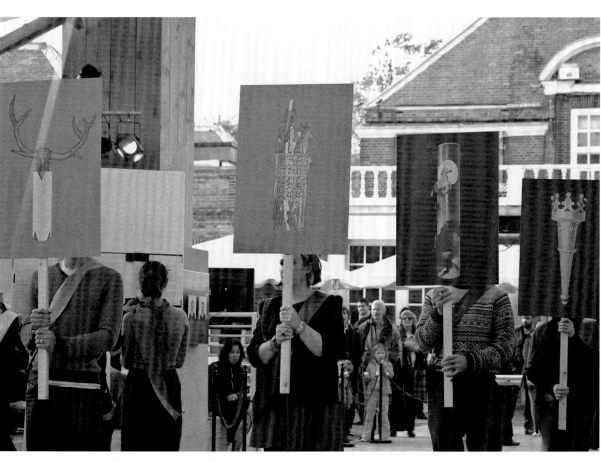

SpRoUt, *A SpRoUt Manifesto (In the Style of a Relay Race)* 14:13

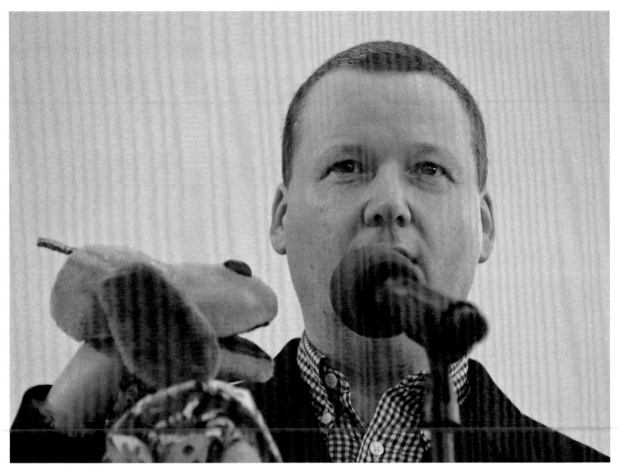

Stewart Home (with Mr Dog), *Art Strike Biennial* 14:17

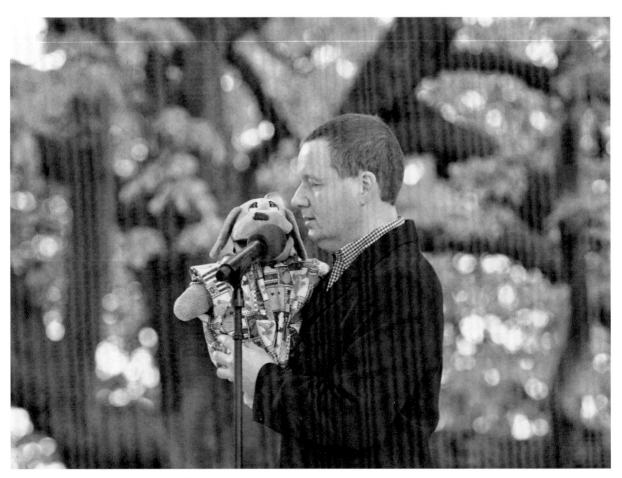

Stewart Home (with Mr Dog), *Art Strike Biennial* 14:20

Mark Titchner, Feel Better Now (Apathy and the New Sincerity) 14:26

Mark Titchner, Feel Better Now (Apathy and the New Sincerity), performed by Jonny Woo 14:27

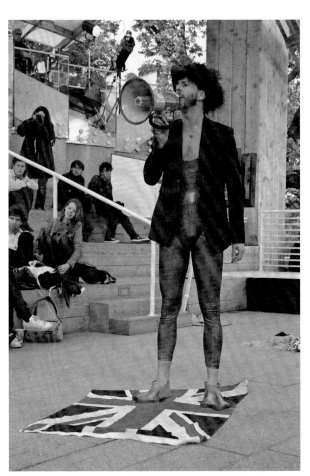

Mark Titchner, Feel Better Now (Apathy and the New Sincerity), performed by Jonny Woo 14:31

261

K8 Hardy, *The Droid Manifesto* 15:17

K8 Hardy, *The Droid Manifesto* 15:16

K8 Hardy, *The Droid Manifesto* 15:19

K8 Hardy, *The Droid Manifesto* 15:21 Fritz Haeg, *London: A Manifesto from your Animals* 15:28

Charles Jencks, *Manifesto2* 15:50

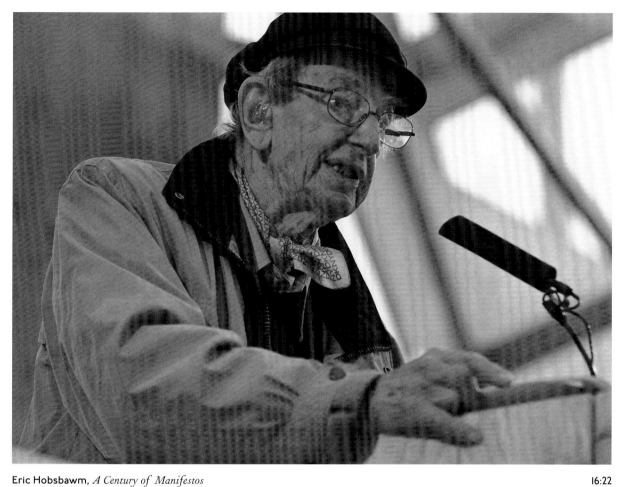

Eric Hobsbawm, *A Century of Manifestos* 16:22

Interview between Eric Hobsbawm and Hans Ulrich Obrist 16:43

Athanasios Argianas, *Manifesto of Non-Durational Time* 17:09

Athanasios Argianas, *Manifesto of Non-Durational Time* 17:11

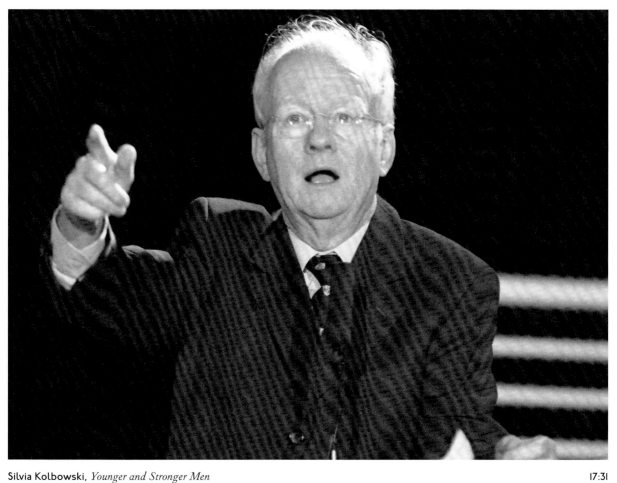

Silvia Kolbowski, *Younger and Stronger Men* 17:31

265

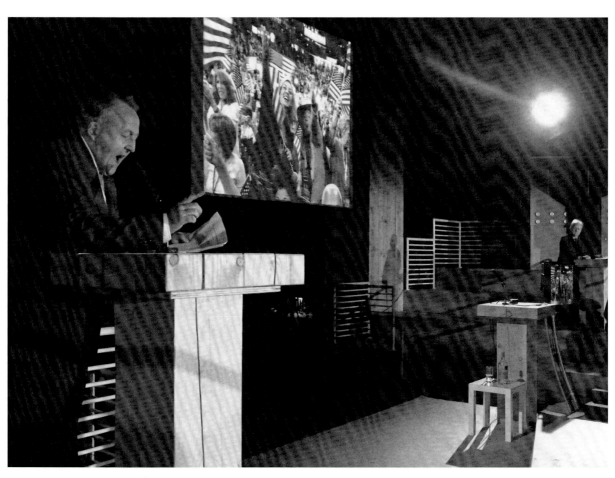

Silvia Kolbowski, *Younger and Stronger Men* 17:37

Giles Round & Mark Aerial Waller *Taverna Especial* 17:59

266

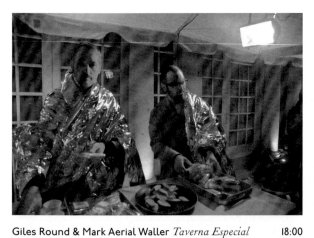

Giles Round & Mark Aerial Waller *Taverna Especial* 18:00

Giles Round & Mark Aerial Waller *Taverna Especial* 18:01

Giles Round & Mark Aerial Waller *Taverna Especial* 18:02

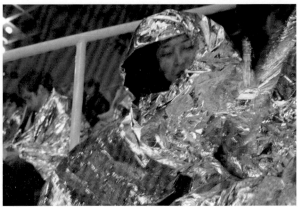

Audience 18:04

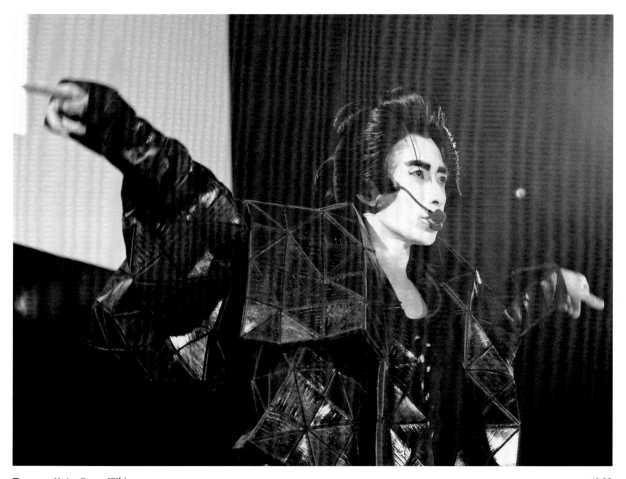

Terence Koh, *Snow White* 18:22

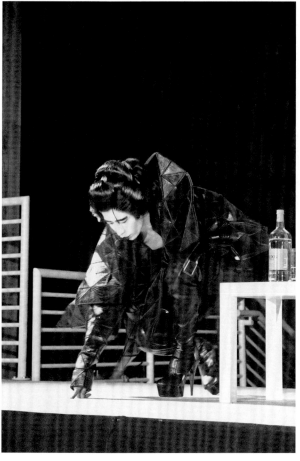

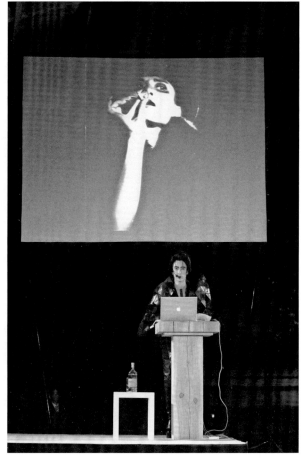

Terence Koh, *Snow White* 18:26 Terence Koh, *Snow White* 18:31

Terence Koh, *Snow White* 18:32

Giles Round & Mark Aerial Waller, 18:32
Taverna Especial Emergency Blanket

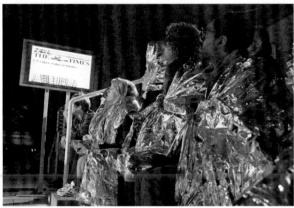

Audience 18:36

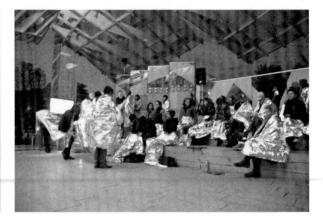

Audience 18:38

268

Julia Peyton-Jones 18:42

BIOGRAPHIES

MARINA ABRAMOVIĆ

Since the beginning of her career in 1970s Belgrade, Marina Abramović (born 1946, Serbian) has pioneered performance as a visual art form – the body has always been both her subject and medium, exploring her physical and mental limits in works that ritualise the simple actions of everyday life. From 1975 to 1988, Abramović and the German artist Ulay performed together, but she returned to solo performances in 1989. She has presented her work at major institutions in the US and Europe, including: Van Abbemuseum, Eindhoven, the Netherlands, 1985; Centre Georges Pompidou, Paris, 1990; and Neue Nationalgalerie, Berlin, 1993. She has also participated in many large-scale international exhibitions, including the Venice Biennale, 1976 and 1997; and Documenta VI, VII and IX, Kassel, Germany, 1977, 1982 and 1992.

RASHEED ARAEEN

Rasheed Araeen (born 1935, Pakistani) is a London-based conceptual artist, sculptor, painter, writer and curator. He graduated in civil engineering from the University of Karachi, Pakistan, 1962, and has been working as a visual artist since his arrival in London in 1964. In 1972, he joined the Black Panther Movement, and six years later he was founding editor of the journal *Black Phoenix*, which in 1989 became *Third Text*, one of the most important journals dealing with art, the Third World, post-colonialism and ethnicity; he described it as an attempt to 'demolish the boundaries that separate art and art criticism'.

ATHANASIOS ARGIANAS

Athanasios Argianas (born 1976, Greek) studied at Goldsmiths College, London, 2003-05, and he still lives and works there. Argianas's works stem conceptually from his exploration of the complexity and beauty of sound, capturing acoustic vibration as voluminous cast-alloy sculptures and precious-wood constructions. Recent projects include: *We All Turn This Way*, the Serpentine Gallery, London (with Nick Laessing, 2008); *Sing Sideways/Sing from the Middle to the Start/End*, Alessandro De March, Milan, 2008; and eponymous exhibitions at the Breeder, Athens, 2007, and the Arquebuse Gallery, Geneva, 2008.

PIER VITTORIO AURELI

Professor Pier Vittorio Aureli (born 1973, Italian) is an architect and educator. He studied at the Istituto universitario di architettura di Venezia, Venice, and the Berlage Institute, Rotterdam, the Netherlands. His studies focus on the relationship between architectural form, political theory and urban history. Aureli teaches at the Berlage Institute, where he is Unit Professor. Together with Martino Tattara, he is the co-founder of DOGMA. In 2006, they received the first Iakov Chernikov Prize for Young Architects.

PABLO LEÓN DE LA BARRA

Pablo León de la Barra (born 1972, Mexican) lives in London but works everywhere. His practice provides a platform for the visibility of the different tensions which give form to contemporary experience. Exhibitions he has curated include *To Be Political It Has to Look Nice*, 2003, apexart, New York; and he co-curated *The George and Dragon at the ICA*, ICA, London, 2005. He is currently preparing *El Noa Noa* in Bogota, Colombia; and *Centre of the Revolution* with Mathieu Copeland in Brasília, Brazil. He is also editor of *Pablo Internacional* magazine and co-curator of White Cubicle Toilet Gallery.

CHRISTIAN BOLTANSKI

The artistic career of Christian Boltanski (born 1944, French) began when he left formal education at the age of 12, at which point he started painting and drawing. Since the 1960s, he has worked with the ephemera of the human experience, from obituary photographs to rusted biscuit tins. Several of Boltanski's projects have used actual lost property from public spaces, such as railway stations, creating collections which memorialise the unknown owners in the cacophony of personal effects.

NICOLAS BOURRIAUD

Nicolas Bourriaud (born 1965, French) is an art critic and curator. From 1999 to 2006, he was co-founder and co-director of the Palais de Tokyo, Paris, together with Jérôme Sans. He was founder and director of the magazine *Documents sur l'art*, 1992-2000, and Paris correspondent for *Flash Art*,

1987-95. In 2009, Bourriaud will curate the 4th Tate Triennial at Tate Britain, London. English-speakers know Bourriaud best for his publications *Relational Aesthetics*, 1998, and *Postproduction*, 2001.

ANDREA BRANZI

The architect and designer Professor Andrea Branzi (born 1938, Italian) graduated in 1966 in Florence, where he was brought up, but has lived and worked in Milan since 1973. From 1964 to 1974, he was a member of the group Archizoom Associati, at the forefront of the Radical Architecture movement, and whose projects are preserved at Centro studi e archivio della comunicazione, Parma. In 1987, he received the Compasso d'oro award for his career in the fields of industrial and experimental design, architecture, town planning, education and cultural promotion. He is professor and president of the graduation course in interior design at the Politecnico di Milano.

PAUL CHAN

Paul Chan is an artist living in New York City.

MATHIEU COPELAND

Mathieu Copeland (born 1977, French) graduated from Newcastle University (BA in Fine Art) in 2002, and then Goldsmiths College, London, in 2003. Past exhibitions include *Expat-Art Centre/ EAC*, Institute of Contemporary Arts, London, 2004 (and touring). In 2006, he curated *Soundtrack for an Exhibition* at the Musée d'art contemporain in Lyons, France, and initiated the touring exhibition *A Spoken Word Exhibition*, currently at BALTIC, Gateshead, UK until 14 March 2009. Forthcoming exhibitions include *VOIDS, A Retrospective* at the Centre Georges Pompidou, Paris, in February/March 2009.

PETER COOK

Sir Peter Cook (born 1936, British) is an architect, teacher and writer. He studied architecture at Bournemouth College of Art, 1953-58, then the Architectural Association School of Architecture in London, graduating in 1960. In the 1960s, he became a founding member of the Archigram group. This avant-garde collective, which drew inspiration from technology to create hypothetical projects, was awarded the Royal Gold Medal for Architecture by RIBA in 2002. Cook was Director of the ICA in London, 1970-72, and in 1984 was appointed Life Professor at the Städelschule in Frankfurt. Now Director of CRAB Studio – building the municipal

theatre of Verbania, Italy, and social housing elsewhere in Italy – he is also Emeritus Professor at UCL and Joint Professor at the RA.

EKATERINA DEGOT

Ekaterina Degot (born 1958, Russian) is an art historian, art critic and curator based in Moscow. She has worked as a senior curator at the State Tretyakov Gallery, art columnist at *Kommersant Daily* and is now Chief Editor of www.openspace.ru/art. She has taught at the European University, St Petersburg, and has been a guest professor at various American and European universities. Exhibitions she has curated or co-curated include: *Body Memory: Underwear of the Soviet Era*, City History Museum, St Petersburg, 2000; and *Moscow–Berlin 1950-2000*, Martin-Gropius-Bau, Berlin, and the History Museum, Moscow, 2003-04. Her books include: *Terroristic Naturalism*, 1998, *Russian 20th-Century Art*, 2000, and *Moscow Conceptualism* (with Vadim Zakharov, 2005).

JIMMIE DURHAM

Jimmie Durham (born 1940, American) is a sculptor who now lives and works in Belgium. During the early 1960s, he was active in theatre, performance, and literature in the Civil Rights Movement. He became a political organiser in the American Indian Movement, 1973-80, Director of the International Indian Treaty Council and representative at the UN. Exhibitions include: Palais des beaux-arts, Brussels; ICA, London; Documenta, Kassel, Germany; Whitney Biennial, New York; and the Venice Biennale. His book of poems *Columbus Day* was published in 1983, and he was included in *Harper's Anthology of 20th-Century Native American Poetry*. Phaidon published a monograph on him in 1995.

BRIAN ENO

Brian Eno (born 1948, British) is a musician, producer and artist who is known as 'The Father of Ambient Music'. Art-school-educated, he first became prominent in the 1970s band Roxy Music. Upon leaving them, he began concentrating upon abstract sound-scapes, in his *Discreet Music*, 1975, and *Music for Airports*, 1978. In the late 1970s, he collaborated with David Bowie in the avant-garde 'Berlin Trilogy' of albums (*Low, Heroes, Lodger*). As producer, his credits include notable albums like Talking Heads's *Fear of Music*, 1979, and U2's *The Joshua Tree*, 1987. In the 1990s, Eno co-founded the Long Now Foun-dation, a group commited to the encouragement of long-term thinking. As an artist,

Brian Eno creates art installations and has created (with Peter Schmidt) *Oblique Strategies*, a deck of cards, each bearing a cryptic remark. He has used these cards extensively in his record productions.

HENRY FLYNT

Henry Flynt (born 1945, American) attended Harvard, but dropped out to give his full time to original work. Flynt is known as a wholesale critic of the existing civilisation. Less well known is that Flynt has made many intellectual proposals which, when woven together, were meant to point to a post-capitalist, post-scientific civilisation, as documented in his *Blueprint for a Higher Civilization* (Multipla Edizioni, 1975). Flynt has swerved in and out of public cultural life over the past few decades. He has often published his work to make it part of the public record. About 20 albums of his music have appeared, and he resumed public music performance this year. Represented by art dealer Emily Harvey until her death, he participated in the 1990 Venice Biennale and the 1993 Lyon Biennale.

FRANCE FICTION

France Fiction is an artistic and curatorial entity created in 2004 by Stéphane Argillet, Eric Camus and Nicolas Nakamoto, and in 2007 joined by Marie Bonnet and Lorenzo Cirrincione. It is simultaneously a social experience, laboratory, vitrine and private club. As an artist collective, France Fiction develops independent projects, exhibitions (gallery and off-site projects), publications, lectures, screenings and performances. France Fiction's areas of research are science fiction, utopias, gaming and narrative. Their video *Le Billard Parisien*, 2007, is being shown as part of Taverna Especial at the *Manifesto Marathon*.

YONA FRIEDMAN

Yona Friedman (born 1923, French) studied architecture at the Technical University, Budapest, 1943, but he left Hungary in 1945, completing his training in 1948 at the Technion, Haifa, Israel, subsequently teaching there. In the 1950s, he came to believe that requirements generated by technological progress and demographic growth were too great to be solved by traditional thinking. In 1957, he settled in Paris and co-founded the Groupe d'étude d'architecture mobile (GEAM) with Paul Maymont, Frei Otto, Eckhard Schulze-Fielitz, Werner Ruhnau and D.G. Emmerich. The group's manifesto was Friedman's *L'architecture mobile*, 1958, in which he rejected the idea of a static

city. In contrast, he developed the principle of 'infrastructure', a skeletal metal 'space-frame grid' of several levels, on which mobile, lightweight 'space-defining elements' could be placed.

GILBERT & GEORGE

Gilbert (born 1943, British) met George (born 1942, British) as sculpture students at St Martins School of Art, London. They soon adopted the identity of 'living sculptures' in both their art and their daily lives, becoming not only creators, but the art itself. Their reputation was established in 1969 with *The Singing Sculpture*. Standing together on a table, they danced and sang 'Underneath the Arches'. It was a telling choice, harking back to vaudeville, while also identifying with society's fringes. Gilbert & George were invited to present *The Singing Sculpture* all over the world. In order that their audience was not restricted to those in their presence, they began to create films and pictures. In 2007, they had a major retrospective at Tate Modern, London.

JOHN GIORNO

John Giorno (born 1936, American) is a poet and performance artist. In 1968, Giorno founded the collective Giorno Poetry Systems, in order to connect poetry to new audiences, using innovative technology, such as for its mass communication experiment *Dial-a-Poem*. This intuition turned out to be very influential on later approaches to poetry, like 'spoken word' and 'slam poetry'. Some of the poets and artists who recorded or collaborated with Giorno Poetry Systems were: William Burroughs, John Ashbery, Ted Berrigan, Patti Smith, Laurie Anderson, Philip Glass, Robert Rauschenberg and Robert Mapplethorpe. Since 2005, along with his solo poetry performances, he has collaborated with avant-garde Spanish composer and musician Javier Colis.

REINIER DE GRAAF

Along with Rem Koolhaas, Reinier de Graaf (born 1962, Dutch) is Partner of the Office for Metropolitan Architecture (OMA), having joined in 1996. In 2002, he became a director for AMO, the think-tank arm of OMA. As Partner of OMA, he is working on the redevelopment of London's Commonwealth Institute, and a harbour redevelopment in Riga including a contemporary art museum. Recently, he has taken responsibility for OMA's growing engagement in the Middle East, leading several projects in Dubai, Kuwait and Saudi Arabia.

MELISSA GRONLUND

Melissa Gronlund is Managing Editor of *afterall*, and a visiting tutor at the Ruskin School of Drawing and Fine Art, Oxford University. She contributes to a number of art publications.

FRITZ HAEG

Like a system of crop rotation, Fritz Haeg (born 1969, American) works between his architecture and design practice (Fritz Haeg Studio), the happenings and gatherings of Sundown Salon/Schoolhouse, the ecology initiatives of Gardenlab (including Edible Estates) and other various combinations of building, designing, gardening, exhibiting, dancing, organising and talking. Haeg studied architecture at Venice's Istituto universitario di architettura di Venezia and at Carnegie Mellon University, Pittsburgh, Pennsylvania. His first book, *Edible Estates: Attack on the Front Lawn*, was published by Metropolis Books in spring 2008. He has produced projects and exhibited work at: Tate Modern, London; the Whitney Museum of American Art, New York; San Francisco Museum of Modern Art; and the MAK Center, Los Angeles, among other institutions.

K8 HARDY

K8 Hardy (American) is an artist who works with performance, photography, installation and co-founding editor of the feminist journal *LTTR*. Exhibitions include: the Moscow Biennial of Contemporary Art, 2007; *Locally Localized Gravity*, the Institute of Contemporary Art, Philadelphia, 2007; *Media Burn*, Tate Modern, London, 2006; *Eat the Market*, the Los Angeles County Museum of Art, 2006; and *Beautiful Radiating Energy*, Reena Spaulings Fine Art, New York, 2004. Her films have been screened at the Kitchen, New York; Le Magasin, Bordeaux; and Film Casino, Vienna. Hardy was a studio fellow of the Whitney Museum of American Art's Independent Study Program in 2003.

SUSAN HEFUNA

Susan Hefuna (born 1962, Egyptian) lives and works in transit. She has recently had solo exhibitions at Albion Gallery, in both its London and New York sites; Third Line Gallery, Dubai, United Arab Emirates; and the Alexandria Contemporary Arts Forum, Egypt (all 2008). Selected group shows include: the Seville Biennial, Spain, 2008; *Museum as Hub: Antikhana*, New Museum, New York, 2008; *Regards des photographes arabes*, Musée d'art moderne et contemporain, Algiers, Algeria, 2007;

the 8th Sharjah Biennial, United Arab Emirates, 2007; *Contrepoints*, the Louvre, Paris, 2004; Photo Cairo, 2003; *Rencontres*, Photo Biennale Bamako, Mali, 2003; *DisORIENTation*, Haus der Kulturen der Welt, Berlin, 2003; and *Fantasies de l'harem i noves Xahrazads (Harem Fantasies and New Scheherezades)*, CCCB Centre de cultura contemporania de Barcelona, 2003.

ERIC HOBSBAWM

Professor Eric Hobsbawm (born 1917, British) is a Modern historian. He was in Berlin when Hitler came to power and has since been Marxist. Specialising in the period 1789-1914 (the 'long 19th century'), his best-known work is the *The Age of...* trilogy – *Revolution*, 1962, *Capital*, 1975, and *Empire*, 1987. As a postscript, he wrote *The Age of Extremes*, 1997, on the 'short 20th century' – most of which he had witnessed. Another interest was popular movements in newly born and would-be nations. For example, *The Invention of Tradition*, 1983, questioned just how old national 'traditions' are. He is now retired from teaching at London University's Birkbeck College and at the New School for Social Research, New York. He says that he has read more manifestos 'than is good for any 91-year-old man'.

DAVID HOCKNEY

The artist David Hockney, CH, RA (born 1937, British) is now based in Los Angeles. He was born in Bradford and educated at Bradford College of Art and the Royal College of Art (RCA) in London. While still a student at the RCA, he was featured in the 1961 exhibition *Young Contemporaries* that announced the arrival of British Pop Art, and he became associated with the movement. Now considered one of the most influential British 20th-century artists, Hockney was made a Companion of Honour in 1997 and is also a Royal Academician. Furthermore, he serves on the advisory board of the new political magazine *Standpoint* and contributed original sketches to be published in its inaugural edition in June 2008.

KARL HOLMQVIST

Karl Holmqvist (born 1964, Swedish) is an artist working with spoken word performances, photocopy artist's books and room-sized installations. Looking to liberate language from written-word rigidity, his experiments combine song lyrics, pop culture, political activism and art-world slogans. Recent solo exhibitions include: The Living Art Museum, Reyjavik, Iceland, and Dépendence Gallery,

Brussels, 2008. The same year also saw him take part in: the Manifesta 7 exhibition *The Souls, or Much Trouble in the Transportation of Souls*, Trentino, Italy; the *Serpentine Gallery Experiment Marathon*, Reykjavik; and *That Social Space between Speaking and Meaning*, White Columns Gallery, New York.

STEWART HOME

When Stewart Home (born 1962, London) was 16, he held down a factory job for a few months, an experience that led him to vow he'd never work again. After dabbling in rock journalism and music, he switched his attention to the art world in the early 1980s. Home now writes novels as well as cultural commentary, and he continues to make films and exhibitions. He is currently editing the *Semina* experimental fiction series at Book Works and also performing as a ventriloquist. His 12th novel, *Memphis Underground*, was published by Snowbooks in 2007, and the sequel, *Blood Rites of the Bourgeoisie*, is due to be issued by Book Works in 2010.

CHARLES JENCKS

Charles Jencks (born 1939, American) divides his time between lecturing, writing, and designing in the US, the UK and Europe. He is the author of the best-selling *The Language of Post-Modern Architecture* (reissued in 2002 as *The New Paradigm in Architecture*). He has also written numerous other books on contemporary arts and building, including *What is Post-Modernism?* (4th edition, 1995), *The Architecture of the Jumping Universe* (2nd edition, 1997) and *The Iconic Building: The Power of Enigma* (Frances Lincoln, 2005). His celebrated garden in Scotland is the subject of his book *The Garden of Cosmic Speculation* (Frances Lincoln, 2003). In 2004, the Scottish National Gallery of Modern Art, Edinburgh, won the Gulbenkian Prize for Museums for his design, *Landform Ueda*.

TERENCE KOH

Terence Koh (born 1977, Canadian) rose to prominence in the mid-1990s, under the *nom de plume* asianpunkboy, for his eponymous website and 'art-porn' zines. His sprawling body of work, which includes paintings, photographs, sculptures, drawings, and performances, quickly drew a large following in the queercore underground and in the larger art world. Since 'killing off' asianpunkboy in 2004, he has concentrated in producing room-sized installations and performances. Solo exhibitions include: *Love for Eternity*, MUSAC, Leon, Spain, 2008; *Captain Buddha*, Schirn Kunsthalle, Frankfurt, 2008; and *Terence Koh*, Whitney Museum of American Art, New York, 2007, and Kunsthalle Zürich, 2006.

SILVIA KOLBOWSKI

Silvia Kolbowski (born 1953, American) is an artist based in New York. Her scope of address includes the ethics and politics of history, sexuality, culture and the unconscious. Her project *Proximity to Power, American Style*, a slide/audio work about the relational aspects of masculine power, was part of a one-person, three-project exhibition, *Inadequate... Like... Power*, at the Secession, Vienna, 2004. In 2007, she exhibited a revised version of her 1999 *An Inadequate History of Conceptual Art* at the Centrum Sztuki Współczesnej, Warsaw. Her most recent project, a video and photo work entitled *After Hiroshima Mon Amour*, 2008, opened as a solo exhibition at LA><ART in Los Angeles in September. She is on the advisory board of *October* journal, and teaches in the CCC programme of the École supérieure d'art visuel, Geneva.

HILARY KOOB-SASSEN

Hilary Koob-Sassen (born 1976, US) is an artist living in London. He works in sculpture, film, and performance and has recently shown at: Transmediale, Berlin; Whitechapel Gallery, London; and Dictionary of War, Graz, Austria. Koob-Sassen performs with his experimental band The Errorists; by announcing their error, The Errorists claim the liberty to make ambitious political and scientific proposals. Their third album, *Faith in Infrastructure*, is available to download now.

REM KOOLHAAS

Professor Rem Koolhaas (born 1944, Dutch) is an architect, architectural theorist, urbanist and Professor in Practice of Architecture and Urban Design at the Graduate School of Design at Harvard University. Koolhaas studied at the Netherlands Film and Television Academy, Amsterdam; the Architectural Association School of Architecture, London; and at Cornell University, New York. He is the principal of the Office for Metropolitan Architecture (OMA) and of its research-oriented counterpart AMO, currently based in Rotterdam. In 2005, he co-founded *Volume* magazine, together with Mark Wigley and Ole Bouman. In 2000, Rem Koolhaas won the Pritzker Prize; in 2008, *Time* magazine put him in their top 100 of 'The World's Most Influential People'.

273

ZAK KYES

Zak Kyes (born 1983, Swiss-American) is a graphic designer based in London whose practice encompasses editing, publishing and curating. His work engages with publications and their dissemination as sites for debate and exchange rather than mere documentation. He joined the Architectural Association as Art Director in September 2006 and has curated the touring exhibition *Forms of Inquiry: The Architecture of Critical Graphic Design*. Kyes has lectured, juried, and taught workshops at Kunstencentrum Vooruit, Ghent, Belgium; Casco Projects, Utrecht, the Netherlands; and Archizoom, Lausanne, Switzerland. He founded Bedford Press, a private press established at the Architectural Association. He established his own studio, Z.A.K. in 2005 and was recently joined there by Grégory Ambos.

NICK LAESSING

Nick Laessing (born 1973, British) searches for answers to unproven scientific phenomena, with investigations and constructions that resuscitate utopian possibilities. After achieving his BA in Fine Art in 1996 at Kingston University, UK, Laessing attended the Kunstakademie Düsseldorf, Germany, before completing a postgraduate diploma at the Royal Academy Schools, London, 1996-99. Laessing now lives and works in Berlin, and has had solo exhibitions at: Arquebuse, Geneva, 2007; Center, Berlin, 2005; and Mary Mary, Glasgow, 2005. Group shows include: *We All Turn This Way*, in collaboration with Athanasias Argianos, Serpentine Gallery, London; *Tales of Disbelief*, La Galerie, Noisy-le-Sec, Paris, 2008; and *Sense of Wonder*, Herzliya Museum of Contemporary Art, Israel, 2002.

JOHN LATHAM

One of the major preoccupations of the conceptual artist John Latham (1921-2006, British) was to map the relation between artistic and scientific modes of perception. The conventional world picture is in terms of 'objects'; Latham held the view that time-based tradition in art uses a dimensionality of 'event' that is incompatible with 'object' language – hence his construct 'event structure'. He was a founder member in 1966 of the Artist Placement Group (APG), a programme for placing artists in positions within industry, government and academia – where they could generate alternatives to what were viewed as divisive systems of power.

There have been retro-spective exhibitions at Tate Britain, London, 2005, and at P.S.1, New York, 2006. His home and studio, FTHo, is open to the public until July 2009.

JEAN-JACQUES LEBEL

Jean-Jacques Lebel (born 1936, French) is a painter, artist and film-maker. With his book *Le Happening*, 1966, his founding of the Festival de la libre expression, and happenings such as *120 minutes dédiées au divin marquis*, he was one of the first practitioners of happenings in 1960s in Europe. A friend of Duchamp and Ernst, Lebel maintained a Surrealist love of wordplay, e.g. his 1964 slogan 'Art is $hit'. A fan of Picabia, Artaud and direct action, he was an active member of the Mouvement du 22 mars during the 1968 uprising, and was also involved with the anarchist group Noir et rouge. He notably championed the work of William S. Burroughs and of Beat poets such as Ferlinghetti, Corso, Ginsberg and McClure, translating them into French in the 1960s. He now organises the Polyphoniz Festival.

MANIFESTO CLUB

Formed in 2006, Manifesto Club's Artistic Autonomy Group is a network of artists, arts administrators, researchers and students who want to defend artistic freedom against restrictive policies and practices. Key members include Josie Appleton, J.J. Charlesworth, Sonya Dyer and Emma Ridgway. The 2007 campaign, *Boxed In*, addressed diversity schemes in arts funding, and the 2008 report focusses on freedom in art schools. The larger organisation, Manifesto Club, is a pro-human London-based campaigning network, with an agenda for a 21st-century Enlightenment. Campaigns are developed through discussions, salons, events, petitions, essays and reports.

TOM McCARTHY

Tom McCarthy (born 1969, British) is a writer and artist. His books include the non-fiction work *Tintin and the Secret of Literature*, 2006, and the novels *Remainder*, 2005 – winner of the Believer Book Award and currently being adapted for cinema by Film4 – and *Men in Space*, 2007. In 1999, McCarthy founded the International Necronautical Society (INS). Part-parody and part-reprise of early 20th-century avant-gardes, the INS surfaces intermittently in the form of publications, proclamations and denunciations, live events and art exhibitions. Recent manifestations include a

public *Declaration on Inauthenticity*, which, initially delivered in the Drawing Center, New York, will be reprised at Tate Britain, London, in January 2009.

JONAS MEKAS

Jonas Mekas (born 1922, Lithuanian) is one of the leading figures of independent and avant-garde cinema. He has dedicated his life and work to establishing independent film as an art form. As a film-maker, critic, curator, editor, distributor, archivist and poet, Mekas has contributed heavily to the creation of the modern avant-garde and independent film movements. Mekas co-founded *Film Culture* magazine as editor-in-chief and began writing his 'Movie Journal' column for New York's *The Village Voice* newspaper. He also co-founded the Film-Makers' Cooperative, the Film-makers' Cinematheque and Anthology Film Archives. His work has been screened extensively at festivals and museums around the world, recently including: the Venice Biennale; Tate Modern, London; and the Museum of Modern Art, New York.

NATHANIEL MELLORS

Nathaniel Mellors (born 1974, British) studied at the Ruskin School, Oxford University, 1996-99, and the Royal College of Art, London, 1999-2001. He is currently resident at the Rijksakademie van beeldende kunsten, Amsterdam. The application of language is a central theme in Mellors's absurdist scripts, psychedelic theatre, film, video, performance, collage and sculpture. Mellors also plays bass guitar in the group Skill 7 Stamina 12 and is co-founder of Junior Aspirin Records. Recent exhibitions include: *Art Now*, Tate Britain, London, 2008; *The Time Surgeon*, Biennale de Lyon, France, 2007; and *Hateball*, Alison Jacques Gallery, London, 2006. Forthcoming ones include: Tate Triennial, London, February 2009; South London Gallery, January 2009; and the Venice Biennale, 2009.

GUSTAV METZGER

Gustav Metzger (born 1926, stateless) is an artist and political activist who developed the concept of 'Auto destructive art' and co-organised the Destruction in Art Symposium in London in 1966. Metzger was also involved in the Fluxus movement and notoriously declared an 'art strike' from 1977 to 1980. Concerned with environmental issues in art already in the 1970s, many of his projects are now seen as prescient. He is still generating new projects – as for Münster Sculpture Projects 2007, Germany – and realising

earlier ideas – as with Project Stockholm. Originally conceived in 1972 for the UN Environmental Conference in Stockholm, now produced for the Sharjah Biennale, United Arab Emirates, 2007, the huge installation consisted of 120 cars that discharged their exhaust fumes into a plastic structure.

ANDREY MONASTYRSKI

Andrey Monastyrski (born 1949, Russian) is an artist who in his installations, videos and actions has explored the connections between word and image, art object and performance, art practice and art criticism, and art and everyday reality. Together with Ilya Kabakov, Yakov Abramov and Nikolai Koslov, Monastyrski belonged to the Moscow conceptualism movement of the 1980s, and can be seen as its methodological founder. In addition, he founded in 1976 the still-existing artists' group Collective Actions, which was of great importance in the promotion of performance-orientated work. He won the Vincent Award in 2006.

INGO NIERMANN

Ingo Niermann (born 1969, German) is a novel-ist, freelance writer, and editor of the book series *Solution*. Now living in Berlin, his published books include: *Solution 9: The Great Pyramid* (with Jens Thiel, 2008, *The Curious World of Drugs and Their Friends* (with Adriano Sack, 2008), *China ruft dich*, 2008, *Metan* (with Christian Kracht, 2007), *Umbauland – Zehn deutsche Visionen*, 2006, *Skarbek* (with Antje Majewski, 2005), *Atomkrieg* (with Antje Majewski, 2004), and *Minusvisionen*, 2003. He co-founded the revolutionary collective Redesigndeutschland, and invented a tomb for all people, the Great Pyramid.

RICHARD NONAS

Richard Nonas (born 1936, American) was educated first in literature and then in social anthropology. He lived as an anthropologist with Native American hunters and trappers in northern Canada's Hudson Bay and Yukon territories and with native farmers and herders in the desert of northern Mexico and southern Arizona. He left anthropology about 40 years ago and began to make sculpture. His sculpture, small and very large, indoor and out, concerns itself with the hidden emotional power of very simple objects. He has built and exhibited such work all over the world. He also continues to write extensively about the meanings, mysteries and strengths of art's peculiar intersection with culture.

YOKO ONO

Yoko Ono (born 1933, Japanese) is a multi-media artist who lives and works in New York City. She is known for her work as an avant-garde artist and musician, and her partnership with musician John Lennon. Yoko is acknowledged as an influential artist who consistently pushes the boundaries of the art, film, music and theatre media.

THE OTOLITH GROUP

The Otolith Group was founded in 2000 by its core members, Anjalika Sagar and Kodwo Eshun, who live and work in London. The Group works with media archives, histories of futurity and the legacies of non-alignment and tricontinentalism. Its work explores moving image, sound, text and curatorial practice and functions as a platform for discussion on contemporary artistic production. Its films and installations have featured widely in international exhibitions and, in 2008, it was a recipient of a LAFVA Award.

CLAUDE PARENT

Claude Parent (born 1923, French) is an architect, author and polemicist known as the creator, with critic Paul Virilio, of the *fonction oblique* theory – which specified that buildings should be about angles and slopes, with minimum walls, and space being more important than surface. Having worked briefly for Le Corbusier, he went on to train some famous architects, including Jean Nouvel. Books include *Vivre à l'oblique*, 1970, and *Claude Parent vu par…* (Édition Le Moniteur, 2006). He designed the French pavilion for the 1970 Venice Biennale, won the Grand prix national de l'architecture in 1979 and was made a member of the Académie des beaux-arts in 2005.

ADAM PENDLETON

Adam Pendleton (born 1980, American) is a New York-based artist. In a conceptual, multi-disciplinary practice that includes painting, writing and perform-ance, Pendleton shifts the meaning of cultural forms, language and images. His work has been exhibited extensively throughout the US and abroad, notably at: the Museum of Contemporary Art, Chicago; the Contemporary Arts Museum, Houston, Texas; the Whitney Museum of American Art, New York; the Stedelijk Museum, Amsterdam; and the Deutsche Guggenheim, Berlin. He is also the co-editor of the occasional magazine *LAB MAG*, which publishes the work of artists, designers, poets and architects.

FALKE PISANO

The body of work of Falke Pisano (born 1978, Dutch) – text-based performances, videos, objects and photocopied publications – has stemmed from a practice of writing. Recent exhibitions include solo shows at: Hollybush Gardens, London (with Benoît Maire); Galerie Balice Hertling, Paris; and Ellen de Bruijne Projects, Amsterdam, 2007. Group exhibitions include: Stedelijk Museum Bureau Amsterdam; Kunsthalle Basel, Switzerland; Berlin Biennale 5; Manifesta 7, Trentino, Italy; and Yokohama Triennale 08, Japan. She is currently editing a publication of her work with Will Holder.

PLATFORM

PLATFORM works across disciplines for social and ecological justice. It combines the transformatory power of art with the tangible goals of campaigning, the rigour of in-depth research with the vision to promote alternative futures. PLATFORM's current work is on oil, coal and gas in relation to social and climate justice. The projects focus on Iraq, Nigeria, Canada and the Caucasus – and the role of London, culture and finance.

MARTIN PUCHNER

Martin Puchner is the H. Gordon Garbedian Professor of English and Comparative Literature at Columbia University, New York. He received his PhD from Harvard University in 1998. Puchner is the author of *Poetry of the Revolution: Marx, Mani-festos and the Avant-Gardes*, 2006 – awarded the 2006 James Russell Lowell Prize for best book by the Modern Language Association – and *Stage Fright: Modernism, Anti-Theatricality and Drama*, 2002, which was translated by Jan Küveler in an expanded edition as *Theaterfeinde: Die anti-theatralischen Dramatiker der Moderne*, 2006. His current project, entitled *Plato's Shadows: Notes on Philosophy, Drama and Performance*, exploring the relationship between philosophy and the theatre.

YVONNE RAINER

Yvonne Rainer (born 1934, American) is a dancer, choreographer, performer, film-maker and writer, who began choreographing in 1961 and made her first film in 1967. She is a key figure in the story of the New York avant-garde, in terms of both her writing and practice. Rainer provided a commentary on the influences that preceded her own aesthetic objectives and articulated her own project through practice and explicatory discourse, establishing her

position within the New York avant-garde from the early 1960s through to the mid 1990s. During this period, she produced 12 films, including silent short works for multimedia performances (which she calls 'filmed choreographic exercises'), as well as features.

RAQS MEDIA COLLECTIVE

The members of Raqs Media Collective (Monica Narula, Jeebesh Bagchi and Shuddhabrata Sengupta) have been variously described as artists, media practitioners, curators, researchers, editors and catalysts of cultural processes. Their work, which has been exhibited widely in major international spaces and events, locates them squarely at the intersections of contemporary art, historical enquiry, philosophical speculation, research and theory. Based in Delhi, they are members of the editorial collective of the *Sarai Reader* series and have curated *The Rest of Now* and co-curated *Scenarios for Manifesta 7*, 2008. 'Raqs' means dance in general, and also the state into which dervishes enter when they whirl.

GILES ROUND

Giles Round (born 1976, British) creates sculptures and assemblages that employ geometric structures, monochromatic panels, lights and typographic schemes. His works utilise the formal language of Modernist and Minimalist art and design, exploring a synthesis between material and form. But these balanced 'displays' also address the co-option of such conventions within décor, and the use of modular elements within high-end living spaces. Moreover, Round's works are highly ritualistic, employing the repetition of purposeless form to invoke the romantic hedonism of a hallucinatory state.

LEE SCRIVNER

Lee Scrivner (born 1971, American) presented and discussed his satiric manifesto *How to Write an Avant-Garde Manifesto* at *Breaking the Rules: The Printed Face of the European Avant-Garde, 1900-37*, British Library, London, February 2008. His poems, music and short plays have been presented at London's Wigmore Hall and Tate Britain, and in Europe and the US. He lectures and writes about a variety of topics, including: insomnia, aphorisms, utopian communities, polygamy, epic poetry and the avant-garde manifesto. He has taught at Birkbeck, University of London, and the University of Nevada, Las Vegas.

TINO SEHGAL

Tino Sehgal (born 1976, Anglo-German) is an artist based in Berlin. His works, which he calls 'constructed situations,' involve one or more people carrying out instructions conceived by the artist over the entire duration of an exhibition. Sehgal studied political economy and dance in Germany (Berlin and Essen) and began to work as an artist in 2000. He has exhibited at a number of important venues, including: the ICA, London; Tate Britain, London, Musée d'art moderne de la ville de Paris; Manifesta 4, Frankfurt; and the German pavilion for the 2005 Venice Biennale.

TARYN SIMON

Taryn Simon (born 1975, American) is a graduate of Brown University and a Guggenheim Fellow. Her most recent major work, *An American Index of the Hidden and Unfamiliar*, 2007, reveals that which is integral to America's foundation, mythology and daily functioning but remains inaccessible or unknown. Her photographs have been exhibited nationally and internationally, including solo shows at: Whitney Museum of American Art, New York; Museum für Moderne Kunst, Frankfurt; and P.S.1 Contemporary Art Center, New York. Simon has been a visiting artist at Yale, Harvard and Columbia universities, and her photography and writing have been featured in *The New York Times* magazine and *The New Yorker*, and on CNN and the BBC.

SPROUT

Formed in 2004, SpRoUt is a UK-based artists collective committed to making interdisciplinary, collaborative and site-sensitive work. The group's most recent project, funded by the Arts Council and the British Council, is the work *Under Construction: Staging the Future*, 2008, based at the Student Centre, Zagreb, Croatia. Previous projects include: *The Space Between*, 2006 – a public art project commissioned by the Towner Art Gallery, Eastbourne, UK – and *Talent on Route*, 2005, in which the audience was transported across London in a Routemaster bus, making a series of 'performance stops' along the way. Core members are: Hannah Chiswell, Laura Cull, Amy Cunningham, Naomi Dawson, Sam Dowd, Hayley Skipper and Sam Steer.

BARBARA STEVENI

Barbara Steveni (British) conceived and co-founded the Artist Placement Group (APG) in London in 1966. APG, later renamed O+I, acted as the

277

precursor to current notions of 'Artist in Residence' and Public Art programmes. Steveni is currently active as artist, curator and lecturer, in particular addressing art and the 'new' economics, art and commerce and 'socially engaged art practice' from (and on behalf of) the artist's voice. Additionally, Steveni is engaged in a personal work under the title *I Am an Archive*, tracing through a series of walks, revisits and interviews, her life and role within APG/O+I, in relation to today's circumstance, and to current and future art practice.

MATTHEW STONE

Matthew Stone (born 1982, British) is an artist and self-proclaimed shaman based in London. Stone's extended practice includes photography, performance, sculpture, writing and curating. Following his graduation from Camberwell College of Arts in 2004, he was a formative member of the !WOWOW! art collective. In recent years, he has been researching the relevance of optimism as a method for avant-garde thought and art practice – culminating in a series of projects, such as the exhibition *Optimism – The Art of our Times* at London's Hannah Barry Gallery in October 2008.

STURTEVANT

Sturtevant (born 1930, American) has exhibited internationally since the early 1960s. She has also written and lectured extensively. Recent exhibitions include: *Vertical Monad*, Anthony Reynolds Gallery, London, 2008; *Higher Power*, Galerie Thaddaeus Ropac, Paris, 2007; and *The Brutal Truth*, MMK Frankfurt, 2004. Recent group exhibitions have included the 2006 Whitney Biennial, New York; and *Digital Click*, 2008 (touring). A major exhibition of Sturtevant's work will be held in early 2010 at the Musée d'art moderne, Paris.

TAVERNA ESPECIAL

Established in the summer of 2003, Taverna Especial is both a kitchen and a salon for the reception and consideration of a singular art work. Co-founded by the artists Giles Round (born 1976, British) and Mark Aerial Waller (born 1969, British), Taverna Especial has a mythic core; as such, it was created through a constantly evolving system of chance happenings. The original premises, situated on a housing estate parade off Hackney Road, closed its doors in 2006 following the traumatic metamorphosis of the area by the set dressers of the dystopic science fiction film fable *Children of Men*.

MARK TITCHNER

Mark Titchner (born 1973, British) has had solo shows at major institutions including: BALTIC, Gateshead, UK, 2008; Arnofini, Bristol, UK, 2006; and De Appel, Amsterdam, 2004. He has also participated in group shows at the Moscow Museum of Art (Petrovka site, 2007); ZKM, Karlsruhe, Germany, 2007; Hayward Gallery, London, 2006; South London Gallery, 2005; Royal Academy, London, 2004; and Tate Liverpool, 2004. In 2006, he was nominated for the Turner Prize, and he was commissioned by Creative Time to produce a site-specific work for Time Square, New York. In 2007, he participated in *A Poem about an Inland Sea* for the Ukraine pavilion, at the 52nd Venice Biennale.

JALAL TOUFIC

Professor Jalal Toufic (born 1962, Iraqi) is a thinker, writer and artist. He is the author of *(Vampires): An Uneasy Essay on the Undead in Film* (1993; 2nd ed., 2003); *Over-Sensitivity*, 1996; *Forthcoming*, 2000; *Undying Love, or Love Dies*, 2002; *Two or Three Things I'm Dying to Tell You*, 2005; *'Āshūrā': This Blood Spilled in My Veins*, 2005; and *Undeserving Lebanon*, 2007. He has taught at the University of California at Berkeley; CalArts, Valencia, California; University of Southern California, Los Angeles; and the Rijksakademie van beeldende kunsten, Amsterdam, and he is currently a professor at Kadir Has University, Istanbul.

AGNÈS VARDA

Agnès Varda (born 1928, Greek father and French mother) briefly studied in Paris. Photographer in the 1950s. First film in 1954: *La point courte*. It gave her the title of 'Grandmother of the French New Wave'. The best-known films of Varda: *Cléo de 5 à 7*, 1961, *Sans toit ni loi* (*Vagabond*), 1985, *Jacquot de Nantes* (*Jacquot*), 1990, *Les glaneurs et la glaneuse* (*The Gleaners and I*), 2000. Video installations: *PATATUTOPIA* at *Utopia Station*, the 50th Venice Biennale, 2003. Big exhibition: *L'île et elle*, Fondation Cartier, Paris, 2006.

BEN VAUTIER

Ben Vautier (French, 1935) hates biographies because they are 'only ego'. The artist wanted to abandon art, but only made art. He says that art 'often bores' him, but that he cannot get it out of his mind. Some consider him a Fluxus artist, but he prefers to say: 'Newness is important, but newness is as old as the world.' Exhibitions include:

278

Rien et tout, Laboratoire 32, Nice, France, 1960; Institut de l'art contemporain, Antwerp, Belgium, 1972; Stedelijk Museum, Amsterdam, 1973; MuHKA, Antwerp, Belgium, 1987; *Le forum des questions*, Centre Georges Pompidou, Paris, 1991; MAC, Marseilles, 1995; and *Le biz'art baz'art*, Musée de Lyon, France, 2004.

MARK WALLINGER

Mark Wallinger (born 1959, British) is an artist best known for his sculpture for the empty fourth plinth in London's Trafalgar Square, *Ecce Homo*, 1999-2000, and for his *State Britain*, 2007, a recreation at London's Tate Britain of Brian Haw's anti-war protest display outside the Houses of Parliament. He studied in London – at the Chelsea School of Art, 1978-81, and Goldsmiths College, 1983-85 – and he continues to live there. Since the mid-1980s, Wallinger's primary concern has been to establish a valid critical approach to the 'politics of representation and the representation of politics'. Shortlisted for the Turner Prize in 1995, he represented Britain at the 49th Venice Biennale in 2001; he won the Turner Prize in 2007.

MARK AERIAL WALLER

Mark Aerial Waller (born 1969, British) graduated in 1993 from Central St Martins College of Art and Design, London, having studied sculpture and film/video; he has exhibited extensively throughout Europe. Working through film and video, drawings and site-specific sculpture and installations, he stages elliptical psychological landscapes, in which fantasy and documentary become almost interchangeable.

AI WEIWEI

Ai Weiwei (born 1957, Chinese) is an artist, curator, architectural designer and cultural commentator. While a student at the Beijing Film Academy, he was one of the founders of the avant-garde group 'The Stars'. From 1981 to 1993, Ai was living in the US, mainly in New York, but moved back to China in 1993. He was artistic consultant for Herzog & Meuron for building the 'Bird's Nest' stadium for the 2008 Beijing Olympics. Exhibitions include the 48th Venice Biennale 1999; the First Guangzhou Triennial 2002, China; 'Zones of Contact', the 2006 Biennale of Sydney; and Documenta 12, Kassel, Germany.

RICHARD WENTWORTH

Richard Wentworth (born 1947, British) is an artist, curator and teacher currently based at the Ruskin School of Drawing and Fine Art, Oxford. He studied at London's Hornsey College of Art and Royal College of Art, and has also taught at Goldsmiths College, London, 1971-87. He was awarded the Mark Rothko Memorial, 1974, and the Berlin DAAD Fellowship, 1993-94. Shunning the monumental gesture, Wentworth finds his materials in the everyday world, a world of things and thoughts already made.

VIVIENNE WESTWOOD

Vivienne Westwood (born 1941, British) has been uniting fashion and music since she opened her first store with Malcolm McLaren on London's King's Road back in 1971. The shop's name (Let It Rock; Too Fast to Live, Too Young to Die; Sex; Seditionaries; World's End) has mirrored sea-changes in popular culture. In 1981, Westwood unveiled her first runway collection, *Pirate*, marking her move from street culture into the world of traditional tailoring. 1990 was a significant year: she unveiled her *Portrait* collection, revealed her first menswear collection and was awarded the title of British Designer of the Year, an accolade repeated in 1991. In 1992, she was made an Honorary Senior Fellow at the Royal College of Art and was awarded an OBE. The Victoria & Albert museum in London recently hosted her first retrospective, now touring internationally.

STEPHEN WILLATS

Stephen Willats is an artist working in London since the late 1950s.

LEBBEUS WOODS

Lebbeus Woods (born 1940, American) is an architect and theoretician whose work focusses on experimentation and critical transformations of buildings, cities and landscapes. His most notable projects include designs for the reconstruction of Sarajevo and Havana, as well as architectural installations in New York, Paris and Vienna. His works are in public collections, including the Museum of Modern Art in New York and the Getty Research Institute in Los Angeles. He was the recipient of the Chrysler Award for Innovation in Design in 1994 and the American Academy of Arts and Letters Award for Architecture. He is presently Professor of Architecture at the Cooper Union in New York.

279

ACKNOWLEDGEMENTS

The generosity of supporters is vital to the Gallery's success. Grants from Arts Council England and Westminster City Council provide 18% of the Gallery's annual budget. The remaining £4 million is raised through the support of individuals, corporate sponsorship, charitable organisations and sales of merchandise. The Serpentine would like to thank the individuals, trusts, foundations and companies whose generosity and foresight enable the Gallery to realise its acclaimed Exhibition, Architecture, Education and Public Programmes.

TRUSTEES OF THE SERPENTINE GALLERY
Lord Palumbo, Chairman; Felicity Waley-Cohen and Barry Townsley, Co-Vice Chairmen; Marcus Boyle, Treasurer; Patricia Bickers; Mark Booth; Roger Bramble; Marco Compagnoni; David Fletcher; Bonnie Greer; Zaha Hadid; Rob Hersov; Isaac Julien; Colin Tweedy

COUNCIL OF THE SERPENTINE GALLERY
Rob Hersov, Chairman, Marlon Abela, Shaikha Paula Al-Sabah, Saffron Aldridge, Goga Ashkenazi, Mr and Mrs Harry Blain, Len Blavatnik, Mark and Lauren Booth, Alessandro Cajrati Crivelli, Jeanne and William Callanan, Ricki Gail Conway, Aud and Paolo Cuniberti, Carolyn Dailey, Guy and Andrea Dellal, Marie Douglas-David, Charles Dunstone, Jenifer and Mark Evans, Lawton W. Fitt and James I. McLaren Foundation, Lorenzo Grabau, Richard and Odile Grogan, Mala and Oliver Haarmann, Jennifer and Matthew Harris, Petra and Darko Horvat, Michael Jacobson, Mr and Mrs Tim Jefferies, Diana and Roger Jenkins, Dakis Joannou, Giles Mackay, Jimmy and Becky Mayer, Pia-Christina Miller, Martin and Amanda Newson, J. Harald Örneberg, Catherine and Franck Petitgas, Eva Rausing, Yvonne Rieber, Spas and Diliana Roussev, Robin Saunders and Matthew Roeser, Silvio and Monica Scaglia, Anders and Yukiko Schroeder, Robert and Felicity Waley-Cohen, Bruno Wang, John and Amelia Winter, Manuela and Iwan Wirth, Cynthia Wu, Anna and Michael Zaoui

And members of the Council who wish to remain anonymous

COUNCIL'S CIRCLE OF THE SERPENTINE GALLERY
Ivor Braka; Nicholas Candy; Johan Eliasch; Elizabeth von Guttman; The Hon. Robert Hanson; Michael and Ali Hue-Williams; Jolana Leinson and Petri Vainio; Elena Marano; Matthew Mellon, in memory of Isabella Blow; Tamara Mellon; Stephen and Yana Peel

FOUNDING CORPORATE BENEFACTOR
Bloomberg

PLATINUM CORPORATE BENEFACTORS
Arup, Finch & Partners, La Fondation Louis Vuitton pour la création and LVMH, Louis Vuitton, NetJets Europe, Omni Colour Presentations, Savant, Stanhope plc, Taylor Woodrow, Tiffany & Co. Europe

GOLD CORPORATE BENEFACTORS
Carey Group plc, Gotshal & Manges, The Independent, Kuoni, Laurent-Perrier, Nüssli, The Observer, Puma, Weil

SILVER CORPORATE BENEFACTORS
Knight Frank LLP, N.G. Bailey, Working Title

BRONZE CORPORATE BENEFACTORS
Art Review, Davis Langdon LLP, DP9, Eckelt Glass, Elephant Beanbags, EMS, GaydarNation.com, GTL Partnership, Hewden, John Doyle Group, Lend Lease Projects, London Review of Books, Saint-Gobain Glass, Simmons & Simmons, Site Engineering Surveys Ltd, TheNod.com, Warburg Pincus, we-ef

EDUCATION PROJECTS SUPPORTED BY
Bloomberg

EDUCATION PROGRAMME SUPPORTED BY
The Annenberg Foundation, Awards for All, Big Lottery Fund, City Bridge Trust, The Dr Mortimer and Theresa Sackler Foundation, The Eranda Foundation, FABA Fundación Almine y Bernard Ruiz-Picasso Para el Arte, Fondation de France, Graham Foundation for Advanced Studies in the Fine Arts, Grants for the Arts, Heritage Lottery Fund, Housing Corporation, John Lyon's Charity, London Councils, The Rayne Foundation

AND KIND ASSISTANCE FROM
The Lone Pine Foundation, The Nyda and Oliver Prenn Foundation, The Philip and Irene Gage Foundation, The Royal Borough of Kensington and Chelsea, Westminster Arts, Westminster City Council

EXHIBITION PROGRAMME
supported by: Aicon Gallery; Austrian Cultural Forum; Austrian Embassy; Cristina Bechtler/Inktree, Switzerland; Calouste Gulbenkian Foundation; Sadie Coles/Sadie Coles HQ; Marie Donnelly; Embassy of the United States of America, London; Foundation for Indian Contemporary Art; Friedrich Petzel Gallery, New York; Larry Gagosian/Gagosian Gallery; Galerie Max Hetzler, Berlin; Linda A. Givon; Christine and Andy Hall; Hauser & Wirth Zürich London; The Henry Moore Foundation; Maja Hoffmann; Sean and Mary Kelly, New York; Mr and Mrs Edward Lee; Aaron and Barbara Levine; Toby Devan Lewis; The Linbury Trust; LUMA Foundation; Pia-Christina Miller; Outset Contemporary Art Fund; John and Amy Phelan; The Red Mansion Foundation; Ruth and Richard Rogers; Victoria Miro Gallery. Emeritus Benefactor: Edwin C Cohen and The Blessing Way Foundation

HONORARY PATRON
Anthony Podesta, Podesta/Mattoon.com, Washington DC

HONORARY BENEFACTORS
Gavin Aldred, Mark and Lauren Booth, Noam and Geraldine Gottesman, Mark Hix, Catherine and Pierre Lagrange, Stig Larsen

PATRONS
Mrs Markvo Alexandrina, Marie-Claire, Baroness von Alvensleben, Alan and Charlotte Artus, Dr Bettina Bahlsen, Steve and Carrie Bellotti, Philippe and Bettina Bonnefoy, Charles and Léonie Booth-Clibborn, Brian Boylan, Patrick Brennan, Mrs Tony Buckingham, Laurent and Micky Caraffa, Rattan Chadha and Catia von Huetz, Patricia Chi, Dr Martin A. Clarke, Sir Ronald and Lady Cohen, Terence and Niki Cole, Stevie Congdon and Harriet Hastings, Alastair Cookson, Kimbell and Yelena Duncan, Frank and

FUTURE CONTEMPORARIES

SERPENTINE GALLERY PAVILION 2008 DESIGNED BY FRANK GEHRY 20 JULY – 19 OCTOBER

The *Serpentine Gallery Pavilion 2008* gives England the first built project by legendary architect Frank Gehry. The spectacular structure – designed and engineered in collaboration with Arup – is anchored by four massive steel columns and comprises large timber planks and a complex network of overlapping glass planes that create a dramatic, multidimensional space. Gehry and his team took inspiration for this year's Pavilion from a fascinating variety of sources, including the elaborate wooden catapults designed by Leonardo da Vinci, as well as the striped walls of summer beach huts. Part-amphitheatre, part-promenade, these seemingly random elements make a transformative place for reflection and relaxation by day, and discussion and performance by night.

SERPENTINE GALLERY PAVILION COMMISSION

The Serpentine Gallery Pavilion commission was conceived in 2000 by Julia Peyton-Jones, Director of the Serpentine Gallery. It is an ongoing programme of temporary structures by internationally acclaimed architects and individuals. It is a unique scheme worldwide and presents the work of an international architect or designer who, at the time of the Serpentine Gallery's invitation, has not completed a building in England. The Pavilion architects to date are: Olafur Eliasson and Kjetil Thorsen, 2007; Rem Koolhaas, with Cecil Balmond of Arup, 2006; Álvaro Siza and Eduardo Souto de Moura, with Cecil Balmond of Arup, 2005; MVRDV, with Arup, 2004 (unrealised); Oscar Niemeyer, 2003; Toyo Ito, with Arup, 2002; Daniel Libeskind, with Arup, 2001; and Zaha Hadid, 2000. Each Pavilion is sited on the Gallery's lawn for three months and the immediacy of the process – a maximum of six months from invitation to completion – provides a peerless model for commissioning architecture.

SERPENTINE GALLERY PARK NIGHTS

Park Nights is a programme of events that run between July and October in and around the Serpentine Gallery Pavilion. *Park Nights* includes Friday and Saturday Performances, music and film screenings. The 2008 programme culminates with the *Manifesto Marathon*. Please find full programme of *Park Nights* on the website.

SERPENTINE GALLERY MANIFESTO MARATHON 18 – 19 OCTOBER 2008

Curators
Hans Ulrich Obrist, *Co-director of Exhibitions and Programmes and Director of International Projects*
Julia Peyton-Jones, *Serpentine Gallery Director and Co-director of Exhibitions and Programmes*
Sally Tallant, *Head of Programmes*
Nicola Lees, *Public Programmes Curator*

Special thanks to Christian Boltanski for the conversations that triggered this project.

Assisted by
Capucine Perrot, *Public Programmes Assistant*
Mia Jankowicz, *Public Programmes Assistant*
Dean Kissick, *Public Programmes Intern*

Editorial and Publishing
Edited by Nicola Lees
Copy edited by Tom Cobbe
Cover by Hans Ulrich Obrist & Zak Kyes
Designed by Z.A.K. (Zak Kyes, Grégory Ambos)
Printed by Printmanagement Plitt, Oberhausen
Printed in Germany

Serpentine Gallery
Kensington Gardens, London W2 3XA
T +44 (0)20 7402 6075 F +44 (0)20 7402 4103
www.serpentinegallery.org
Open daily 10am – 6pm, Fridays 10am – 10pm
Admission free

96739

Photography credits
© Mark Blower

First published by Koenig Books London

Koenig Books Ltd
At the Serpentine Gallery
Kensington Gardens
London W2 3XA
www.koenigbooks.co.uk

Distribution
Buchhandlung Walther König, Köln
Ehrenstr. 4, 50672 Köln
T +49 (0) 221 / 20 59 6 53
F +49 (0) 221 / 20 59 6 60
verlag@buchhandlung-walther-koenig.de

UK & Eire
Cornerhouse Publications
70 Oxford Street
GB-Manchester M1 5NH
T +44 (0) 161 200 15 03
F +44 (0) 161 200 15 04
publications@cornerhouse.org

Outside Europe
D.A.P. / Distributed Art Publishers, Inc.
155 6th Avenue, 2nd Floor
New York, NY 10013
T +1 212 627 1999
F +1 212 627 9484
eleshowitz@dapinc.com

ISBN 978-3-86560-694-5 (Koenig Books)
ISBN 978-1-905190-31-7 (Serpentine Gallery)

THANK YOU LIST

Annalaura Alifuoco, Frank Anthony, Sabina Arthur, Divide Balliano, BFI, Giovanni Bienne, Klaus Biesenbach, Carmen Billows, Victoria Boucher, The British Library, Stephen Bury, Alison Clarke, James Clossick, Martyn Coppell, Moira Dalant, Meline Danielewicz, John Decemvirale, Shenna Ellis, Tim Etchells, Julia Fabry, Sophie Fiennes, Camila Fiori, Doug Fishbone, Koene van Geene, Fabrizio Gallanti Jette Gindner, John Gorick, Clara Giraud, Ashley Gould, Heather Haslett, Steve Hubbard, Martin Jady, Koo Jeong-A, Shanay Jhaveri, Elisa Kay, Ohki Kindaichi, Bettina Korek, Chryssanthi Kourie, Deborah Levy, Gemma Lloyd, Antonia Lotz, Elizabeth Lovero, Silvana Maimone, Genevieve Maitland-Hudson, Karen Marta, Teresa Mavica, Kevin McDermott, Karla Jane Merrifield, Fiontan Moran, Michelle Nicol, Molly Nesbit, Benn Northover, Owen Parry, Chris Peacock, Q2Q Productions, Frederick Roll, Shannon Simon, Eve Smith, The South London Gallery, Beatriz Souviron, Tune Spierings, Aida Strkljevic, J. Milo Taylor, Somi Umolu, Jonny Woo

283

769.22
Ser

PARK NIGHTS

Supported by
KUONI

FUNDACIÓN
ALMINE Y BERNARD
RUIZ-PICASSO
PARA EL ARTE

Media Partner
DAZED

SERPENTINE GALLERY PAVILION 2008
DESIGNED BY FRANK GEHRY

Sponsored by
NETJETS

With
TIFFANY & CO.

Media Partner
THE
INDEPENDENT

Advisors
ARUP

STANHOPE

Platinum
Sponsors
Sa**y**ant Taylor Woodrow

Gold
Sponsors
CAREYS NÜSSLI WEIL, GOTSHAL & MANGES

Silver
Sponsors
Knight Frank NG Bailey

Bronze
Sponsors
DAVIS LANGDON DP9 EXCEL / Saint-Gobain Glass Solutions EMS GTL Partnership

HEWDEN INDEPENDENT ACCESS JOHN DOYLE Lend Lease Projects SAINT-GOBAIN GLASS

 we-ef

Café
GAIL's

Supported by
ARTS COUNCIL ENGLAND Supported by City of Westminster THE ROYAL PARKS